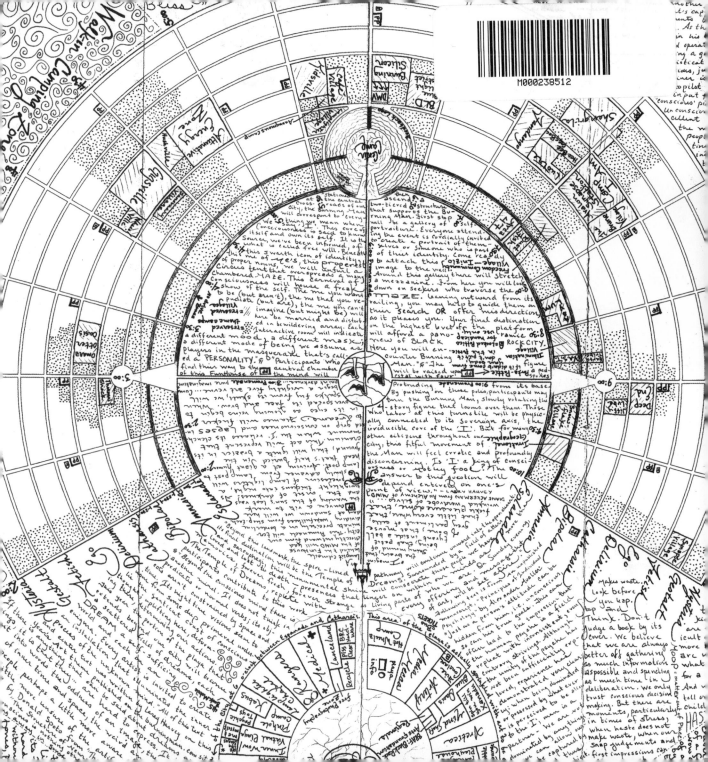

BURNING

A VISUAL HISTORY OF BURNING MAN

JESSICA BRUDER

FEATURED PHOTOGRAPHY BY

NK GUY • TIM TIMMERMANS • STEWART HARVEY • RICK EGAN • AND MANY MORE

SIMON SPOTLIGHT ENTERTAINMENT

NEW YORK
LONDON
TORONTO
SYDNEY

FOR MICHAEL EVANS,
WITH PIE

SIMON
SPOTLIGHT
ENTERTAINMENT
AN IMPRINT OF
SIMON & SCHUSTER
1230 Avenue of the Americas
New York, New York
10020

TEXT
COPYRIGHT
© 2 0 0 7
by Jessica Bruder
ALL RIGHTS RESERVED,
INCLUDING THE RIGHT
OF REPRODUCTION IN
WHOLE OR IN PART IN
ANY FORM.

SIMON
SPOTLIGHT
ENTERTAINMENT
AND RELATED LOGO
are trademarks of
SIMON & SCHUSTER,
INC.

MANUFACTURED
in the
UNITED
STATES OF
AMERICA

FIRST
EDITION
10 9 8 7 6 5 4 3 2 1

Book design by Martin Venezky/Appetite Engineers

Library of Congress Cataloging-in-Publication Data
Bruder, Jessica.
Burning book : a visual history of Burning Man / Jessica Bruder.—1st ed.
p. cm.
ISBN-13: 978-1-4169-2824-9
ISBN-10: 1-4169-2824-3
1. Burning Man (Festival). 2. Performance art—Nevada—Black Rock Desert.
3. Black Rock Desert (Nev.)—Social life and customs. I. Title.
NX510.N32B632 2007
394.2509793'54—dc22
2006028838

Excerpt on page 279 from "Ballad of La Contessa,"
copyright © by Kelek Stevenson, Anna Fitch, and Sarah Hanken
Excerpt on page 297 from "La Contessa," copyright © by Daryl Henline

Photo credits appear on pages 353 and 354.

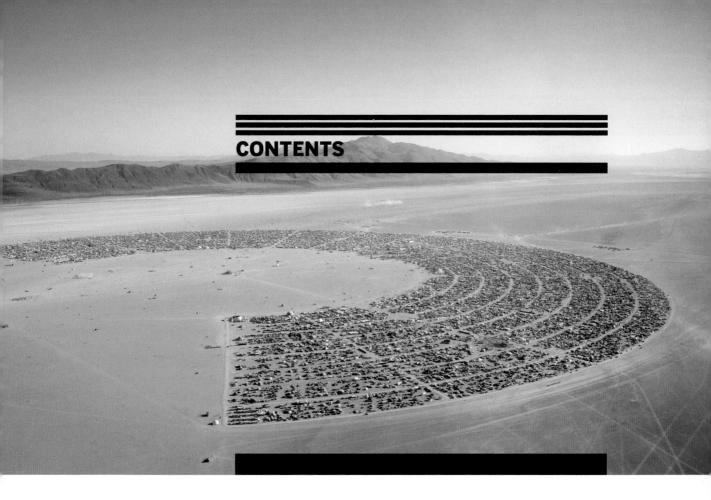

CONTENTS

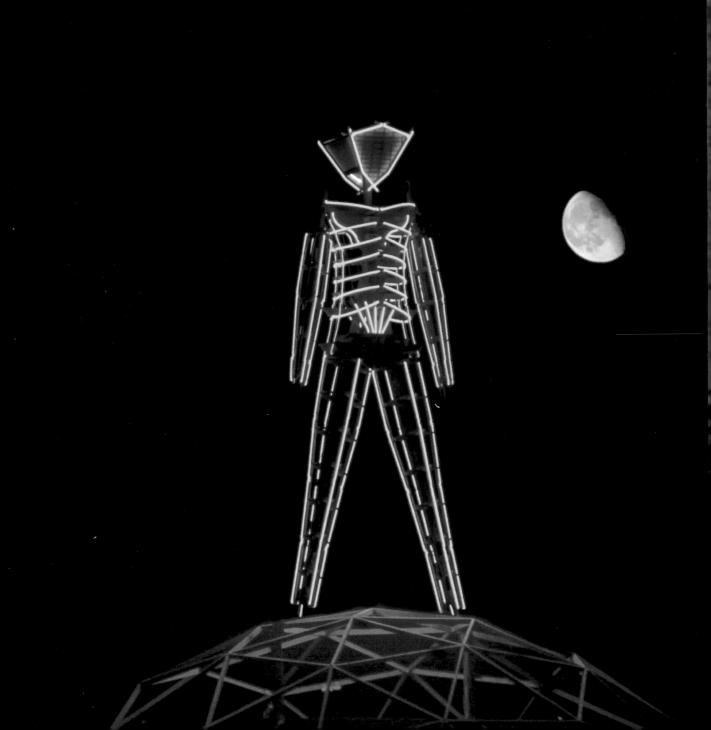

★ TINDER

THE MAN IS A WOODEN MONUMENT

to nothing specific, in the middle of nowhere. He's a stick figure drawn huge, a splinter jutting out of the Nevada desert.

He looks like a man only in the way folded paper looks like an airplane—suggestive lines, not much definition. Still, you can't mistake him. Anchored to a giant pedestal, he rises eighty feet from the ground. When the sun drops behind the Granite Range to the west, his spindly frame lights up with neon tubes. You can see him **{ glow }** like a truck stop sign from more than a mile away.

For the past week a temporary city has been swelling around him, hoisted out of the dust and duct-taped together by nearly forty thousand pairs of hands. The city is roughly circular, with the Man as its axle. Everything turns, grows, and changes around him.

Then, on Saturday evening, it's the Man who changes. His arms rise slowly from his sides like levers on a corkscrew. The gesture

is triumphant, but it also means that he doesn't have much time left. Thousands of temporary homes—tents, RVs, geodesic domes draped in parachute fabric—are emptying. From all directions, revelers converge on the Man.

They're dressed like Egyptian gods and leather angels, sci-fi space jockeys and feral children. They come on stilts and bicycles, dangling from cranes and cherry pickers, riding on the decks of homemade pirate ships. Their faces are streaked with glitter and dirt.

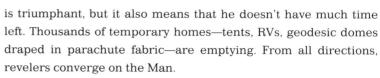

"Burn!"
"Burn it!"
"Burn *him!*"

They form a wide ring around the Man. Inside the circle, lean dancers twirl balls of fire on chains, tracing bright arcs that illuminate their bodies.

Another contingent is dancing, kissing, screaming. A few happy contrarians chant "Save the Man!" and brandish picket signs. Dozens of drummers bang out a deafening cadence. Camera flashes alternate with sudden puffs of fire from car-mounted flamethrowers, ignited past the fringe of the crowd.

All week long these audience members were the show. They gave heartfelt gifts to strangers, cooked communal dinners, washed each other's hair, welded towering sculptures, enacted whatever ideas bubbled up in their brains. They outdid each other with displays of courage and cunning, effort and care. But tonight they're all part of the same crowd, watching.

With a sudden crack, fireworks spit into the sky from the base of the Man and explode. There's a second volley, and the Man catches fire. People are grinning and punching fists in the air, or hanging

on to each other like they could fall off the world. The fire casts its light on them, and a few faces are tracked with tears.

Flames climb the Man's skeletal torso. Sparks erupt from his joints. The neon tubes begin to fail, and limb by limb, rib by rib, his glowing bones go dark. By the time the fire reaches his head—a latticed polygon, like the face of a Japanese lantern—the Man's skeleton is in full flame, a brighter silhouette at the center of a growing blaze. Dark smoke billows up from the pyre. Overhead, more fireworks burst and fade. Each one illuminates the crowd like a strobe.

The Man begins to fall apart. One arm crashes down and dangles at his side. All that's left of his pedestal is a red-hot jungle gym of two-by-fours. The moment nears. He can't bear his own weight; he could drop at any second. The crowd roars with impatience.

Now, **now,** *now* . . .

No one breathes. Then, all at once, the Man falls. He tips like a bottle, hitting the ground in a draft of sparks.

The Man is down.
The Man is down.

Burning Man 1999

The Man is down, and the circle collapses as people rush in, getting so close that it's too hot to stand still. If they don't keep moving, shimmering currents of heat will start to sear their skin. The air is full of hot, drifting embers that burn like immediate stars. A few people peel off their clothes and toss them onto the flames. The mob is shoulder to shoulder, lumbering around the remains of the Man in a counterclockwise circle. Every few seconds someone breaks from the pack to leap and twist over the lip of the fire, before plunging to safety in a mass of bodies on the other side. A misjudged step will bring disaster.

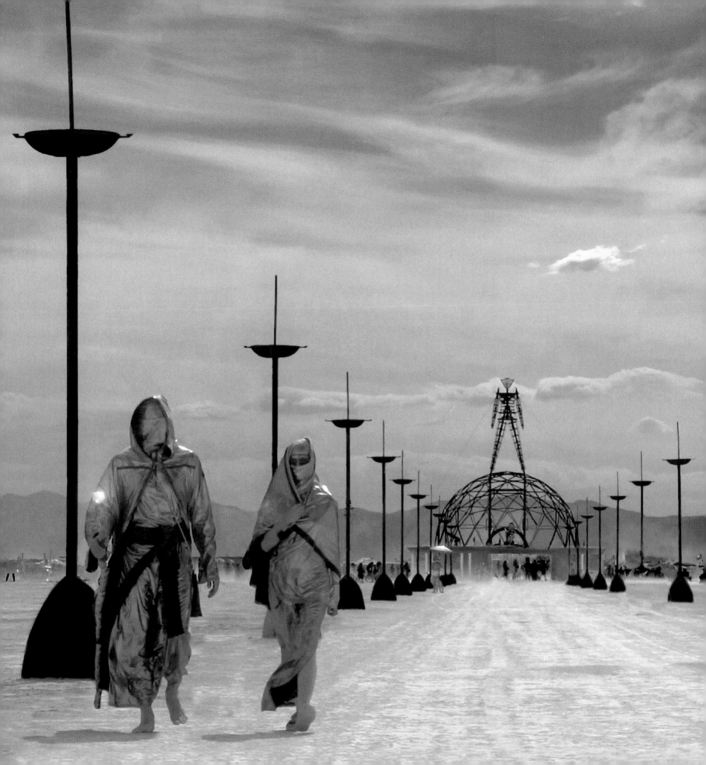

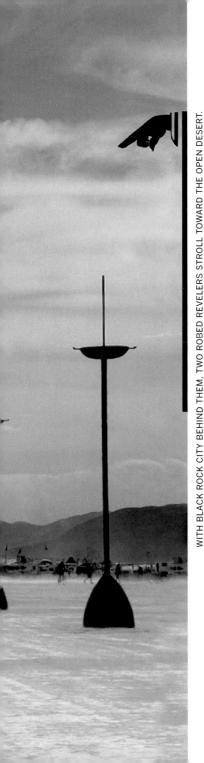

You can see the end from here. No one wants to talk about that, but a quiet urge is spreading while the hours narrow: ··················

DO IT NOW, WHATEVER "it" MAY BE, OR DON'T.

Starting tomorrow, the week's spell will break. Pieces of the city will be packed away in crates, consumed by fire, or dragged out in trash bags. Neglected sunburns will start to peel. The lack of sleep will tug at shoulders. There will be an exhausted exodus, and then a bleary reunion with jobs and bills, the cling of responsibility, and strangers who don't meet your eyes in the street. The evening news will come from another desert, where a war is happening.

This last bacchanal will stretch through the night. It will run and rage until dawn leaks over the mountains and reveals, where the Man went down, a curl of smoke and a shallow pile of ash.

The custom looks simple, *IF* **STRANGE :** Thousands of pilgrims arrive each summer in the Black Rock Desert, a parched, forbidding stretch of alkali dust in northwestern Nevada. They build a temporary city around a wooden man. Then they set him on fire. That flaming finale is an ultimate catharsis, something like **LORD OF THE FLIES** on the Fourth of July. It's also completely overwhelming in scale, casting a glow that lights thousands of faces.

Back in 1986, when a few friends roasted a rough-hewn effigy on a San Francisco beach, they didn't realize that they were founding a ritual. Their bonfire evolved from a small gathering into an annual party; gradually the event gathered steam, got a name, and **EXPLODED** into the center of an enormous, celebratory metropolis. Their tradition grew into a culture. It spawned a scene so beguiling that people now travel from all over the world to take part in what has become America's most fascinating festival. They take

leave of comfortable lives and spend the week before Labor Day in an unforgiving landscape, a venue vast and empty enough to support impossible acts of creativity. Together, they re-enact a strange vision: a rite that rose from bits of tinder.

Many of the people who gather at Burning Man have been here before. They've already watched that one big fire, acting out roles in a show that seems choreographed to incinerate inhibitions and reveal the naked id. Through the years, they have changed—gotten older and launched careers, marriages, and families—but the climactic scene, the burning of the Man, hasn't changed very much. The first time you see it, ••

•••••••• there's a

But after you've watched it a couple of times, the sensation starts to caramelize. How many times can one thing feel spontaneous, even if that thing is on fire?

Nowadays you can see the show from almost anywhere. Footage of the fire is transmitted to television sets across the country. There's a free simulcast on the Internet. You can watch the Man fall from a cozy armchair in your living room, without getting so much as a speck of desert dust (OR FLYING HOT EMBERS) in your hair. You won't be tired, or thirsty, and chances are you'll have a much better view than some of the people who are actually there. You can also read the headlines. Dozens of them have distilled Burning Man since 1996, when Bruce Sterling's big story made the cover of **WIRED** magazine, crowning the festival **"THE NEW AMERICAN HOLIDAY."**

Since then, Burning Man has been called everything from **"WOODSTOCK AT THE STAKE"** to **"THE NEON BABYLON," "PAGAN**

SACRIFICE in the NEVADA DESERT,**"** **"**OPERATION DESERT SWARM,**"** and **"**BONFIRE of the INANITIES.**"**

So why do the pilgrims, in growing numbers, still journey to that bleak desert? They go because the burning Man—a one-ton monument in flames—isn't the whole of Burning Man. At best, the Man is a vaguely coherent ambassador for everything else that happens in the five square miles around him, the area known to its inhabitants as Black Rock City. This settlement—a place that writer Stephen Black once called, with admirable precision, an **"Ephemeropolis "** —requires the work of their own hands. They fill the desert with a staggering variety of art and amusements, gatherings and performances, and when the week is over, they scour the dust to make it all disappear. The festival runs on a simple credo: **"NO SPECTATORS."** To put it plainly, the city is the work of the people who live there. If everyone came to sit back and absorb the culture, there would be nothing for them to see.

Burning Man is a collective, participatory experience. How does it happen? For an analogy, consider **STONE SOUP**, the fable of a few hungry travelers who set up camp in a village of strangers, build a fire, and drop a "magic rock" into a pot of water. The stone, they declare, will simmer into a sumptuous feast. The spectacle is so ludicrous that villagers are drawn to it, and each one adds a little garnish: cabbage, carrots, onions, whatever happens to be lying around the pantry. Finally the villagers share a meal more satisfying than any of them could have prepared alone. Of course, no one eats the rock—it's a garden-variety pebble and, as such, has little nutritional value—and what they consume is the sum of what they gave.

At Burning Man, that "magic rock" is something much flashier: a giant, burning effigy. The Man is the catalyst of the festival, but

not its core. He bears no more significance than a soup stone. Black Rock City is a strange and savory place, and its essential ingredients come from the villagers, the people who bring a homemade metropolis to life. When they've done their work, the Man becomes the least important part of the story.

Since thousands of people are enacting their own visions of what Burning Man ought to be, Black Rock City is inherently plural and constantly changing. Some people believe that Burning Man is an arts festival: a gallery of invention that grows in the desert dust. Some say it's an experiment in community: a test drive for new models of human interaction. Other folks treat it like it's a spiritual journey, a sex romp, a pyrotechnic potlatch, or an excuse to run around for a week in outlandish clothes and, on occasion, no clothes at all. People call it the best party of the year. Others consider it a political statement against consumer culture, a self-absorbed ode to decadence, a big dirty campout, or an oddly inconvenient vacation. Some old-timers say that Burning Man has gone soft since its fabled outlaw years, when it was much easier to get maimed or lost in the desert.

When definitions fail, people describe the scene as a confusing kaleidoscope of references. Something like: Burning Man is Fellini directing **ALICE IN WONDERLAND** on the set of **MAD MAX** in one of Italo Calvino's **INVISIBLE CITIES,** with props by Duchamp and Dali, second-hand costumes from **BARBARELLA,** the Beatles, and Ringling Bros., casting by Hieronymus Bosch, and a planned premiere on Tatooine. This is a decent simulation of sensory overload, but it doesn't tell you very much. It's an elaborate way of saying,

"**MAN,** YOU HAD to BE THERE !!!!!!!!!!" that takes ten times as long.

No matter how they explain what they're doing out there, people assemble on the playa—the ancient, crumbling lakebed of the Black Rock Desert—to live how they wish, at least for a while. Referred to en masse, the congregants are commonly known as "burners," but it's a label that some of them openly disdain. (NO MATTER HOW INTENSE BURNING MAN MAY FEEL, THEY ARGUE, IT DOESN'T AMOUNT TO AN IDENTITY OR A LIFESTYLE: IT'S AN EVENT.) But language offers few other ways to describe them, apart from repeating "people who go to Burning Man" over and over; so, for the sake of saving ink, this book will stick to the word "burners," with the caveat that it's a wide, weird canopy that stretches over thousands of lives and across a desert, offering barely enough shade from the August sun.

The festival isn't about what you call them, anyway. It's about what they do. For years observers have been identifying nebulous social forces to which Burning Man can be—**MUST BE!**—a response: the rise of secular and corporate culture; the expansive connectivity (AND LATER, THE PHYSICAL ALIENATION) of the Internet; the hardening of America in an era of homeland security. These subtexts are interesting enough, but none of them quite scream, "Let's go to the desert and make something!" They aren't intimate enough to account for some subtler explosions: what actually happens in the desert when thousands of people embark on a collective experience.

That story is a journey: how they get there, what they do, and how they integrate a week's worth of dust, ashes, and ideas into their lives after the last fire goes out. It's about what they burn and, even more, about what they build.

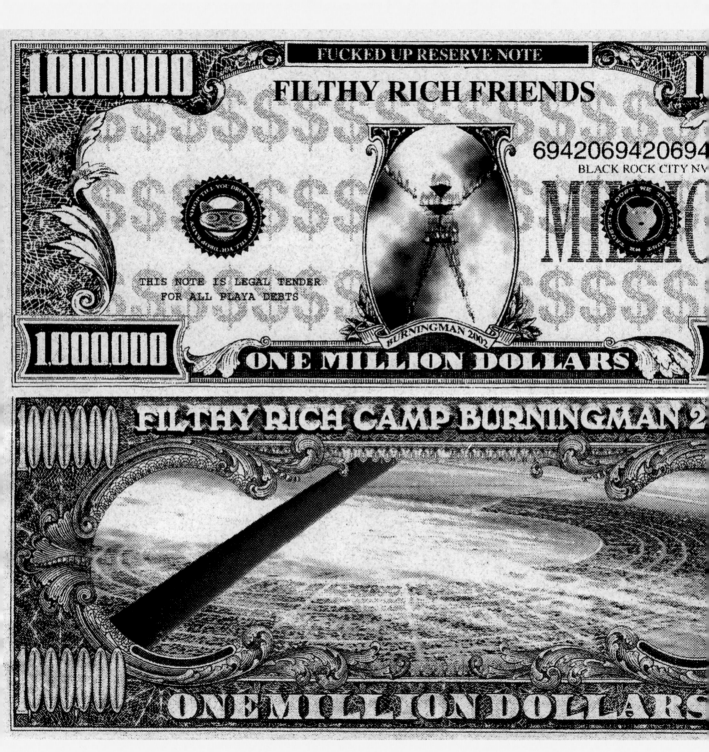

LAST CHANCE
CITY

RENO IS A GOOD PLACE TO LOSE
a fortune, get a quick divorce, or pawn gold jewelry.
If you are already down on your luck, you might feel
at home in the town that calls itself....................
.............. **66** THE **BIGGEST LITTLE CITY** IN THE WORLD. **99**
If you are going to Burning Man, however, Reno is
......................LAST **CHANCE** CITY:
a sprawling strip of convenience stores, the last place
to get anything you might need, a shower, and a solid
night of sleep, before driving a hundred and twenty
miles out to the desert.

Of course, the city was not designed with quick stopovers in mind. The gambling halls of Reno, like most casinos, don't have windows. There are no cues to distinguish day from night, nothing but the constant rhythm of slot machines—bells chiming, quarters hailing down on chrome—to mark time. Still, the casinos, decorated in gaudy circus and Western themes, have cheap rooms and even cheaper food. That's enough to pull Burning Man pilgrims through the doors. They drag duffel bags still coated in stubborn dust from last year's trip to the desert. They pass the game tables and disappear into the elevators, up to the rented suites without a backward glance.

N O T EVERYONE STOPS IN RENO. More than a third of festivalgoers come from the San Francisco Bay Area, and some of them speed past the supermarkets and

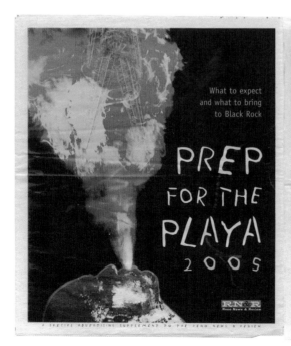

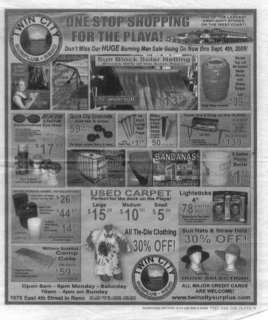

casinos, their cars already brimming with supplies. Nevertheless, the city is besieged by thousands of burners, who constitute a reliable, if odd, niche market. The days before Burning Man are set to a soundtrack of cash registers. Jo-Ann Fabric & Crafts sells fake fur by the yard. Kmart and Safeway have pallets of bottled water stacked chest high. At one end of Home Depot, there's a hand-lettered sign with a flaming stick figure and the words..............

Burning Man Necessities

The display is crammed with items you could easily do without: rolls of AstroTurf, self-venting spout diesel cans, and tiki torches (THESE HAVE BEEN BANNED FROM BURNING MAN SINCE 1998, WHEN A STAFFER ACCIDENTALLY INCINERATED HIS OWN CAMP WITH ONE). The display is untouched. At the other end of the store are things you will actually need, including piles of rebar, the heavy-duty steel rods that reinforce concrete. In a tempestuous place like the Black Rock Desert, rebar is useful for staking down your tent. You'll need a sledgehammer just to pound it into the ground. Still, the effort is worthwhile. Without it, the first puff of wind will send your tent somersaulting away like a tumbleweed.

The August 25 issue of the RENO NEWS & REVIEW has an eight-page advertising supplement called **PREP FOR THE PLAYA.** **DON'T MISS OUR Huge BURNING MAN SALE,** blares an ad for an Army-Navy surplus store. **LIFE'S TOO SHORT, ENJOY IT TO THE Fullest,** urges a mortgage company, which is pushing the **BURNING MAN SPECIAL: $350 Off CLOSING COSTS.** A pair of lawyers wants you to call them, and they promise to get your criminal records sealed. **IT NEVER HAPPENED,** reads the ad. **WE CAN MAKE THE PAST GO AWAY.** A car wash is planning for the days after Burning Man, when thousands of dusty vehicles will straggle back through Reno. **WE CAN HELP YOU GET BACK TO**

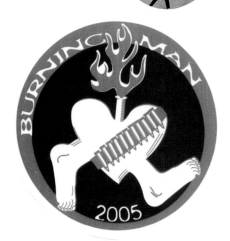

NORMAL LIFE: SHOW YOUR BURNING MAN TICKET & GET 10 PERCENT OFF ANY CAR WASH OR DETAIL,** reads the pitch.
........................ **" *Even Mutant Vehicles!* "**

Some of the ads misfire and hawk things no one wants. Others hit the mark and are appended to endless packing lists, which read like the inventory for a survivalists' costume jamboree.

They include fake eyelashes and goggles; capes, crinolines and dust masks; first aid packs and fairy wings; earplugs, stilts, lip balm, and jackknives; glow sticks, mess kits, sunscreen, condoms, and lots and lots of water.

The lists are very long because once you arrive at Burning Man, you won't be able to buy anything. There are no gearheads vending emergency hardware, or hippies selling grilled cheese sandwiches for gas money. Black Rock City relies on a gift economy: a cash-free system that emphasizes goodwill over legal tender. The object is to freely share what you can—meals, nine-volt batteries, buckets of glitter, back rubs, bad jokes—without expecting anything in return. Most camps bring an overabundance of supplies, so if you're craving canned pineapple rings, or you need to borrow some nail clippers, your neighbors can probably help you out. The city feels like a giant potluck supper, though there are always a few lazy hustlers, folks who show up bereft and sponge off their friends. When karmic justice prevails, they get stuck doing the dishes.

Commerce doesn't disappear entirely at Burning Man, but the official exceptions—central kiosks selling ice and espresso drinks—aren't enough to nourish anyone for a week. To stave off dehydration, you will need to bring a gallon and a half of water for each day in the desert; food is a bit more flexible. Some camps will set up elaborate kitchens, bake bread in solar ovens, and prepare four-

course feasts with fresh ingredients that have been basking in coolers of ice or in full-sized electric refrigerators that run on portable generators. Others will squeak by on beef jerky and peanut butter.

The festival's moratorium on money means that burners bear a financial hangover before the party begins. The Melting Pot World Emporium on South Virginia Street does more business in the days leading up to Burning Man than during the entire Christmas season. The owners, Monique and Eric Baron, are Burning Man veterans who sell last-minute tickets and costumes to eager customers. In the week before the festival, business suddenly triples, and it takes four clerks to run the store, instead of the usual two.

"**THERE'S** *definitely an* **ENERGY** **IN THE AIR,**" Eric reflects.

"From our standpoint, it's kind of lucrative in that way because it seems to be………**'Burning Man** *or bust,'**…………………………

and they're not really thinking much about post–Burning Man. It's all about getting to Burning Man, and what they're going to do or wear at Burning Man. So putting stuff on their credit cards is not much of a consideration, spending five hundred dollars on crazy costumes.

"I've often said there's nothing I could do on my own to create that kind of frenzied energy that is …………………………… ………'*BURNING MAN'S ABOUT TO HAPPEN*

 '" he adds.

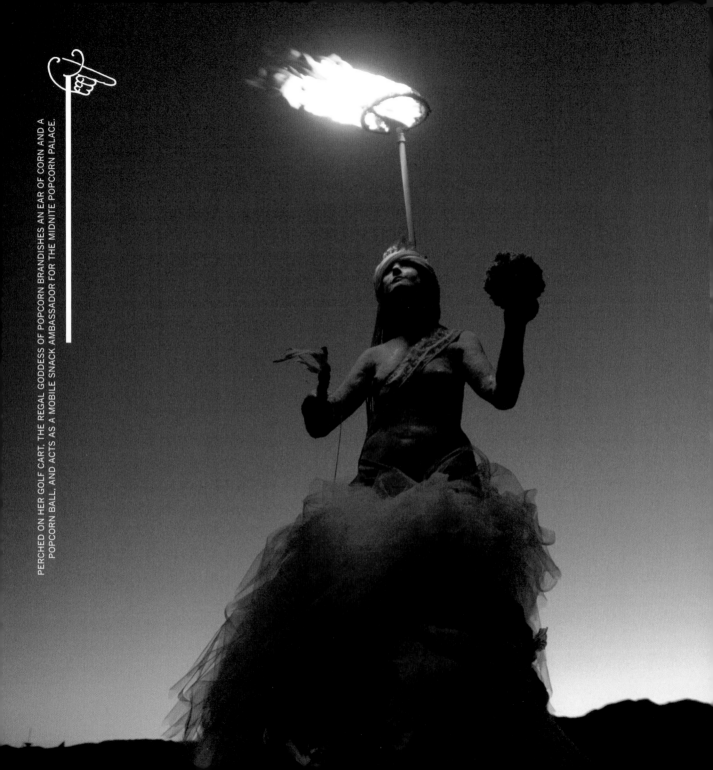

PERCHED ON HER GOLF CART, THE REGAL GODDESS OF POPCORN BRANDISHES AN EAR OF CORN AND A POPCORN BALL, AND ACTS AS A MOBILE SNACK AMBASSADOR FOR THE MIDNITE POPCORN PALACE.

The Barons understand the consumers' contagious excitement. They've felt it, too. They are the former proprietors of the Midnite Popcorn Palace, which ran for several years at Burning Man before it burned them out. In 2004 the Palace popped four hundred pounds of kernels, feeding long lines of people each night and offering postpopcorn relief at a twenty-four-hour dental floss station. For emergency deliveries, the Barons drove a vehicle topped with a statue of the Goddess of Popcorn: a life-size casting of Monique's body beneath a flaming halo, brandishing a popcorn ball in one hand and an ear of corn in the other.

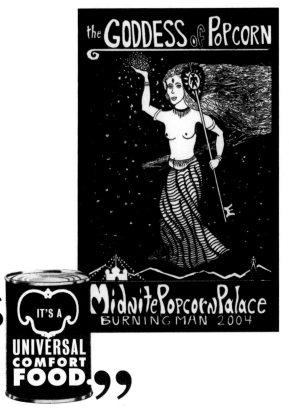

"The popcorn itself was almost more like a hook. It was a way to connect with people, so that we could meet people. Everyone's kind of vying for your attention out there, and we thought, 'Well, popcorn, everyone understands that,'" Eric recalls..............

In the summer of 1995 Eric was working at an espresso bar when he struck up a conversation with some customers who were going to the desert. They handed him a computer printout with a few details on Burning Man (IT PROMISED, FOR EXAMPLE, A COLOSSAL GAME OF FLAMING CROQUET). Eric decided to go. "I felt totally changed when I came back, like I'd been to a different world," he says. The next year he opened the Melting Pot and went back to Burning Man. He hasn't missed a year since.

While some people are immersed in shopping, others are just arriving, coming to town from all over. They are driving in from surrounding states. They are flying into Reno-Tahoe International Airport. They are renting vans from nervous clerks who ask them, again and again, "Would you like to put insurance on that?" In August 2003 THE ONION described their migratory patterns as a series of satirical mishaps. The article, entitled **"NO ONE MAKES IT TO BURNING MAN FESTIVAL,"** reported,.........................

The Burning Man festival, a prominent artistic and counter-cultural event that draws tens of thousands of people to the Nevada desert annually, is in danger of cancellation this week because "no one had their shit together enough to even make it," organizers said Tuesday. . . . [An organizer] received apologetic phone calls from a squadron of recumbent bicyclists lost somewhere in southern Nebraska, a Kentucky artist whose pet python was too carsick to continue the journey, and a group of Germans who uncovered a fatal structural flaw in their "Freak Harnesses" art installation at the last minute.

Fanning out across Reno, burners recognize each other on line at the registers of Sak 'n Save or buying energy bars at REI. Some wear homemade pendants with the Burning Man logo—stick figure, arms raised—that identify the initiated like Freemasons' rings. There are a couple of Mohawks, a lot of dreadlocks, and some candy-colored dye jobs so new that scalps and hands are still stained. Other folks are more subtle, but they're pushing blatantly obvious shopping carts. Forty gallons of water and a case of pink glow sticks? You might as well tape a sign to your back. Reno knows why you're here. Still, everyone grins like there's some electric, shared secret and, well, if only they knew! Here in the city, which feels like a sad museum of Las Vegas castoffs, something is stirring. But that something is just passing though.

Burners also stop off in Sparks, Reno's eastern suburb. A century ago Sparks sprang up from nothing, just swamps and ranches, when the Southern Pacific Railroad built a switchyard here. Today it's the uncomplaining butt of an old joke—**66Reno is so close to hell, you can see Sparks99**—and a magnet for outdoorsy pensioners, who snap up $250,000 homes. And while

burners tromp through town, Sparks is bustling to prepare its own banner festival: the Best in the West Rib Cook-off, a six-day affair that also runs through Labor Day and draws gigantic, hungry crowds. In 2006 a swarm of 500,000 barbecue enthusiasts landed in Sparks. That's more than a dozen times the number of people who make it out to Burning Man, and they chewed through 200,000 pounds' (OR 1.4 MILLION BONES') worth of pork ribs.

There are a few reasons to linger here on the way to the desert. You could stop by Rat's Bikes, a homegrown rental outfit arranged by Ray "Rat" Leslie, a retired mail carrier in his mid-sixties who has been attending the festival since 1997. Rat spends much of the year fixing tire tubes, brake cables, and rusty chains on a fleet of up to 210 bicycles, which are reserved for burners coming from more than a thousand miles away. He knows his regulars, like the guy from New York who needs a woman's bike so he can play an accordion while riding it. Rat will wait until all of his bikes are picked up, then follow them out to the desert in a twenty-two-foot Winnebago.

In Sparks you could also stop to see Fred Hagemeister, though his neighbors wish that you wouldn't. Fred, better known as Hagey, is a fifty-five-year-old retired high school teacher and self-described

" FULL-TIME BURNER. "

Every August before Burning Man, his two-thousand-square-foot ranch house used to transform into the International Burner Hostel, a refuge for travelers on their way to Black Rock City. For a few years the hostel was a freewheeling pre-party, which snarled street traffic and filled his back-yard with fire-spinners, drum circles, and skinny-dippers splashing giddily in the aboveground pool. Hagey's door was open to anyone who wanted to stop by and hang out, or hook

up with a ride to the festival, or crash for the night. Five hundred people passed through the hostel in 2004. Eighty of them bunked at his place in a single evening. They sprawled across the floors of Hagey's home, occupying each of the dozen couches he'd collected to bring to the desert. When the house ran out of room, they pitched tents in his half-acre yard.

Have You Seen Him?

Black Rock City 2000

" IT WAS MADNESS. | IT WAS BEAUTIFUL MADNESS,"

Hagey reminisces. "There were three people that were laying on my floor down the hallway. I had to step over them just to go to the bathroom, and at that point, I thought, 'Oh my God, this is amazing.'" In the years that he's kept track, Hagey welcomed people from places like the Netherlands, New Zealand, Israel, Scotland, Norway, Spain, Japan, New York, and Canada. He still builds another refuge for them—the Black Rock International Burner Hostel—out in the desert, and adorns it with flags from all of his guests' home countries. For Hagey, the flags mean friends and open doors all over the world. In July 2005, when a bunch of European burners were organizing Nowhere, a festival in Spain, they took up a collection and flew him out to join them. One of his guests even wrote a Burner Hostel theme with techno beats and a robot voice: "*Thump-thump-thump-thump /* Hagey is nobody's fucking mother! / *Thump-thump-thump-thump /* Me god! Fifty bodies naked in the pool."

10

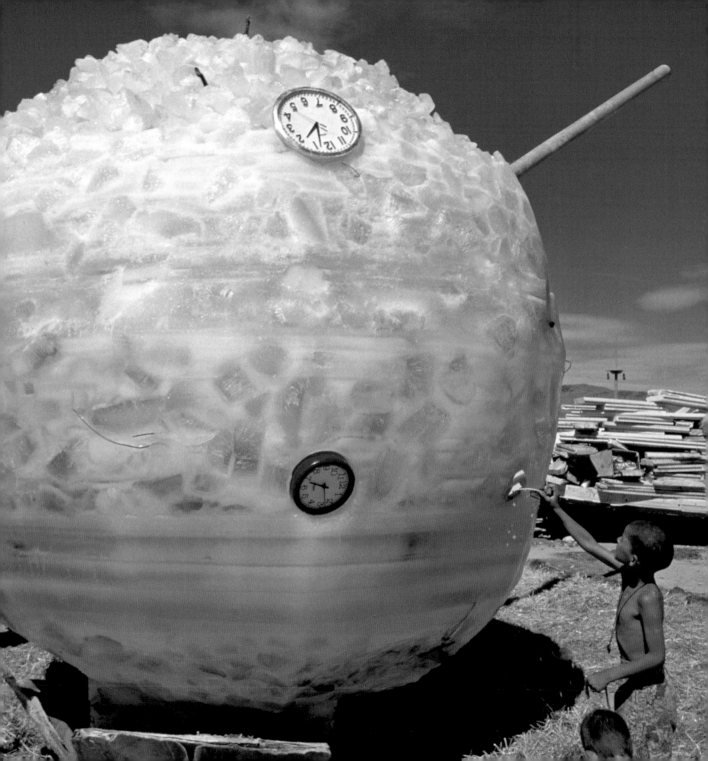

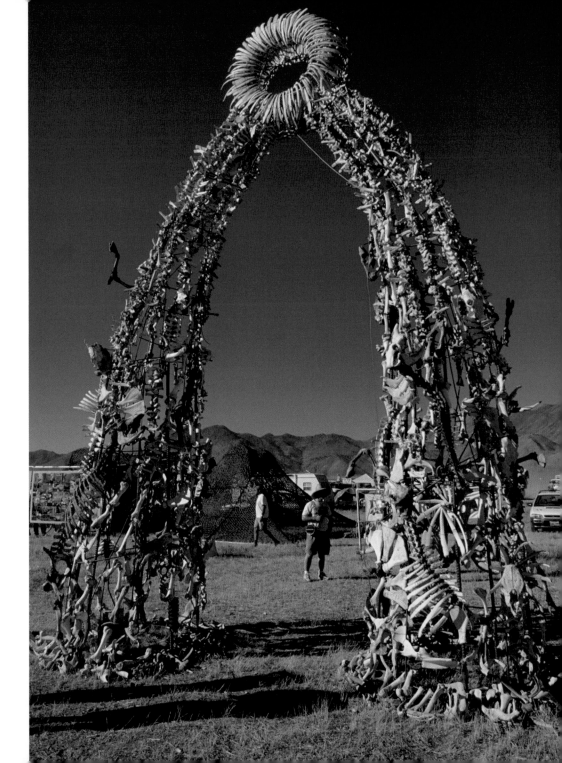

MAJESTIC AND MACABRE, THE THIRTY-FOOT-TALL BONE ARCH IS MADE OF SUN-BLEACHED CATTLE BONES MICHAEL CHRISTIAN CULLED FROM LOCAL RANCHES AND WIRED TO A STEEL FRAME.

When Hagey went to Burning Man for the first time in 1997, he didn't plan to become a hospitality junkie. He wanted to rage, to **" BE A HEATHEN, "** to look out for his own good time. Then he got an unexpected traveling companion: a friend who was dying of a rare neurological disorder called adrenoleuko-dystrophy. The guy was confined to a wheelchair. He told Hagey that he'd been hoping to go to Burning Man for years. Instead of letting loose, Hagey ended up pushing him around the desert all week. There were a lot of staggering sights to take in that year, including Jim Mason's **TEMPORAL DECOMPOSITION,** a fifty-seven-thousand-pound sundial made of ice that gradually melted, revealing two hundred clocks and watches frozen inside. There was the **BONE ARCH:** a grandiose, albeit slightly menacing, thirty-foot archway of bones that sculptor Michael Christian had culled from local cattle graveyards. But the timing was better for art than it was for wheelchairs. In 1997 Burning Man had temporarily migrated a few miles away from the hardpan Black Rock Desert to a scrubbier private enclave called Fly Ranch, on another

playa called Hualapai Flat. Hauling a wheelchair over the uneven ground was exhausting, and the two men sometimes opted to just hang out at their campsite. They got into the habit of feeding their neighbors, cooking up meals on the stove of a rented RV to share with anyone who came along.

"Being nice to people, taking care of people, and hosting people, that's where it's at, at Burning Man," Hagey says fondly. But that's harder to do back home, particularly when your home turns into a hostel. Down the block from Hagey's house, an elderly couple started to **simmer** when travelers' cars and RVs clogged Breaker Way and gobbled up parking spots. Other neighbors became an unwilling audience to a parade of nudity, visible at times through a cyclone fence in Hagey's backyard. In the summer of 2005, a few malcontents got together and complained to the local authorities. Representatives from the police, fire, health, and code-enforcement departments converged on the home of Fred Hagemeister on the last Thursday in August.

Solving the parking problem fell to Pete Litano, the assistant fire marshal for the Sparks Fire Department. "People were very cooperative and moved everything around," he recalls. "There were some trailers and motor homes and stuff, and it was kind of narrow, so they just staggered stuff and everything worked out really well for us." But the rest of the visit went less smoothly. Hagey's other uniformed guests set to work cataloging potential code violations: too many propane tanks, cars parked on the grass, extension cords stretching outside to electric freezers, and one Sani-Hut portable toilet in the backyard. And, of course, too many people.

"There was such a long list of things that they were slapping me with that I was just sort of dumbfounded," Hagey recalls. He decided to shut down the hostel immediately. He posted a distress call on the

Welcome to The Land of OZ
Emerald City
at Burning Man 2001

Join us any evening at 2:15 & Esplanade
(just follow the Emerald Laser)
INFO: www.emeraldcity.tv, www.radiov.com/oz

Internet, and other people bound for Burning Man started coming by to pick up his guests. One by one, the hostelers disappeared.

That was a very bad week. Two days before the hostel was busted, Hagey's Chevy Suburban had been stolen, along with a borrowed trailer, two thousand square feet of carpeting, and a $3,500 shade canopy, which were all intended for his camp in the desert. Now, with the cops crawling over his home, he was lucky to scrape by with stern warnings instead of fines. Still, he was devastated. He made it to the festival a few days later, but barely. "I was literally a sobbing, slobbering idiot by the time I got there," he recalls. The next summer, Hagey officially rolled up his welcome mat in Sparks, shifting his focus to build the biggest-ever version of the Black Rock International Burner Hostel, which hosted 135 guests in the desert. Hagey's house became more of a waypoint than a destination, one less reason to linger.

There's no real reason to stick around the city and its outskirts, anyway. This is a place to pause before moving on. The best part comes when all the packing is done and the road opens up. Then there's little to do but watch the city dissolve, mile by mile, in the rearview mirror.

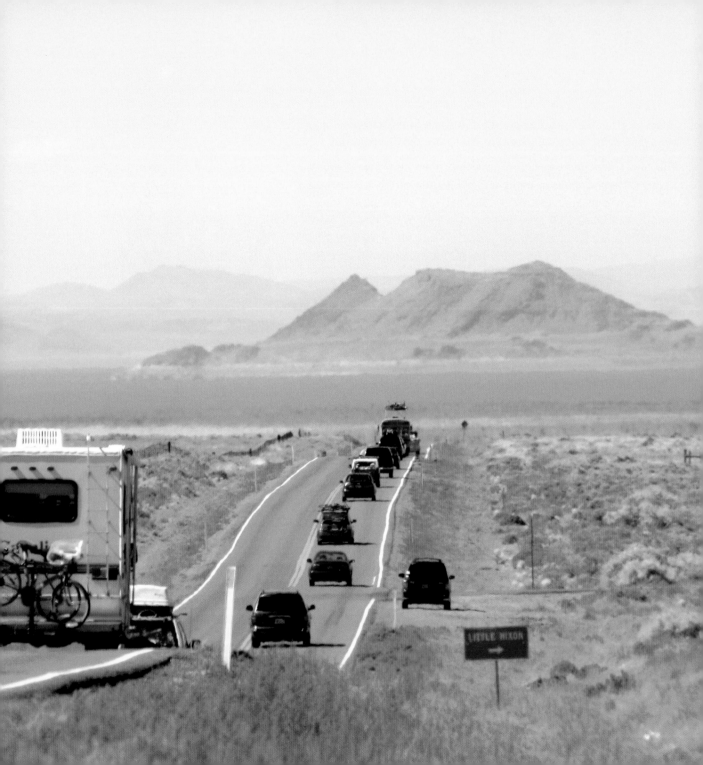

THE ROAD

WHEELING EAST OUT OF RENO
on Interstate 80, there's an eclectic convoy of pickup
trucks and psychedelic buses, rockabilly jalopies,
a few vintage Airstream trailers, and a repurposed
hearse or two. There are family minivans and old
motor homes, spruced up for the journey with duct-
tape tattoos of the Man, pulling trailers stacked with
secondhand couches. There are plenty of sedans that
would be inconspicuous if they were not so over-
burdened: bikes strapped on top, trunks roped shut,
passengers pressed to the windows. The same goes for
the rental trucks, which don't look like anything out of
the ordinary until you notice that some of their side-
walls have been creatively altered with paint, tape, and
cardboard to read **"U-Hell"** and **"Fudget,"** a
nod to Burning Man's ban on commercial logos.

A CARAVAN OF
CARS CRAWLS TOWARD
PYRAMID LAKE ON THE
WAY TO BURNING MAN.

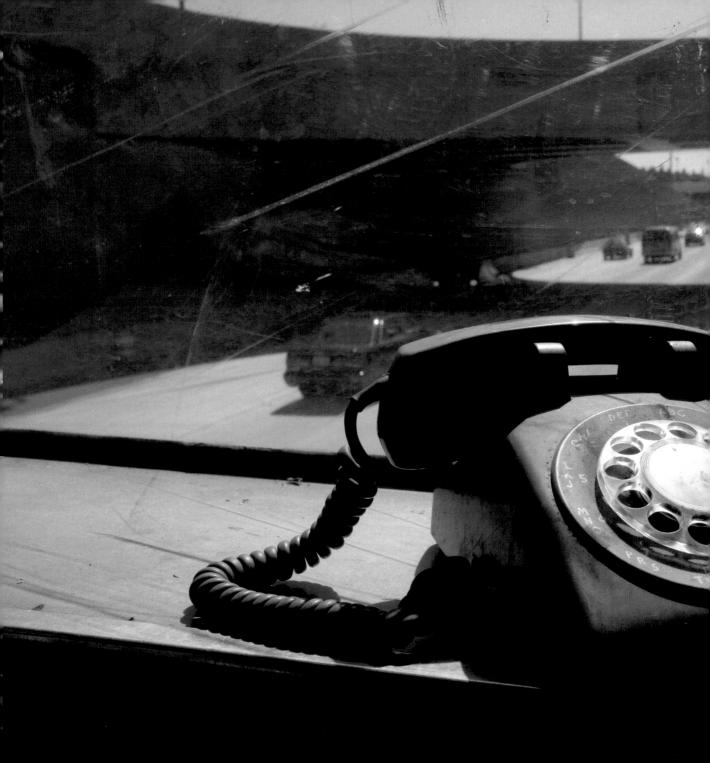

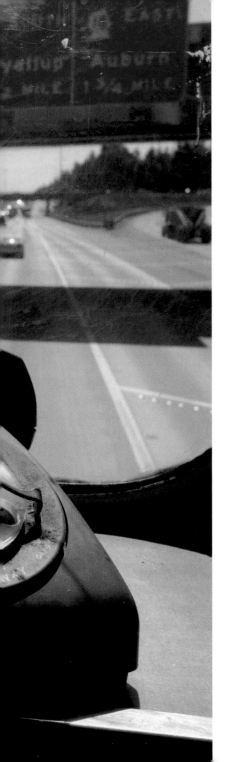

CLOSER TO THE DESERT, CELL PHONES WILL BECOME JUST AS USELESS AS THIS UNPLUGGED ROTARY-DIAL RELIC, WHICH SITS ON THE DASHBOARD OF A DOUBLE-DECKER LONDON BUS DRIVING FROM SEATTLE TO BLACK ROCK CITY.

Sergeant Tom Ames of the Nevada Highway Patrol watches a giant silver shark drive past his outside his window. Cruising down West Williams Avenue in Fallon, the shark pulls over across from the patrol substation where he works. It bellies up to the gas pumps. This is one of the strangest cars that Sgt. Ames has ever seen, but the sighting is routine, something he expects toward the end of August. "It's like, '**OH**,

HERE COMES THE
shark guy,'"

he sighs amiably. The Burning Man crowd generates what he calls

..........**" a heavy and EXUBERANT AMOUNT OF TRAFFIC. "**

For Ted Mattison, a forty-one-year-old actor from Los Angeles, seeing all the oddball traffic on the way to Burning Man in 2000 felt like an omen. "I'd driven all day myself, I didn't know much about it," he says, remembering his first trip to the desert, a twelve-hour odyssey that took him until two in the morning. When he finally merged onto the main festival route, he found himself behind a car with an unlikely vehicle in tow. "I was following a car that had this gigantic, globe-head car thing. You've probably seen this vehicle out there. There's this guy who just takes his golf cart and puts this big sort of tubular, metallic, aluminum-welded head with big eyes on it. It can flip around, does all kinds of great moves," he explains nostalgically. "I'm right behind that guy. I'm in my orange pants and my tie-dye or something. I've been going through these kind of rural, conservative parts of California earlier in the day. Then all of a sudden, I get off the interstate, about an hour out of Burning Man, and I'm behind this car, and I'm like, ..
..

......................❝ *OH MY GOD.*

This is BRILLIANT. ❞

That feeling spreads quickly. Once the drive is under way, giddiness takes hold. Stereos are cranked up and dog-eared directions litter the dashboards. If you need to reach the folks back home ("DID YOU SAY YOU'RE GOING TO BIRMINGHAM, DEAR?") or you've waited this long to call in sick to work, now is the time to deal with it. There are no cellular towers near the Black Rock Desert, and reception will fade in the next hour. Other things will also fade:

unanswered e-mail,

> **dishes waiting in the kitchen sink,**
>> **outstanding mortgage payments,**
>>> the blinking light on your answering machine.

You're going somewhere uncontained and entirely impractical. Just the thought of this is hilarious. The Black Rock Desert is a bad host, with no interest in sustaining anything but its own blankness, **and you are barreling toward it.**

In 1844 the explorer John Charles Frémont encountered the Black Rock Desert while searching for the Buenaventura River, a majestic waterway believed to flow from the Rockies to the Pacific. The river turned out to be a myth. The desert, however, was terrifyingly real. In his journal, Frémont described the land as "a perfect barren" and wrote, "The appearance of the country was so forbidding that I was afraid to enter it." Five years later, during the 1849 California gold rush, Peter Lassen blazed an

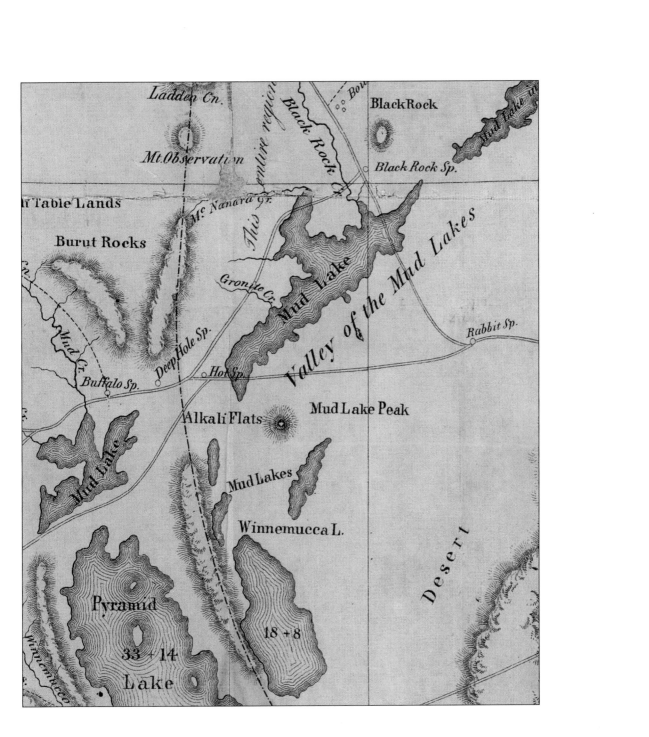

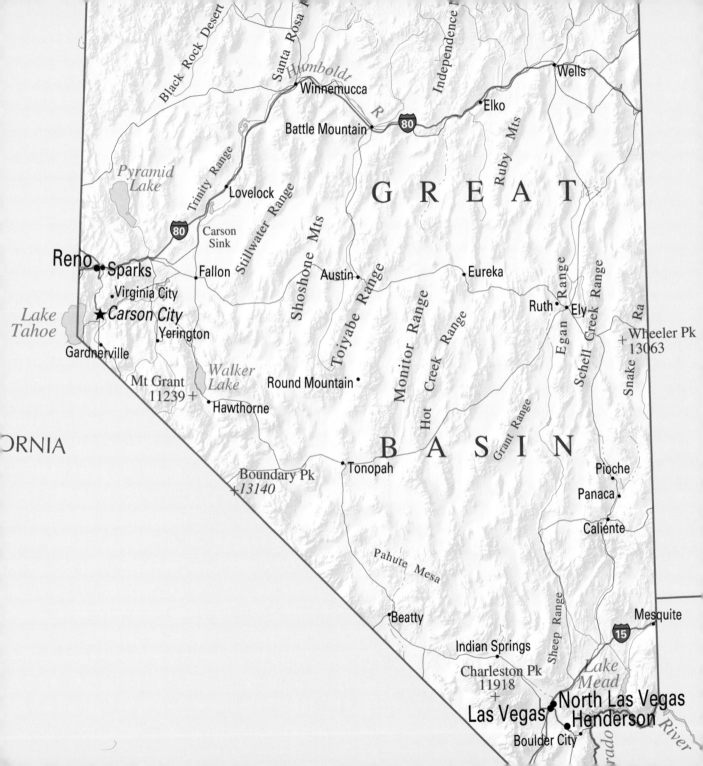

emigrant trail through the Black Rock. His path was promoted as a shortcut to Sacramento Valley, but abandoned after prospectors— SOME RESENTFUL, OTHERS DEAD—discovered it was two hundred miles longer than the established trails. It came to be known as

"the Death Route."

Fortunately, all that remains of the covered wagon era are wheel ruts and historic graffiti, scratched into the rocks of High Rock Canyon by the pioneers, who would now be considered vandals. They might also think you're an idiot for going to Burning Man.

Thirty miles from Reno, the road to the desert bends north along Highway 447 and pushes through Paiute country. Pyramid Lake appears to the west, a startling expanse of bright, turquoise water and the largest leftover of ancient Lake Lahontan, which covered more than eight thousand square miles at its peak in the Pleistocene Era. Pale formations of calcium carbonate, called tufa, hover on the water like ghost islands. The lake looks like an inland sea, glittering miles into the distance.

The Paiutes own Pyramid Lake and the 475,000-acre reservation that surrounds it. They sell seven-dollar permits to anglers seeking Nevada's state fish, the Lahontan cutthroat trout, which is named for a crimson mark, like a gash, below the gills. When the highway brings Burning Man traffic, they set up stalls and sell Indian tacos on fry bread. Some of the travelers buy six-dollar day passes to swim in the saline waters of Pyramid Lake. According to Paiute legend, those waters are tears from the first woman, who sat and wept until she turned to stone. You can see her silhouette if you squint long enough at the rocks along the lake's eastern shore. The Paiutes call her **Stone Mother.**

The caravan crawls farther up the highway. A bottleneck is forming at the edge of Empire, a company town owned by United States Gypsum, the creators of Sheetrock brand gypsum panels. This is the same company that, in the late 1960s, pioneered drywall construction for stairwells and elevator shafts in commercial buildings, a method that was used first (AND MOST FATEFULLY) at the World Trade Center. In Empire, United States Gypsum runs a quarry and a wallboard plant. Most of the people who live in the town's 122 homes work at one or the other. Their market, the Empire Store, is the only grocery stop for at least seventy miles in either direction, and its door bangs open and shut all day. Usually the only customers are locals, but now enormous statues of recognizable characters—SHREK, THE CAT IN THE HAT—have been set up outside like awkward bait for burners. A few RVs are nosed up against the shoulder of the road. Cars squeeze into a tiny parking lot. Towering above them all, a tall sign reads:

WELCOME TO NOWHERE
ON ONE SIDE
and
HAVE A SAFE TRIP
ON THE OTHER.

Don Lawson, who is forty-four years old and grew up in Reno, has been encountering burners since he began running the Empire Store in 1995. "When it first started, I used to call it my thirteenth month," he says. "It got to the point where it was an extra month's worth of business." Now Burning Man generates up to a fifth of his annual sales. He has posted two maps—ONE OF THE UNITED STATES, THE OTHER OF THE WORLD—on his walls and invites customers to stick pins in their hometowns. Don and his staff have to hustle to keep up with

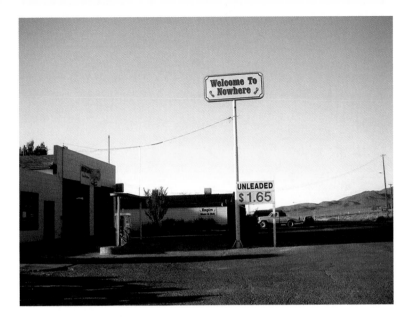

MOST OF THE TIME, THE "WELCOME TO NOWHERE" SIGN ABOVE THE EMPIRE STORE MAKES A FITTING CAPTION FOR A NEAR-EMPTY GAS STATION AND PARKING LOT.

OVERLEAF: NOWHERE BECOMES SOMEWHERE IN LATE AUGUST, WHEN BURNERS SWARM THE EMPIRE STORE AND OWNER DON LAWSON ERECTS A GIANT SHREK STATUE TO WELCOME THEM.

the shoppers, but he says they enjoy it. "It's one of the few times I allow drinking on the job," he declares. "We have a keg tapped in the garage, and it helps with the madness."

There's a line around the gas pumps, and another one at the counter inside. Heat ripples from the asphalt. Tubes of sunscreen emerge from rucksacks. The desert is getting closer, and suddenly the air feels different. Travelers stretch their legs, milling around as they sip cold drinks, or sit on the curb and smoke cigarettes, watching the colorful caravan creep past. Some of them skip Empire altogether. They drive seven miles farther to Gerlach, a town that sticks like a burr to the back of the desert.

Gerlach is home to 170 people who share one gas station, two schools, a scattering of saloons, one post office, a historic redwood water tower, and a taste for old-fashioned solitude that comes across in the town's slogan:

> **❝ WHERE THE PAVEMENT ENDS**
> **AND THE**
> **WEST BEGINS. ❞**

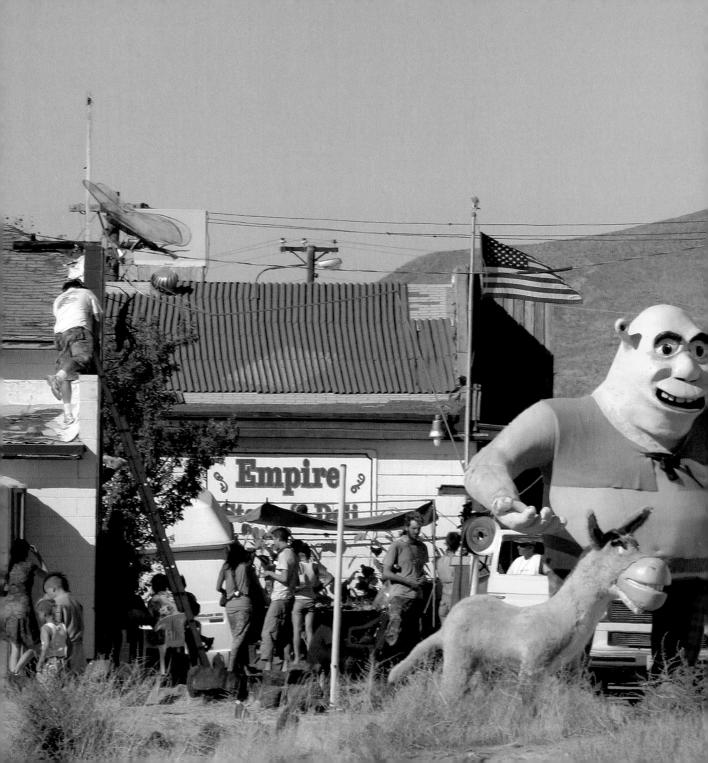

Many of the people who live here are retired. Others are teachers or bartenders. Some take jobs for the Washoe County road department or work at the gypsum plant in Empire.

Most of the locals are now accustomed to the partiers' annual passage, even if they scratched their heads through the early years. Some of them have gone out to see the show for themselves. "The very first time we went, it was at night and they were burning the Man. They were just dancing crazily around the Man," recalls Victoria Williams, the sixty-three-year-old chief financial officer of the Gerlach General Improvement District. What did she think of it?

"I don't know what I *did* think. Just WOW. What crazy people."

She returned the following year and found even *more* of those crazy people. "At that point we decided we would never go back out there when they burned the Man," she remembers, laughing. "It was a little scary." She started taking annual day trips instead.

John Forster, the owner of Granite Propane, has been selling fuel to the festival organizers ever since he set up shop in Gerlach around fifteen years ago. Now they buy upward of three thousand gallons from him in a single month, which is more than four households in town would purchase for an entire year. John is glad to see the money coming in, but not the traffic and the noise. Gerlach is usually dead quiet. Most everyone who lives here likes it that way.

"I mean, at seven thirty, eight o'clock this town shuts down," he says, "and I can hear my neighbor fart in his front yard." His nearest neighbor, he adds, is a guy at the other end of town.

John likes some of the Burning Man people he's met, but also suspects that the event is a yearly summit for undesirables: **Satanists,** FOR SURE, MAYBE SOME **druggies,** AND OTHER VARIED SPECIMENS OF THE **great unwashed.** He has been baffled by occasional sightings of women with tattoos on their faces. "I think that there's some supercreative people and really neat stuff going on out there," he says. "There's also just waaaaaaaaaaʌʌAʌAaAaAaAaAaAaAaA AAAAAY too many weird people. Art is not starving yourself to death, dude, and if you'd just take a bath, man, you'd have to feel better. You know?" He chuckles. What's another thing that riles him? Burners who go by funny, adopted nicknames. They call them "playa names." These monikers range from the simple—

Rhinestone, Frog, Juicebox

—to the more elaborate—*Officer Fancy Beauregard,*

Skeeter Diego, and

Dr. Mogamboo O'Boogie.

"I really don't have any place for that 'Zappa' thing," John says. "That doesn't work for me. If you've got a real name, let's use it. If it's Zappa, well, what's your social security number? I don't really give a shit, you know what I'm saying?"

Most of the time, Gerlach is Zappa free, though Burning Man maintains a small satellite office in the heart of town (AND THE WOMAN WHO WORKS THERE HAS HER OWN PSEUDONYM: **Trixie**). The office has a live Web camera that looks out on Main Street and transmits a new image to the Internet every fifteen seconds. The funny thing is this:

Geriatric Rant Camp &

Octogenarian Social Club
Burning Man 1998

CARD NO. 16/32
DECK 136/200
ID:SULPHURQUEEN
PASSWORD:ENTER

SIGNET OF STAR-GLO
Quest for the ring (/16/16.html)

For most of the year in Gerlach, nothing happens in fifteen minutes. Watching this remote settlement in the Great Basin is not like tracking traffic in downtown Los Angeles. Most of the time, the same picture recycles over and over, except for when night falls and a street lamp blinks on. If you're lucky, a stray cat might wander across the street.

That's about it, until Burning Man comes to town with noise, and exhaust fumes, and lines for the pay phones scattered around town. Some of the old-timers grumble, but others see a chance to make good money. The local post of the VFW Ladies Auxiliary holds a rummage sale at the community center on Cottonwood Street. They sell cooking utensils, clothes, furniture, garden tools, and whatever bric-a-brac has been cluttering up local attics. They also make yard art and crochet afghans for a raffle. "One year we had a whole lot of stuffed animals and they really went for that," says Barbara Conley, who is seventy-seven years old and a member of the Auxiliary.

"I DON'T KNOW WHAT WAS GOING ON OUT THERE, BUT THEY BOUGHT A LOT OF STUFFED ANIMALS."

Do they sell water or sunblock? "No," Barbara replies. "I never thought about sunblock."

The senior center is busy arranging a field trip to Black Rock City for later in the week. Barbara likes to take the tour, even though she can remember one time some guy mooned the senior bus. Her husband, Bud, who served in Germany in World War II as a staff sergeant with the Fourth Armored Division, has also gone to see

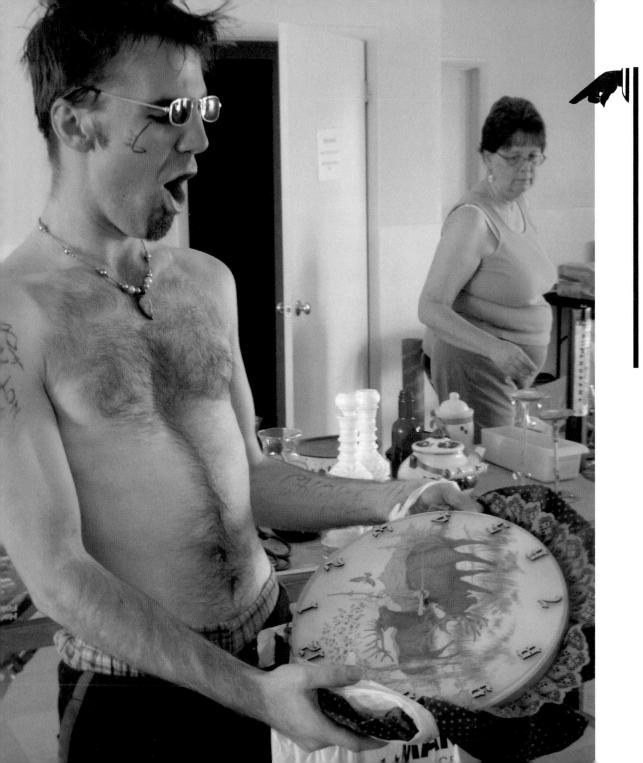

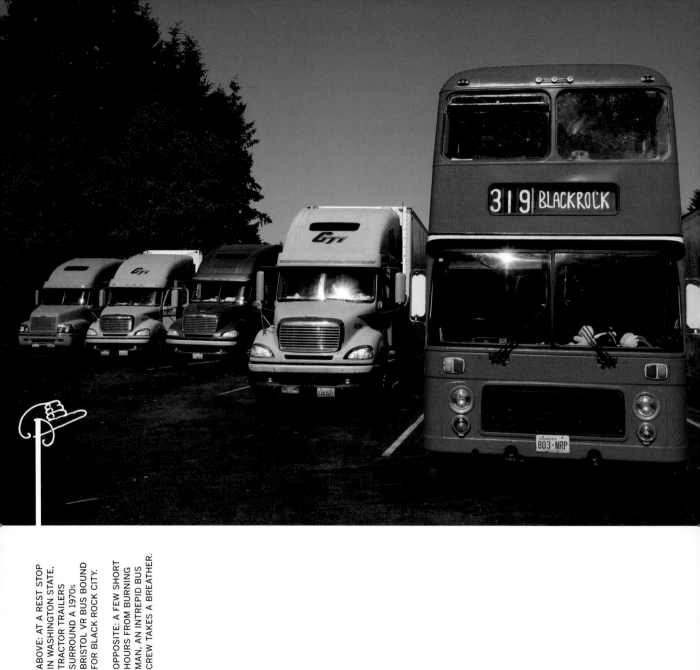

ABOVE: AT A REST STOP
IN WASHINGTON STATE,
TRACTOR TRAILERS
SURROUND A 1970s
BRISTOL VR BUS BOUND
FOR BLACK ROCK CITY.

OPPOSITE: A FEW SHORT
HOURS FROM BURNING
MAN, AN INTREPID BUS
CREW TAKES A BREATHER.

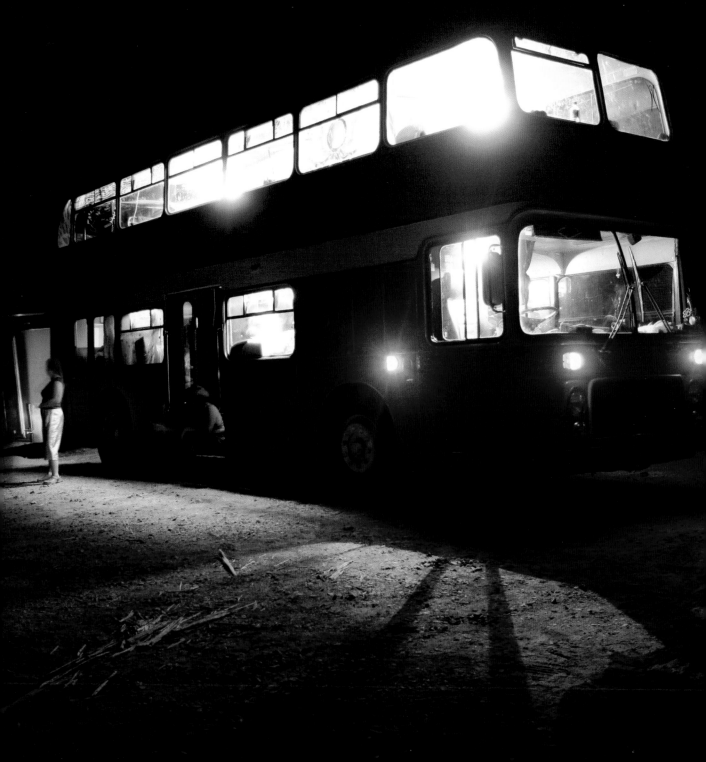

Burning Man. "You meet some real nice people, educated. There's doctors and lawyers, but then there's the riffraff, too, more of that than there is good people," Bud says. "They're just plumb free when they get out there. They just let their hair down and do anything they want to do."

Over at the Miners Club bar, a sign outlines the limits of Gerlach hospitality:

NO HIPPIES. **NO** WHINERS. **No** GLOW STICKS. **NO** PACIFIERS. **NO** RAVERS.

Bruno's Country Club (AND MOTEL–CAFÉ–CASINO–SALOON) also posts a warning, which is stuck to the restroom door and reads:

ABSOLUTELY

NO

BATHING ALLOWED!!
VIOLATORS WILL BE REPORTED TO THE
SHERIFF'S DEPT.

Even though you can't bathe in the bathrooms, Bruno's Country Club is something of a local legend. The place has been around since 1953, when Bruno Selmi, an eighty-four-year-old Italian immigrant, first set up shop here; since then, he has been praised by the state tourism commission for serving "what many visitors have declared the best ravioli in Nevada." For those who wish to bathe, or to sleep,

Bruno also operates a fifty-room motel. There aren't any vacancies right now. By the time the festival crowd passes through, the motel has been booked to capacity by cops and a handful of hunters.

At the far end of town, taxidermists are showing off trophy antelope heads, along with their best deer and elk. August is the start of antelope season, so the glass-eyed heads are mounted on boards by the road, where hunters pass between Gerlach and the mountains.

Gerlach is the last outpost. Once you've passed it, the road splits. To the right is Highway 34, which runs along the eastern edge of the Granite Range toward the Black Rock Desert. This is a treacherous leg of the trip. The asphalt bucks and dips, and there's just one lane going in either direction, with no shoulder. On both sides of the road, the ground is hard and dusty, dotted by plants with names you can taste: saltbrush and bitterbush, greasewood and sage. Jackrabbits dash out of the scrub, and catapult themselves into traffic. It's hard to keep your eyes on the road. Everyone is squinting off to the east, where the playa, a flat field of cream-colored dust, has come into view. During the last Ice Age, this was the floor of ancient Lake Lahontan, submerged beneath five hundred feet of water. Now it's a hardpan plain of alkali silt. Past its fringes, nothing grows. The emptiness stretches over four hundred square miles, as blank as a new sheet of paper.

A now-defunct festival website called Burning Man **66***part of the* **smoking hole** *in reality.***99** Substitute "topography" for "reality" and you've pretty much summed up the Black Rock Desert.

Everything stops at its edge, except for a drifting haze of dust
that blurs the air like smoke.
It looks like someone blew a hole
in the fabric of
nature.

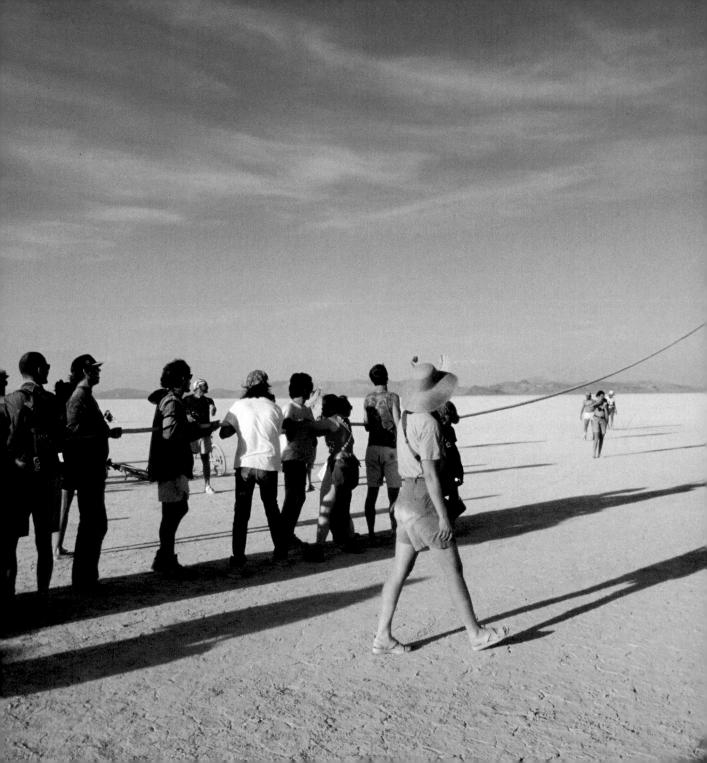

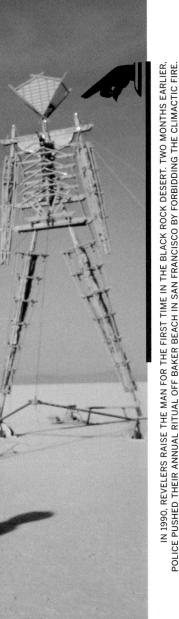

THE FIRST MAN

BURNING MAN FIRST CAME
out to the Black Rock Desert in 1990, but it started a
few years earlier in San Francisco. The event's ori-
gins were modest. Back in 1986, a landscape gardener
named Larry Harvey recruited one of his friends, a
carpenter named Jerry James, to help build an eight-
foot-tall effigy from wood scraps. Their creation was
a rudimentary human figure, all hips and elbows. His
skeleton came together at funny angles, and spikes
of hair poked out of his head like Popsicle sticks.

On June 21, the longest day of the year, Larry and Jerry carted their
effigy down to Baker Beach, a sandy enclave near the foot of the
Golden Gate Bridge. They propped him up in the sand, baptized

him with a healthy amount of gasoline, and set him on fire. Curious strangers ran over to see what was burning, and a cluster of friends swelled to an audience of around twenty people. A guy with pants on his head improvised a song on the guitar. When the wind sucked the flames off to one side, a woman clasped the Man's hand—or at least where a hand would have been, if he'd had any—and held it while he burned. Without thinking too much, people were jumping in to make the party their own.

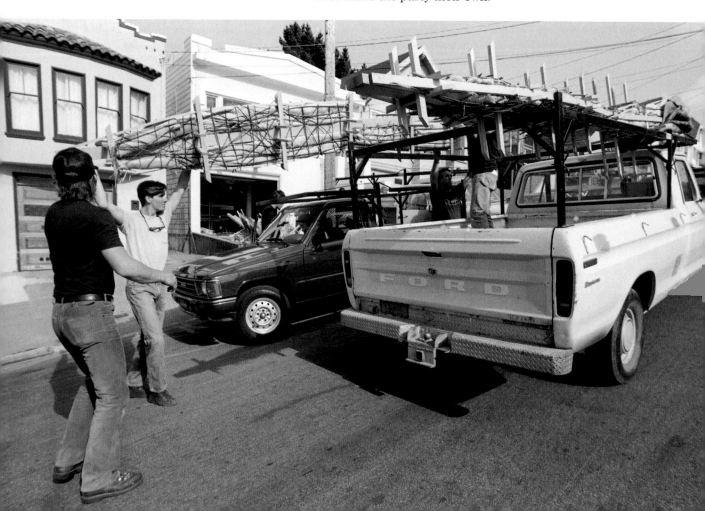

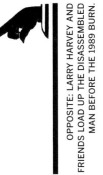

OPPOSITE: LARRY HARVEY AND FRIENDS LOAD UP THE DISASSEMBLED MAN BEFORE THE 1989 BURN.

BELOW: REVELERS ASSEMBLE THE MAN ON BAKER BEACH IN 1989, UNAWARE THAT POLICE INTERFERENCE THE FOLLOWING SUMMER WILL MAKE THIS THEIR LAST BEACH BURN.

Nowadays, Larry Harvey is fifty-nine years old and looks like someone who has been to Burning Man every day of his life since 1986. He seems at once energetic and exhausted, chain-smoking Camels with an unsteady hand. His gray hair is cropped close and frames a face with sleepy eyelids and a sudden, shy smile. When he speaks, the words rush out in a torrent, then jam up in sudden, stammering syllables. In two decades Larry has gone from

A SMALL-TIME **FIREBUG** *and* **BOOKISH** COLLEGE DROPOUT to the

EXECUTIVE DIRECTOR *of the* **BURNING MAN PROJECT**, *chairing a* LIMITED LIABILITY CORPORATION *with a* SIX-MEMBER BOARD *and an* **ANNUAL BUDGET** *of more than*

$8.5 MILLION.

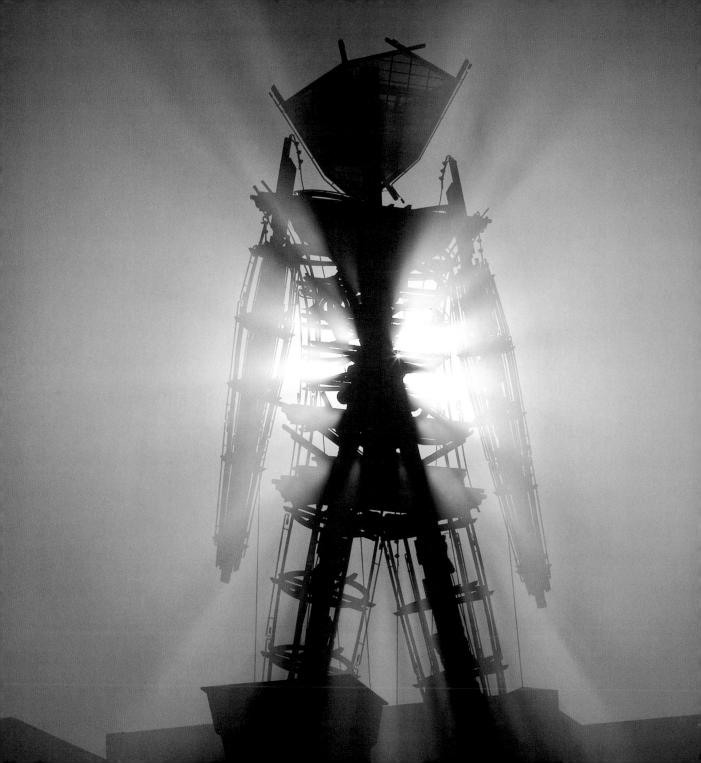

He's become an awkward kind of cult celebrity. Growing up, he says, he had to struggle to get a word in at the dinner table. Now he's used to giving speeches, tossing out remarks that get taped, transcribed, and broadcast. During the Burning Man event, he spends a lot of time talking to the press. He's the ringmaster, after all, so the job of explaining how the whole thing started falls to him. Everyone wants to know how Burning Man happened.

Over the years, Larry has offered several versions of what inspired that first human-shaped fire. What POSSSSSSSSESSSSSSSED him? He was purging a broken romance. He was paying tribute (PERHAPS SUBCONSCIOUSLY) to his self-made, hardworking father. He was engaging in "an act of radical self-expression." This last account sounds deliberately vague. Still, it may be closest to the truth. Burning Man is not outlined like a murder mystery. There may not be a simple secret for him to divulge, the kind of neat dissection of motive you'd get at the end of an episode of SCOOBY-DOO. Maybe it all began with an act of poetic theft. A local sculptor, Mary Grauberger, hosted numerous art parties and solstice bonfires on Baker Beach through the early 1980s, well before Larry came on the scene. Reporters have been asking Larry the same question since they started probing Burning Man over a decade ago. But if Larry had a better motive for making and burning a wooden man than those he has already offered—heartache, patrimony, **66why not?99**—he has been keeping it under his hat, the pearl gray Open Road–model Stetson that he wears nearly everywhere, for a very long time. The only sure answer to why he burned the Man is a simple one: He felt like it. And that idea harmonizes with how he sees the festival today. **66BURNING MAN, YOU KNOW, ALLOWS PEOPLE TO BE AS FOOLISH AS THEY PLEASE,99** he says. **66IT ALLOWS THEM TO DO THINGS THAT THEY NEEDN'T JUSTIFY OR RATIONALIZE, SIMPLY BECAUSE THEY FEEL A PRESSING NEED TO EXPRESS THEMSELVES IN SOME WAY.99**

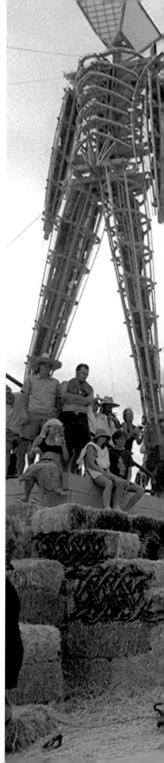

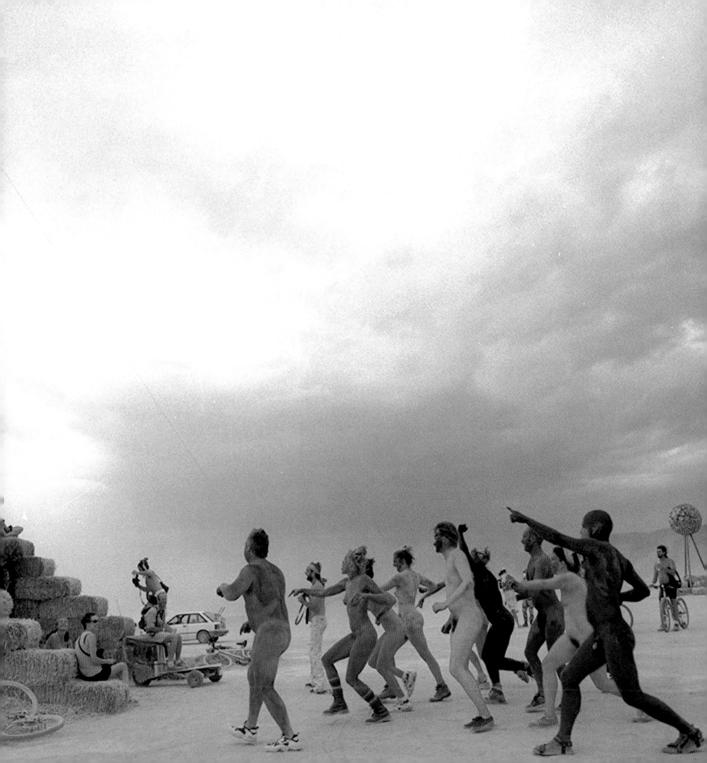

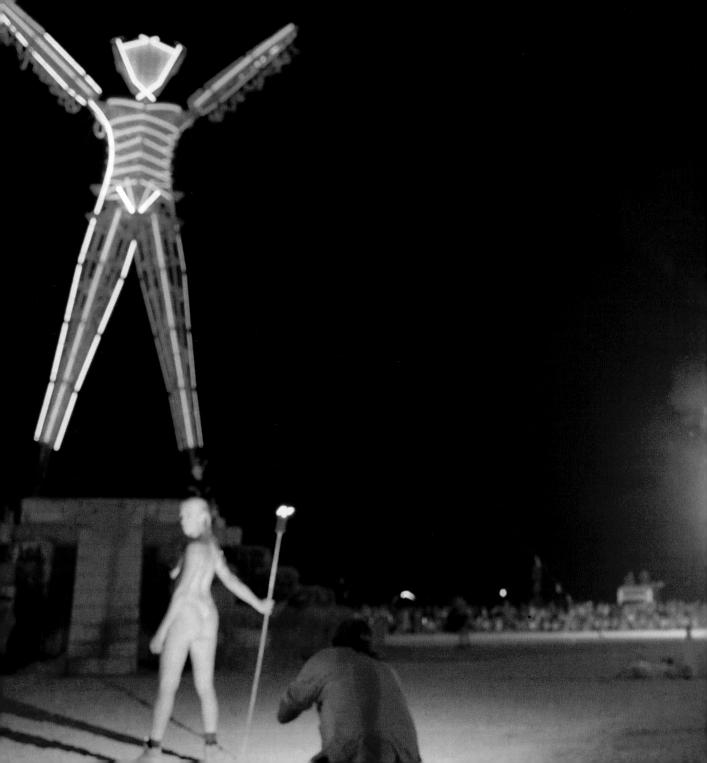

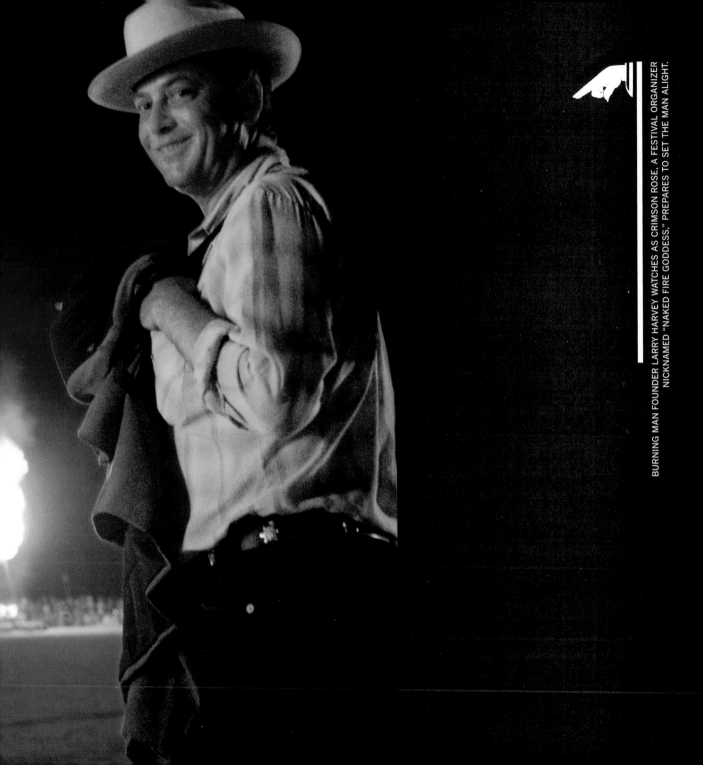

BURNING MAN FOUNDER LARRY HARVEY WATCHES AS CRIMSON ROSE, A FESTIVAL ORGANIZER NICKNAMED "NAKED FIRE GODDESS," PREPARES TO SET THE MAN ALIGHT.

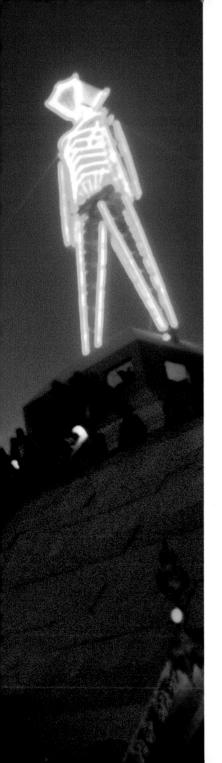

There is, of course, an easier question to ask. Of all the things you could burn, why choose a man? "Certainly a burning man is more accessible than a burning dog, or a burning centipede," Larry suggests, not quite helpfully. "And a burning centipede would be more accessible than something that was not alive in some sense."

So the first Man—NOT THE FIRST CENTIPEDE—was burned in 1986. Over the next few years, a widening circle of friends joined Larry to celebrate the homemade rite of summer. The bonfire on Baker Beach became a party, and that party picked up speed. A klatch of carpenters joined in, BUILDING THE EFFIGY STEADILY **TALLER.** The Man got so big that he finally had to be carried down to the beach in pieces, like the victim of some horrible dismemberment. When all of him—LIMBS, TORSO, HEAD—made it down a steep embankment, he was assembled near the shoreline. A rope was bound to his chest, and a line of people tugged on it to raise him into a standing position. Then everyone celebrated, and the Man burned. That's how the story went every year until 1990, when a policeman on a motorcycle delivered some grim news. To the chagrin of the crowd, about eight hundred strong by some estimates, there would be no fire this time. The Man was dismantled and hauled away. For the first time ever, the party broke up without reaching its peak.

By then, however, the cops weren't the only ones who had developed a keen interest in Burning Man. A couple of years earlier, the party had started attracting members from the San Francisco Cacophony Society, a group of artists, provocateurs, and friendly edge-seekers who defined themselves as **"A RANDOMLY GATHERED NETWORK OF free spirits UNITED IN THE PURSUIT OF EXPERIENCES *beyond the pale* OF MAINSTREAM SOCIETY."** The Cacophonists were connoisseurs of unusual happenings, and Burning Man

was just one event on their long list of excursions. They staged Laundromat poetry readings and turned a Bay Area Rapid Transit train packed with evening commuters into a Vegas-style lounge. They cavorted through deserted industrial landscapes and held lavish picnics. They seized chances to inject the routines of urban life with unpredictable fun.

Cacophonists had been slinging around the city since 1986, the same year Larry started his ritual, although they didn't encounter him until later. Their own origins stretch further back into the canon of San Francisco subculture. The founders of the Cacophony Society were ex-members of a secret circle called the Suicide Club, which formed in early January 1977 under the leadership of Gary Warne, in the wake of a harrowing adventure. At midnight during a wintry gale, Gary and three friends convened at Fort Point and stood on a sea wall below the Golden Gate Bridge. The story, now old enough to carry the patina of legend, is that they clung to a flimsy, salt-chewed railing while breakers hammered the rocks below and crashed thirty feet above their heads. The water roiled around them, but mercifully no one was dragged out to sea. They staggered away, feeling soggy yet defiantly **ALIVE**, and recuperated at Gary's bookstore, Circus of the Soul. There they discussed the evening's exploits and drew up plans for the future. That conversation grew into the Suicide Club, a group of friends who, through the pursuit of strange and extraordinary experiences, vowed to live each day as though it were their last.

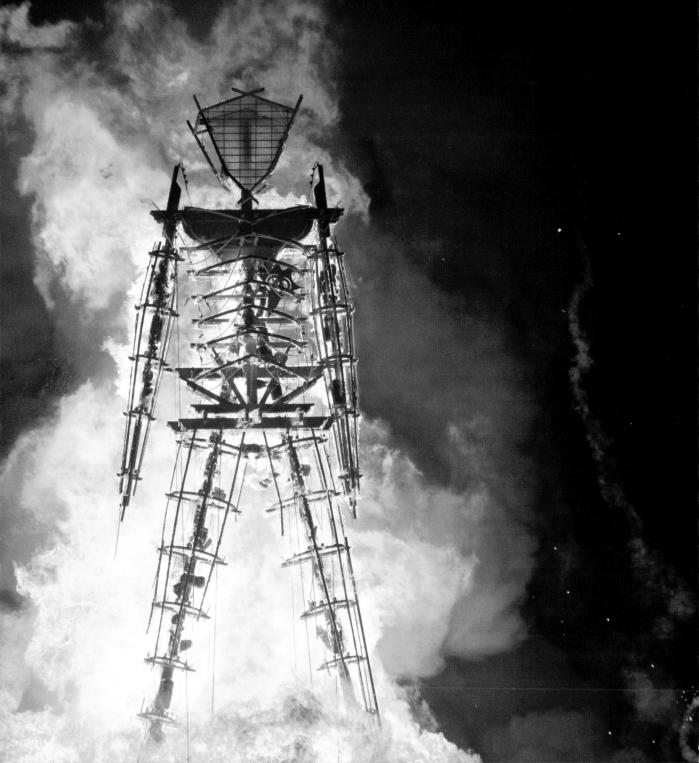

Ye SAN FRANCISCO Suicide CLUB Nooseletter

#26 December 1978

```
NOV 28,29   7-10 PM   Call for instructions for ROBYN HOODE VS THE XXANTHONS
SAT DEC 2   3:30 PM   ROBYN HOODE VS THE XXANTHONS
SAT DEC 2   7:00 PM   FIVE MILE TUNNEL
SUN DEC 3   11:30AM   ARCON- THE SWAMP DEMON
FRI DEC 8   10:00PM   SANTA TIES THE KNOT
WED DEC 6   5 or 6 PM DINNER AT REV. MOON'S
FRI DEC 8   dinner to SUN DEC 10, 10 PM   THE BOONEVILLE FARM
WED DEC 13  DEADLINE: reservations for Dec 19 ENTER THE UNKNOWN
FRI DEC 15  DEADLINE: $4 for NEW YEARS EVE must be received by Gary Warne
SAT DEC 16  9-12 PM   A CHANCE TO SAY "I HEARD HIM WHEN..." (PART TWO)
SUN DEC 17  DEADLINE: reservations for RETURN TO DAVEY JONES' LOCKER
SUN DEC 17  1:00 PM   RINGOLEVIO IV
TUE DEC 19  1:45 PM   ENTER THE UNKNOWN
WED DEC 20  DEADLINE: January Nooseletter items
FRI DEC 22  6:00 AM   COITUS GASTRONOMICUS
SAT DEC 23  2:00 PM   CREATING THE UNKNOWN
SUN DEC 24  5:00 PM   RETURN TO DAVEY JONES' LOCKER
TUE DEC 26  7:00 PM   COMMUNIVERSITY TEACHER FORMS MAILING PARTY
SAT DEC 30  5:00 PM   AN EVENING OF MIRACLES
SUN DEC 31  8:00 PM   NEW YEARS EVE WITH THE SOCIALLY DISEASED
```

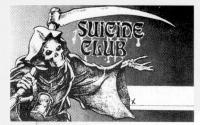

The Bearer:
has agreed to get all
worldly affairs in order, to
enter into the world of Chaos,
cacophony & dark saturnalia, to
live each day as if it were
the last, and is a member in
good standing of the
Suicide Club

UNDATED EVENTS

USFS, INC.
DRIVE-IN MOVIE

PARTING WORDS

MARITIME ADVENTURES
MEMO TO ALL WHO WERE INVOLVED IN MOMMY FORTUNA'S MIDNIGHT CARNIVAL
SUICIDE NOTE
CONGRESSMAN RYAN

JANUARY NOOSELETTER DEADLINE IS WED DEC 20. Editor is the mysterious, hard-to-get-hold-of Kathy Kay. Mail items to 899 Noe or slip them under the back basement entrence on 22nd St. (Not NOT under the 899Noe door, for aliens live there) Or call Kathy TODAY at these toll-free numbers: ███-████ (home) or ███-████ T,TH,F (work). Unless items are typed triple-spaced, the editor cannot be responsible for their final appearance... or non-appearance.

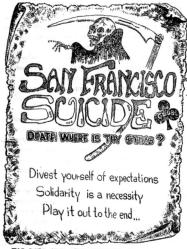
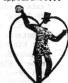

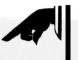

THIS PHOTOGRAPH, SHOT IN 1977 ON EASTER SUNDAY, WAS PRINTED AS THE FIRST IN A SERIES OF "WELCOME TO SAN FRANCISCO" POSTCARDS BY THE SUICIDE CLUB. THE OTHER SIDE READS: "PICTURESQUE CABLE CARS: WHEN IN SAN FRANCISCO, BE SURE TO ACCOMPANY THE SUICIDE CLUB ON ONE OF THEIR CURIOUS ADVENTURES."

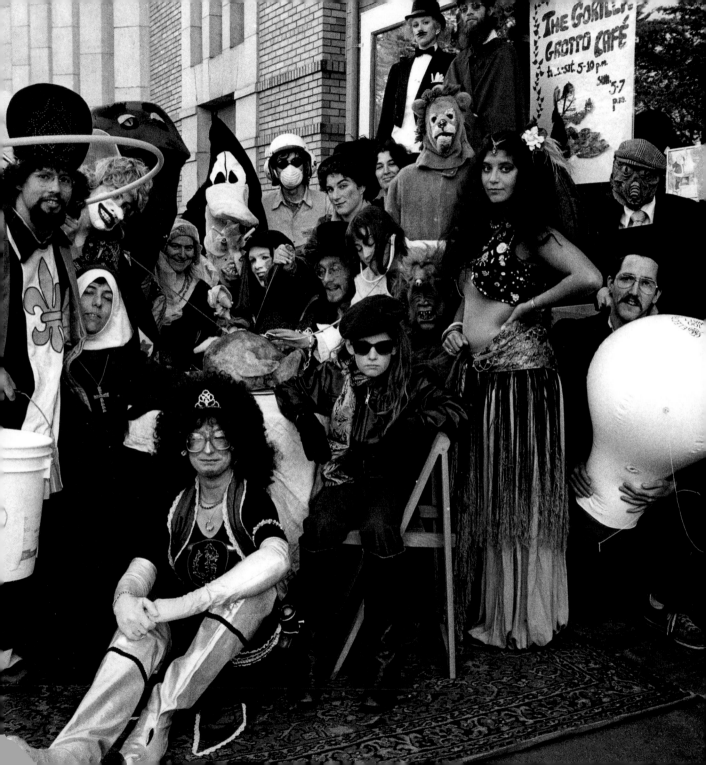

ROUGH DRAFT

The Official Organ of the
San Francisco Cacophony Society

#47
August 1990

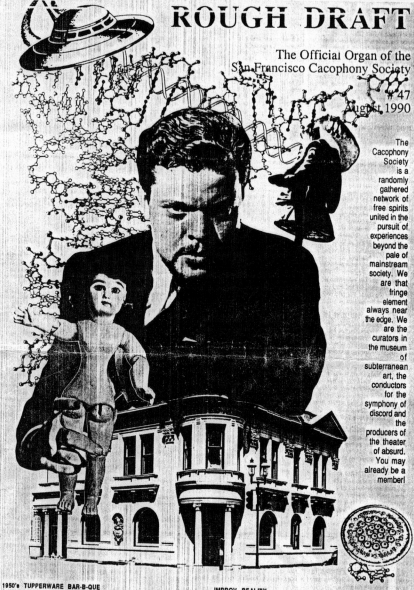

The
Cacophony
Society
is a
randomly
gathered
network of
free spirits
united in the
pursuit of
experiences
beyond the
pale of
mainstream
society. We
are that
fringe
element
always near
the edge. We
are the
curators in
the museum
of
subterranean
art, the
conductors
for the
symphony of
discord and
the
producers of
the theater
of absurd.
You may
already be a
member!

1950's TUPPERWARE BAR-B-QUE
When: Sunday, Aug 19th, 4 pm until ?
Where: A suburban home in the Sunset District, ▓▓▓ - ▓▓▓ ▓▓▓▓▓
▓▓▓▓▓▓ ▓▓▓▓▓▓▓▓ ▓▓▓▓▓, ▓▓ ▓▓▓▓▓▓▓
▓▓▓ ▓▓▓▓▓▓▓▓▓

Pull on your Peddle Pushers and Bermuda Shorts for the Great 1950's All-American Backyard Bar-B-Que and Big Band Party. In the spirit of all great cookouts, bring something to throw on the grill and food or drinks to share. (Please bring food in your best picnic Tupperware). Don't forget musical instruments and your favorite '50's records and tapes.

SEEDS OF CACOPHONY
When: Monday, Aug 20th, 7:30 pm
Where: Sacred Grounds Coffeeshop, ▓▓▓▓ ▓▓▓▓▓▓ ▓▓ ▓▓▓▓
Everyone is welcome at the monthly cacophony society "meeting" where we cultivate new event ideas and savor the garden of events past. Look for the table with the most fruit.

IMPROV REALITY
When: Saturday, Aug 25th, 7:00 pm
Where: Sacred Grounds Coffeeshop, ▓▓▓▓ ▓▓▓▓▓ ▓▓ ▓▓▓▓, ▓▓
If you don't like reality, create some of your own. Improvise it! In the best tradition of Mal Sharpe and the old Candid Camera TV show, we'll take to the streets to stage improvised skits, plays and fake interactions, and see how folks react.

What if a bickering couple turned to other passengers on a streetcar and solicited marital advice? How would patrons of a bar react if a well-dressed couple sat down, accompanied by a pet lobster? Would tourists give money to six folks carrying an apparently dead body and asking for spare change to buy a coffin? The possibilities , as they say, are limitless. Bring ideas for your own scenarios, and any props/costumes you think are appropriate. We'll brainstorm and rehearse for a while, then hit the streets. Also bring vehicles (the more bizarre the better), and dress up: who knows where we'll go? Jeffrey Spaulding ▓ ▓▓▓▓▓ ▓▓▓▓

RETURN OF THE RED VIC DRIVE-IN

When: Thursday, August 30th 8:00 pm

Where: Entrance to the Geneva Drive-In, Carter off Geneva near the Cow Palace in Daly City.

Since the esteemed Haight movie theater is in hiatal dispersement for the Summer, we feel the need to recreate the movie-going experience during its hibernation. To quote from Rough Draft #23, "For an outdoor cinematic experience in the kind of overstuffed comfort which is impossible in an automobile, we will be replicating the thrift shop comfort of the Red Victorian movie house, and taking it on the road to the drive-in." In order to create our own luxury outdoor living room/cinema, please bring chairs, sofas, blankets, warm clothes, truck/vehicles, food and drink. To coordinate transport, call Amanda at ████████ a few days in advance. Note: Focus Magazine gave the Cacophony Society the Tristan Tzara Award for this event, when it was held back in August 1988.

ZONE TRIP#4 - ASCENT INTO THE BLACK ROCK DESERT

An established Cacophony tradition, a trip into *the zone* is an extended event that takes us outside of our local area of time and place. On previous trips, Cacophony and company has discovered a point where the very nature of reality begins to change. We have defined that point as the boundary into *the zone*. On this particular expedition, we shall travel to a vast, desolate, white expanse stretching onward to the horizon in all directions... A place where you could gain nothing or lose everything and no one would ever know. A place well-beyond that which you think you understand. A place deep within the sector that is known as *the zone*. On this trip, we will be accompanied by the Burning Man. This 40 foot tall wooden icon will travel with us to that unknown location in the desert and there, will meet with destiny surrounded by throngs of Cacophonists and Burning Man enthusiasts. This excursion is an opportunity to leave your old self and be reborn through the cleansing fires of the trackless, pure desert. Bring with you something of strong symbolic value.

When: Labor day weekend, September 1-3.
Where: Somewhere in Nevada.
RSVP: ███████████

We will be camping in the high desert for 3-4 days. It's a 7 hour drive from SF to the Zone. You must RSVP by phone with your name, address, and phone number. You will receive explicit info on what you will need to bring: food, water, camping and cooking supplies. Ride sharing will be available and is encouraged. We also need additional trucks to carry supplies and materials for the caravan.

Objet Trouve - HAUTE TRASH FASHION SHOW

When: Friday & Saturday, September 14 & 15
Where: Nevada Theater, Nevada City, CA

Another long standing event in September? YES! This event has been going on for 7 years up in Nevada City and is a fashion show in which all the modeled clothing has been constructed from materials scavenged from the local dumpsites, and designed and assembled by people with names such as: Prima Debris, Disposabelle, House of Original Sin, Rayona Visqueen, Polly Ethylena, Recyclarella and Venus de Mylar. This may be the last year this show is held so we think it is important to make this important cultural journey. If you intend to go, it is important to purchase your tickets in advance, because tickets always sell out in advance. You can can purchase your tickets from Synergy II Bookstore, ███ ██████ ████, ██████ ████, ██ phone ████████ Tickets are $8 per one night or $15 for a 2-night pass.

CACOPHONY SINGLES CLUB

Sponsored by Isadora Landers

Lonely? Looking for that special someone? Tired of calling the dial-a-date lines? We are going to place a relationship ad in one of the local papers which reads something like this: "Are you looking for an adventurous man who practices law during the day and explores abandoned industrial buildings at night? Are you looking for a vivacious woman with multiple personalities and a wardrobe to match? The Cacophony Society has the greatest concentration of creative eccentrics you'll ever find. Now you don't have to pretend to be normal." In September, we will bring everyone together (at a very unlikely place) for a Cacophony Singles Night. The Marina Safeway was never like this.

Deadline for September events is Saturday, Aug 25th.

Quote of the month: When asked about her relationship preferences, Elaine Affronti (an early Cacophonist), replied "You can find an ordinary man in any bar, but good crazies are really hard to find."

------ Future Events in the Planning ------

Under The Waterfront - an Obscure Tours canoe trip under the piers of San Francisco.

Birthday Party - Sept. The Cacophony Society is 4 years old.

Caveman Camp Out - Release those primal urges as you spend the weekend in a secluded mountain retreat dressed as a member of the Cave Bear Clan.

Night of the Exquisite Corpse - Surrealistic theater written by the audience.

Magic Mushroom Festival - When: October 5-7. Where: Wales/England. What? We are told that it's fresh, organic, & legal. Just say know.

Return of the African Queen - A Sacramento river odyssey.

Halloween Madness - Halloween pranks by the Mister Bubble Conspiracy. MBC is looking for a Castro Street conspirtor.

Vampires of Los Banos - An 8mm film production.

The Grinch Whom - Interactive video with Doctor Seuss.

You can do an event, just call Cacophony.

Rabid Reviews:

<<<>> BUG- The organization and routine of a large, impersonal corporation is wrenched apart when a computer glich is uncovered by a nerd working on the assembly line. A great theatrical performance by the Z Collective. Playing thru Aug 13 on the 17th floor of the PG&E building. ██████████ $8 <<<>> DARK CIRCUS- After entering the theater you pass thru a midway which assails your senses until you become enmeshed in this reality of Kafka freaks. Don't miss it. Eureka Theater thru Aug 18th. ██████████ $9 <<<>> Calling DICK TRACY- Will Warren's Dick go down in history? Will it be bigger than 'Batman'? Do we care?

Cacophony Comments:

<<<>> Blow-up sheep are available from City Entertainment, ███ █████. <<<>> Jesus Christ, what next? Survival Research Labatories needs 3,000 copies of the Holy Bible. We know that these machines are on a mission from Hell, but the burning question is..."Can they be saved? John 5:47, Corinthians 3:15 <<<>> Our favorite supermarket tabloid has revealed that WD-40 cures arthritis... And you thought that it was just a nasal spray! <<<>> More tales from the Zone. Having a street sign on the wall of your room was once a symbol of the rite of passage thru adoselence, but now with the popularity of Teenage Mutant Ninja Turtles, there appears to be a new fad catching on with the kids. In the last month, 185 manhole covers have disappeared from the streets of Los Angeles... and they look great under that Nintendo game. <<<>> Glasnost is legal but skate boarding is still a crime in some parts of Europe, even so, there are some radical dudes over there. With a 36 cent stamp, you can send a postcard to a group of communist-punk-techno-artists/musicians:

████████████
████████████
████████████
█████ ███████████

Brief notes from last month's events.

<<<>> The Psychotic Road Rally was led by a giant dog head. <<<>> Eighty-five elegant explorers made it thru the sewers in the Oakland underground. To get your copy of the newspaper article, send a S.A.S.E. and a dollar to Rough Draft. <<<>> Fantasia South - After the arrival of Bacchus, no one seems to remember anything until waking up the next day.

We are everywhere! Do you know of any strange events, unusual restaurants, weird bars, lunatic cults, or secret passageways into underground tombs? Call the Cacophony Society at ████████

What will the VICIOUS RUMORS CLUB think of next? Find out what's brewing, Monday, Aug 27th, 8:00 pm at the San Francisco Brewing Company, ███ ████████ ████. I'll be the one with the snake.

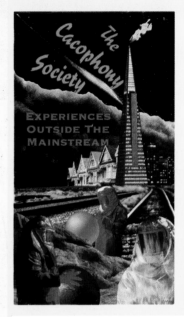

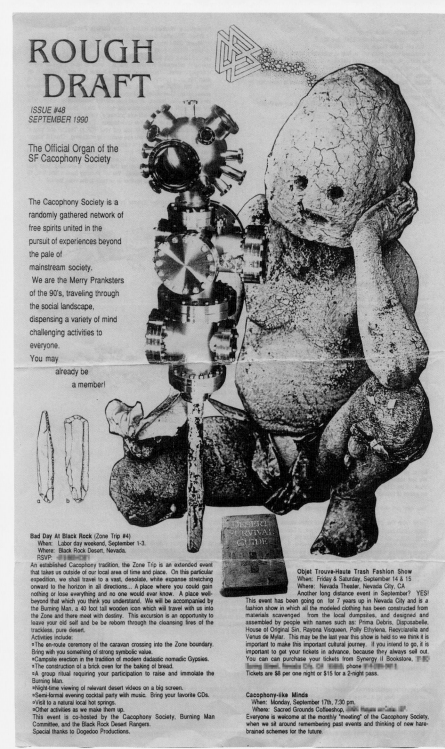

ROUGH DRAFT

ISSUE #48
SEPTEMBER 1990

The Official Organ of the
SF Cacophony Society

The Cacophony Society is a
randomly gathered network of
free spirits united in the
pursuit of experiences beyond
the pale of
mainstream society.
 We are the Merry Pranksters
of the 90's, traveling through
the social landscape,
dispensing a variety of mind
challenging activities to
everyone.
You may
 already be
 a member!

Bad Day At Black Rock (Zone Trip #4)
 When: Labor day weekend, September 1-3.
 Where: Black Rock Desert, Nevada.
 RSVP:
An established Cacophony tradition, the Zone Trip is an extended event
that takes us outside of our local area of time and place. On this particular
expedition, we shall travel to a vast, desolate, white expanse stretching
onward to the horizon in all directions... A place where you could gain
nothing or lose everything and no one would ever know. A place well-
beyond that which you think you understand. We will be accompanied by
the Burning Man, a 40 foot tall wooden icon which will travel with us into
the Zone and there meet with destiny. This excursion is an opportunity to
leave your old self and be reborn through the cleansing fires of the
trackless, pure desert.
Activities include:
▫The en-route ceremony of the caravan crossing into the Zone boundary.
Bring with you something of strong symbolic value.
▫Campsite erection in the tradition of modern dadastic nomadic Gypsies.
▫The construction of a brick oven for the baking of bread.
▫A group ritual requiring your participation to raise and immolate the
Burning Man.
▫Night-time viewing of relevant desert videos on a big screen.
▫Semi-formal evening cocktail party with music. Bring your favorite CDs.
▫Visit to a natural local hot springs.
▫Other activities as we make them up.
This event is co-hosted by the Cacophony Society, Burning Man
Committee, and the Black Rock Desert Rangers.
Special thanks to Dogedoo Productions.

Objet Trouve-Haute Trash Fashion Show
 When: Friday & Saturday, September 14 & 15
 Where: Nevada Theater, Nevada City, CA
 Another long distance event in September? YES!
This event has been going on for 7 years up in Nevada City and is a
fashion show in which all the modeled clothing has been constructed from
materials scavenged from the local dumpsites, and designed and
assembled by people with names such as: Prima Debris, Disposabelle,
House of Original Sin, Rayona Visqueen, Polly Ethylena, Recyclarella and
Venus de Mylar. This may be the last year this show is held so we think it is
important to make this important cultural journey. If you intend to go, it is
important to get your tickets in advance, because they always sell out.
You can can purchase your tickets from Synergy II Bookstore,
 phone
Tickets are $8 per one night or $15 for a 2-night pass.

Cacophony-like Minds
 When: Monday, September 17th, 7:30 pm.
 Where: Sacred Grounds Coffeeshop,
Everyone is welcome at the monthly "meeting" of the Cacophony Society,
when we sit around remembering past events and thinking of new hare-
brained schemes for the future.

The Mutant's Beach Party
When: Sunday, September 23rd, 2pm till ...?
Where: Baker Beach, SF

A costumed beach party will be held in celebration of the Fall Equinox. At this clothing-optional beach, you may show as much or as little skin, scales, fur, feathers, or other cuticle as you wish. There will be a contest with prizes for the Most Beautiful, Ugliest, Silliest, and the Most Authentic Mutant. Please bring picnic food and drink. This event is sponsored by our favorite group of pagans, the Compost Coven.
For carpool info call ▪▪▪▪▪▪▪▪
Come in costume, anyone who looks normal will be cast into the Pacific!

Surrealist's Wannabe Home Video Collage Festival
When: Thursday, September 27th, 8 pm
Where: ▪▪▪▪▪▪▪▪▪▪▪▪▪▪
Info: ▪▪▪▪▪▪▪▪

Legend has it that Salvador Dali and Andre' Brenton, at the heighth of the surrealist movement in Paris in the 20's, used to have a special way of watching movies. They would hop from theater to theater, walking in on each film at a random time. They would stay only until they started to figure out what was going on in the plot...and then they'd leave immediately. Their visual experience was thus entirely abstract. That's the idea of this video festival. Armed only with the necessities of modern life, a TV and VCR with remote controls, todays couch potato virtuosos are encouraged to mine the late-nite pallette of visual jetsom and flotsom for the distilled gems of collective unconscious. The technique for harvesting these cultural icons is simple: just put your VCR in "record" and "pause" then flip the channels until you see something interesting. Then hit "pause" at the beginning and end of the sections you want. If you hit "stop", rewind just a little and hit "record" and "pause" again... this way should get invisible edits and weave a rich tapestry out of a few nites of insomnia. Remember, we are not looking for the first layer of meaning: keep your clips fairly short and nonsensical. We will probably have a time limit, 15 minutes, depending on the number of entrants to the video festival.

Deadline for October Events is Saturday, September 22nd.

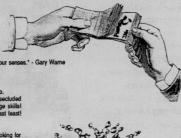

Quote of the month:
"Welcome to chaos, cacophony, and dark saturnalia. Leave your mind and come to your senses." - Gary Warne

------ Future Events in the Planning ------
Cacophony Birthday - A repeat of the very 1st event held four years ago.
Under The Waterfront - an Obscure Tours canoe trip under the piers of San Francisco.
Caveman Camp Out - Release those primal urges and spend the weekend in a secluded mountain retreat dressed as a member of the Cave Bear Clan. Learn new language skills! Thrill to the mastodon hunt! Dance to the primitive drum beat. Stuff yourself at the beast feast!
Night of the Exquisite Corpse - surrealistic theater written by the audience.
Return of the African Queen - a Sacramento river odyssey.
Halloween Madness - Halloween pranks by the Mister Bubble Conspiracy. MBC is looking for Castro Street resident for help.
Vampires of Los Banos - an 8mm film production.
The Grinch Whom - interactive video with Doctor Seuss.
Cacophony Garage Sale - Remember those weird props and costumes that you used in that event last year? Well, now is your chance to donate them for this most unusual garage sale. Give us a call to arrange for pick-up. No ordinary items will be accepted.

Cacophony Comments:
Survival Research Labs is about to open the gates of hell for a SF show in October. Forget about the bibles, watch out for the ultimate in *MACHINE SEX* ! Also there will be a SRL fund raising party this month. The Pacific Film Archive in Berkeley will present a series of surrealistic films this month. Call ▪▪▪▪▪▪▪ for details. Barbie & Ken cross-dressing? A lot of kiddies were suprised at a Toys-R-Us store in Tampa, FL last month. It stopped happening after they fired the night stockboy. Oh well.

Notes of recent events:
We saw some great underground films at the No Nothing Cinema which is so far underground we don't know when the next show will be. The Tupperware Bar-B-Que was a feast of 50's food, music, and dress. Improv Reality left a lasting impression on scores of tourists at Fishermans Warf.

You can call the San Francisco Cacophony Society at ▪▪▪▪▪▪▪▪.

Tales From The Zone?
Here is a sample of future events from the Los Angeles Cacophony Society:
James Dean Road Rally - September 30, 5:59 pm, at Cholame, CA. Bring your cultural icons.
Free Harry Houdini - Rumor has it that his spirit is still lingering around, waiting to be re-united with his dear mother. Although the original mansion has long ago decayed into ruins, the wooded grounds of the estate is still a bizarre maze of pathways, stone arches, and brickwalls. On a recent foray, we uncovered some newspaper clippings from 1923 relating to Houdini. One night during the month of October, we will use these items to hold a midnite seance somewhere on the grounds.
Poetry In Motion - A series of poetry readings in some very unlikely and unusual locations.
Crash Dining: A Guide For The Undercover Gourmet - Have you ever wondered what it's like to eat in the employees cafeteria of Universal Studios? Would you like to sample the food at the Police Training Academy? Ever wonder what the reporters talk about when having coffee at the LA Times? There are a large number of private restaurants in and around the Los Angeles area. In this on-going series we will provide information on how you can experience the cuisine behind those doors marked "Employees Only". We'll let you know what to expect on the menu including price and quality. And our complete dining guide includes details like: dress code, how to get past the security guard, where the back doors are, using the freight elevator, and what to say if you get stopped. Forbidden fruit is the sweetest kind.
Hidden Tunnels Under The University of Los Angeles? - Sounds like a great place for for a formal walking tour. More info after our exploration team returns.
To get the next issue of Tales From The Zone, send $1 to:

 LA Cacophony Society
 P.O. Box 7667
 Van Nuys, CA 91409
(or send $10 for a subscription of 12 issues)

Eonomy with stone (above)
A Length of cutting edge per pound of stone produced by the Neandertals' technique
B Length of cutting edge per pound produced by the Cro-Magnons' technique

Puzzle your postal carrier with mail art. Subscribe to Rough Draft. Each issue comes to you in an envelope bearing a unique visual image and may also contain any manner of strange inserts.
For one event-filled year, send $10 to:
 ROUGH DRAFT
 P.O. BOX 6392
 SAN FRANCISCO, CA 94101

BLACK ROCK CITY 2006
The Journey Home

©2006 Screen Print By Jeff Wood · jeff@drowningcreek.com · Burn, Baby, Burn

In the following years they toured the Oakland sewer system, rode a cable car naked, and scaled the Golden Gate Bridge. They launched an annual treasure hunt during the Chinese New Year parade that ended in a pie fight. The most daring adventurers staged a number of **"INFILTRATIONS,"** posing as prospective members to probe the Moonies and the American Nazi Party. Suicide Club initiates also infiltrated the National Speleological Society but found they enjoyed caving expeditions too much to keep up the ruse and befriended the explorers instead.

"I think the Suicide Club is the precursor to almost anything interesting happening in San Francisco for the last thirty years, including Burning Man. It definitely influenced all of it, and it's not well known at all, because we were a secret society," says John Law, who joined the Suicide Club in 1978, at the tender age of eighteen. John later became a core Burning Man organizer but severed his ties to the festival in 1996, after a close friend died in a motorcycle crash on the playa. By then, he says, the event had grown too large, too focused on a central icon—the Man—to align with his vision of what it should be. (Years later, after more than a decade of silence, John would reappear with a 2007 lawsuit asserting that festival organizers had violated his claim on Burning Man trademarks, the latest salvo in a multiparty dispute among festival founders over the marks. If this was a new prank, it was a bitterly barbed one, venting rifts among burners across the Internet and in the media before it disappeared under the veil of arbitration.)

Between 1978 and 1979, the Suicide Club's newsletter (THE **NOOSELETTER**) had more than a hundred subscribers, but in the following years the club began to fall apart. "In the last two years we did bigger, and more amazing, and more grandiose events," John recalls, "but the social core of the group was starting to atrophy." In 1982 the club disbanded. The next year, Gary Warne died from a heart attack at age thirty-five.

But the wild impulses that seeded the Suicide Club wouldn't stay down, and some of its restless alumni launched the Cacophony Society in 1986. The Cacophony Society vamped on a similar ethos but developed a more inclusive attitude than the Suicide Club. They referred to themselves as the Merry Pranksters of the 1990s. "**YOU** *MAY ALREADY BE A* **member!**" was a favorite slogan. They published a monthly newsletter of events called **ROUGH DRAFT**. Anyone who wanted to host a gathering was welcome to do so.

One of the group's early members, an electromechanical engineer called Michael Michael (NÉ MICHAEL MIKEL), felt that the Suicide Club had fallen apart because it was so insular. "Basically, they suicided because of lack of new input and new ideas," he says. "So I thought the best thing to do with Cacophony was to open it up and do something called cross-fertilization.

GET MANY MORE PEOPLE INVOLVED.
MANY MORE
brains.

So we would go and look for people who were doing stuff, and I came across some information that a bunch of people were going to go down to the beach to burn a wooden man." And that's how Burning Man and the Cacophony Society came to cross paths. In 1988 Michael attended Larry's bonfire on Baker Beach. "It went very well with the Cacophony Society," he recalls. "It was a really amazing thing, to go down there and do something so ABSURD, like burning this huge wooden sculpture." The next year he added the event to the society's calendar.

By the time the police brushed Burning Man off Baker Beach in 1990, Cacophonists had swelled the ranks of the gathering. Members of the society were there when the Man, unharmed, was lugged

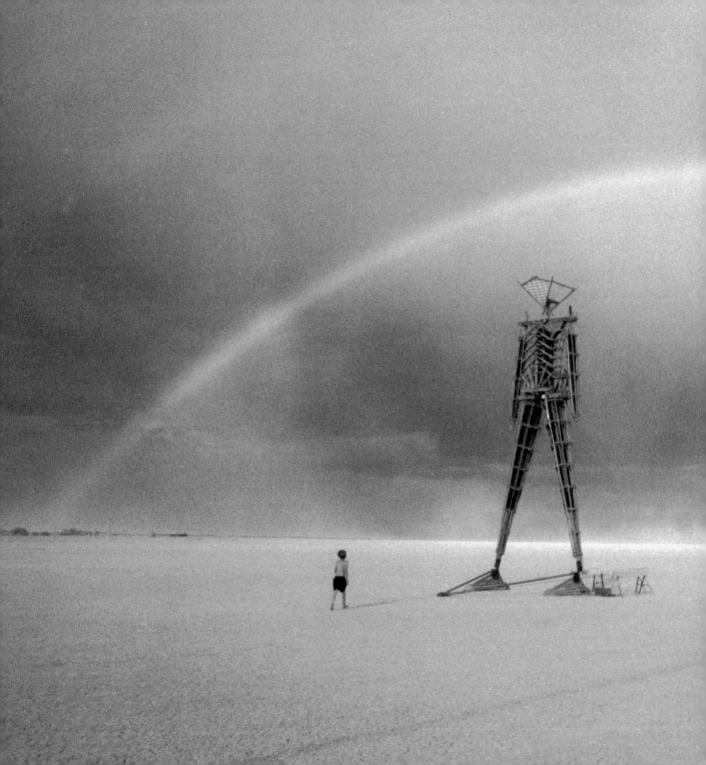

back up the hill from the beach. Some of them—notably John Law, P. Segal, and Kevin Evans—had already visited the Black Rock Desert in Nevada. They knew that the desert was a perfect home for **"don't try this at home":** a wide, seemingly invisible place where nobody would care how they carried on, or what they burned. If there was a better place to immolate a large wooden Man, no one could think of one. **And so** *the move was on.*

At the start of Labor Day weekend in 1990, around eighty friends assembled near a baseball diamond in Golden Gate Park. They loaded up a Ryder truck with sleeping bags, tents, and the Man. By the time they set off in a caravan across the Sierra Nevada, it was already after dark.

They reached Gerlach at dawn and stopped at Bruno's for breakfast, then continued onward. The procession stopped at the edge of the Black Rock Desert. Folks tumbled out of their cars. Michael Michael drew a line in the dust and pronounced,

"On the other side of this line, everything will be different.

REALITY *itself* WILL CHANGE.**"**

Everybody held hands. Together they stepped across the line.

Over the next decade, their adventure would swell into what Burning Man is now. But then it was just a peculiar happening, the kind of out-of-place excursion that Cacophonists called a "Zone Trip." Earlier that month the Cacophony Society newsletter had welcomed any of its readers to come along. The invitation read:

On this particular expedition we shall travel to a vast, desolate, white expanse stretching onward to the horizon in all directions. . . . A place where you could gain nothing or lose everything and no one would ever know. A place well beyond that which you think you understand. We will be accompanied by the Burning Man, a forty-foot-tall wooden icon which will travel with us into the Zone and there meet with destiny. This excursion is an opportunity to leave your old self and be reborn through the cleansing fires of the trackless, pure desert.

Were they reborn?
Who knows.
EITHER WAY, THEY HAD ESCAPED THE CITY.

THIS RAINBOW FOLLOWED A RARE DESERT HAILSTORM IN 1995.

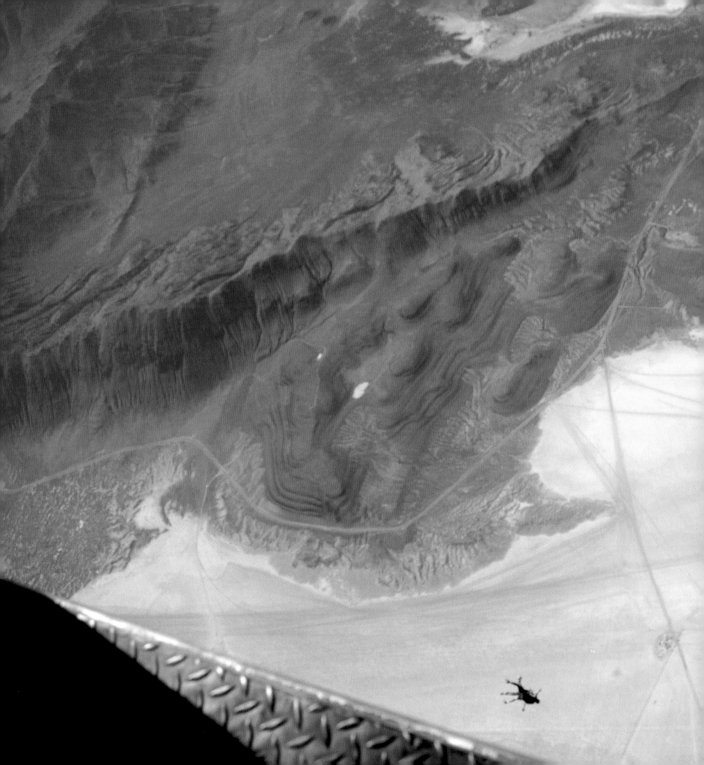

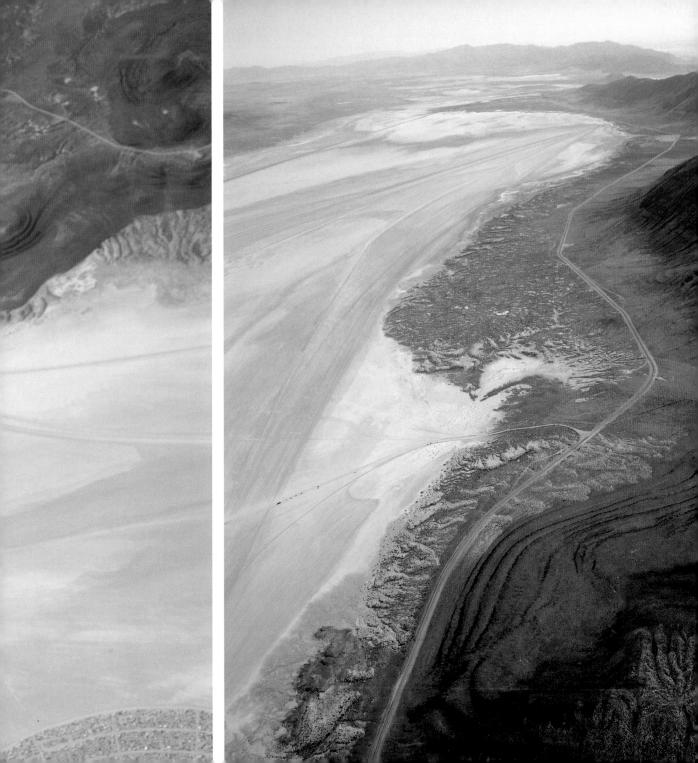

PREVIOUS SPREAD: AERIAL PHOTOGRAPHS OF THE PLAYA, SHOT FROM A SKYDIVER'S PLANE, REVEAL STEPPED
HILLSIDES WORN AWAY OVER THOUSANDS OF YEARS AS LAKE LAHONTAN RECEDED.

WHIRLWINDS OF SILT, CALLED DUST DEVILS, FORM WHEN HOT AIR ON THE DESERT SURFACE
RISES RAPIDLY THROUGH COOLER CURRENTS.

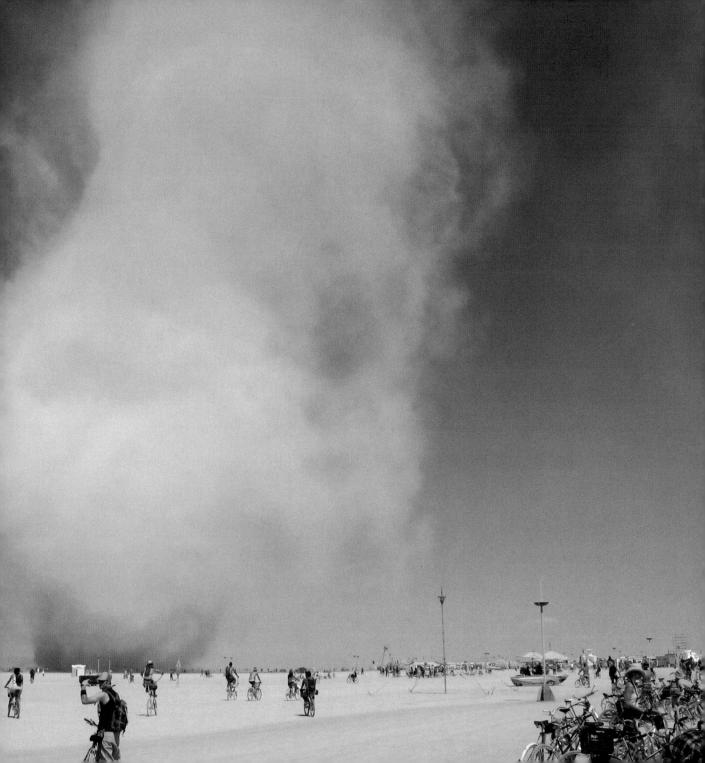

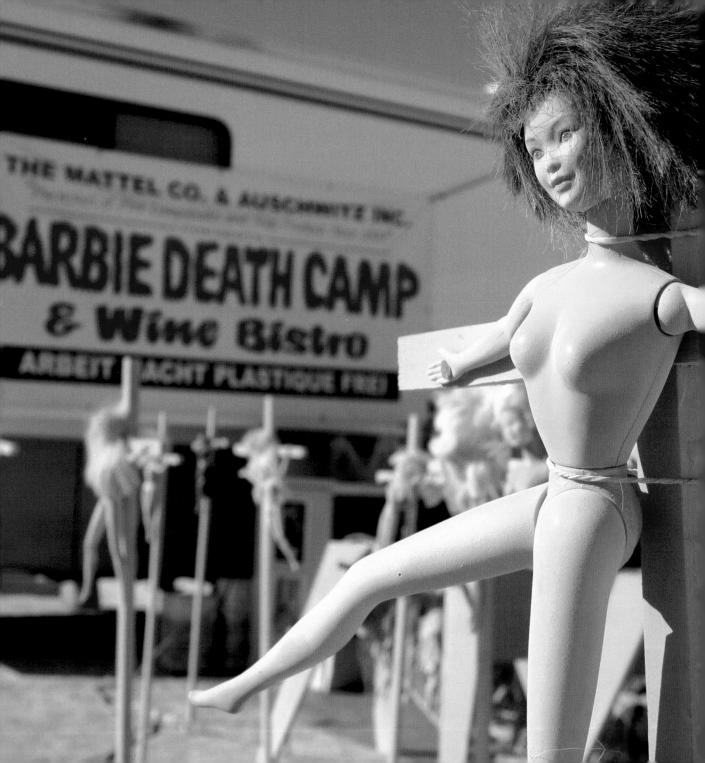

THE DESERT WANTS TO KILL YOU

THE MODERN INCARNATION OF Black Rock City is overwhelming up close, but it sure doesn't look like much from the highway. Pushing up from the desert floor, hundreds of windswept tents, trucks, and tarps clump together to form a rough skyline. Sometimes there's a silvery reflection „„„„„„„„„„„ *a mirage* „„„„„„„„„„„ where the city touches the ground, as if the whole thing is sitting in a shallow puddle. The scene is haphazard, and if you didn't know better, you could be approaching a redoubt for survivors of a nuclear disaster.

$200

BURNING MAN
August 28 – September 4, 2006
Black Rock Desert, NV

One by one, cars turn off the road and into the desert. They cruise slowly toward the city's front gate, raising trails of dust that hang in the air like fog. Signs along the well-traveled track hail the newcomers:

WELCOME —to the— *VACANT HEART* —of the— **WILD WEST**

WARNING: **you** **ARE** *TEMPORARY*

BURNING MAN —was— *MUCH BETTER* **LAST YEAR**

One of them urges drivers to tune in to **94.5, Burning Man Information Radio,** which broadcasts music, tongue-in-cheek travel advisories, and the constant admonition to drive slowly.

BMIR is one of a couple dozen low-wattage radio stations on the playa, and the programming blends public service content with off-kilter talk and music. Fiddling with your radio dial is like spinning a

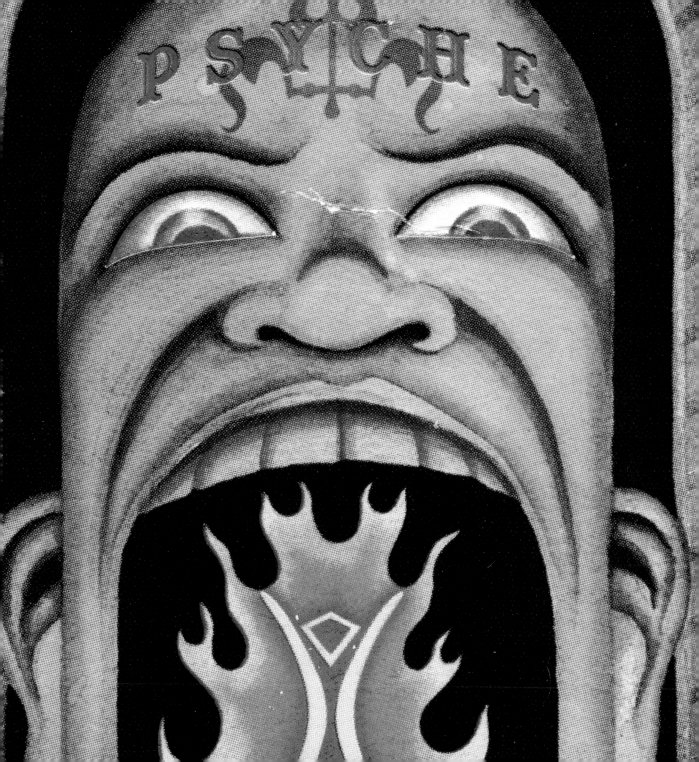

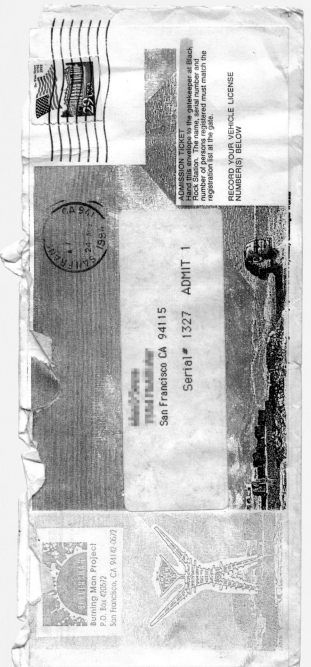

Serial # 1327 ADMIT 1

San Francisco CA 94115

Burning Man Project
P.O. Box 420572
San Francisco, CA 94142-0672

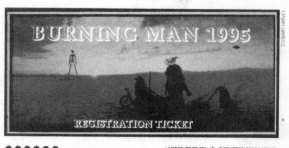

BURNING MAN 1995

REGISTRATION TICKET

956968

Burning Man '97

Fertility: the Living Land

BLACK ROCK CITY, NV
August 27 through September 1, 1997

BURNING MAN
P. O. Box 420572 • San Francisco, California 94142-0572
Hotline: 415. 985. 7471
Live Webcast: www.burningman.com

№ 119882

Admission Ticket

№ 119882

Burning Man 1996
Registration Ticket

11428

roulette wheel. You might catch an actual traffic update, or perhaps something like the report prepared by an act called the Evolution Control Committee...

"GOOD AFTERNOON!
I'm BMIR traffic reporter Maxine Swank,"
CHIRPS A FEMALE VOICE, WITH THE STACCATO THROB OF A NEWS CHOPPER IN THE BACKGROUND.
"A FEW SNARLS IN **BURNING MAN TRAFFIC CURRENTLY.**
IF YOU'RE TRAVELING IN THE **FOUR** TO **FIVE O'CLOCK BLOCK**
OF THE **ESPLANADE** *you've probably noticed already*
THAT THE **GROUND** IS ENTIRELY COVERED WITH
PEPPERMINT CANDY CANES *following a*
RECENT DOWNPOUR.
—meanwhile—
OVER AROUND 8:30 AND **AMNESIA,**
AN **ART BUS** *made out of* **LICORICE WHIPS** AND **NECCO WAFERS**
HAS STALLED, BLOCKING TRAFFIC *in both directions.*
AND **IF YOU'RE UNLUCKY ENOUGH**
TO BE IN THE **NINE O'CLOCK PLAZA** AT **BIPOLAR,**
A **WICKED WITCH** *is about to* **CAST** A **SPELL**
TO **TURN EVERYONE** IN THE AREA
INTO **CHOCOLATE STATUES....**"

There is little danger of getting transformed into a chocolate statue while you're waiting on line to enter Black Rock City. You may, however, wish to consider some less delectable hazards. Now is a good time to pull out your ticket (MADE WITH HEMP AND SOY INK) and flip it over. The fine print begins, "By attending this event, you voluntarily assume the risk of serious injury or death . . ." and continues for a few dozen lines. Translated, it's not just a disclaimer, but an ode to self-sufficiency and an *aperitif* for adrenaline junkies.

Burning Man 2002
Black Rock City ~ August 26 - September 2
The Floating World

$200

GENERAL ADMISSION

SECTION	ROW/BOX	SEAT
06 SEP '99	100.00	

BURNING MAN 1999
Black Rock City, August 30 - September 6, 1999
YOU VOLUNTARILY ASSUME THE RISK
OF SERIOUS INJURY OR DEATH BY
ATTENDING.

You must bring enough food, water, first aid to survive in a harsh desert environment, and all other explosives prohibited. Your image may be captured without your consent or compensation. Commercial use of images taken at Burning Man. A Survival Guide will be made available in the Survival guide. This is not a consumer event. Leave nothing but footprints.

*** PARTICIPANTS ONLY, NO SPECTATORS ***
Info: http://www.burningman.com or 415-TOFLAME

GENERAL ADMISSION

SECTION	ROW/BOX	SEAT
28 AUG 2000	200.00	

BURNING MAN 2000
Black Rock City, August 28 - September 4, 2000
YOU VOLUNTARILY ASSUME THE RISK
OF SERIOUS INJURY OR DEATH
BY ATTENDING.

You must bring enough food, water, shelter, and first aid to survive one week in a harsh desert environment. Commercial vending, firearms, fireworks, rockets and all other explosives prohibited by ALL rules in the Survival Guide. You agree to read and abide by all rules in the Survival Guide. This is a LEAVE NO TRACE. Pack it in, pack it out of playa clean up before departure. Commercial use of images taken at Burning Man is prohibited without the prior written consent of Burning Man. You appoint Burning Man as your representative to take actions necessary to protect your intellectual property or privacy rights, recognizing that Burning Man has no obligation to take any action whatsoever.

*** PARTICIPATE ***
Info: http://www.burningman.com or 415-TOFLAME

GENERAL ADMISSION

SECTION	ROW/BOX	SEAT
27 AUG 2001	125.00	

BURNING MAN 2001
Black Rock City, August 29 - September 3, 2001
YOU VOLUNTARILY ASSUME THE RISK
OF SERIOUS INJURY OR DEATH
BY ATTENDING.

You must bring enough food, water, shelter, and first aid to survive in a harsh desert environment. Commercial vending, firearms, fireworks, rockets and all other explosives prohibited by ALL rules in the Survival Guide. You agree to read and abide by all rules in the Survival Guide. This is a LEAVE NO TRACE event. In addition to your own camp clean up, you are asked to contribute 2 hours of playa clean up before departure. Commercial use of images taken at Burning Man is prohibited without the prior written consent of Burning Man. You appoint Burning Man as your representative to take actions necessary to protect your intellectual property or privacy rights, recognizing that Burning Man has no obligation to take any action whatsoever.

*** PARTICIPATE ***
Info: http://www.burningman.com or 415-TOFLAME

ADMIT ONE HUMAN
BURNING MAN
2⊕⊕3
BEYOND BELIEF
AUGUST 25 - SEPTEMBER 1, 2003

BURNING MAN 2003
BLACK ROCK CITY
AUGUST 25 - SEPTEMBER 1, 2003

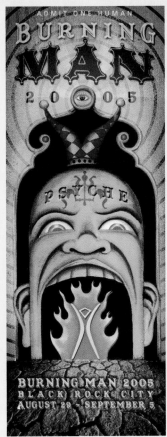

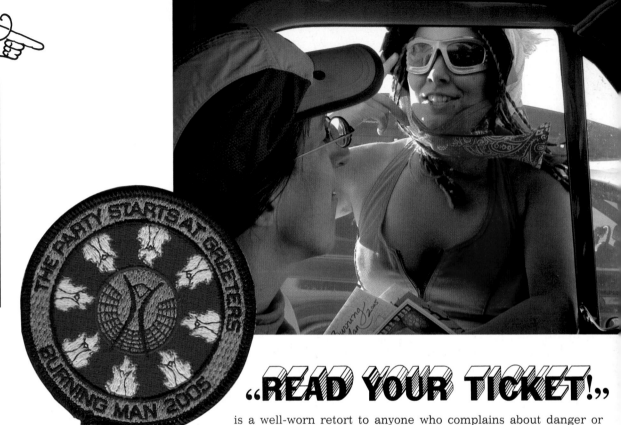

"READ YOUR TICKET!"

is a well-worn retort to anyone who complains about danger or discomfort on the playa. For the privilege of confronting your own mortality, you've shelled out anywhere from **$195** to **$280** per ticket if you thought to buy in advance. The prices are calculated on a sliding scale, rewarding early buyers and getting steeper as the event nears. At the Gate, last-minute tickets cost as much as $100 more than the highest pre-event price.

The fine print also articulates a series of commandments in capital letters:

"PACK IT IN! PACK IT OUT! LEAVE NO TRACE!"

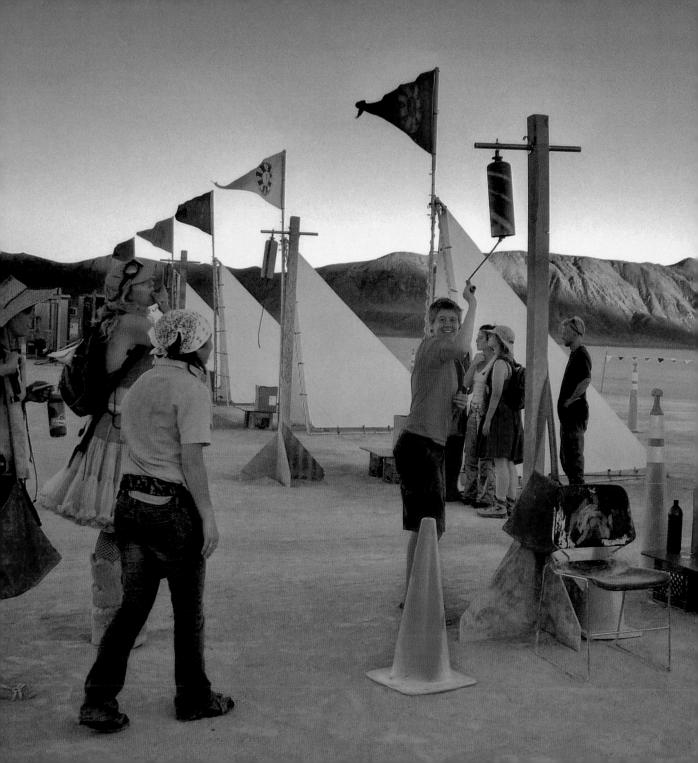

The **"it"** invoked here includes everything you bring past the gate, from tarps and tent poles, to bottles and cans, all the way down to gum wrappers and the lint in your pockets. There are no garbage cans on the playa. Trash is hauled away the same way it arrives here: in the back of your car. Litter has a special name—

"MOOP," for Matter Out of Place—and most burners are vigilant about keeping it off the ground. Once the Black Rock Desert was proposed as a landfill for San Francisco's garbage; in 2001 it became a National Conservation Area instead. The federal Bureau of Land Management is serious about keeping it pristine, and an eco-friendly attitude permeates festival culture. Even smokers break a perennial habit. Rather than dropping cigarette butts on the ground, they carry Altoids tins as portable ashtrays.

When you reach the gate, tickets are collected and the backseats and trunks of cars are poked for stowaways. A team of greeters—barely dressed or fully costumed, spangled, cowboy hatted, and dusty—hands out maps and copies of an events guide called the **WHAT WHERE WHEN,** which half of the population will instantly forget about or lose. First-timers are dragged from their vehicles, with cries of ..
........................**"WE'VE**
GOT A
VIRGIN
!"

THE DESERT WANTS TO KILL YOU

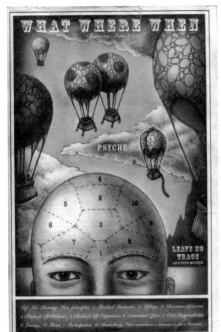

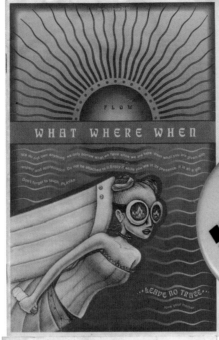

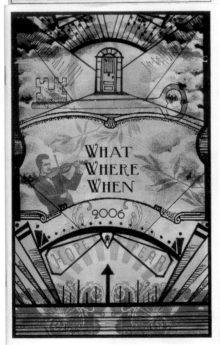

Some of the virgins look freaked out or vaguely embarrassed. Years ago they would have been initiated with a spanking. Now all they have to do is ring a **big** **loud** **bell.**

"The main gate, how cool was that?" says Lowry Igleheart-Keach, a fifty-six-year-old woman from Kentucky who attended Burning Man for the first time in 2005, after hearing breathless reports about the festival from her daughter. At the entrance, Lowry was happy to hop out of her car and take a whack at the bell. When the gate crew was searching for stowaways, it reminded her of how she and her friends used to smuggle themselves in to see drive-in movies. (THOUGH FREELOADING IS FROWNED UPON AT BURNING MAN AND CAR SEARCHES ARE INFAMOUSLY THOROUGH, THERE'S STILL ROOM FOR COMEDY, LIKE THE TIME A CARLOAD OF BURNERS CRAMMED A MANNEQUIN IN THEIR TRUNK TO PRANK THE INSPECTORS.)

 Twisting of **REALITY,** Lowry confesses, "Everybody has this amazing wit and sense of humor in how they see things, and I really appreciate that in other people. I'm not very much that way, but I appreciate the and making it different, and the wittiness of it, and the comedy of it. That hits you when you get to the main gate." At home Lowry runs a franchise restaurant called Maxine's Café and Bakery, where some of the younger customers were surprised to hear about her Burning Man plans. They warned her about what they imagined she'd find: a hedonistic hive of naked hippies and dope smokers. That did not dissuade her, and in the end, she found

A PAIR OF PERFORMERS REHEARSE FOR *THE TEMPLE OF RUDRA*, AN OPERA BY PEPE OZAN, WHICH WAS CHOREOGRAPHED AROUND FOUR SPIRES SCULPTED FROM STEEL MESH AND PLAYA MUD.

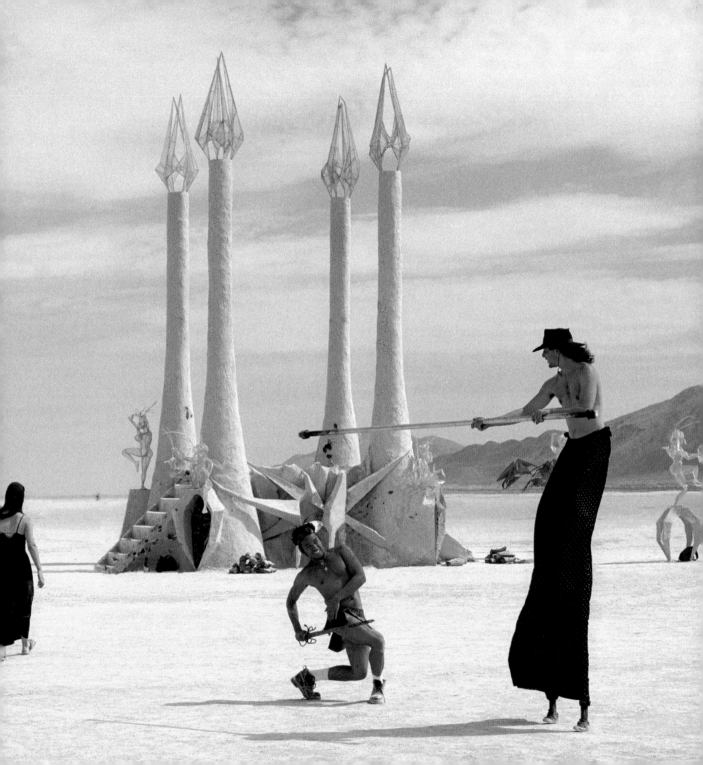

Black Rock City to be a neighborly place, which suited her just fine. **“HOW COULD YOU NOT FEEL PART OF IT, UNLESS YOU'RE A *stick-in-the-mud*, AND YOU'RE JUDGING PEOPLE FOR WHAT THEY'RE DOING?”** she asks.

When you arrive at the gate to Burning Man, whether you're a newcomer or an old salt, there are lots of hugs, embraces from strangers who look absolutely thrilled to see you. This is when you'll hear them say a most unlikely thing:

“WELCOME HOME.”

Who could possibly feel at home in such an alien place? For starters, the desert wants to kill you. The Black Rock Desert sits **3,848 feet** above sea level, and the elevation alone is enough to make you feel woozy and short of breath. The heat is hallucinatory and can reach a punishing **110 degrees.** The sun will make your brain feel like a raisin, and the air is dry enough that you can't even work up a sweat, because it evaporates too fast. In the words of Doc Velie, the town mortician in the 1955 Western **BAD DAY AT BLACK ROCK,** this is "a country so dry you have to prime a man before he can spit." Your body's natural distress signals aren't very helpful here. If you feel thirsty, it means you are already dehydrated. Among friends, the invocation ..

“DRINK!”

leaps into conversations every few minutes. The reminder is so fundamental, it's even seeped into the name of Black Rock City's alternative newspaper, **PISS CLEAR,** which refers to the outcome of drinking enough water.

THE DESERT WANTS TO KILL YOU

The playa surface is pale alkaline dust, as light and fine as talcum powder. When the weather is dry, it forms a hard crust that cracks like old paint. The dust gets into everything: your tent and your clothes, your lungs, eyes, and ears, the creases in your palms and knuckles. It forms a chalky film on your skin. Over the course of the week, it settles into your hair and eyebrows, powdering them a gentle shade of gray. In the early days of Burning Man, one clever saboteur revised a **NO SPECTATORS** banner to read **NOSE TATORS.** That phrase entered the local vernacular; it evokes nostrils plugged with playa dust.

The desert will stealthily colonize your body, just as you—with your tents, your footprints, and your fires—occupy the desert. And the dust isn't benign. It's corrosive enough to rust bicycles and burn feet. Taunting you, it will rise on the breeze in the thin, tall twisters called dust devils. The wind can gust to seventy miles per hour out here. When it picks up, dust storms plunge the desert into a blinding whiteout, so dense that you can't see more than a few steps in any direction. Sometimes entire camps are tempted to fly away. A dance club called Xara, known for its lush jungle foliage and genuine grass floor, was razed by high winds in 2000. But the punishing

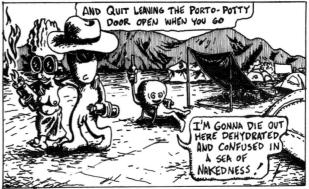

weather can also cultivate weird comedy. The same year, a smaller camp with a very long name ("THE GAZEBO COMES AND KILLS YOU ALL") fought to keep from losing its shade structure. Everyone braced the poles with their bodies and, as they struggled to hang on, a woman wearing nothing but a gas mask emerged from the dust. She approached each of them in turn, extending a Tupperware dish like a kind hostess and repeating an offer of refreshment: **"*Olive?*" "*Olive?*"**

Summer rain is rare, but when it comes, the desert gets impossible to cross. The hardpan surface melts into a pit of slurping mud that sticks to whatever it touches. Step in it, and your boot will come away with a four-inch platform sole. Try to drive, and your car will sink in up to the axles. If you think you can fight the mud (AND WIN), it's worth taking a lesson from seventeen thousand years ago, when a male Imperial mammoth sank along the shore of ancient Lake Lahontan and perished. His bones, which were found in 1979 up along the eastern edge of the Black Rock Desert, earned him the distinction of His gaffe was comically reenacted in 1993, when a hapless HBO video crew saw a squall rolling in. They ignored the desert dictum of patience and tried to flee. Instead of escaping, they swamped their vehicle. They ended up winning Burning Man's second **"DONNER AWARD,"** which was conferred annually through 2000 on an
— 𝕴𝖓𝖉𝖎𝖛𝖎𝖉𝖚𝖆𝖑 OR 𝕲𝖗𝖔𝖚𝖕 WHO PUSHES THE LIMITS OF 𝕻𝖊𝖗𝖘𝖔𝖓𝖆𝖑 𝕾𝖚𝖗𝖛𝖎𝖛𝖆𝖑 THROUGH 𝕾𝖙𝖚𝖕𝖎𝖉𝖎𝖙𝖞, 𝕴𝖓𝖆𝖙𝖙𝖊𝖓𝖙𝖎𝖔𝖓, OR JUST 𝕭𝖆𝖉 𝕷𝖚𝖈𝖐 — at the festival.

The local mud, however, has made at least as many friends as enemies. The edges of the Black Rock Desert are fringed with hot springs, and before the city's population got large enough to over-run them and visits during the festival were banned, you could go for a soak and slather yourself in the rich, blue-green sludge. Cloudbursts over the playa don't happen very often, but they've been known to spawn legions of naked, wallowing mud-people. During the 1990s, artist and voodoo priest Pepe Ozan adopted the muck as a creative medium. He daubed it on metal mesh arma-tures, using it like papier-mâché to build giant, phallic chimneys. These became the stage sets for a series of operas, with hundreds of ritually painted performers singing and capering their way to the end of each script, when the sets were burned.

In Black Rock country, rain showers typically arrive in winter through late spring. A shallow lake, just a few inches deep, forms on the desert floor. When the wind blows, sheets of water skim across the playa, scouring away footprints and tire tracks left over from the dry season. The water also revives the only creatures (APART FROM MICROBES) presumed to live on the playa: tiny brine shrimp, cousins of the critters toy stores sell as Sea Monkeys. They thrive in the shallow waters and lay their eggs in the puddles. When the desert dries out, the eggs lie dormant, ready to hatch with the next rains.

Even under the best conditions, when the playa is bone dry and the sun is bright, the landscape can be hard to navigate. William L. Fox suggests in his book **THE BLACK ROCK DESERT**:

> As a species, we are mentally so unprepared for the playa that we cannot see it for what it is. Without the visual benchmarks of the mixed woodlands and savanna landscapes in which we evolved as hominids—without trees to show us our scale in the

landscape and without humidity to fade the mountains with distance—we are lost. . . . What looks like a car a mile away turns out to be a tin can resting on its side. What looks like an hour's walk is more than a day off. Light comes from every angle.

For such a harsh and discombobulating place, the desert draws an unusual scattering of visitors, and not just people who go to Burning Man. The playa is a popular backdrop for auto-industry porn: those commercials where SUVs blast over blank landscapes, going nowhere but driving fast. In 1997 a needle-nosed racecar powered by twin turbojets set the world land speed record here; averaging **763 miles per hour** across two trials, it was the first car to break the sound barrier. Land yachts, essentially sailboats on wheels, arrive in early July to compete in the annual Holy Gale regatta. Other desert pilgrims include amateur rocket builders, who make the desert a sort of Cape Canaveral for armchair astronauts, and renegade golfers, who tolerate what is, in essence, a giant sand trap.

The Black Rock Desert seems like an awfully inconvenient place to throw a party. It is, however, a reasonable place to throw a party that is also a temporary city, a metropolis isolated by custom and geography from anywhere else on Earth. Depending on how you look at it, the desert could be a vision of gorgeous austerity or nature's version of an endlessssssssssssssssssssssssssssssssss parking lot. Either way, it demands that visitors take care of themselves and each other. If the desert is a huge Etch A Sketch, then each person is just a tiny scratch on the screen, threatened with erasure at the slightest shake. Survival is no longer an unconscious, reflexive act like breathing. It takes planning, effort, and cooperation. It stretches people to do things that they forget they're capable of back home.

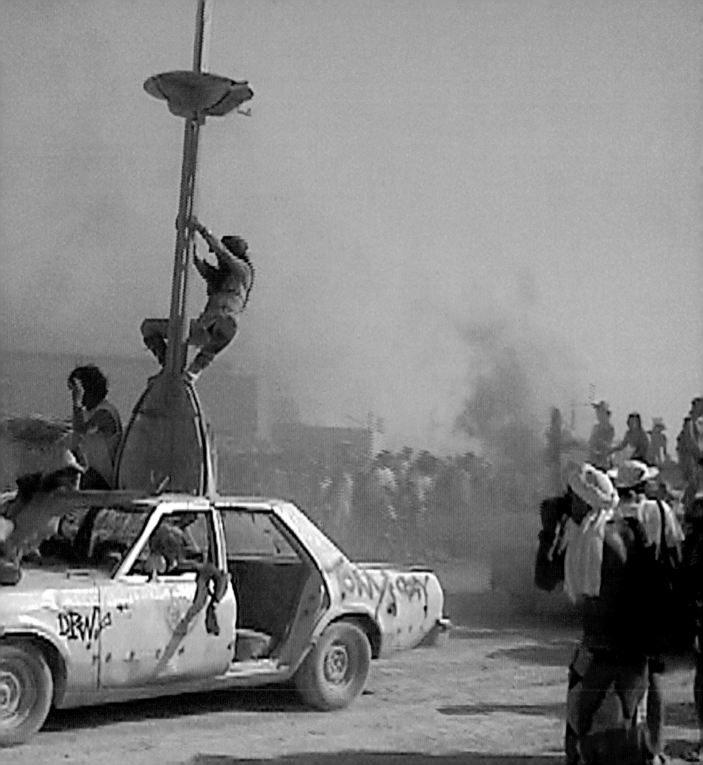

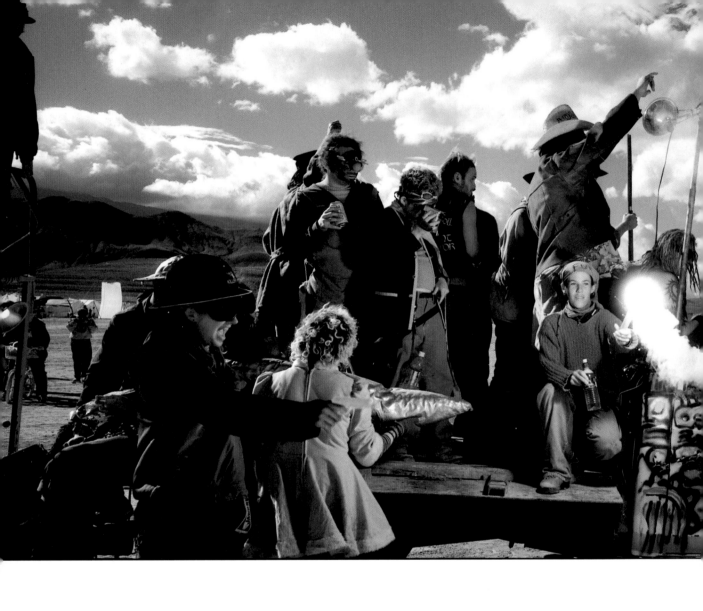

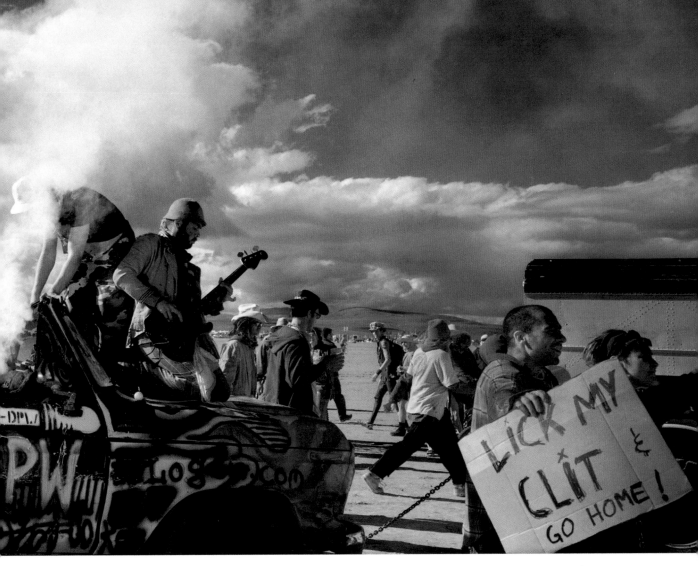

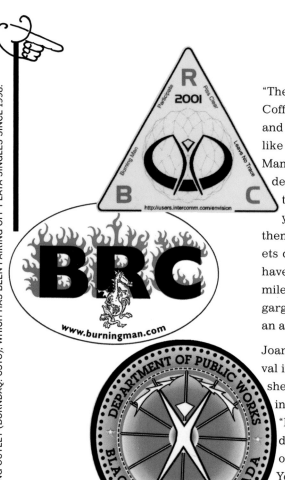

"The first thing I saw was a car pulling a sled," recalls Zachary Coffin, a sculptor from Atlanta. "There was a toilet on the sled, and a dude with his pants down, reading a newspaper, going by at like forty miles an hour." That was Zachary's first time at Burning Man, more than a decade ago. He'd decided to check out the party, despite early misgivings that it was one big hippie hoedown. Back then there was no real gate, just some parched fellow who told you to drive eight miles straight—watch that odometer—and then turn right and drive for another two miles. Back then, tickets cost around forty dollars. Things have changed. Ticket prices have more than quadrupled, and now the festival speed limit is five miles per hour. Still, Zachary kept going back. He began installing gargantuan sculptures of his own in 2000 and, for three years, held an annual party for burners in Atlanta called Ripe.

Joan Baez, the folk singer and political activist, attended the festival in 2005 and says she tried not to build any expectations before she got there. That may have been for the best. "It is like landing on another planet, but I mean in a nice way," she recalls. "I mean, after about forty-eight hours I knew I could really do absolutely anything. If I felt like lying down in the middle of the street and masturbating, nobody would have noticed. You know?" She laughs.

..."IT'S ABOUT AS FAR OUT AS ANYTHING I'VE EVER SEEN."

Beyond the gate, cars crawl into the beginnings of the festival and disperse, as drivers search for their campsites. Much of the infrastructure is already in place, thanks to the Black Rock City Department of Public Works. Informally, they're just called the DPW; sarcastically, they're

Greetings From BLACK ROCK CITY NEVADA

Dangerous People Working or Drunk People Welding. The DPW is made up of the kind of folks who can drink hard all night, then stumble out of bed for a seven thirty a.m. meeting and a long day of labor. The bulk of them are unpaid or get small stipends, trading their toil for meals at Bruno's and bunks at "Gerlach Estates" (A LOCAL TRAILER PARK) before Black Rock City is habitable. The actual festival is a short interruption on their work calendar, which can extend for months around the event. During the week of Burning Man, they get to brag, wearing grime, scars, and sunburn as badges of honor. The crew assembles midfestival to ride in the annual DPW parade. It's a rowdy procession of yelling, jeering, and chest-thumping crew members. They hang from every imaginable handhold on forklifts, cranes, water tank trucks, pickups, and a few smashed-in, limping sedans.

"GIVE US YOUR BEER!" they yell. **"WE BUILT THIS CITY!"**

They look tough, flipping off the crowd and snarling through bullhorns. A few onlookers take affront at the verbal abuse, but most grin and cheer. Their biggest boosters run off and return with six-packs of beer, which they deliver gratefully into the parade riders' chapped hands.

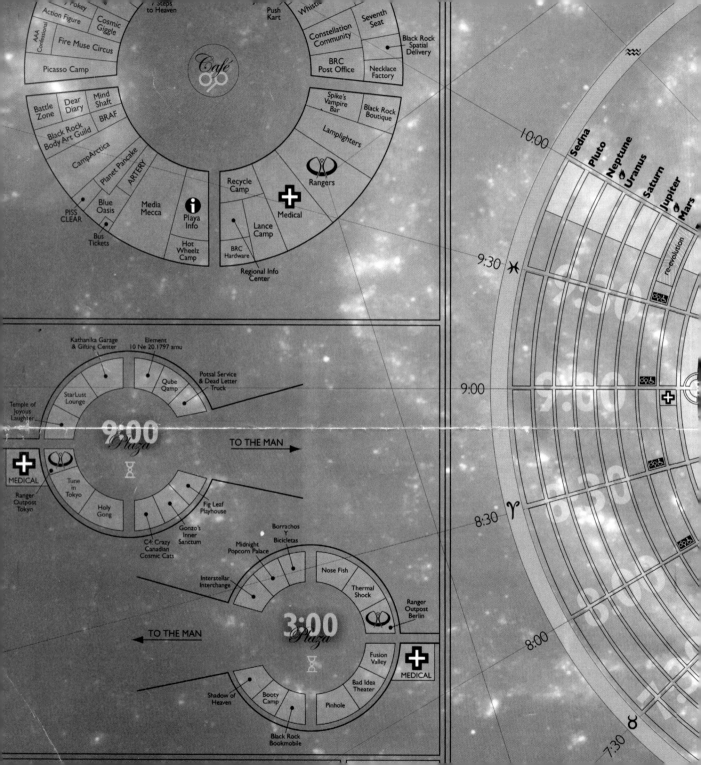

Café

7 Steps to Heaven
Push Kart
Whistle
Constellation Community
Seventh Seat
Black Rock Spatial Delivery
BRC Post Office
Necklace Factory

Pokey
Action Figure
Cosmic Giggle
AAA Confessional
Fire Muse Circus
Picasso Camp

Battle Zone
Dear Diary
Mind Shaft
Black Rock Body Art Guild
BRAF
CampArctica
Planet Pancake
ARTERY
PISS CLEAR
Blue Oasis
Media Mecca
Bus Tickets
Hot Wheelz Camp

Spike's Vampire Bar
Black Rock Boutique
Lamplighters
Rangers
Recycle Camp
Medical
Playa Info
Lance Camp
BRC Hardware
Regional Info Center

10:00

Sedna
Pluto
Neptune
Uranus
Saturn
Jupiter
Mars

re-evolution

9:30

9:00

Kathanika Garage & Gifting Center
Element 10 Ne 20.1797 amu
Potsal Service & Dead Letter Truck
Qube Qamp
StarLust Lounge
Temple of Joyous Laughter

9:00
Plaza

TO THE MAN →

MEDICAL
Ranger Outpost Tokyo
Tune in Tokyo
Holy Gong
C4: Crazy Canadian Cosmic Cats
Gonzo's Inner Sanctum
Fig Leaf Playhouse

Interstellar Interchange
Midnight Popcorn Palace
Borrachos Y Bicicletas
Nose Fish
Thermal Shock
Ranger Outpost Berlin

3:00
Plaza

← TO THE MAN

8:30

8:00

Fusion Valley
Bad Idea Theater
MEDICAL
Shadow of Heaven
Booty Camp
Pinhole
Black Rock Bookmobile

7:30

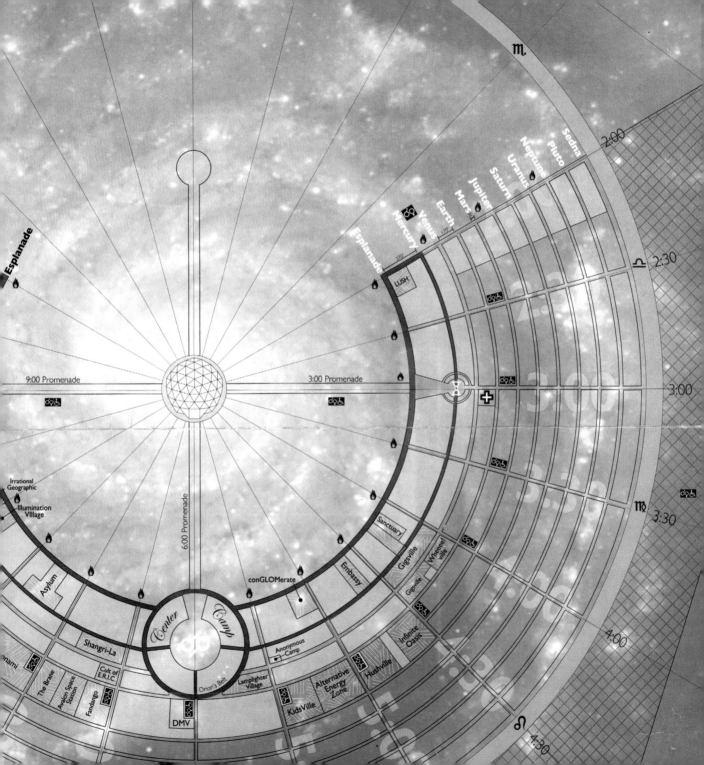

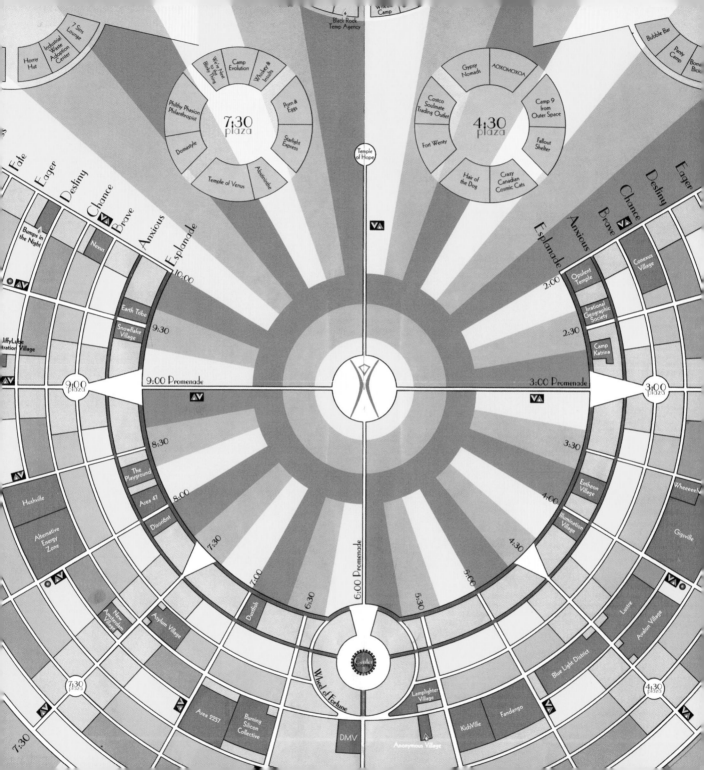

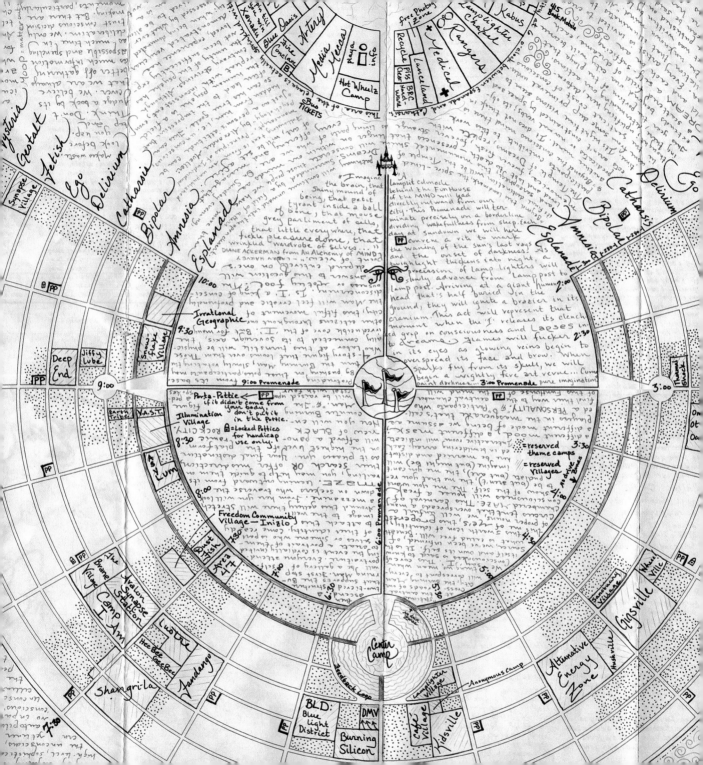

For the month before Burning Man, the DPW has been tracing a map into the desert and setting landmarks. A ceremonial

" Golden Spike "

is forced into the dust at the beginning of August to mark the center of the planned city, where the Man now stands. The spike is painted yellow, and everyone takes a turn hitting it with a sledgehammer, driving it down into the ground and then breaking a champagne bottle over the top. (AN *empty* CHAMPAGNE BOTTLE, EMPHASIZES TONY "COYOTE" PEREZ, A BURNING MAN EMPLOYEE AND THE DPW'S SITE MANAGER. "THE DPW," HE EXPLAINS PROUDLY, "WILL NEVER SMASH A FULL BOTTLE OF CHAMPAGNE.") Once the center of the city is established, the DPW begins some of the harder jobs. They pound in more than five thousand **T** stakes to form a seven-mile circle, then connect them with orange construction netting to create a perimeter fence. They lay out the roads. They build Burning Man's social hub, the Center Camp Café. They erect dozens of signs and install hundreds of lampposts for kerosene lanterns.

The city sketched out by the DPW will continue to fill in. The population will swell toward forty thousand, making Black Rock City the ············

THE DESERT WANTS TO KILL YOU

By the end of the week, it will feel unimaginably gigantic. The street grid measures almost two miles across in the form of a giant letter **C**; that shape comes from the main boulevards, a series of concentric arcs, which intersect with a series of radial streets aligned like spokes on a bicycle wheel. Between the roads are curved city blocks, which become crowded with camps and all manner of distractions. You'll find board games built to human scale. Colossal versions of Mousetrap, Connect Four, Operation, foosball, and chess have all appeared out here at one time or another. Giant trampolines are everywhere, and they never seem to go out of style. In some parts of town, you'll see bodies bouncing giddily every few blocks. There are homemade labyrinths and rickety carnival rides, rowdy taverns and lascivious lounges, neon forests and black-lit jungles. There are quiet citadels of contemplation, and throbbing rave clubs with sound systems loud enough to lobotomize you.

There are two things you won't find: vending and commercial advertising. After the shopping stampede that leads up to Burning Man, this comes as a relief. No billboards or neon signs are vying to sell you soft drinks, or hamburgers, or MP3 players. Every now and then some crafty marketer slips through; in 2001 a company called Sex.com emblazoned its web address overhead with skywriting aircraft. But for the most part, the only logos you'll see are satire. The newspaper **PISS CLEAR** is full of fake ads that riff on the real thing, inviting you to buy a game called Grand Theft Artcar, or shop at Playazon.com, or do your banking at Black Rock Citi. The Black Rock Post Office has a sign for an ambulatory delivery service: PedEx. An energetic gay sex salon with the slogan

Get in, get off, get out.

went by the name Jiffy Lube until the Shell Corporation served its organizers with a cease and desist letter in November 2005.

"I was actually surprised it took them seven years to say something about it," J.D. Petras, one of the camp's founders, said breezily. "I'd been expecting it since day one."

The boys of Jiffy Lube got the last laugh. They rebranded themselves Stiffy Lube and posted a promise on the front page of their camp's website: "We'll be at Burning Man 2006 fucking in our 🐚Shell Oil🐚 workman outfits." Similar clashes over mock branding at Burning Man had happened earlier. In 2000 the National Geographic Society, which has featured the festival on the cover of its magazine, went after a theme camp called the Irrational Geographic Society. The Costco Wholesale Corporation hassled the team behind another venerable desert institution: the Costco Soulmate Trading Outlet, which calls itself "Black Rock City's leading supplier of high-quality, low-cost soulmates." (ONE CORPORATE LAWYER PREFACED HIS DEMANDS WITH THE DISCLAIMER: "COSTCO HAS A SENSE OF HUMOR, HAS NOTHING AGAINST YOU OR BURNING MAN, AND DOES NOT WANT TO SUE ANYONE.") In both cases, the intrepid burners persisted, and their parodies prevailed.

No one could create the spectacle of Burning Man alone. Many denizens of Black Rock City band together in tribes called theme camps. Camp members live communally and cooperate on projects to amuse (OR TITILLATE, ENLIGHTEN, DISGUST, INCINERATE, CONFOUND) the rest of the city.

AT

Barbie Death Camp and Wine Bistro,

HUNDREDS OF BARBIE DOLLS HAVE BEEN IMPALED,
CRUCIFIED, SLID INTO OVENS LIKE CUPCAKES, SET ON FIRE,
OR DAMNED TO OTHER TORMENTS.
VISITORS CAN SIP CABERNET AND INVENT NEW FATES FOR THEM.

The Black Rock Roller Disco

HAS DOZENS OF SKATES TO LOAN. IF YOU CAN FIND A MATCHING PAIR,
YOU'RE WELCOME TO TAKE A LAP AROUND THE PLYWOOD RINK.

AT *Swinger's Lounge,*

YOU CAN SLIDE DOWN A ZIP-LINE, ENTERTAINING THE BARFLIES BELOW
WITH YOUR FLAILING, WHITE-KNUCKLED RIDE.

Flight to Mars

HOSTS A SPACE-AGE FUNHOUSE WHERE PEOPLE
—PARTICULARLY THE INEBRIATED—
HAVE BEEN KNOWN TO GET LOST FOR HOURS.

Depending on your mood and the time of day, other theme camps will offer to give you a henna tattoo, flog you, trim your pubic hair, slather you in body paint, bind you with ropes, sear you with a branding iron, teach you to make absinthe, administer **"free electroshock,"** massage your tired muscles, lead you in deep meditation, train you in Balinese monkey chant, or stick you in a casket to witness your own mock funeral, so you can hear all the nice things your friends have to say in memoriam.

As more and more people arrive, the city gets bigger, brighter, and weirder. People are creating things to share with the rest of the population. There's a friendly sense of competition, too. Everyone is racing to close a gap: the space between what can be imagined and what can be done. As that margin narrows, when thought and action come close enough to brush against one other, you get a

STATIC CHARGE.

AUGUST-SEPTEMBER 1995

piss clear

another
Burning Man
'zine from
Adrian Roberts

opinion
lists
style
rants
survival ideas
humor
blurbs
beauty tips
music
art
quips
commentary
thoughts
sound bites
plugs
puzzles

piss clear

issue 2.1 • friday 30 august 1996

The single most
important survival
tip for the
Black Rock Desert
see page 3

piss clear

issue 2.2 • saturday 31 august 1996

Head trips
see page 4

piss clear

issue 2.3 • sunday 1 september 1996

10,000 BURNING MAN FANS CAN'T BE WRONG
Or can they? Ex-Black Rock Gazette editor Stuart Mangrum rants. See page 4.

28 august 1997 • issue five • version 3.0

piss clear

Black Rock City's alternative weekly

Burning Man finally
sells out! see page 56

FUTURE HOME OF
BLACK ROCK
SHOPPING CENTRE

piss clear

Black Rock City's only alternative newspaper

the return of the
DRUG GUIDE
FOR THE PLAYA

Black Rock City
NEXT 5 EXITS

5 september 1998 • issue six • version 4.1

piss clear

1 september 1996 • issue eight • version 5.1

Black Rock City's only
alternative newspaper

I LOVE THIS TOWN!
WE LOVE THIS TOWN!

5 september 1999 • issue nine • version 5.2

piss clear

Rumor mill
No more opera!
Killer BM ideas
Newbie advice
Sassy garbage tips
No RU hookups?
Top 10 albums
...and much more!

Black
Rock City's
only
alternative
newspaper

piss clear

Black Rock City's only alternative newspaper

our first annual
best of
black rock city
ISSUE

5 september 1998 • issue seven • version 4.2

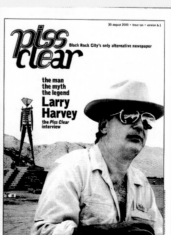

30 august 2000 • issue ten • version 6.1

piss clear

Black Rock City's only alternative newspaper

the man
the myth
the legend
Larry
Harvey
the Piss Clear
interview

1 september 2000 • issue eleven • version 6.2

piss clear

Are dot.com yuppies
killing Burning Man?

Probably.
See inside.

Black Rock
City's only
alternative
newspaper

There are plenty of intoxicants to be found in Black Rock City—thrill-seekers are ingesting drugs so new, they don't have names yet—and a thousand ways to seek ecstasy or oblivion. But few experiences here feel as seismic as bringing the city to life. And in a town like this, keeping up with the neighbors isn't easy. For anyone who bothers to try, it means creating a spectacle that will knock your friends flat whenever they walk past:

MORE WATTS !!!!!!!! MORE STEEL !!!!!!!! MORE LIGHTS& FIRE! MORE MARSHMALLOWS !!!!!!! MORE RUBBER CHICKENS !!!!!!!!!

"Burning Man is work," suggests Dave X, the festival's fire safety manager, who cultivates an air of mystery with his single-letter surname. He's an affable, long-haired fellow who, at forty-two years old, is equally at ease talking about propane fittings, making your own fireworks, and the years he spent on the road following the Grateful Dead. "It's like going to Mecca," he says of Burning Man, "except you're supposed to build it when you get there."

Making your own Mecca is an engrossing task. The drive to build Black Rock City gets compulsive, becoming a rabid, frothing desire that can overwhelm even the urge to party. Dave Cooper, an official with the federal Bureau of Land Management who oversees the Black Rock Desert, brought his brother, a recovering meth addict, to Burning Man two years ago. "It was a life-changing event for him," Cooper says. "He came in early, so I said, 'You're going to have to work and volunteer.'" His brother pitched in with the builders, first helping to put up the Man, then enlisting for other projects. "He stayed sober, and he was on his own," he recalls. "You know, it was a big test. The temptations are there at Burning Man."

piss clear

Black Rock City ranked
MOST LIVABLE CITY
by Rand McNally *Places Rated Almanac*
(Despite ranking #343 in climate)

#1

Black Rock City's daily alternative newspaper

piss clear

Black Rock City's daily alternative newspaper

20TH ANNIVERSARY ISSUE!
Celebrating two decades on the playa

piss clear

TAKE BACK BLACK ROCK CITY!

Black Rock City's daily alternative newspaper

piss clear

Black Rock City's favorite alternative newspaper

YOUR ART IS WRONG

The *real* story behind last year's infamous 'Jiffy Lube incident.' Was it art censorship? Homophobia? Or just one *really* uppity queen?

piss clear

Black Rock City's favorite alternative newspaper

We built this city
A kinder, gentler DPW builds Black Rock City

piss clear

our second quadrennial best of black rock city issue

Black Rock City's favorite alternative newspaper

piss clear

Black Rock City's favorite alternative newspaper

Why are only a handful of radio stations left in Black Rock City?

The FCC Won't Let BRC Be

FCC

piss clear

THE DRUG ISSUE

Black Rock City's favorite alternative newspaper

piss clear

the Fashion Issue

Black Rock City's favorite alternative newspaper

piss clear

our third ever best of black rock city issue

Black Rock City's favorite alternative newspaper

piss clear

FOR THOSE ABOUT TO BLACK ROCK, WE SALUTE YOU

Black Rock City's favorite alternative newspaper

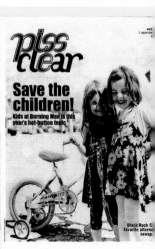

piss clear

Save the children!
Kids at Burning Man is this year's hot-button topic

Black Rock City's favorite alternative newsp

The biggest, showiest theme camps are built along the city's inner arc, an electric boulevard called

The Esplanade.

It feels like the midway of a psychedelic carnival, or a Champs-Elysées as imagined by extraterrestrials. Here you might find a one-third-scale replica of the Parthenon's façade—the home of THE SPACE VIRGINS—then ascend to the pediment and survey your surroundings like a Greek god. If you're suffering from urban withdrawal, you could seek out a small Times Square built by bonafide New Yorkers, who ring in New Day's Eve every night with a miniature ball drop when their countdown clock strikes twelve. Many of these installations are perennial, but the Esplanade is considered a prime piece of Black Rock City real estate, and chunks of it are rescrambled and doled out to different groups each summer. There's a rough system of zoning that relegates loud dance clubs to the far ends of the Esplanade's arc, but otherwise the layout is in flux. This holds true for the rest of the city as well, since it maintains a similar shape but is reinvented every year, shuffled like a deck of cards, which can befuddle the most seasoned of burners.

With the exception of the Esplanade, the concentric streets are renamed depending on the event's theme. The theme of Burning Man changes annually. It's usually pretty abstract; in 1998, for example, the theme was 66THE NEBULOUS ENTITY.99 Some burners would like to see the theme abolished altogether, or suggest their own satiric ideas, like 66HANG IN THERE, KITTEN,99 or 66THANKS-GIVING DINNER AT GRANDMA'S,99 or 66BURN A BIG WOODEN MAN AND HAVE A BIG PARTY.99 Both loved and loathed, the theme provides a glimmer of continuity in the festival's chaos, offering a conceptual sketch given life by some of the art installations and, more

obviously, on the street grid. When the theme was **"PSYCHE"** in 2005, street names were alphabetical: **Amnesia, Bipolar, Catharsis, Delirium, Ego, Fetish, Gestalt, Hysteria.** At other times, the streets have been given names of body parts (FROM HEAD WAY TO FEET STREET), planets in the solar system (FROM MERCURY TO SEDNA, THE PLANETOID PAST PLUTO), or the parts of a ship (FROM BOWSPRIT TO FANTAIL TO THE MYSTERIOUS ABYSS). The radial streets, the spokes in the wheel of the city, are easier to grasp. If you imagine the map as a giant clock face, they are named for the angles of each hour, from **2:00** to **10:00.**

When the bustling streets get too chaotic, there is also a quieter place to wander. Opposite the Esplanade is the open edge of the desert. Seen from overhead, it's the empty area between the two curves of the city's C shape. Here is an uninhabited frontier, wide enough to hike around in for hours and littered with improbable art. Some of it is massive in scale. You might encounter a giant chandelier crash-landed from some heavenly ceiling, or a barn-size rubber duck with a jazz club in its belly. You could wander into a urinal that is three stories tall and houses a fountain (*HOMAGE À MARCEL DUCHAMP*), or approach a filigreed temple that, from a distance, looks fragile enough to be a reconfigured dragonfly wing. There are smaller curiosities, too: a drinking fountain that pumps water in the middle of nowhere; an immaculate office cubicle, complete with halogen lamp, computer, and a flurry of memos; a tiny tepee that glows like stained glass but, on closer inspection, is made of Chinese food condiment packets—mustard, duck sauce, soy sauce—all taped together and lit from inside. People careen from one diversion to the next like pinballs, or simply park their bikes and stay awhile. No matter how long you spend roaming the city and its outer limits, you will never find every installation.

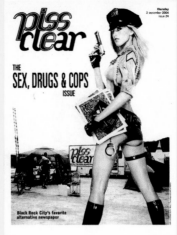
THE SEX, DRUGS & COPS ISSUE
Black Rock City's favorite alternative newspaper

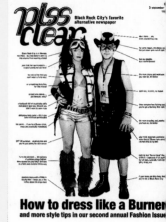
How to dress like a Burner
and more style tips in our second annual Fashion Issue

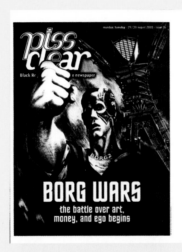
BORG WARS
the battle over art, money, and ego begins

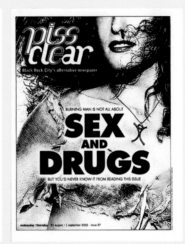
BURNING MAN IS NOT ALL ABOUT
SEX AND DRUGS
BUT YOU'D NEVER KNOW IT FROM READING THIS ISSUE

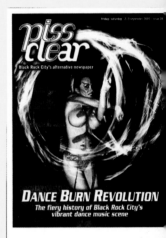
DANCE BURN REVOLUTION
The fiery history of Black Rock City's vibrant dance music scene

It's the 10-Year Anniversary of Burning Man '96!

the obligatory DRUG ISSUE
Black Rock City's alternative newspaper

BACK BY POPULAR DEMAND! IT'S THE RETURN OF...
PLAYA FASHION DOs & DON'Ts
Black Rock City's alternative newspaper

There are **TOO** **built in** **TOO** **by** **TOO**
MANY **MANY** **MANY**
THINGS TO SEE | H O U R S | P E O P L E.

The gates to Black Rock City officially open the last Monday of August. Artists building large-scale projects are allowed in early, with the most ambitious showing up at the beginning of the month to install their work. Theme camps start setting up a few days before the festival begins. When the city opens on Monday, some of the newest arrivals pitch their tents and immediately sink into long hours of labor, building all sorts of other absurdities their neighbors will enjoy. Others set up rudimentary camps, pull on fairy wings and furry leg warmers, and hit the town. In these beginning stages of the festival, it can be hard to tell who's doing what. Everyone wants to feel involved. Inevitably, a few others start pointing fingers at people who seem less committed to the experience.

ARE you
FEELING
the **SPIRIT** of
BLACK ROCK CITY? | **ARE you A**
CITIZEN
or just a
TOURIST? | **A**
PARTICIPANT
or ...
A SPECTATOR?

This evangelical fervor is enough to make you wince; some refer to this style of condescension as **"** 𝔟𝔲𝔯𝔫𝔦𝔢𝔯 𝔱𝔥𝔞𝔫 𝔱𝔥𝔬𝔲 **."** John Mosbaugh, a forty-one-year-old festival veteran, has known its wrath.

"In 2000 we had this big camp called the Headless Maiden," he recalls. The grounds included a stage, where a wicked-looking doll

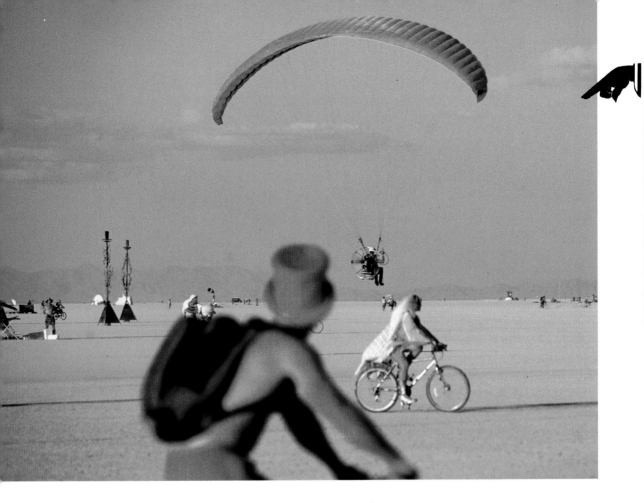

A MOTORIZED PARAGLIDER SWOOPS IN FOR A LANDING.

wielded a knife over a beheaded woman in a casket, powered to life (OR DEATH) by a twelve-volt windshield wiper motor. There was a "Wheel of Kink" (SOMEWHAT LIKE A "WHEEL OF FORTUNE," BUT SMUTTIER). There was a bar for parties, and a huge banquet table in the form of a woman's spread legs and torso. The camp was large, bizarre, and labor-intensive.

"You know, we'd been working for three days, four days, just totally gnarly, dirty, whatever, and we finally, for the first time, made it out to the Man. And we're out there hanging out, and we're totally

dustified, you know, just wearing our regular clothes. These people were all clean, with their glitter and their wings. This girl looked at us and she was like, '

Some of the most serious builders and doers, he emphasizes, are too busy putting the city together to dress in anything but dirty street clothes as the week begins. Some people are already bouncing around on stilts, or flying kites, or painted blue and doing exotic dances with parasols. Just because you're not outwardly frolicsome doesn't mean you're a "yahoo"—which, in the local vernacular, is a frat guy driven by two desires: **getting tanked** AND **ogling naked chicks.** John knows about yahoos; he helped author the Yahoo Education Pamphlet, a guide to Black Rock etiquette and acculturation stealthily titled HOW to GET LAID at BURNING MAN. Dispensed with a dose of humor, the guide's essential advice is this: Be respectful, don't act like an asshole; in sum, "Don't be a Yahoo Johnny!" The pamphlet's third edition featured a sarcastic offer, a hit back at the glitterati. "ARE YOU A HOT CHICK WHO WANTS TO MAKE THE SCENE?" it read. "WELL, SUIT UP WITH THESE OFFICIALLY SANCTIONED BURNING MAN FAIRY WINGS! ONE SET, SMALL AND EXTRA SMALL: $25⁹⁹."

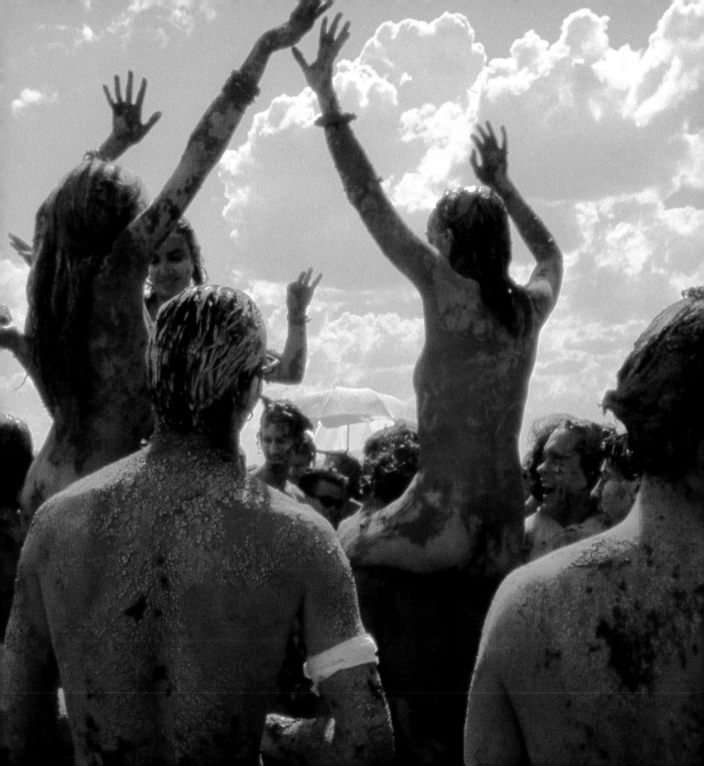

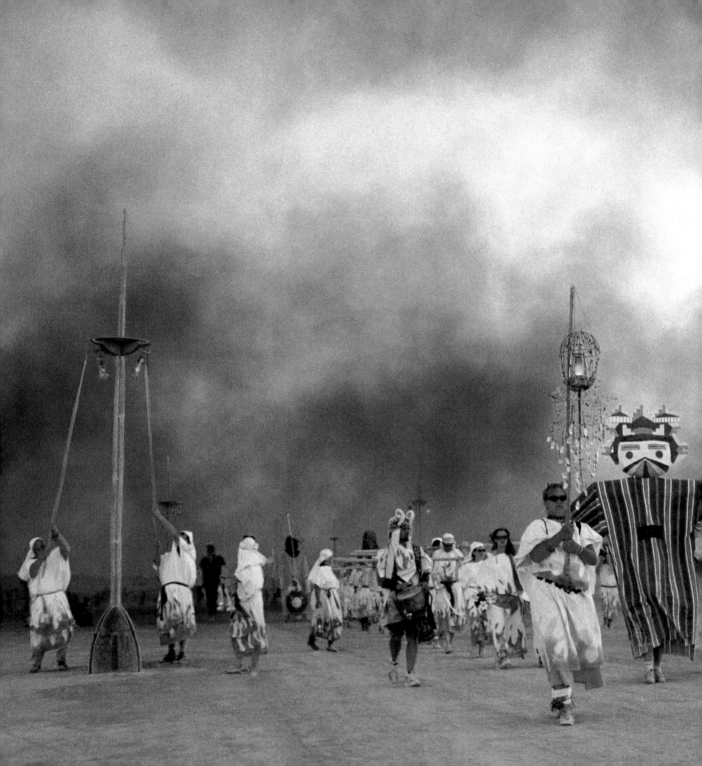

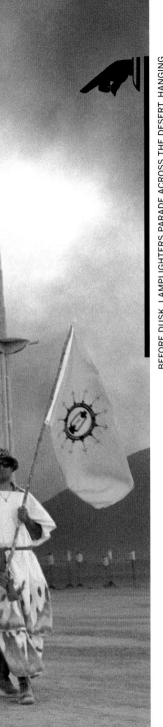

Chapter **05**

WORKING FOR THE MAN

BLACK ROCK CITY IS not a great place to sleep, unless you're accustomed to dozing inside a rock tumbler, or in the basement of a house that is getting hit by a tornado. Even on Monday morning, when the city is still growing, there's a of techno music and drum circles. The rhythm pauses for a few hours around daybreak, then starts up again. As you acclimate over a period of days, the noise seems

to fade, but at first it's enough to wake the most stalwart sleepers and render earplugs almost useless. If you're particularly unlucky, someone camping near your tent has set up a full drum kit and will **bang away** like Animal from the Muppets whenever you try to rest your head. Some tipsy troubadour with a bullhorn will stagger past at dawn, yelling " **Chirp!** " at the top of his lungs, like he's the first bird of springtime.

The sun rises a bit after six a.m. and starts raking across the desert. In the next couple of hours, your sleeping bag will start sticking to you like the foil around a baked potato. Tents become sweat lodges, evicting their groggy occupants into the daylight. Outside, the desert is **DIZZZZZZZZYINGLY BRIGHT.**

People stagger around, brushing their teeth, pouring mimosas, and greeting each other with tales of the night before. A few determined burners attempt to bathe. Some have built elevated wooden stalls equipped with solar showers, which look like big IV bags and dispense water through thin tubes. Others will swab themselves with baby wipes and washcloths, or sprint naked behind passing tanker trucks that cruise the city streets and spray water to keep the dust down. Later in the day, camps like *ASTRAL HEADWASH,* which specializes in shampoos, will open up to lather and detangle their neighbors. *HEAVENLY FEET CAMP* will soothe cracked and dusty extremities with a special recipe: **❝THE ORIGINAL VINEGAR FOOT WASH.❞** Yet the grime always seems to win

I smell like PLAYA

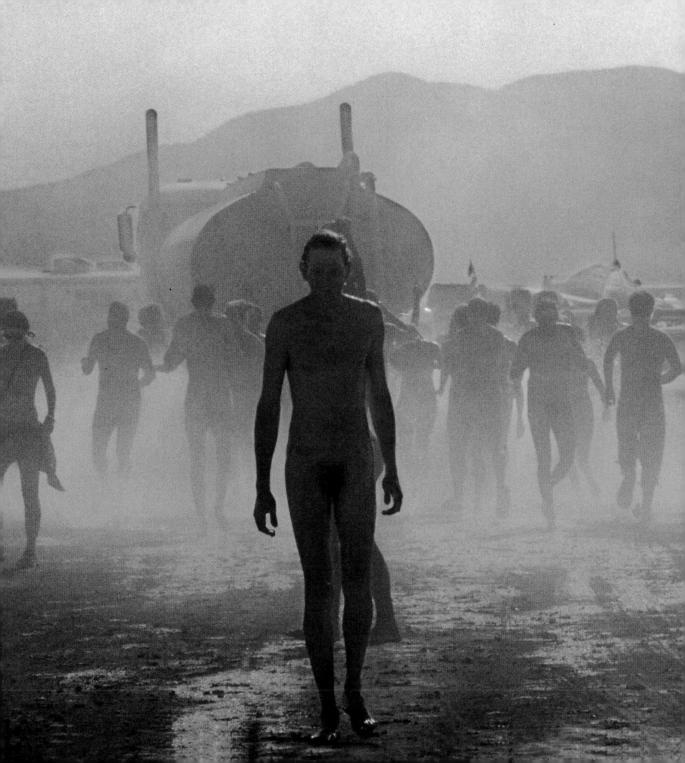

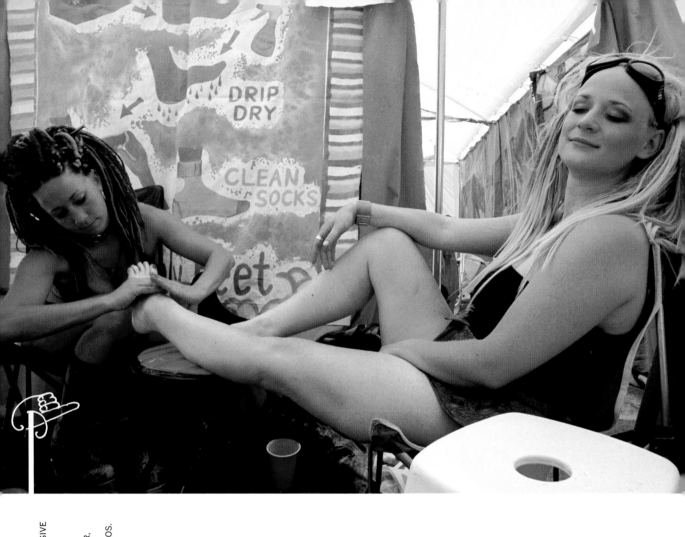

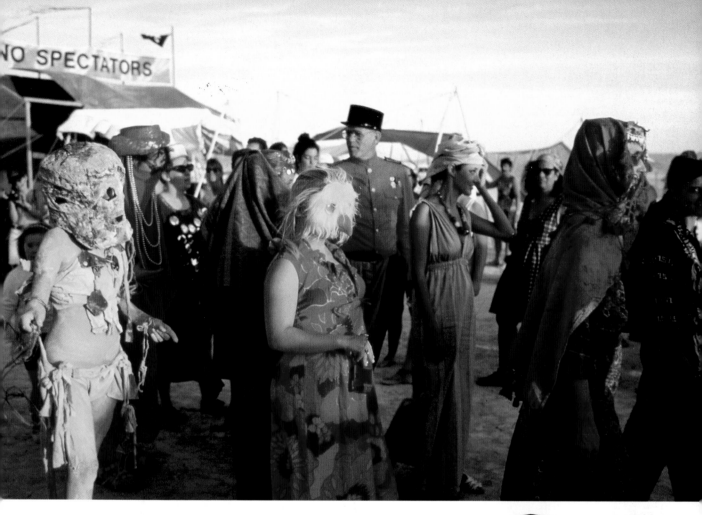

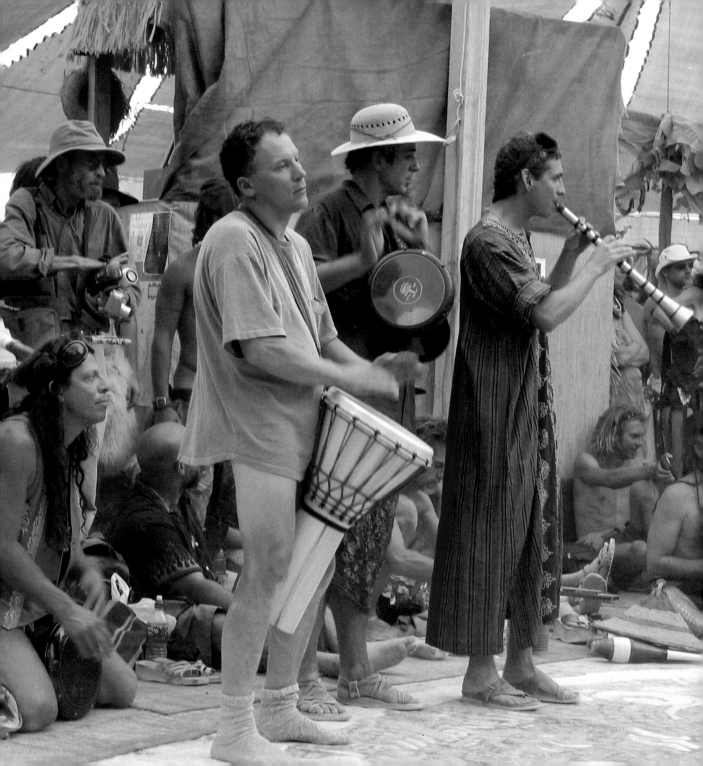

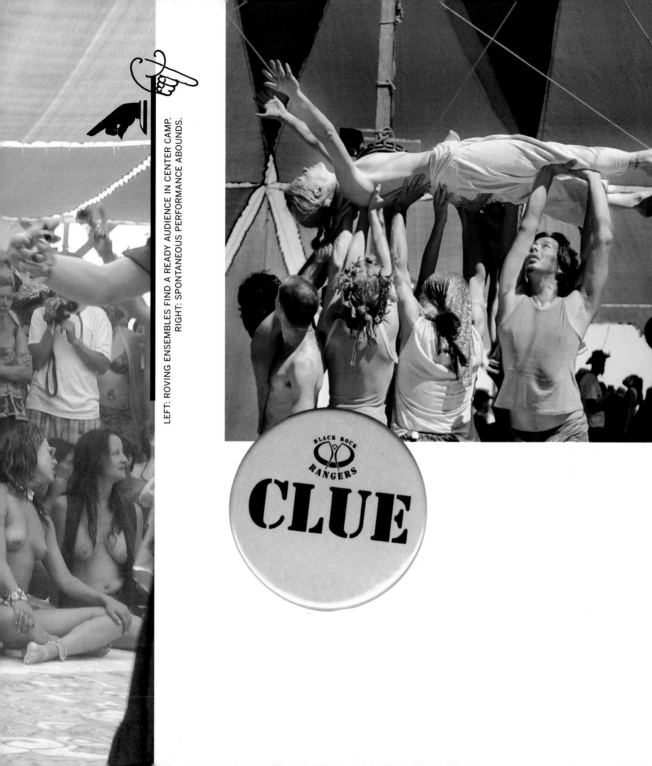

BLACK ROCK
RANGERS

CLUE

AN AERIALIST DANGLES FROM A TRAPEZE IN THE OPEN ATRIUM OF CENTER CAMP.

OPPOSITE: BURNING MAN'S MORATORIUM ON MONEY DOESN'T INCLUDE THE ESPRESSO BAR AT CENTER CAMP, WHERE CASH BUYS CAFFEINE.

out. "What I always say is, you don't have a community till you can smell people," Larry Harvey once quipped, "so by that standard we have a hell of a community out here."

Burning Man doesn't seem to attract a lot of "morning people," but the up-and-at-'em crowd isn't entirely lost; the **_HEEBEEGEEBEE HEALERS_** have early classes with guided meditation and yoga. The healers are such a nurturing bunch that, according to a report in the **BLACK ROCK GAZETTE,** they once fed and rehabilitated a mouse that accidentally traveled to the desert in a roll of carpet. If morning hurts, it's a good time to brew a strong pot of coffee, or to get on a bicycle and ride over to Center Camp Café, a shade pavilion two-thirds the size of a football field. You'll want to lock your bike on a rack outside. Despite the feel-good, trusting vibe in the air, bicycles have a habit of wheeling off without their owners. Inside, the exhausted masses are sleepwalking through their morning routines. They are

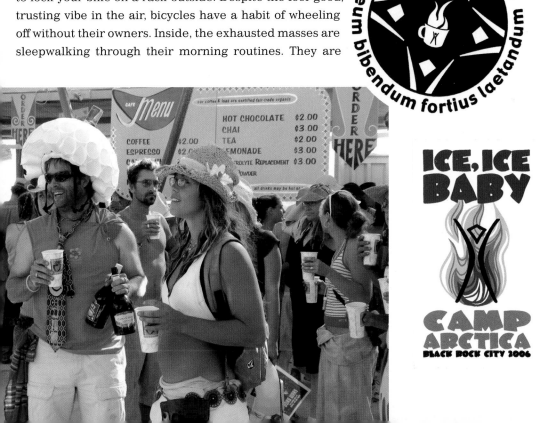

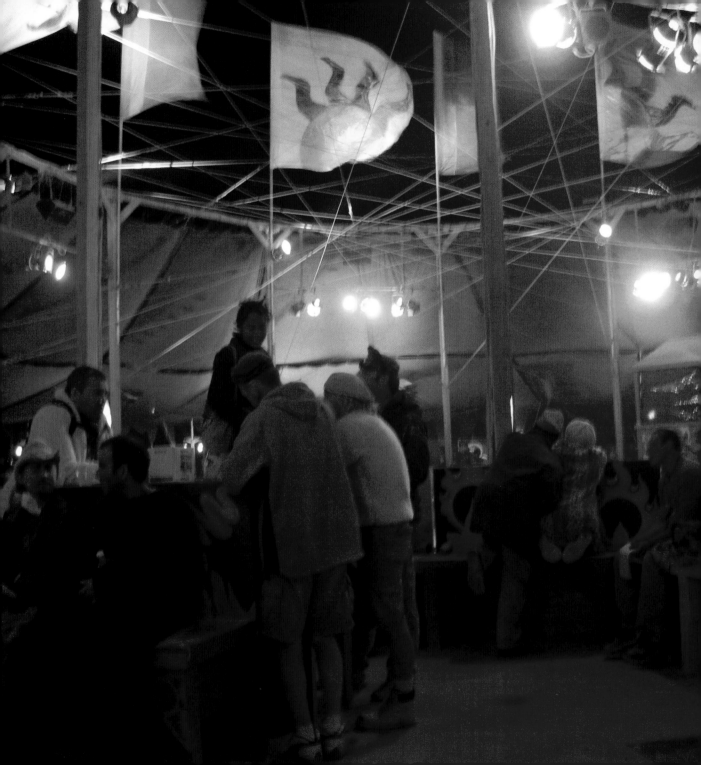

lining up to buy lattes, lemonade, and iced chai, fishing crumpled wads of dollars from their pockets and surrendering the cash to volunteer baristas. The café is one of a few exceptions to Burning Man's "no commerce" rule, which makes it the bane of local purists who would like to see the festival entirely moneyless. Sometimes these radicals revolt with acts of coffee terrorism, distributing free drinks to subvert the café economy. Along with caffeine, there's a very short list of goods and services you can buy around Black Rock City: festival tickets, two-dollar bags of ice, waste water pumping for RVs, and five-dollar shuttle rides into Gerlach. (THE LAST OF THESE SERVICES, AS DULY NOTED ON THE BURNING MAN WEBSITE, DEMANDS, "YOU MUST BE SOBER [AND] DRESSED APPROPRIATELY FOR TOWN.")

Center Camp is full of drowsy couples, taking shelter from the rising heat, lounging on couches at the foot of a sound stage. The stage is a perpetual open-mic cabaret. Anyone can sign up to be the entertainment, so the program is barely coherent. A classical cellist might precede an accordion player dressed like Donald Duck, or a belly dancer, or a carnival sideshow, or someone with a brand-new didgeridoo who is itching to try it out on a captive audience. If you've always yearned to perform, sing, play an instrument, or tell stories or knock-knock jokes, you'll find appreciative listeners, and occasional hecklers, gathered here and at other venues around the city. HOTD, short for Hair of the Dog, has a popular bar and performance space with plenty of gear—GUITARS, DRUMS, BASS, AND A KEYBOARD OR TWO—for musicians to act out their rock-'n'-roll fantasies. A few years ago a man entertained dozens of rapt listeners there by covering songs by the Doors in a growly voice, which sounded like a cross between Tom Waits and Chewbacca from **STAR WARS,** and left out the lyrics completely. "Come on baby, light my fire" was reduced to••••••••••••••••••••••••••••
••

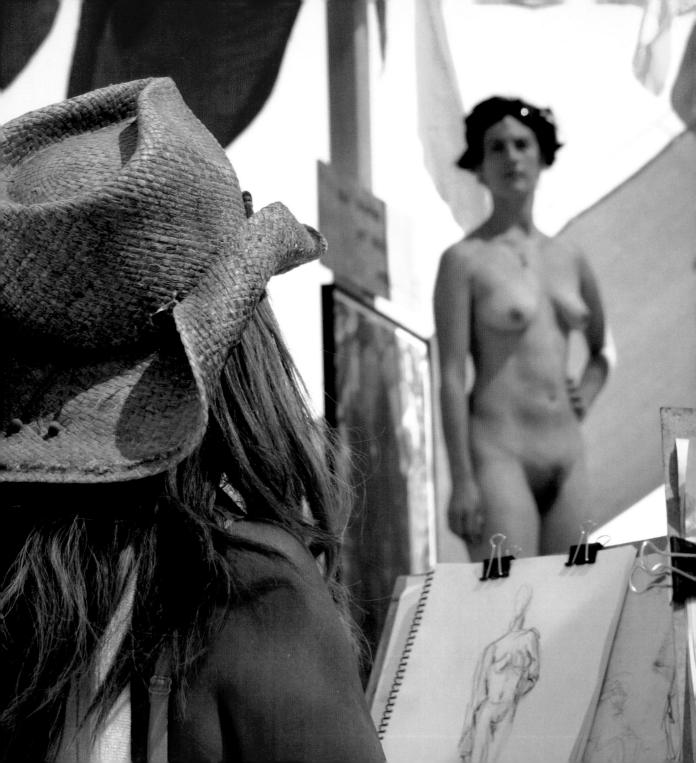

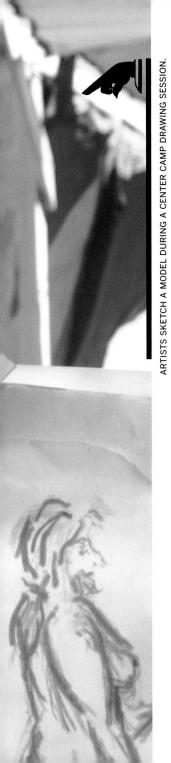

"Ra-rah ra-rah ra-rah rarr-rarrrrrgh."

THERE WAS NO INTELLIGIBLE CONTENT, BUT IT WAS VERY EASY TO SING ALONG.

No one will stop you from lazzzzzzzzzzzzzzzzzzzzzinnng around Center Camp all day long, but the slacker scene gets boring fast. That's why legions of burners commit an act that is absent from more mundane vacations: They get jobs. Their labor goes unpaid but is rewarded by camaraderie and the sense of finding a niche in Black Rock City. Like the café workers and the greeters at the gate, many civic groups recruit volunteers. The Earth Guardians educate burners about the desert environment and spread the gospel of Leave No Trace. The Perimeter patrol busts gate-crashers with a sophisticated arsenal of radar, military-grade night vision equipment, infrared cameras, laser trip wires, and footfall-detecting geophones. At Media Mecca, spin masters persuade jet-lagged journalists that Burning Man is more than the second coming of Mardi Gras. Aviation buffs run a local airstrip, where visiting pilots touch down in private planes. Volunteers also inspect art cars for the DMV (Department of Mutant Vehicles), run a kiosk called Playa Info, and sell ice at CampArctica. The Lamplighters don ankle-length robes and bear yokes laden with hundreds of kerosene lanterns, which they hang on spires during a ritual procession each evening to illuminate the city. Not all of the jobs have written all over them.

So why would anyone want to work in Black Rock City?

123

CHERYL HARMELING, A NEW YORK PHOTOGRAPHER, HAULS A PROPANE TANK TO
FUEL "ANCESTORS," CENTER CAMP'S FLAMING FRONT GATE, IN 2005.

OPPOSITE: DAN GLASS, TIM FARNAM, AND TOUCH ARE WORKING
ON FIRE CANNONS THAT WILL FLANK THE CENTER CAMP GATE.

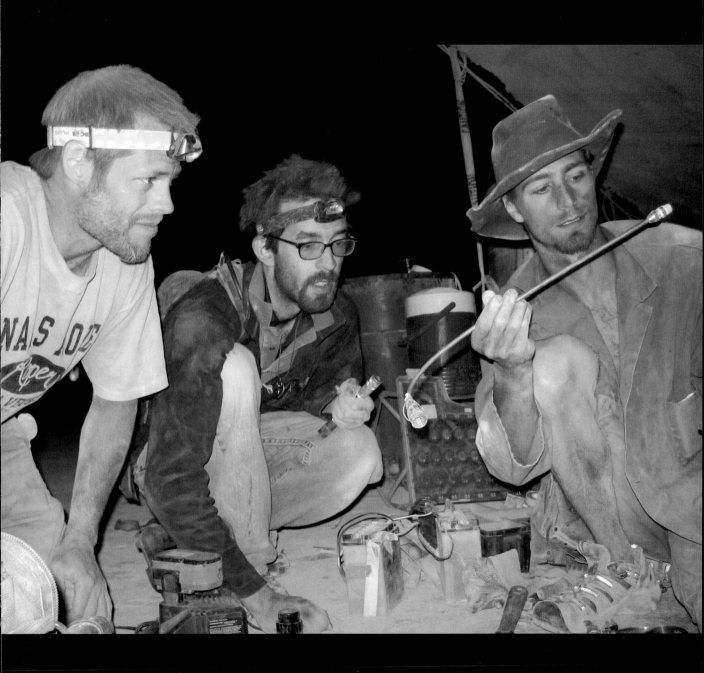

"I think the trick with Burning Man is they really do allow people to find whatever it is that they enjoy doing," suggests Katherine Chen, who wrote her sociology dissertation at Harvard University on the organizational structures of Burning Man. "It may not be necessarily something that they're the most qualified for, but they'll actually give them the chance to do it that they may not get in their workplace, or even other types of volunteer organizations." For some people, she says, it gives structure to what can otherwise be a bewilderingly amorphous experience.

"You see motivated folks who will find joy in the most onerous activity," she adds, raising the Earth Guardians, who spend a lot of time picking up litter, as an example. "Most of us would think, 'Okay, the reason janitors aren't paid that much in society is because it's not really a desirable career, and maybe it's not that important to people.' It's actually been a theory advocated in sociology. But in this instance, with the Earth Guardians, they realize they're on a mission. They're trying to educate people that you should be environmentally friendly, you shouldn't throw things onto the ground, you should pack it out, you can do certain things to minimize waste." Could Black Rock City exist without so many people volunteering their time? "I don't think at this scale, particularly in the middle of nowhere," she says.

Some of the most tireless volunteers are the **Black Rock Rangers,** who, as their slogan goes, have been ················

MAKING REASONABLE EXCUSES for YOUR BEHAVIOR since 1992.

OVERLEAF: LAMPLIGHTERS NIMBLY HANG LANTERNS ALONG A MAIN BOULEVARD.

They wear khaki uniforms and traverse Black Rock City two abreast on eight-hour shifts. "The Rangers are what stand between the participants and traditional law enforcement. If the Rangers weren't there, it would be an entirely different event," says Michael Michael, early Cacophony Society member and longtime Burning Man organizer. He is also known as Danger Ranger. Under this persona, he founded the group fifteen years ago and modeled it after the Texas Rangers.

Back then there wasn't a fence around the festival, and the Black Rock Rangers staged search-and-rescue missions out on the open playa. They rounded up disoriented drivers like stray cattle and led them safely back to camp. Now the Rangers work inside the city. They intervene in the kind of civic disputes that might otherwise attract law-enforcement brass. They are the first responders to accident scenes. They maintain safety perimeters when giant pieces of art are burning. They also mediate arguments that inevitably erupt; the stark environment of the desert polarizes personalities and frays nerves. "Say there's a fistfight and this guy in a Ranger costume with pink fuzzy bunny ears walks up to you," Michael explains. "It just kind of switches the situation."

ESTABLISHED RELATIONSHIPS BLOW APART *in moments of* **acrimony.** Neighbors annoy each other. Disputes arise over problems that, in calmer surroundings, wouldn't be worth a second thought, let alone a screaming match. Sometimes the Black Rock Rangers are therapists in a theater of the absurd. What would they do, for example, if they were called to mediate a serious squabble

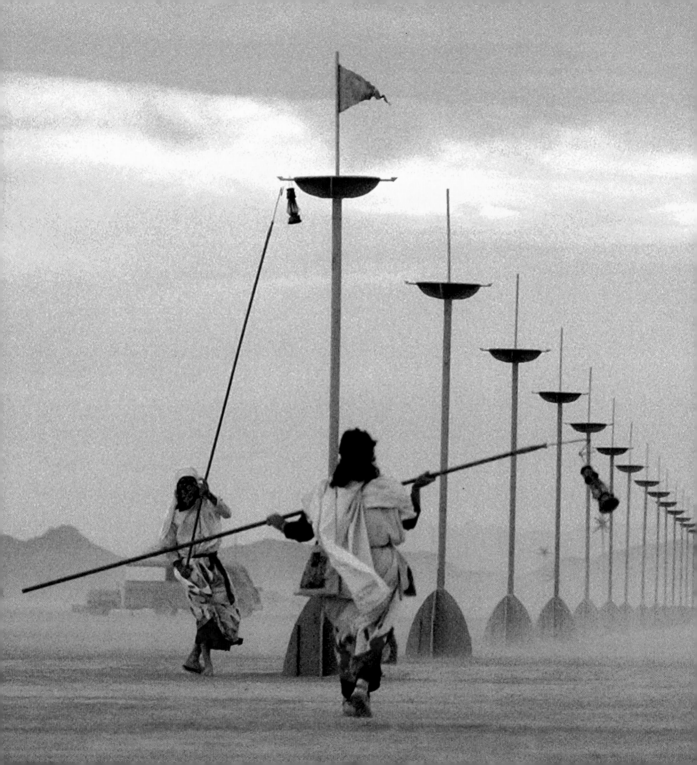

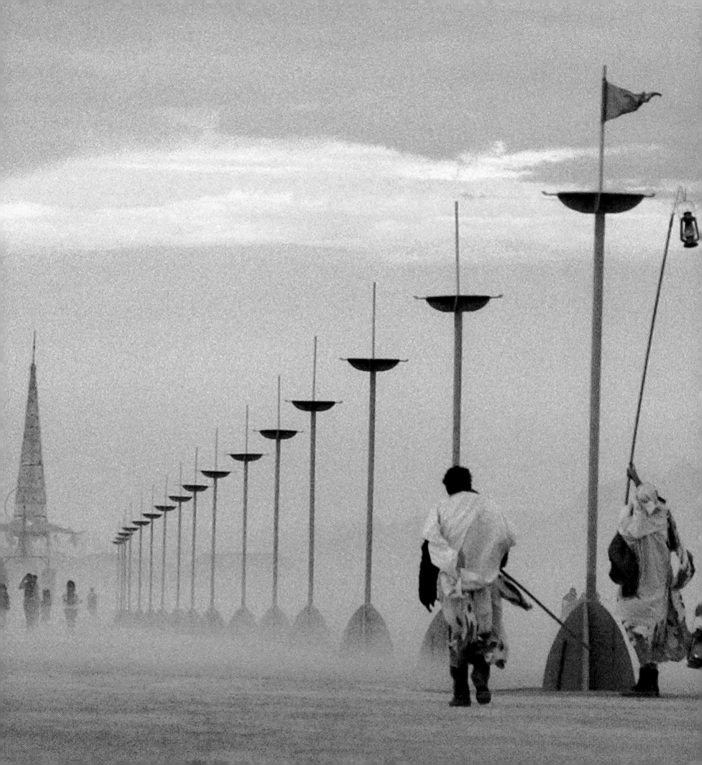

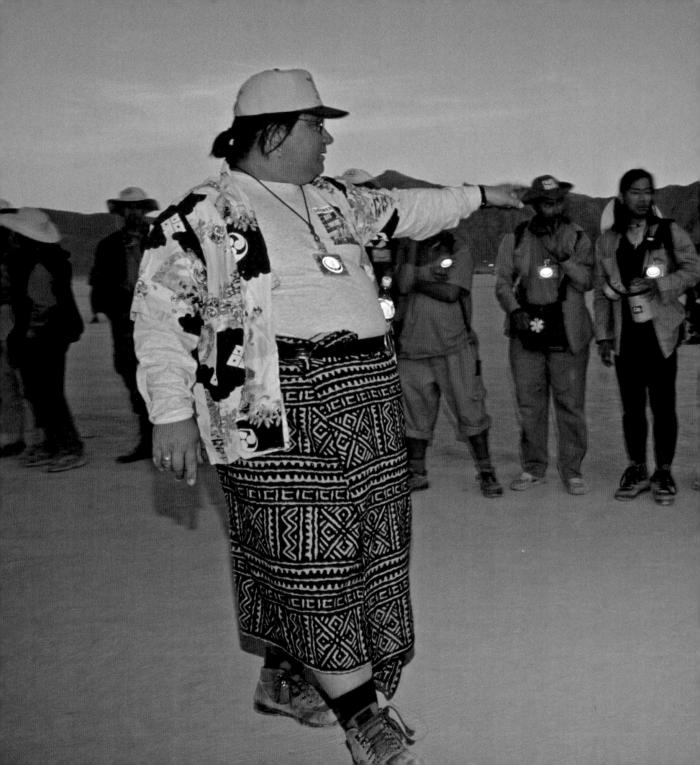

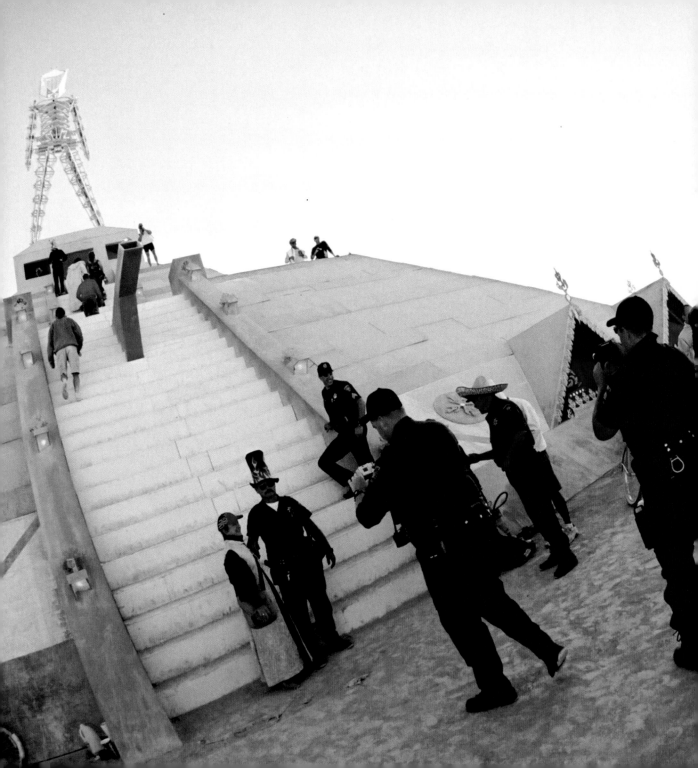

over a watermelon? They'd help sort it out, in an unobtrusive, non-confrontational style, Michael says.

"Why is this guy really obsessed with watermelons? You know, did his mother hate watermelons as a child or something, and he doesn't like his mother?" He chuckles. "It can be very complex at times."

It's worth noting that, volunteer peacekeepers aside, there are plenty of **GENUINE** police at Burning Man, including federal rangers from the Bureau of Land Management and officers representing the State of Nevada and local counties. Undercover cops prowl for drugs, and openly smoking a joint could land you in handcuffs. The officers also intervene in rare episodes of violence, though Dave Cooper, who manages the area for the federal Bureau of Land Management, says of Black Rock City, "My perception is it's one of the safest places you could ever be. It's certainly safer than being in any other city of 40,000 people." In 2006 there were six arrests and 157 citations issued at the festival; 80 of the citations went to burners found with illegal substances.

If you want a job but aren't attracted to any of the volunteer posts, you can always make something up. The personnel of Black Rock City Animal Control wear red jumpsuits and drive a dogcatcher's van, touring the city to capture stray creatures. Since pets are not allowed at Burning Man, their quarry consists of people dressed up like animals, who get auctioned for adoption at sunset. Members of the French Maid Brigade run around waving ineffectual feather dusters. Deranged neat freaks push vacuum cleaners across the desert floor. Jokers in full business suits bark orders to imaginary minions, or yammer on broken cell phones.

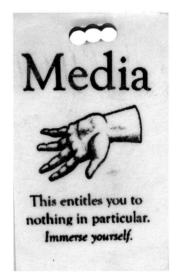

Media

This entitles you to nothing in particular. *Immerse yourself.*

BLACK ROCK CITY
ANIMAL CONTROL
2002

THESE AREN'T BURNERS IN COSTUME, AND THEIR HANDCUFFS AREN'T FOR FUN. REAL, LIVE LAW ENFORCEMENT OFFICERS PATROL BURNING MAN. SOMETIMES THEY STOP TO TAKE PICTURES.

For burners who assume volunteer jobs, the festival week can run on something that loosely resembles a schedule. But most of the people here aren't punching the clock. With a few exceptions, the days tend to blur together. There are a few large-scale, preplanned traditions like **CRITICAL TITS,** a topless bike ride where hundreds of bare-breasted women pedal along proudly, and the **BILLION BUNNY MARCH,** a rabbits' parade complete with protesters from the **CARROT LIBERATION FRONT.** But mostly the week runs on chaos, not a fixed calendar. There are few regular rhythms apart from the cycle of day into night. And when dusk comes, whether you've been working hard or dozing off in Center Camp, a moment of shared enthusiasm brings everything to a halt.

You can get a sunset anywhere.
But at Burning Man,

the
SPECTACLE
merits
EXTRA
ATTENTION.

Everyone cheers at dusk,
as if nature were just another one of the festival's performers,
executing a
PARTICULARLY EXTRAVAGANT
piece of theater.

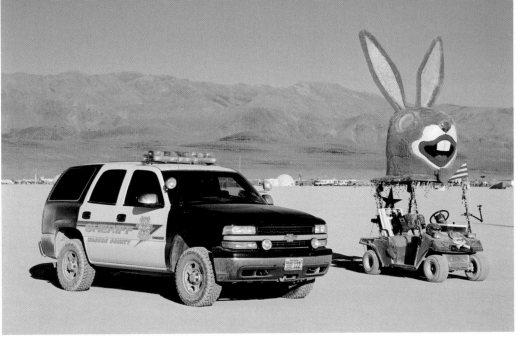

As the sun drops past the edge of the mountains, the whole encampment erupts in hollers, war whoops, and ululations. There are drums and air horns, gongs and bells, a rising tide of cacophony sweeping the city. The desert heat subsides for the evening: the revelers have won. Everywhere, night people emerge from their daily stupor, abandoning the shelter of shade tarps and parasols, slipping into warmer clothes. By now, the Lamplighters are finishing up their work. Kerosene lanterns flicker along every city street. The evening holds the promise of strange adventures, the kind of exploits that will be recounted over coffee the next morning.

Black Rock City is made of camps and art. It's also made of wood and nails, paper and glue, parties and performances. But above all that, this is a city made of stories. Tales are passed along from one reveler to the next, giving Burning Man a kind of continuity— a cross-section of **grand exploits,**

SMALL MOMENTS,

and the people who lived them.

"WHAT'S UP, COP?": A WASHOE COUNTY SHERIFF'S VAN SIDLES UP TO A BUNNY WABBIT.

OVERLEAF: CRITICAL TITS IS A PROUDLY TOPLESS TAKE ON CRITICAL MASS, THE MONTHLY RIDE THAT ATTRACTS THOUSANDS OF CYCLISTS WORLDWIDE AND PROMOTES PEDALS OVER PETROL.

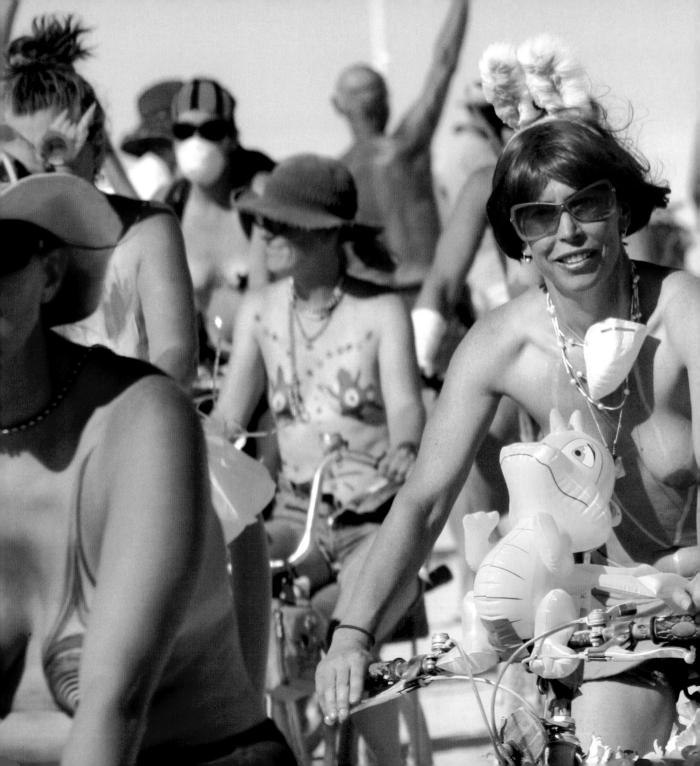

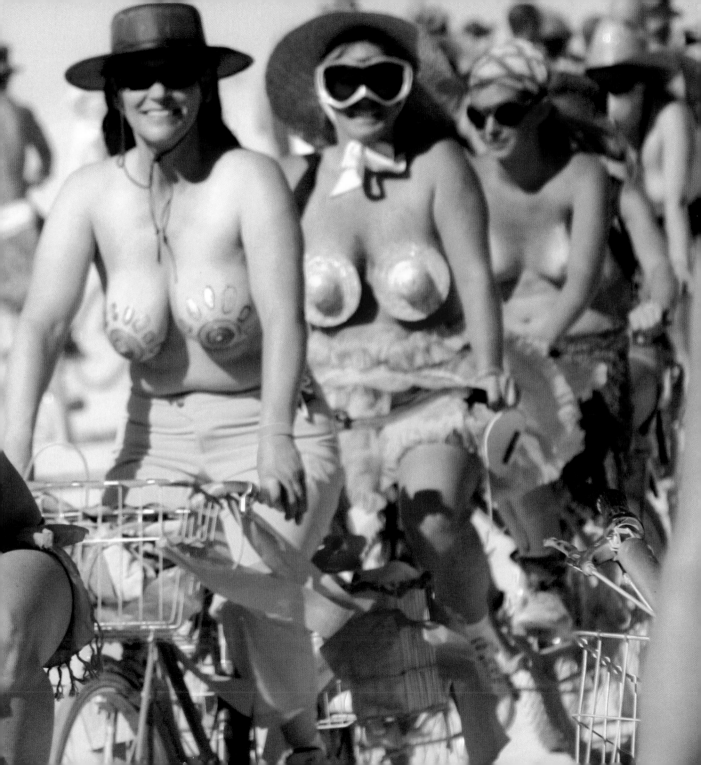

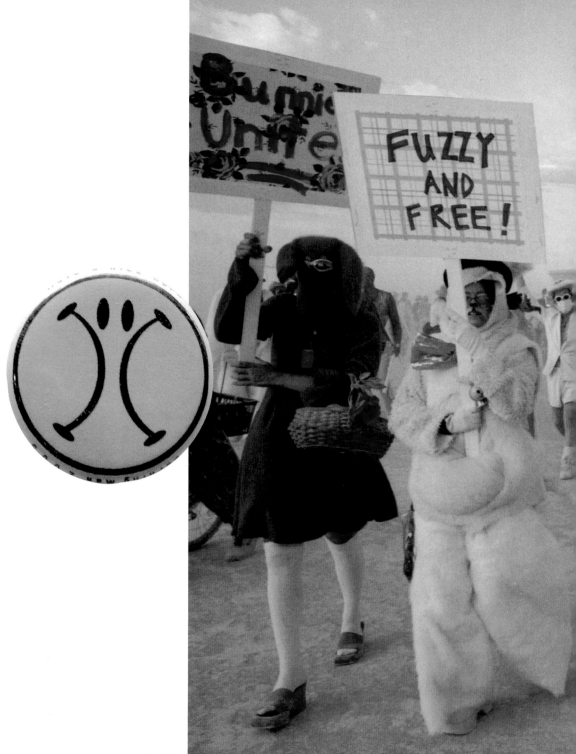

RABBITS RUN RAMPANT AT THE ANNUAL BILLION BUNNY MARCH, AS MEIN HARE (A.K.A. SAN FRANCISCO PERFORMANCE ARTIST STEVEN RA$PA) WIELDS HIS BULLHORN AND SIGNATURE TWIN BEARDS.

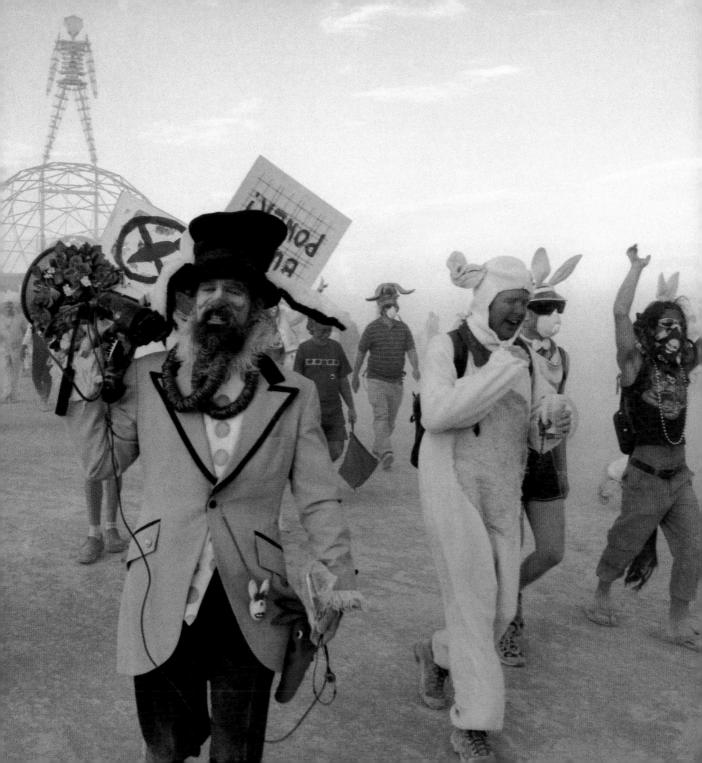

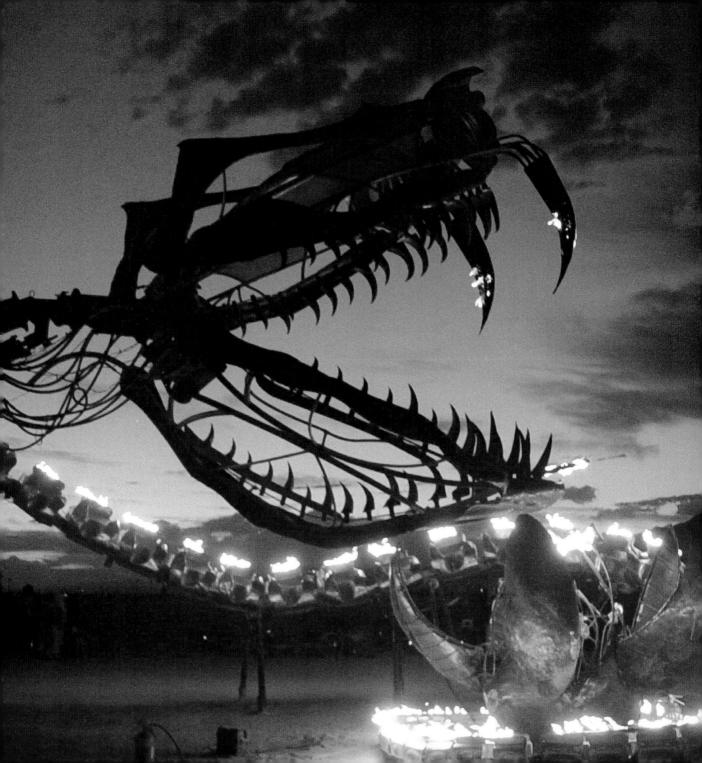

THE SERPENT MOTHER, AN INTERACTIVE SCULPTURE BY THE FLAMING LOTUS GIRLS, INCLUDES FIRE-SPOUTING VERTEBRAE, GNASHING JAWS, AND A COPPER EGG WITH A METHANOL FLAMETHROWER INSIDE.

DON'T ROAST
YOUR FRIENDS

EVEN AT THE BEGINNING, WHEN the city is taking its first, toddling steps, there's

The Man won't burn for nearly a week, but pyromania is already pandemic in Black Rock City. After sunset, the desert goes dark and the temperature plummets. Familiar landmarks disappear, while hundreds of blazes crackle to life. Each fire is like a ᵀᴵᴺʸ LIGHTHOUSE that beckons wanderers in from the evening chill.

Up and down the city streets, groups of people are warming their hands around "burn barrels," oil drums with artful patterns cut into their sides. Filled with wood and lit, the barrels glow like industrial jack-o'-lanterns. Itinerant performers are practicing their fire-breathing skills, taking great gulps of liquid paraffin and spitting it over torches in bursts of flaming vapor. There are fire-spinners, fire jugglers, and fire-eaters, too. You might come upon a firefall, a burbling fountain that burns with a slick of lit fuel floating on the water. Some art cars have flame-throwers in place of hood ornaments, and they blaze criss-crossing paths through the air.

Still, you can't just run arund and burn things willy-nilly. At one time, personal bonfires and random acts of arson were expected. If you were possessed by a sudden, mad desire to ignite your couch, and thereby choke your neighbors with toxic fumes, no one would stand in your way. Now fires are regulated, in part because the festival has grown more environmentally conscious over the years.

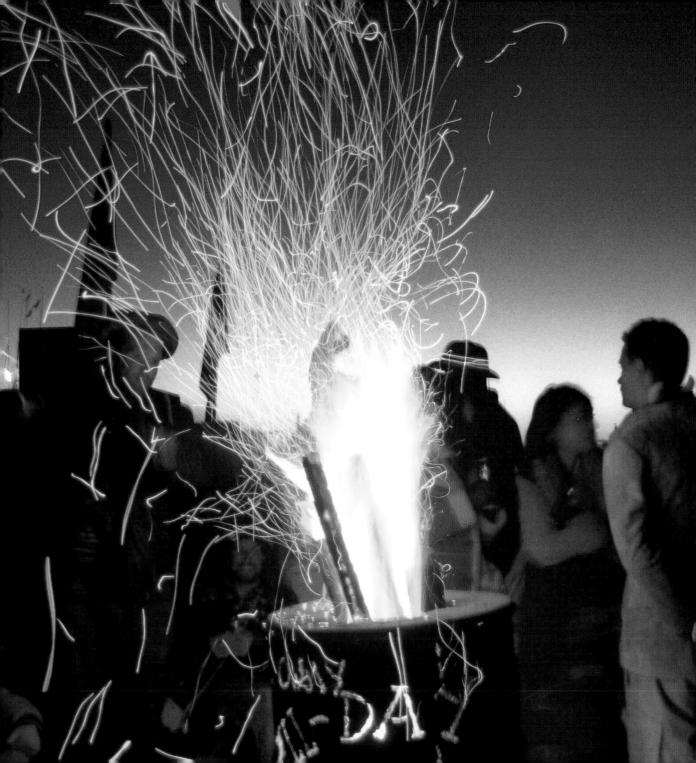

Open flames can scorch the desert floor, leaving behind dark, hardened burn scars that have to be dug out of the earth. If you feel compelled to burn something big, you're urged to first drag it over to one of the burn platforms scattered throughout the city as a public service. These platforms are elevated, and they smolder at a safe distance above the playa surface.

There is still a lot of combustion at Burning Man, even though it's not exactly spontaneous. Fire artists have been planning for this week all year, creating elaborate works of art to contain their flames. Their imagination has ignited dozens of diverse installations, from the *ICP,* or *IMPOTENCE COMPENSATION PROJECT,* a series of five fire cannons encircling the Man with three-hundred-foot columns of burning kerosene, to fire pendulums set in motion by burning jets, to *DANCE DANCE IMMOLATION,* a modified arcade game that challenges contestants to follow dance steps while wearing flame-retardant suits, then toasts the clumsiest ones with blasts of fire. Most of the projects require months of meticulous care to create, followed by a few frenetic days of construction in the desert. Take, for example, the

ANGEL
of the
APOCALYPSE

The *ANGEL* is a massive steel sculpture of a phoenix half submerged in the ground. You might imagine it sinking down into the earth, or straining upward to free itself. The bird's beak, wings, and belly protrude into the air. Its wings encompass sixteen curved, hollow feathers of stainless steel. Some of the feathers stand twenty feet tall and are lit with burning trails of kerosene. Others are half that height and end in fire-belching tips. You can wander among the

feathers, with all that warmth radiating out, and feel like you're visiting a strange, volcanic forest. If you approach the far end of the sculpture, you'll find the beast's head: a wood-burning hearth that stands fourteen feet tall, with a gaping beak and eyes of blown glass. The body is a hill of driftwood, enough to fill five pickup trucks, bolted together in a broad structure that is sturdy enough to climb on. Embedded in this body are eight glowing buttons. Anyone can press a button to trigger a jet of flame from one of the feathers. Of course, it helps to make sure the area is clear first. Do not push the button if fire-entranced revelers—NICKNAMED "MOTHS"—are within melting distance. Or if some hippie in a billowy skirt is whirling nearby. Or if a long-haired drunkard is trying to light a cigarette between gaps in the steel or, worse, is blissed out and has decided to hug one of the feathers.

"YOU DON'T WORRY about the *naked* PEOPLE, because they know when they're TOO CLOSE to the fire,"

explains Rebecca "Hotmetal" Anders, a thirty-three-year-old sculptor with bleached-blond hair and a warm, blunt voice. Rebecca describes herself as an "overeducated welder" and works for an exhibit business, fabricating museum and store displays. After hours, she is a member of the Flaming Lotus Girls, a San Francisco arts collective, which built the ***ANGEL OF THE APOCALYPSE*** in 2005 based on her original design. She says they had to keep a close eye on their artwork to keep people from incinerating each other. "The last thing

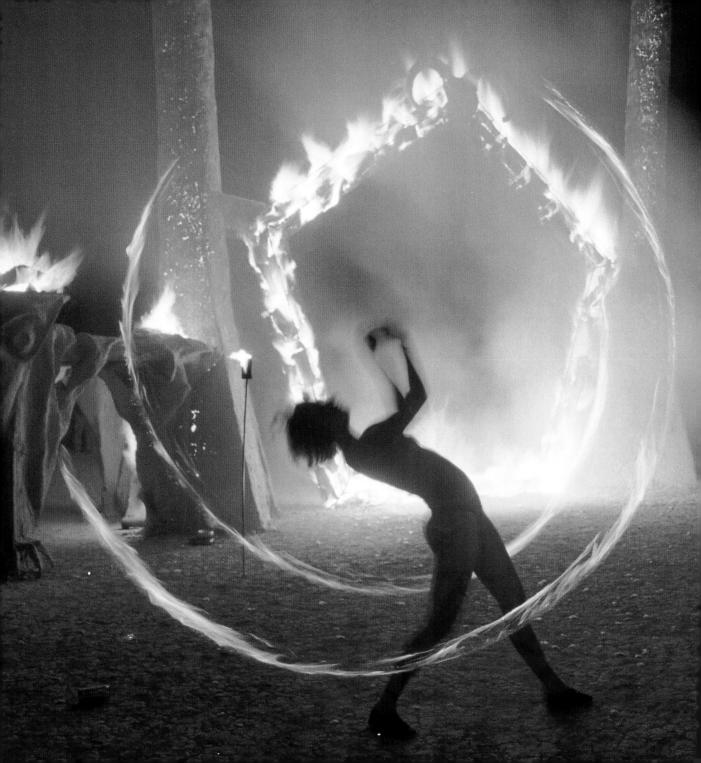

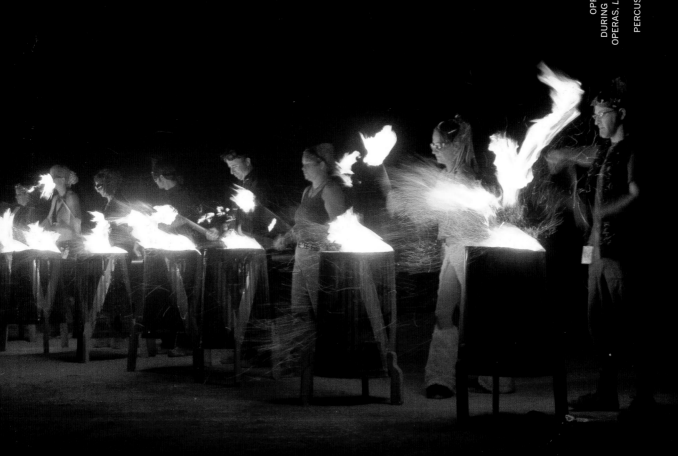

we wanted to do was roast our friends even as we were making them," she says. One of the best things about the *ANGEL* was watching strangers interact with it. "When people found out that it was **them** controlling the blaster poofs, they were fucking psyched," she says emphatically. "The next thing you know, .. YOUR SHY, MOUSY PERSON HAS turned into a

RAVING LUNATIC.

IT'S NOT ONLY SUPEREMPOWERING,
BUT IT'S REALLY DISARMING.
IT'S A GREAT METAPHOR FOR THE WHOLE GROUP."

The Flaming Lotus Girls teach metalworking and fire wrangling skills, with an emphasis on educating women. Boys are allowed in the club, too, as long as they're comfortable stepping back to let the girls take charge. The group has around one hundred members from different backgrounds; they are computer programmers and waitresses, photographers, scientists and writers, even a high school student. Many develop new specialties that might bewilder their professional colleagues, including a pair of research scientists, Rosa Anna DeFilippis and Caroline Miller, who became expert plumbers to work on the fuel systems for the *ANGEL.*

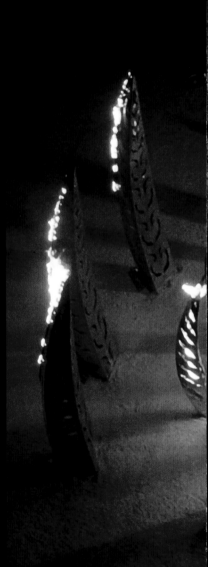

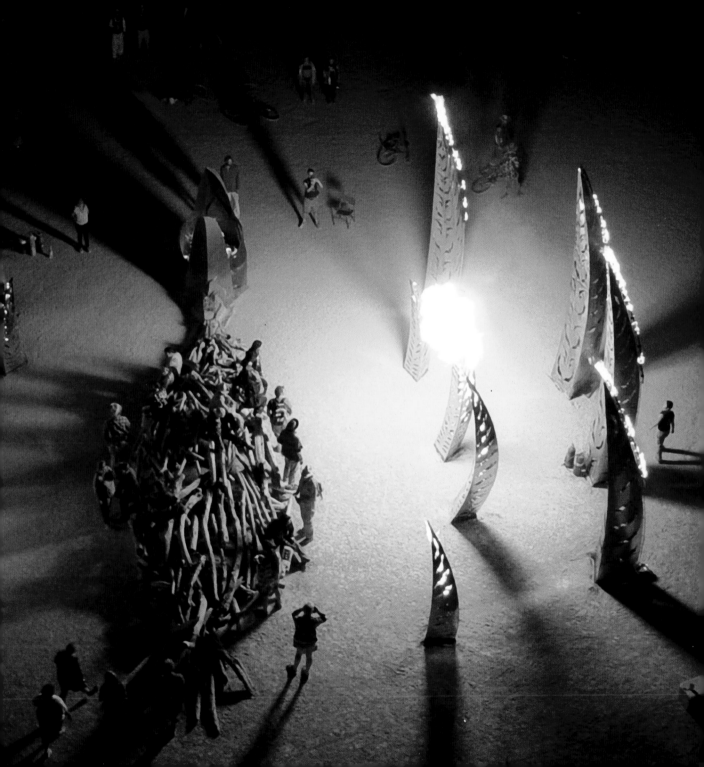

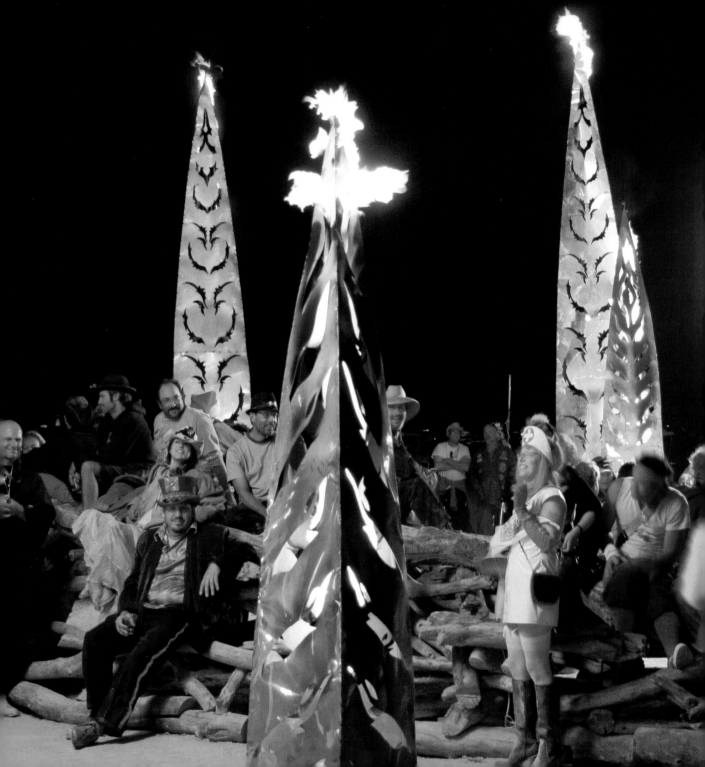

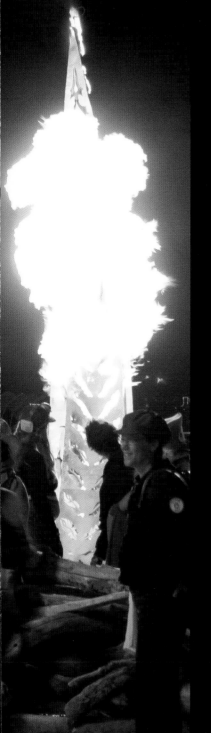

The Flaming Lotus Girls started small. Back in 2000 a handful of female friends got together to learn the subtle art of building flamethrowers. They sought counsel from the aforementioned Dave X. He wasn't working for Burning Man just yet but was a local flame effects guru whom a few of them had dated (DON'T CALL THEM DAVE'S EXES; THEY'VE HEARD ALL THAT BEFORE). The women wanted to make flamethrowers that weren't just brutish and functional. They wanted flamethrowers that were

ornate. *Pretty, even.* "AT BURNING MAN, ALL THE FLAMETHROWERS ARE VERY UTILITARIAN AND **ALL** THE **ART** IS IN THEIR **FUNCTION,**" SAYS POUNEH MORTAZAVI, A FOUNDING MEMBER OF THE GROUP. "WE WANTED TO BUILD **FLAMETHROWERS** THAT WERE **MORE** ABOUT **BEING ART** AS WELL AS **FLAMETHROWERS.**"

Not everyone was thrilled by these early ambitions, including Rebecca Anders. At the time, Rebecca was working on her sculptures in a converted warehouse called CELLspace, and the neophytes got on her nerves. "Who are these stupid bitches who keep coming into our shop and fucking up the tools?" she remembers thinking. "Whatever. It was a bunch of people who wanted to

151

was on fire when I got here

do this stuff, so they decided the best way to learn how was to do it. So they broke a bunch of our tools," she says, laughing. A few years later she joined them.

Their first project was a massive six-chambered fire cannon, the *FLAMING LOTUS,* which spat gouts of burning kerosene thirty feet into the air. Before dragging it out to the Black Rock Desert, they added a feminine touch, spray-painting it pink and nesting it in a ring of metal flower petals. The *FLAMING LOTUS* was a success and gave the group its name (AN EARLIER SUGGESTION FROM DAVE, "PROFESSOR X AND HIS FLAMING VIXENS," HAD BEEN SUMMARILY REJECTED). It also became the first in a series of dangerous, albeit lovely, projects, each one wilder than the last. Among their greatest hits was the *HAND OF GOD,* a twelve-foot-tall copper sculpture, with fingers that shot**..........**

HUNDRED-FOOT *streams of* **FIRE** *to the* **HEAVENS.**

It was built for Burning Man in 2003 and has since gone on tour to other art festivals, complete with the later addition of long, manicured fingernails.

But not even the *HAND OF GOD* could touch the *ANGEL OF THE APOCALYPSE,* a staggering project that, in the beginning, must have sounded like lunacy. Building it was time-consuming and expensive. To offset the cost, the Flaming Lotus Girls received a $23,000 grant from the Burning Man Project, which now parcels out around $400,000 a year to artists who are building work to bring to the festival.

The Flaming Lotus Girls spent months toiling over the *ANGEL* at the Box Shop, a warehouse-size artists' workspace in the remote Hunters Point neighborhood of San Francisco. In August half a dozen of them arrived at Burning Man more than a week early to install the sculpture. But there were hitches and hassles. The truck carrying the sculpture's components showed up two days late. When it finally rolled in, the contents were a disaster. The *ANGEL*'s steel feathers were bent out of shape, as if they'd slam danced their way to the desert.

"It looked all crumpled on the truck," Rebecca remembers. "I started crying behind my shades. Everyone's like, 'Rebecca, what do we do?' And I'm like, 'BE COOL, BE COOL, JUST BE COOL.'" The panic didn't last for long. With some coaxing, most of the pieces popped back into shape. Then the installation began, with an earthmoving trencher digging out grooves for the *ANGEL*'s plumbing and electrical systems. That part wasn't easy either. The blueprint for the trenches had fallen behind Rebecca's car seat, where it was discovered only after the plan had been re-sketched and the digging was complete ("THEY DIDN'T LYNCH ME," SHE SAYS OF HER COMRADES, "WHICH WAS GOOD.")

Pulling off a sculpture as large and lovely as the *ANGEL* was worth the frustrating moments. It set a new standard for nighttime gathering spaces at Burning Man and led to another landmark Flaming Lotus Girls installation the next year: *THE SERPENT MOTHER*, a 168-foot-long skeletal snake that coiled protectively around a giant copper egg, and boasted 41 interactive flame-throwing vertebrae; an underbelly lined with pulsing LED lights; and a set of gnashing, hydraulically powered jaws. For Rebecca, the *ANGEL* was also a personal triumph, the culmination of a project that began in the late 1990s, long before the Flaming Lotus Girls were even a flicker

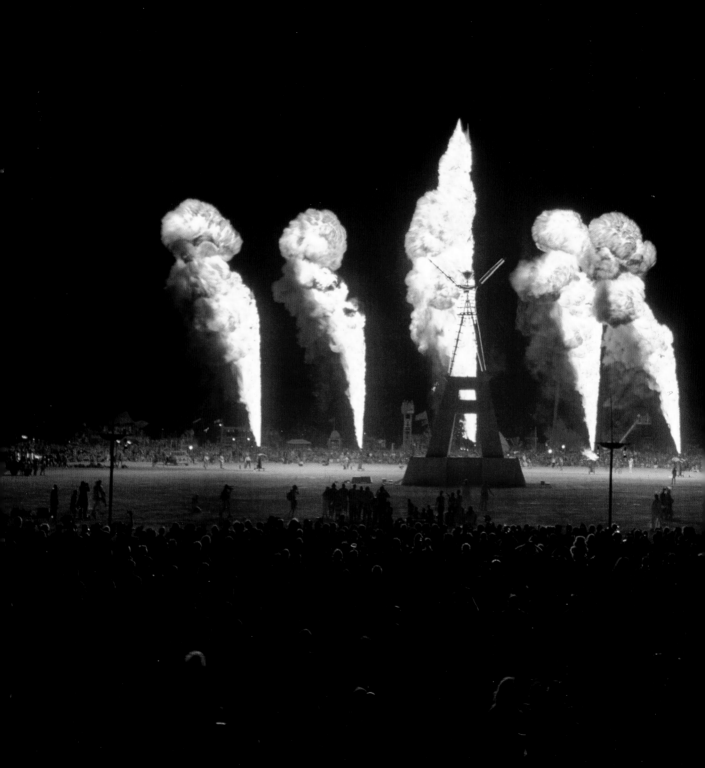

of an idea. She had built a smaller version of the phoenix, without fire, for display on the floor at a local art show. Gallery patrons would stumble into her spiky artwork by accident, nicking their shins and shredding their nylons. While the *ANGEL* was lighting up the Black Rock Desert, her early sculpture hung on a wall in the San Francisco apartment that she shared with Charlie Gadeken and Pouneh, both founding members of the Flaming Lotus Girls. Months later, it was almost shocking to see the original sculpture installed there, small and silent, a reminder of how one idea grew into a team project:

...........................

... A HUGE, FLAMING

COLLAGE OF

THAT YOU COULD WALK AROUND

INSIDE.

Rebecca muses, "When I first made it and I put it on the floor, I said, 'I want to be three inches high and walk through this thing,' because I love the way it takes up the space by not actually being a complete thing." She didn't have to shrink to get her wish. Instead, the *ANGEL* grew large in the desert. On Monday evening, the first night of the festival, the Flaming Lotus Girls were already testing its fire systems. Soon the sculpture was alive and working. It began attracting visitors, who congregated among the *ANGEL*'s flaming feathers until five or six in the morning, when the day's supply of fuel usually ran out. The *ANGEL* burned a remarkable amount of propane. In less than a week, it ran through 1,360 gallons, consuming more than a third of the festival's fuel supply. But even the most ambitious fire artists aren't immune to mundane problems. As the week wore on, the Flaming Lotus Girls were beset by various annoyances. Their utility vehicle, a 1986 Ford

THE IMPOTENCE COMPENSATION PROJECT (OR ICP FOR SHORT) BY JIM MASON SPEWED FIVE JETS OF BURNING KEROSENE NEARLY THREE HUNDRED FEET HEAVENWARD. SHOWN HERE IN 2001, IT WAS THE DRAMATIC PRELUDE TO THE BURNING OF THE MAN.

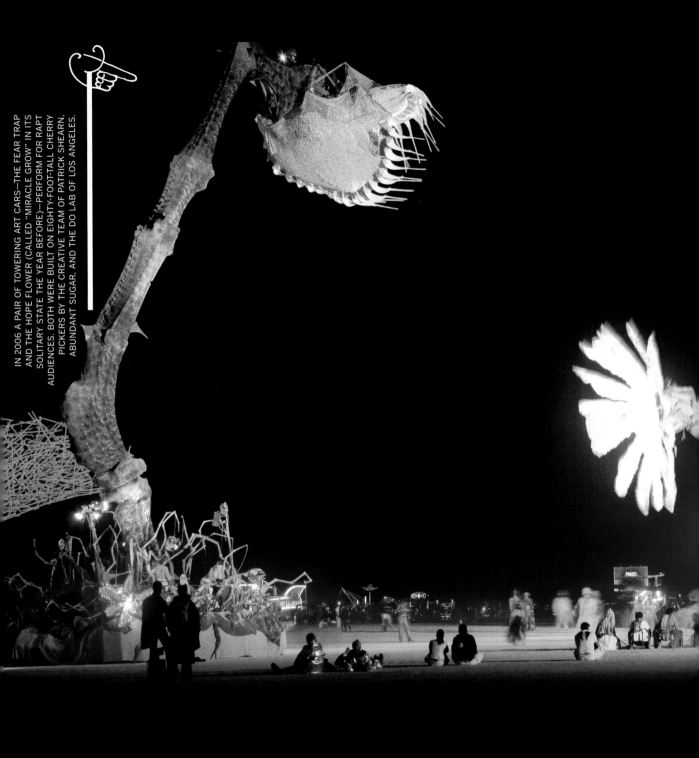

IN 2006 A PAIR OF TOWERING ART CARS—THE FEAR TRAP AND THE HOPE FLOWER (CALLED "MIRACLE GROW" IN ITS SOLITARY STATE THE YEAR BEFORE)—PERFORM FOR RAPT AUDIENCES. BOTH WERE BUILT ON EIGHTY-FOOT-TALL CHERRY PICKERS BY THE CREATIVE TEAM OF PATRICK SHEARN, ABUNDANT SUGAR, AND THE DO LAB OF LOS ANGELES.

station wagon with homemade fins and a pink paint job, known lovingly as the ***STEALTH SHARK BUNNY OF THE APOCALYPSE***, was a magnet for cops, who pulled it over regularly, demanding to see their Burning Man driving permit. Other episodes were more surreal. One night, an eighty-foot-tall cherry picker refashioned into a giant flower drove up to the ***ANGEL.*** The flower, named ***MIRACLE GROW,*** was a gorgeous contraption created by a team of Los Angeles artists. It roamed the desert, unfurling lacelike petals, exhaling plumes of mist, craning and bowing at the end of its tall mechanical stem, attracting swooning audiences wherever it traveled. When ***MIRACLE GROW*** met the ***ANGEL OF THE APOCALYPSE*** late one night, however, things got a little sloppy. The lift operator was goofing off at the controls. The big blossom bobbed and bent over the spiky sculpture in some sort of botanical dance, as if the two pieces of art could cross-pollinate. Then one of the flower's petals snagged on one of the ***ANGEL***'s tallest feathers. One of the Flaming Lotus Girls, an ordinarily affable fellow named John DeVenezia, had seen this coming. He'd lobbed a can of Tecate beer, still three-quarters full, at the flower while hollering at the driver. But it was too late. By then, the petal was snarled twenty feet above the ground, well out of reach. The Flaming Lotus Girls probably could have just hit the gas and incinerated the flower in a blast of fire. Finally, Charlie took charge of disentangling the mutant floral arrangement. He tried a ladder, but that wasn't tall enough. After an hour or two of frustration, he flagged down a red double-decker party bus and balanced on the roof to gently pry the petal loose.

By the time the flower drove away, the sun was coming up. The Flaming Lotus Girls had been admiring ***MIRACLE GROW*** all week, but now, as they straggled back to camp, muttering amongst themselves, there was a common refrain: "**Fucking flower**

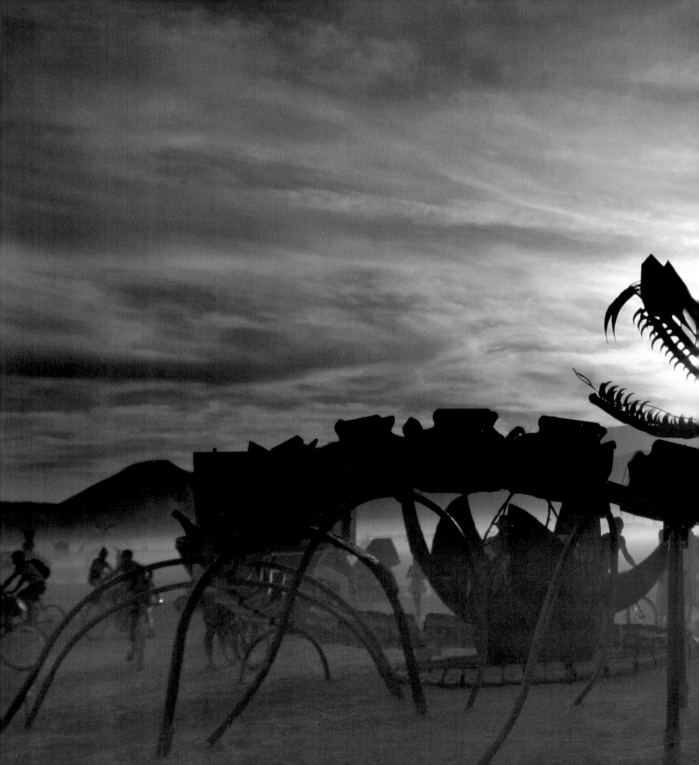

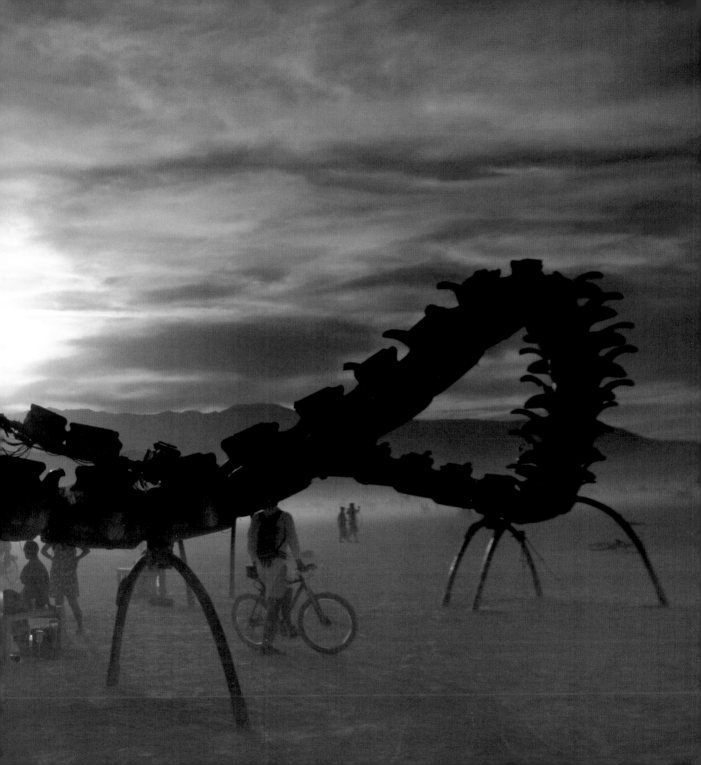

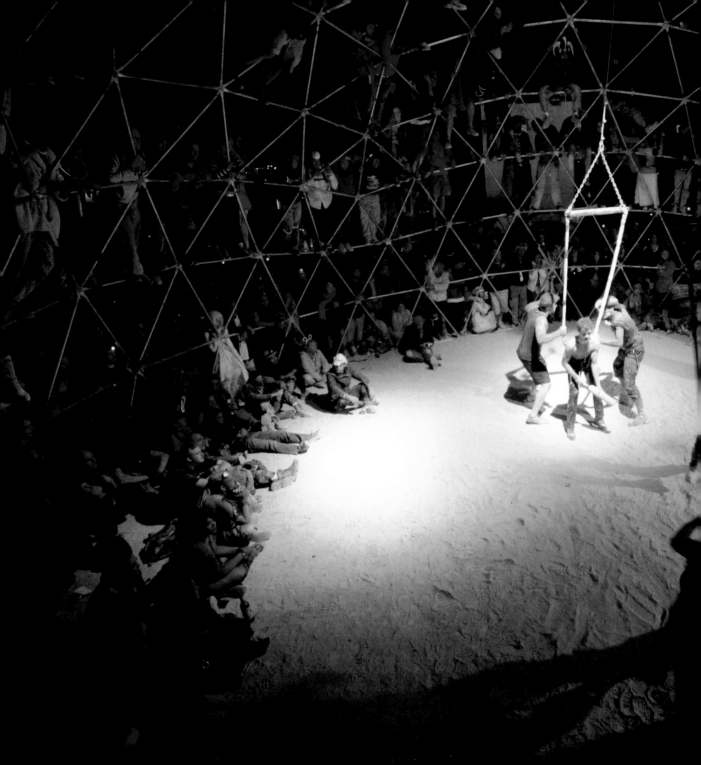

DANGER
DAYS

EVERY CITY NEEDS A PLACE to vent the darker sentiments of the soul. The Romans had their Coliseum. Burning Man has the

THUNDERDOME.

The Thunderdome may be the most aggressive jungle gym in the world. More specifically, it's a geodesic dome that has been rigged up as a fighting arena. It looks like a giant hemispheric cage, modeled after sets in the 1985 film **MAD MAX BEYOND THUNDERDOME,** where combatants fought to the death as a slavering crowd watched from all sides. At the Thunderdome in Black Rock City, you'll find civilians purging grudges and settling scores. Two adversaries are strapped into bungee harnesses that dangle from the apex of the

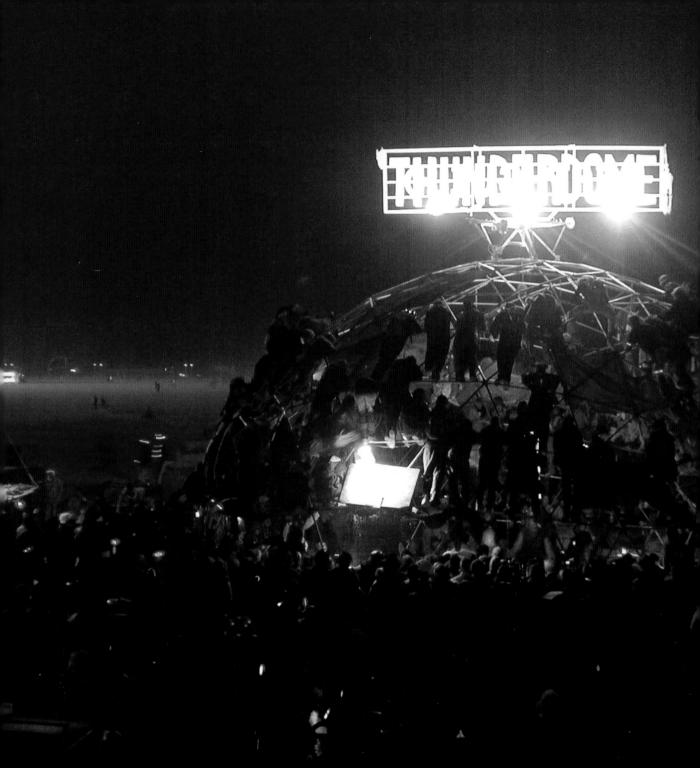

dome. When a match begins, they crash through the air. Egged on by a blaring industrial soundtrack and the din of the crowd, they smack each other with foam bats. They kick and flail and dole out bruises. Surely some of this will ache tomorrow, but for now it's drowned out by the will to win.

Onlookers pump their fists and scream their throats raw. The rowdiest ones have climbed the sides of the dome to get a better view. Sometimes half the audience seems to be clinging to the crossbars up there. Staring down at the show, they heckle and holler, some of them chanting the Thunderdome's traditional battle cry:

A TIDE OF SPECTATORS SURGES OVER THE DOME. WHERE CAREFUL CLIMBERS ARE REWARDED WITH VIEWS OF THE ACTION BELOW.

TWO MEN ENTER ▷▷ ONE MAN LEAVES! ▷

As the noise surges and echoes around the dome, the fighters seem to pummel each other even harder. Sometimes two opponents lock together in a clawing, struggling embrace. That's when a referee—who might glide through the dust in custom rugged-tire Rollerblades and a billowing cape—intercedes. He waves his staff in the air. Attendants rush in from the sides to pull the contestants apart, giving them a moment to take a few ragged breaths and wipe away the sweat. Then they return to the fray.

The proprietors of Thunderdome call themselves **the Death Guild.** They're a proud band of misfits, tattooed and clad in black, with enough piercings and spikes between them to short out an airport metal detector. They don't look like the kind of people you'd want to face in a fight. One time when a guy from the DPW named

Cowboy Carl was offering to sharpen pocketknives, the Death Guilders shook out their clothes and came up with enough blades to cover the tailgate of his car. They aren't too surprised when strangers look at them suspiciously.

"The **H**appiness-and-light people view us as a **dark spot in the desert,**" says David King, a broad-shouldered, dreadlocked fellow who dreamed up the Thunderdome years ago. His story goes back to 1992, when he hitchhiked cross-country and ended up in San Francisco. "I was positive that if I stayed in New Jersey, I would either end up dead or in prison," he adds brightly. After he got to the West Coast, David started taking odd jobs at a club called the Pit, then started up a goth and industrial music night called Death Guild. The event's logo is a hanged man dangling from an oak tree. Nowadays, you can see that image adjacent to the Thunderdome, stretched across a banner on a scaffolding tower.

David ambled out to Burning Man in 1997 when, in his words, it was "uncoordinated artists' mayhem." Kurt Harland, a friend who sang in the tech-pop band Information Society, was there too, and Kurt decided to add to the bedlam by blowing up his car. Wrecking old cars at Burning Man is a hallowed tradition; to this day, a theme camp called Gigsville hosts an annual Car-B-Q. In any case, Kurt's car was a 1973 Plymouth Satellite Sebring, lovingly modified to look like the low-tech battle cars from the MAD MAX films. It was a hulking, matte black monster everyone called......

......

TANKS ALOT
BRTC
HOPE BM06 FEAR

VECTOR.

The roof had pipes that JUTTED OUT LIKE GUN BARRELS,

along with a red laser sight **AND A DEER PELVIS ALL SPRAY-PAINTED BLACK.**

The body was **A TANGLE OF TUBING** and expanded steel mesh, **WITH A PAIR OF PLASTER SKULLS** adorning the front bumper.

David convinced him not to destroy it. "You owe it to your fans," he insisted. So Kurt gave the car to him.

After getting the car, David explains, the next logical step was to build a **THUNDERDOME** to match it, in keeping with the **MAD MAX** theme. Two years later he made that happen with a group of around two dozen friends. They bought a geodesic dome in pieces. It took them four days to connect all the struts and hubs. It was so tall, they had to build an adjacent scaffolding to work on it, and a guy walking past on stilts stopped to help tighten the bolts. But when the dome was done, the battles began. Post-apocalyptic gladiators defied gravity in the bungee harnesses. They hovered in the air and swooped down to deal crushing blows. The audience was mesmerized.

"It was basically a giant jungle gym with a TV in it, and if they screamed loud enough, blood would come spurting out," says David. He's exaggerating a little, but over the years contestants

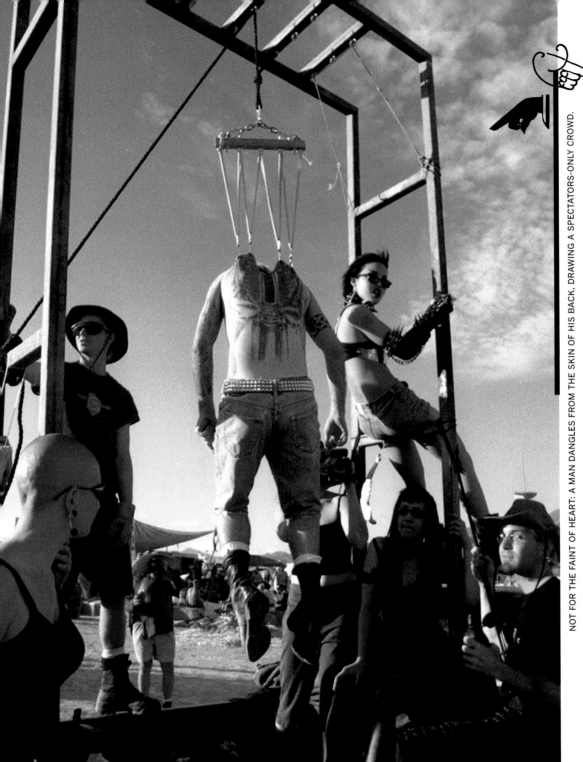

NOT FOR THE FAINT OF HEART: A MAN DANGLES FROM THE SKIN OF HIS BACK, DRAWING A SPECTATORS-ONLY CROWD.

OPPOSITE: NO ONE GETS THUMPED HERE: IN THIS THUNDERDOME SEND-UP, PLUSH BUNNIES PADORN A HEARTWARMING DOME OF THEIR OWN.

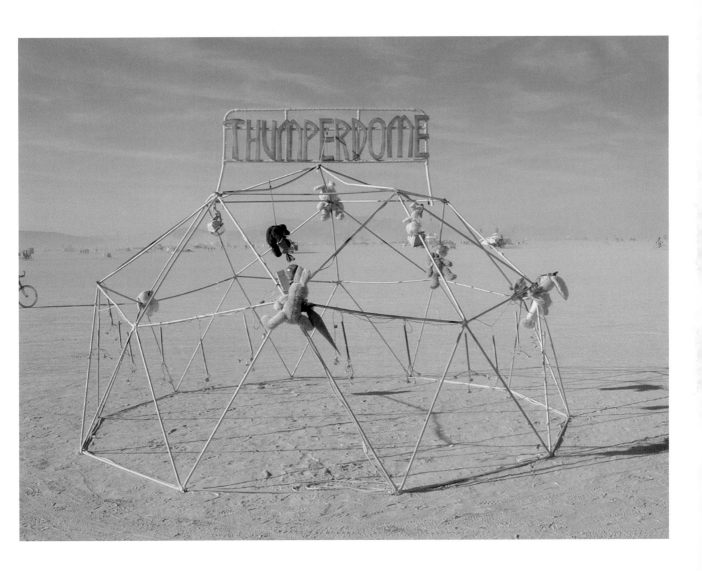

managed to break noses, orbital sockets, and other vulnerable parts. One woman suffered a crunching knee to the rib cage—her sister's knee, no less—and was evacuated by helicopter. Another guy took an upward kick in the groin so hard that he had to spend a few days in Reno, getting a bit of his anatomy surgically extracted. The Death Guild coined a descriptive cheer for him: **"Two balls enter. One ball leaves."** Considering that dozens of people fight in the dome each year, the list of serious casualties is actually pretty short. They keep the tally down by requiring contestants to pick their own sparring partners. Marisa Lenhardt, an opera singer who now coordinates the Death Guild's camp, explains it like this: **"If you know you're going to have to see somebody the next day,** THERE'S LESS OF A LIKELIHOOD THAT YOU'RE GOING TO INJURE THEM. **"**

THUNDERDOME

·········· ARRIVED ··············

on the playa at an interesting time. In Burning Man's younger days, catharsis came easy. Fires were largely unregulated. If you wanted to drive like a maniac with people surfing on top of your car, or drop acid and drag race into the sunset, you'd have plenty of company. Weapons were welcome, and a group called the *DISGRUNTLED POSTAL WORKERS* armed themselves to make extra-surly deliveries of the **BLACK ROCK GAZETTE,** the festival's first newspaper. In games of *GOLF-SKEET,* competitors with shotguns vied to blast airborne golf balls out of the sky. At the *DRIVE-BY SHOOTING RANGE,* a target gallery of

BLACK ROCK CITY
5 YEARS
EMERGENCY SERVICES

OFFICIAL DUMMY SMUNCHER

DUM CHUCK

BLACK ROCK GOLF-SKEET TOURNAMENT

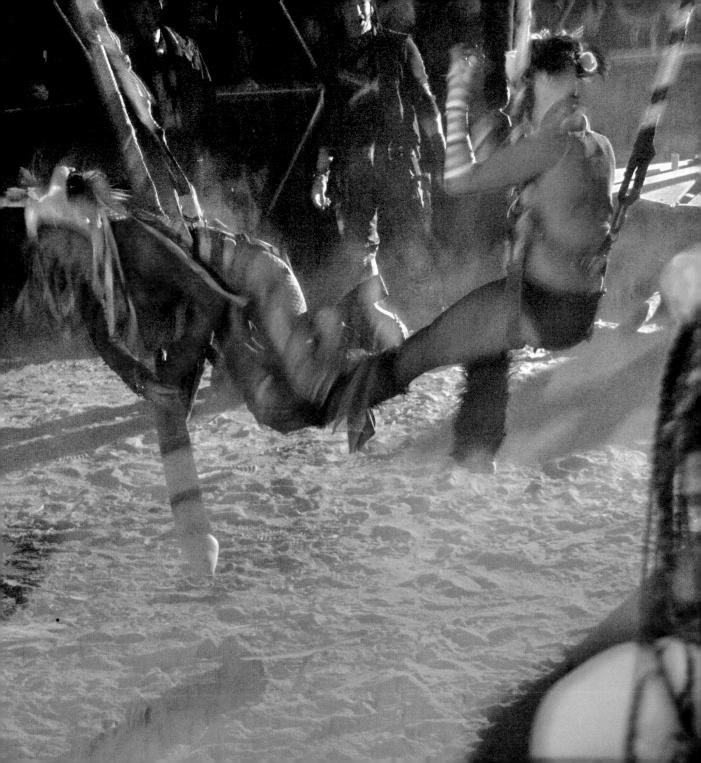

stuffed animals awaited execution on the fringe of the playa. Marksmen breezed past the lineup on cars and bicycles. As if exorcising the demons of childhood, they riddled the toys with bullet holes. *These were the festival's danger days.* They were immortalized on an old bumper sticker that read:....................................

...... BURNING MAN:

GRANOLA, GUNS, & VIDEOTAPE.

But such raw elements disappeared as Black Rock City shifted from a sparse frontier town to a burgeoning metropolis. New regulations had been cropping up ever since 1996, when eight thousand people showed up in the desert, doubling the city's size from the year before. The festival's theme that year, **"The Inferno,"** told the story of a fictitious corporate entity called Helco that was trying to buy Burning Man. That devilish plot failed late in the week, when the Helco Towers fell in a dramatic show of explosives. But the dark cast of the theme seemed to spill over into real life, and there were some gruesome accidents. A motorcyclist who had arrived early for the festival slammed into a van's side view mirror and died. A car flattened a tent with three people inside it. Until that year, the desert revelers had felt close to invincible. Now the illusion was evaporating fast, and as it faded, the danger days began to wane. The Burning Man organizers started establishing boundaries that remain in place today. No driving at the festival, except for art cars, which were held to a speed limit of five miles per hour; no guns; no rockets, personal fireworks, or open fires. A perimeter fence went up around the city. Some burners bemoaned the death of anarchy and abandoned the festival; others regarded the institution of civic order as a reasonable sacrifice to keep Burning

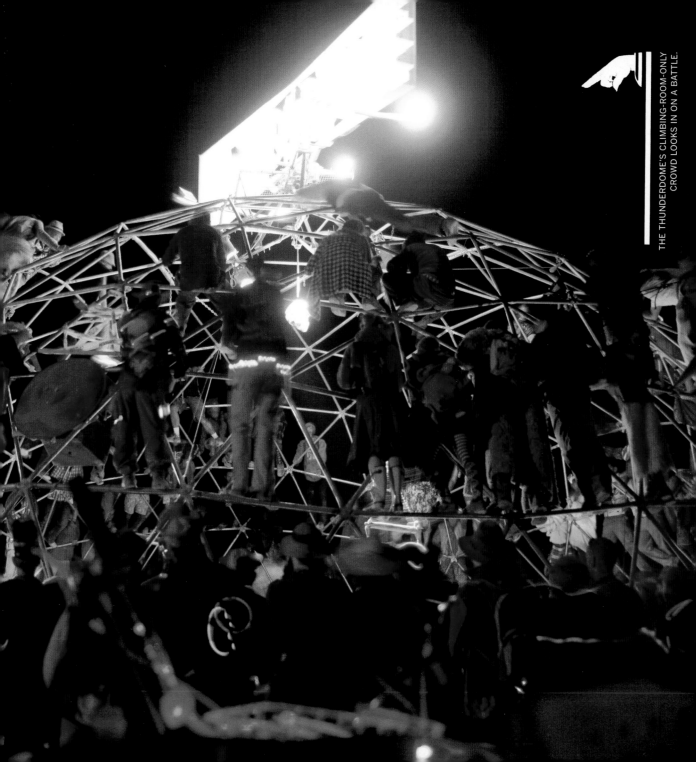

In any case, the ***THUNDERDOME*** came to represent some of the edgier impulses that you couldn't exercise anywhere else at Burning Man. The dome could be brutal, sure, but it was also a contained game. After it opened in 1999, the Thunderdome became a hit, and one that kept getting more elaborate each year. A big, rotating sign with skeletons dangling from either side was installed on top. A chalkboard that read **"Days Since Last Injury"** was posted on the side, and there was usually a **BIG ZERO** scrawled on it. The Death Guild members ran the dome for two to three hours a day, once in the afternoon and again in the evening, exhausting themselves to the point where they seldom got out to see the rest of the festival. They got more theatrical. Fire dancers filled the circle inside the dome and performed before the fights. Marisa Lenhardt sang haunting arias. There was a choreographed flaming swordfight one year, and it culminated with the contenders' bodies getting dragged out of the dome.

"We go out to Burning Man, and there's this impression of what it should be like, and we don't represent what a lot of people think it should be like," Marisa says, expounding on the idea that burners have come to expect a kinder, gentler atmosphere in Black Rock City. Still, the Thunderdome has legions of admirers, too. In tribute, members of the DPW built the Death Guild a "Thumbderdome"—a booth for no-holds-barred thumb wrestling. Another group built an impromptu "Thumperdome" on the playa, a small dome with plush bunnies dangling harmlessly from the bars.

The number of Death Guild campers has swelled from the initial two dozen to around fifty. There's one major requirement for new recruits: that they work hard to make the dome happen. There are fund-raisers to arrange during the off-season, and plenty of manual labor to do in the desert. Pitch in, and no one will judge you

based on who you are at home. "It's interesting because it doesn't matter who you are or what you do, and I think that's one of the things that makes [Burning Man] still a fantastic place to go," says Marisa. "It doesn't matter what you are out there, but what can you do out here?"

Underneath the snarling and strutting, there's a sense of camaraderie, and a quiet, earnest vision of teamwork. "Anything you put this much energy into that you're not getting paid for, you can be cynical on the surface about it, but when the truth comes out, your heart and soul goes into it, no matter who you are," Marisa concludes. "If you're busting your ass to do this, it's not because you're getting paid, and it's not because you're getting famous.

So why are you doing it?"

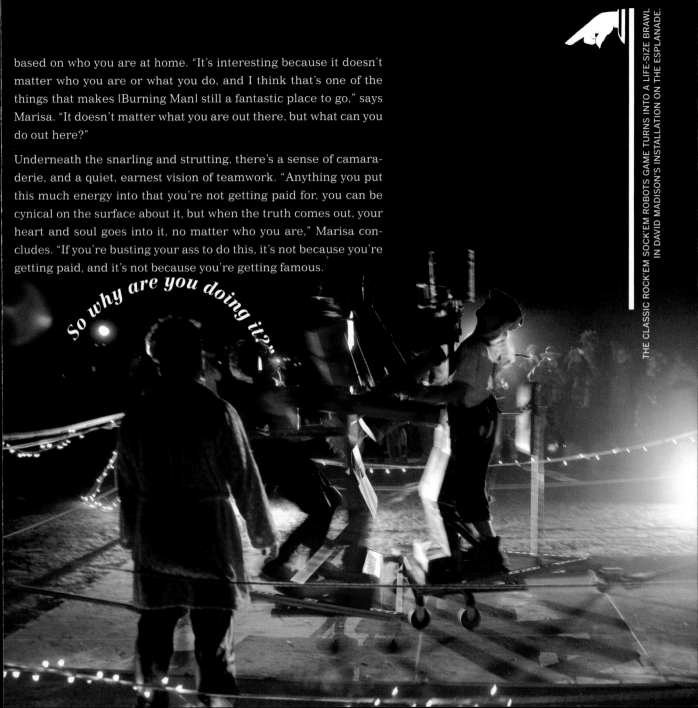

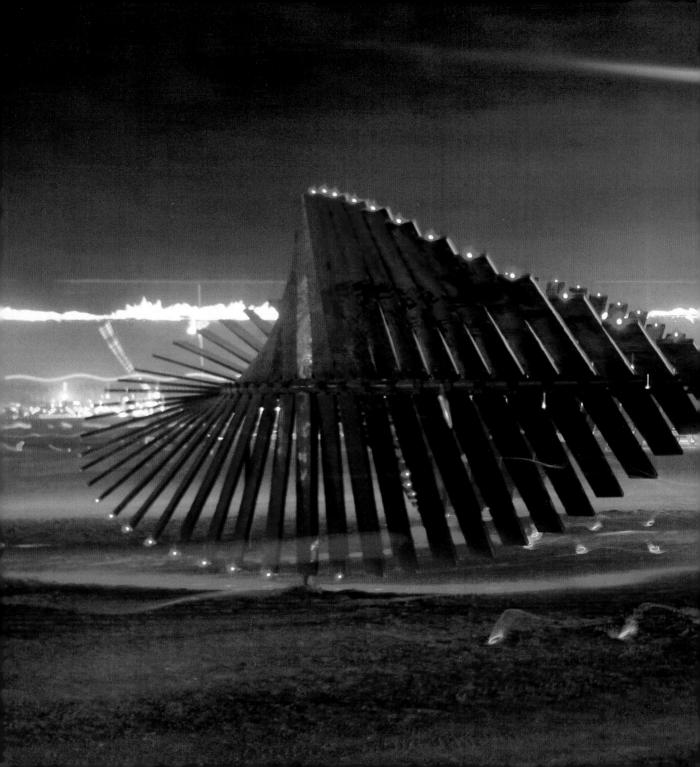

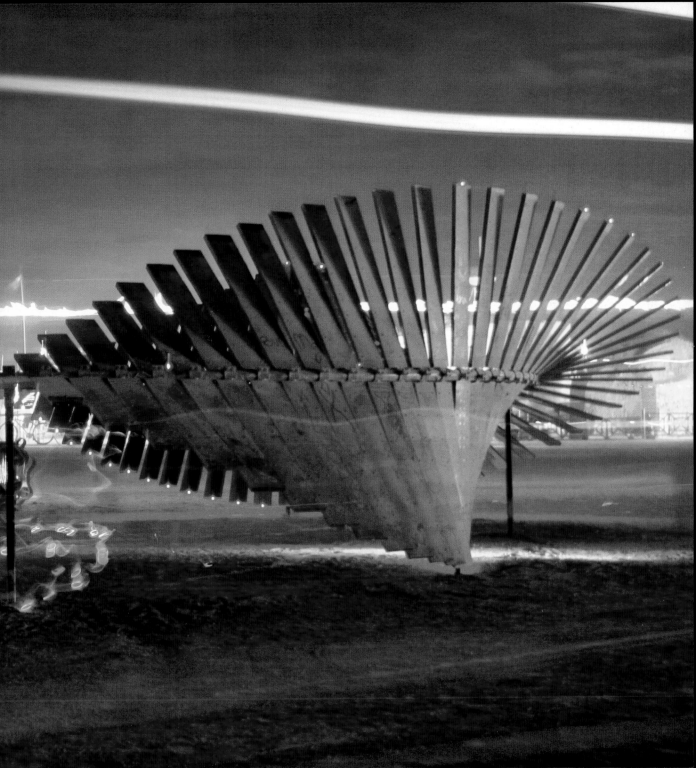

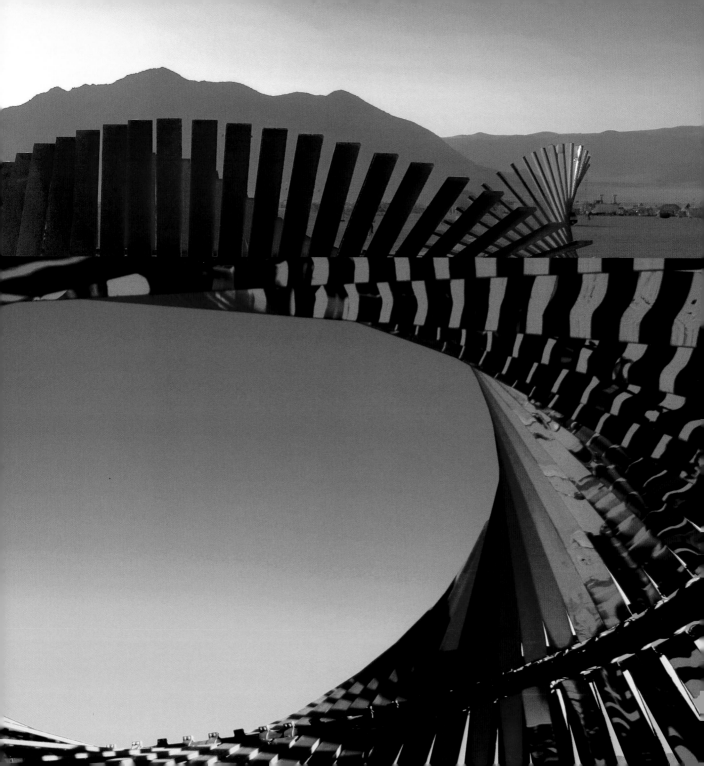

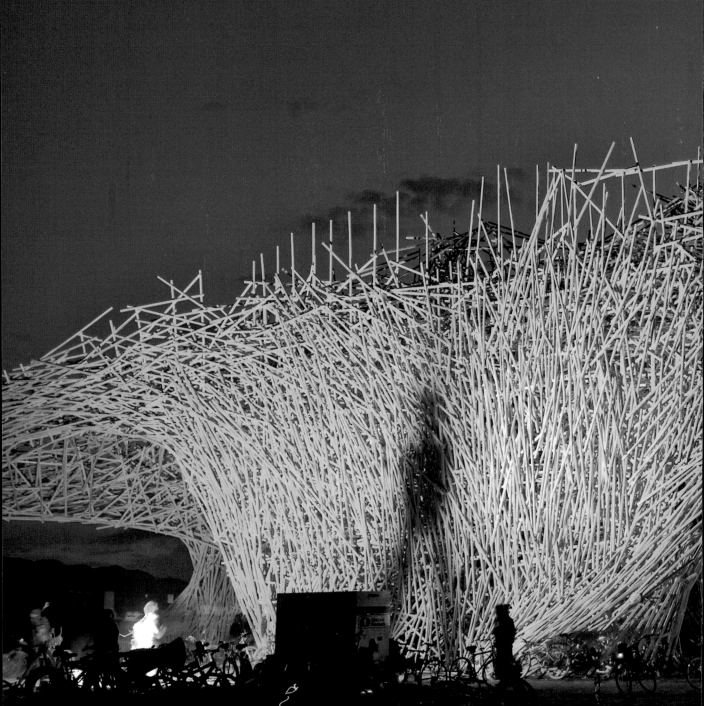

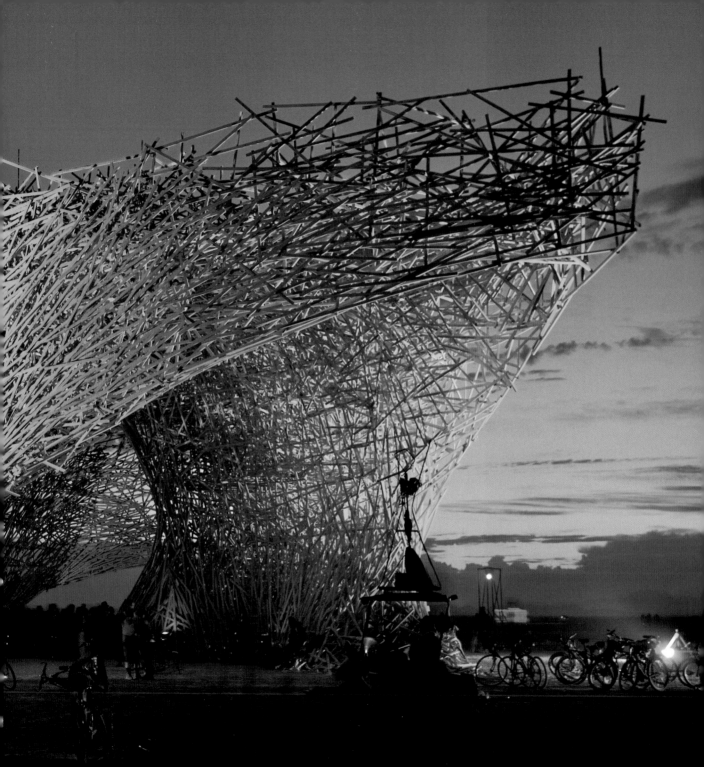

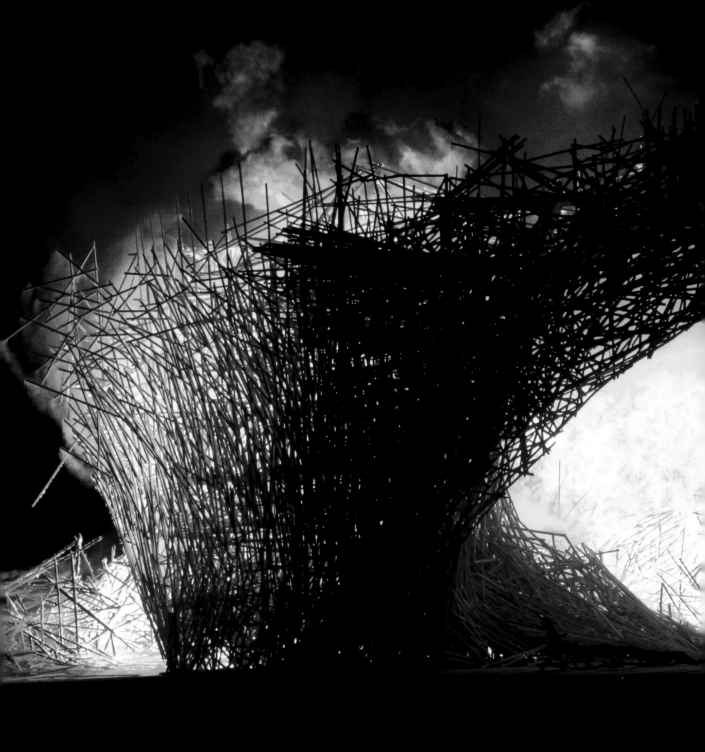

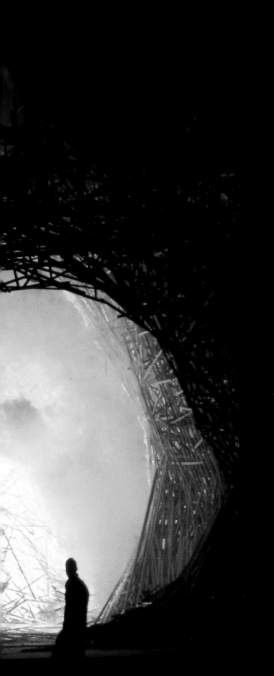

PREVIOUS SPREAD: IN 2006 A TEAM OF NINETY BELGIANS BUILT UCHRONIA: MESSAGE OUT OF THE FUTURE, A CAVERNOUS DANCE CLUB THAT BURNERS NICKNAMED "THE WAFFLE."

OPPOSITE: UCHRONIA BURNS.

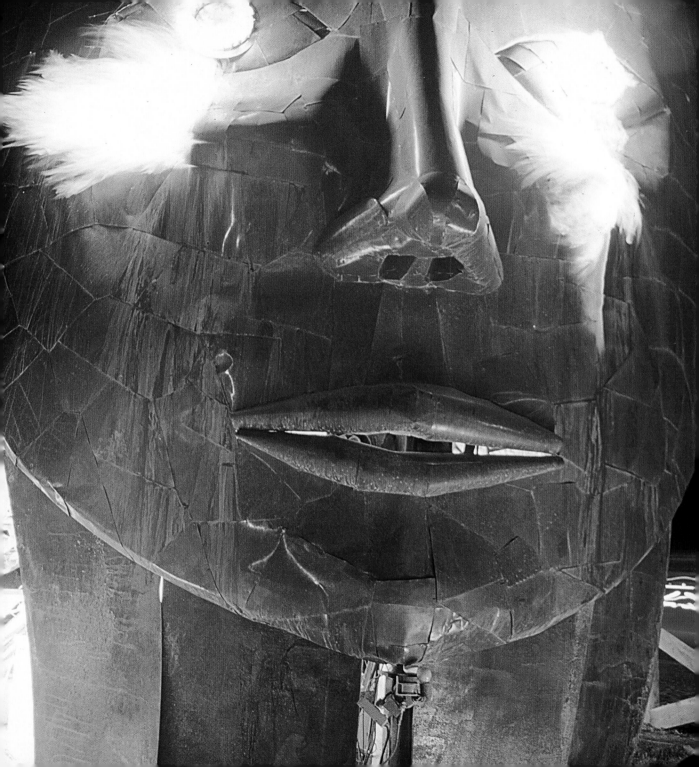

LIVING LARGE

THE IDEA FOR THE MOST

exquisite electroshock device ever built came to Rosanna Scimeca in bed. She was hanging out in a friend's room in San Francisco, lying on his mattress and staring up at the ceiling. She focused on a chandelier. Then, she recalls, she imagined an accident: The chandelier came unanchored and **CRASHED DOWN** on her.

A TWENTY-FOOT-TALL COPPER MASK WEEPS FLAMING TEARS WHEN VISITORS APPROACH THE THREE FACES OF MAN. A SCULPTURE BY DAN DAS MANN WITH TWO MORE SIDES: A DRIFTWOOD FACE WITH TEARS OF WATER AND A GRASS-COVERED FACE CRYING SAND.

WHAT IF
THE CHANDELIER
WAS

IMMENSE,

lighting up some

celestial ballroom, AND THEN IT
FELL FROM THE SKY?

It could tumble to Earth and rest there, half broken but still flickering on and off, glowing with some vestigial current. If you touched it, you'd feel a jolt. She decided she could probably build it.

"Looking back, I didn't know exactly what I was getting myself into, building the chandelier," muses Rosanna, a twenty-nine-year-old artist. "If I knew what I learned from it before I started, I would have been a little scared. Terrified. I might not even have done it."

The wide, flat canvas of the Black Rock Desert begets big sculptures. Some of them are charmingly absurd, like ***ANAS VULCANUS,*** a whimsical walk-in rubber duck by Aaron Muszalski, whose earlier projects included a towering pair of dice and a set of dominoes; or ***JOHNNY ON THE SPOT,*** the urinal and fountain that was built and burned by Saul Melman, an ER doctor from Brooklyn, and his girlfriend, a dancer named Ani Weinstein; or Mark Griffin's staggering ***LADDER,*** which was supported by steel guy wires and allowed unharnessed climbers to ascend eleven stories skyward (IN FOUR DAYS, THREE HUNDRED DAREDEVILS TOOK THE CHALLENGE). In 2006 a squad of ninety industrious Belgians surprised Black Rock City and built an elaborate dream: a massive cavern shaped by hundreds of

184

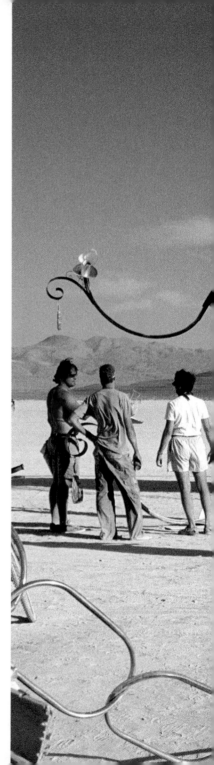

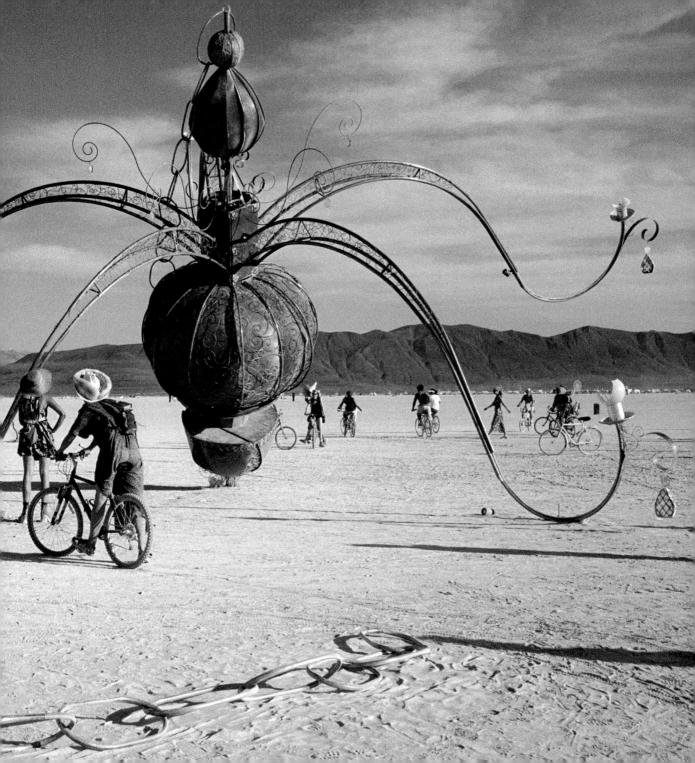

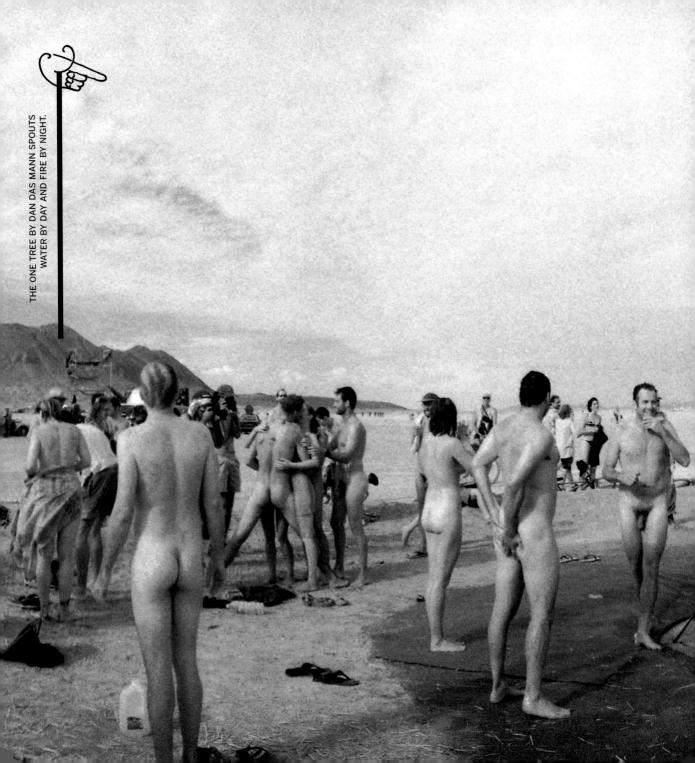

THE ONE TREE BY DAN DAS MANN SPOUTS
WATER BY DAY AND FIRE BY NIGHT.

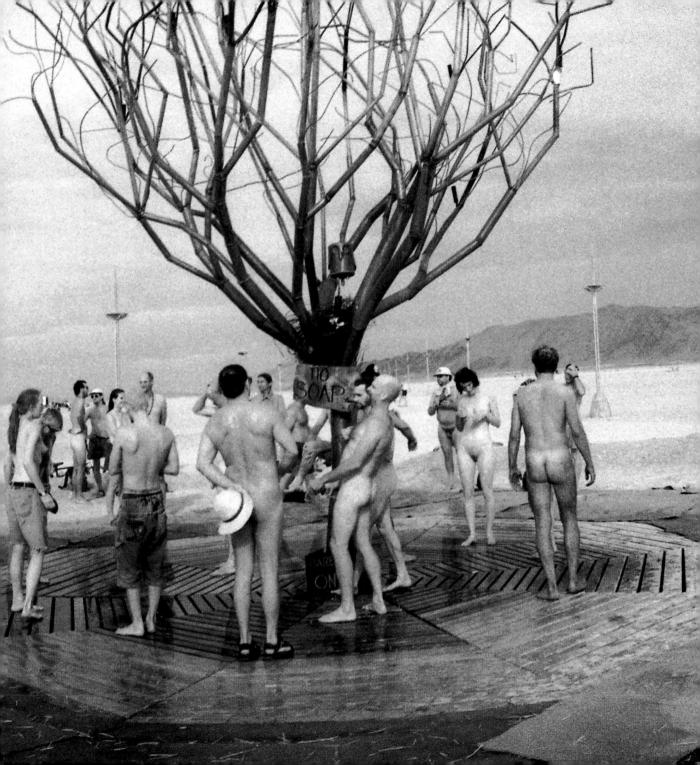

two-by-three wooden planks that formed a soaring, delicate lattice. Part dance club, part cathedral, the structure was named **UCHRONIA: MESSAGE OUT OF THE FUTURE.** (TO ITS CREATORS' DISMAY, BURNERS QUICKLY RENAMED IT THE BELGIAN WAFFLE.) Big art can be very heavy. In 2003 Zachary Coffin's **TEMPLE OF GRAVITY** suspended four slabs of rough-hewn granite and weighed over seventy tons altogether. Two years later his **COLOSSUS** (NICKNAMED "THE HIPPIE CRUSHER") dangled a triad of eight-ton boulders. So, for all its supersized strangeness, Rosanna's chandelier would seem to have a natural home in Black Rock City.

Like many people who are drawn to **GARGANTUAN,** ABSURDLY AMBITIOUS & **SOMEWHAT DISTURBING** art projects, Rosanna had an independent streak. She was notorious for bringing a stun gun to parties and zzᶻzᶻᶻzapping̃gg̃g̃gg people with

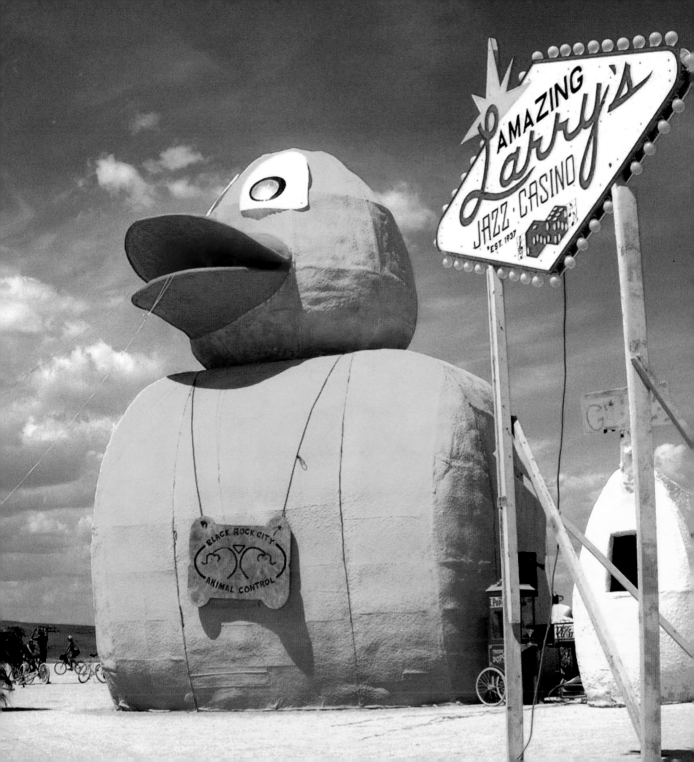

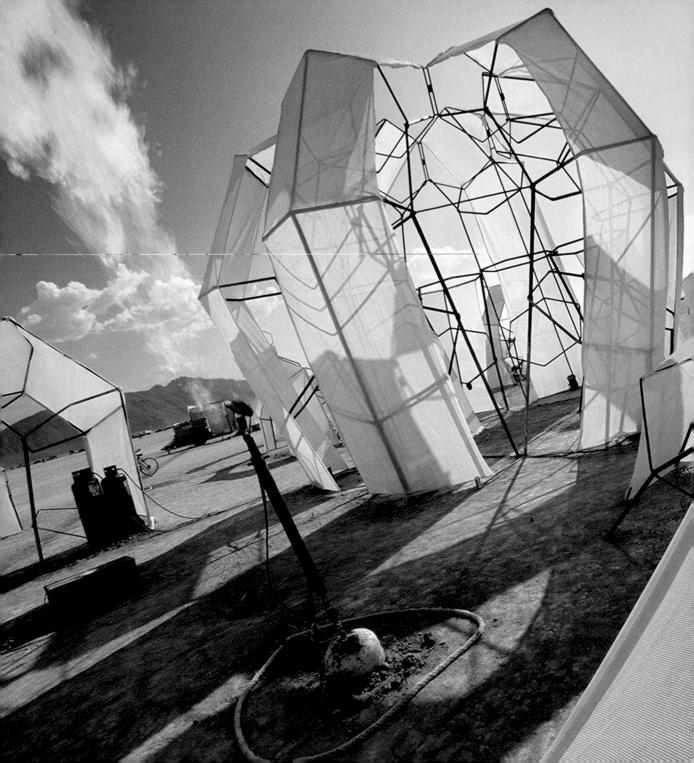

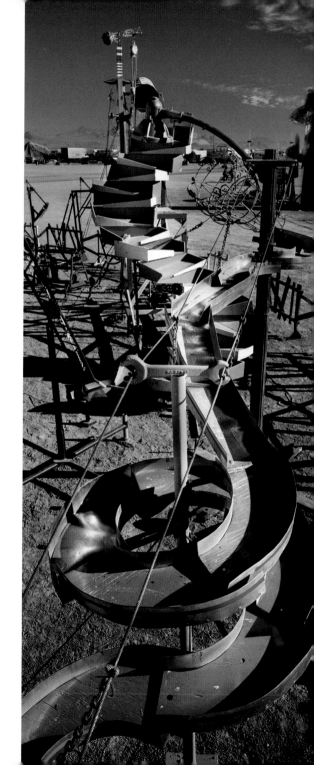

LEFT: IT TOOK A HALF MILE OF REBAR, AN ACRE OF AGRICULTURAL NETTING, AND TWO WEEKS IN THE DESERT TO BUILD CREATURE OF THE DEEP, A CLIMBABLE OCTOPUS SCULPTURE BY THE MADAGASCAR INSTITUTE, A BROOKLYN-BASED ARTS COLLECTIVE.

RIGHT: A LARGER-THAN-LIFE-SIZE VERSION OF THE BOARD GAME MOUSETRAP, WHICH MARK PEREZ FIRST TRIED TO RUN AT BURNING MAN IN 1996, TRIUMPHS ON ITS SECOND TRY IN 2005.

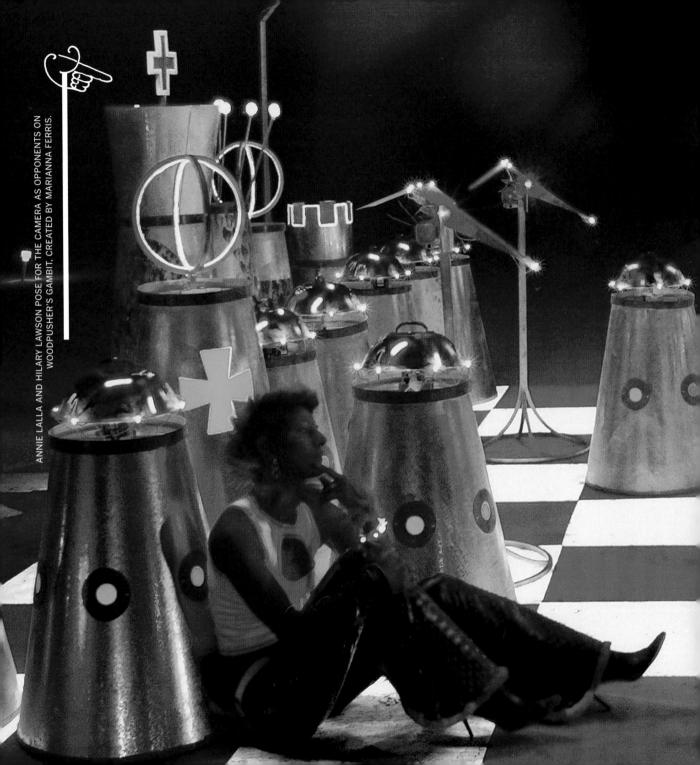

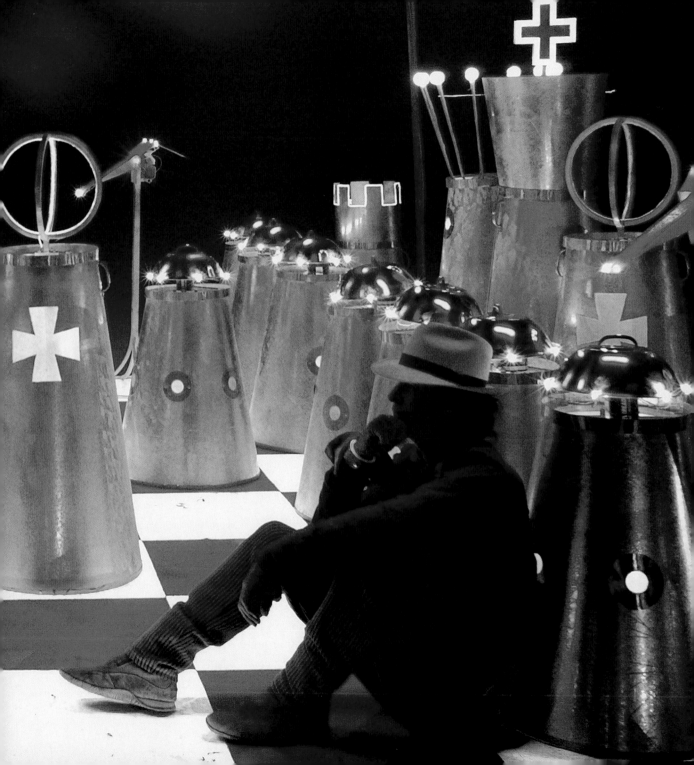

it for kicks. Her teenage hobbies included Brazilian jiu-jitsu, tae kwon do, and competitive hairdressing. After a stint working in beauty salons, she got fed up with styling and started studying 3-D animation at Bergen Community College in New Jersey. That was where she encountered Burning Man, quite by accident. A classmate she barely knew was planning a trip in 2000 and showed her the festival's website. At the time, Rosanna was mired in a messy breakup with her former tae kwon do teacher. It felt like a good time to leave town. "I was in a total funk," Rosanna explains, "and I read this thing and I was like,

........."**'Oh my God. You're KIDDING me.**

I've GOT to GO."

The classmate introduced her to a guy with room for an extra passenger in his truck. So they set off cross-country for Burning Man.

"I got there in the middle of the night, and it was just so quiet and the sky was so big," she says. "I was just like a sponge. I wasn't even thinking that much, to be honest. . . . the whole thing was a shocker to me. I wasn't distracted by all my problems. I was just

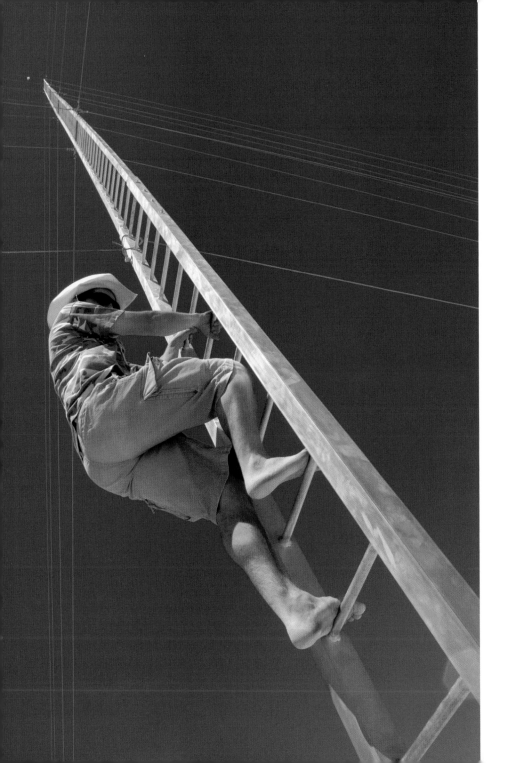

wandering, looking at things with my jaw dropped." Many adventurers describe their first impressions of Black Rock City that way. The amount of social and visual stimulation is overwhelming. It's impossible to walk ten feet without stopping to stare at something or talk to someone. To get anywhere fast, you'd have to strap a set of blinders to your head and stuff your ears full of wax.

Still, Rosanna thought she'd never end up back at Burning Man. Then she moved out to San Francisco. She started to pitch in on large-scale art projects for the festival. The first one was Lisa Nigro's art car, **DRAKA THE DRAGON,** a 124-foot winged beast made from three trailers and a box truck. The dragon was covered in metal scales and puffed fire from its jaws. Then came Dan Das Mann's **THE LAST STAND,** a sculpture garden with sixteen thousand square feet of lush grass installed, incongruously, on the desert floor. A path enclosed by chain link fence surrounded the garden's perimeter, and to get inside, you had to walk all the way around it twice. Rosanna also worked on a team from the Madagascar Institute, a Brooklyn-based art collective. In 2002 they built **CREATURE OF THE DEEP,** a massive, ethereal octopus made of steel and agricultural netting. After all that, she says, ••••••••••••••••••••••••••••••••••••

•••••••••••••••••••••••••• **"I** DECIDED *IT WAS JUST TIME TO* do my OWN THING."

But "doing your own thing" is seldom as solitary as it sounds. That's doubly true with Burning Man projects. Triply true if your thing happens to be large, heavy, and intricate. And Rosanna's project—a gigantic chandelier torn from the sky—had all those qualities. After she proposed it to the Burning Man organizers, who awarded her a grant, she began working on the chandelier with some friends in a

LIVING LARGE

West Oakland warehouse. As the undertaking grew, so did the crew, which swelled to a dozen people within five months. There was a lot of work to be done. Rods of steel were twisted on a jig by hand and assembled into a ball-shaped cage. Sheets of fiberglass were dyed blood red, coated in polyester resin, and nested inside the ball. Pipes were bent into links and joined in a giant chain. "We would get up in our pajamas and keep on welding until we passed out," recalls Marlene Kryza, an artist who flew out from New York to help.

The chandelier migrated in pieces to the Black Rock Desert in 2003. It arrived two weeks before Burning Man began. Most of the chandelier's parts were ready, and everyone assumed they would fit together (THANKFULLY, THEY HAD A MATHEMATICIAN ON BOARD). But it had never been completely assembled before.

"Everything was hypothetical up until that point, and then all of a sudden everything was actually happening," says Dan Rabino-vitch, a crew member better known as "Skunk," for an unlikely white patch in his hair. "I remember people being a little scared:

.............'IS THIS ACTUALLY going to WORK?'" IT DID.

Days later, with the help of a sixty-foot crane operated by a guy named Pogo, the sculpture was complete and stood three stories tall. "I stared at it for a long time," says Rosanna. ("YOU CRIED," INTERJECTS SKUNK.)

The chandelier looked as if it had tumbled from tremendous heights. Half of the intrigue was the strangeness of it all: The crew had put something together that looked *gorgeously broken.* The piece was structurally strong but also seemed fragile. It leaned on two of its five steel arms, which were each

twenty-two feet long and undulated outward in graceful S curves. The arms radiated from a central sphere of red fiberglass. They terminated in sharp, broken bulbs. A chain trailed from the apex of the structure and snaked along the ground, ending in a giant canopy, made from gypsum cement and mounted on a wall of splintered boards: the remains of an imaginary ceiling. At night the red fiberglass lit up inside. Sometimes the lamp flickered and dimmed. **The effect was...**

HYPNOTIC.

It was also the bait for a startling surprise. If you felt compelled to reach out and grab one of the chandelier's arms, you'd get a sudden low-voltage shock. An electrical engineer had wired up the arms to a cattle fence charger. **❝*It was definitely not enough to* kill you,❞** insists Skunk. Some people found that sensation appealing.

"I went there one morning and there was a guy lying on it." Rosanna laughs. "He was lying across the arm. I thought it was so funny. I was like, 'This guy's so high.'" Though, she added, she understood the attraction. "It kind of feels good. You know, it wakes you up. It's like a really intense static charge. Sort of."

At night members of the chandelier crew hid in the shadows, some fifty feet away from their sneaky masterpiece. They had a remote control box, which could toggle the lights and the cattle fence charger on and off. No one could tell that they were doing it. When the

A WOULD-BE COWGIRL RIDES ONE OF THREE RUBBER HORSES, WHICH BROOKLYN ARTIST DOROTHY TROJANOWSKI BUILT FROM REBAR AND TIRE SCRAPS SALVAGED OFF THE NEW JERSEY TURNPIKE.

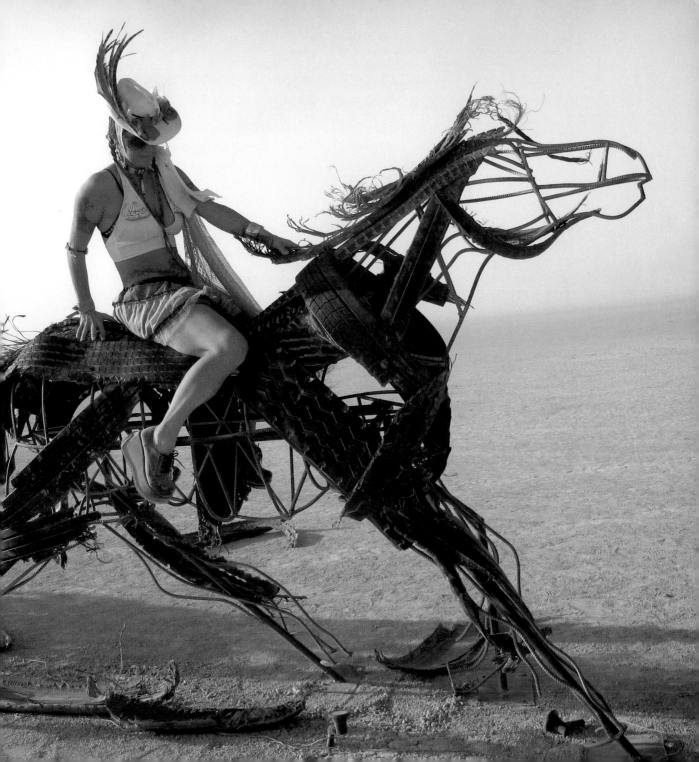

chandelier brightened, people walking by got confused. They froze and then looked around for a motion sensor. They retraced their steps and made wild gestures to see if they could get the light to change again. Rosanna and the crew watched their antics, doubled over with laughter. Some passersby invented stories about where the chandelier had come from. Others got hung up on its official name, *CLEAVAGE IN SPACE,* and made bad jokes. On Tuesday night a marching band came and played beneath its branching arms.

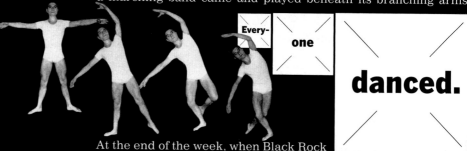

Every-one danced.

At the end of the week, when Black Rock City disappeared, the chandelier went back to Oakland. There is a problem, however, with building and owning a chandelier from the heavens. Unless the gods come back to reclaim it—or you have a celestial-size apartment—there's nowhere permanent to install it. So the chandelier currently resides, in pieces, in a warehouse-turned-artists'-space called NIMBY, where Rosanna rents a studio. She wants to sell it or, at the very least, find a good place to keep it on display. "It's my first-born child," she jokes, "that I'm now trying to send off to college, so it can make me some money."

LIVING LARGE

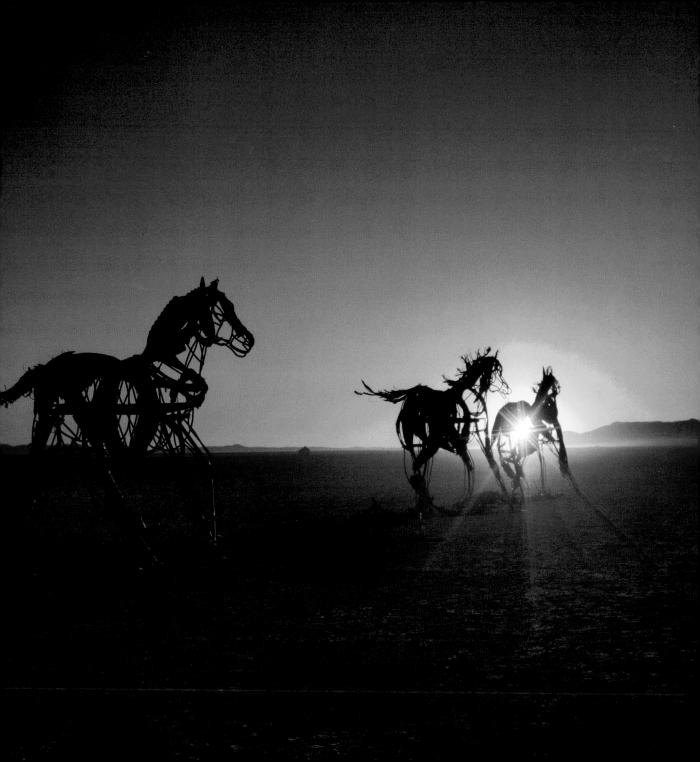

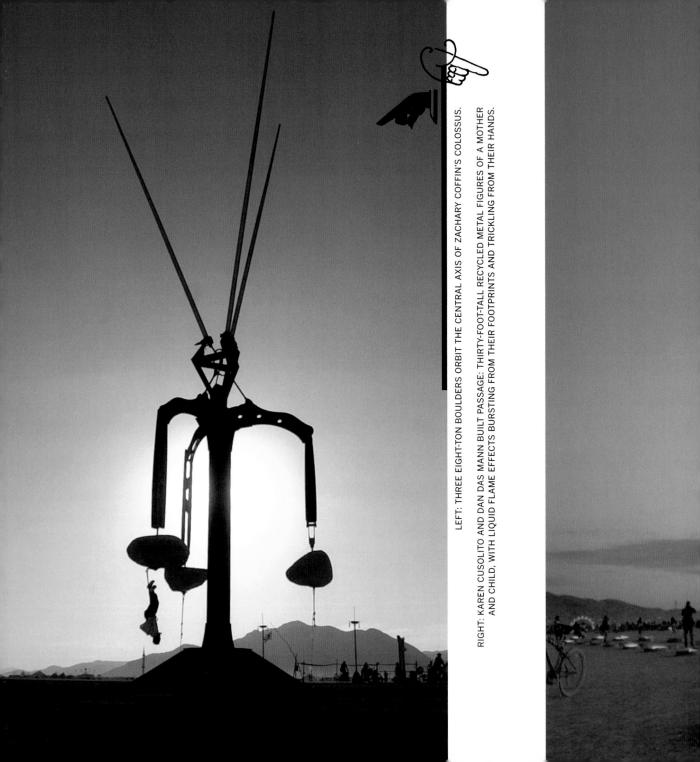

LEFT: THREE EIGHT-TON BOULDERS ORBIT THE CENTRAL AXIS OF ZACHARY COFFIN'S COLOSSUS.

RIGHT: KAREN CUSOLITO AND DAN DAS MANN BUILT PASSAGE: THIRTY-FOOT-TALL RECYCLED METAL FIGURES OF A MOTHER AND CHILD, WITH LIQUID FLAME EFFECTS BURSTING FROM THEIR FOOTPRINTS AND TRICKLING FROM THEIR HANDS.

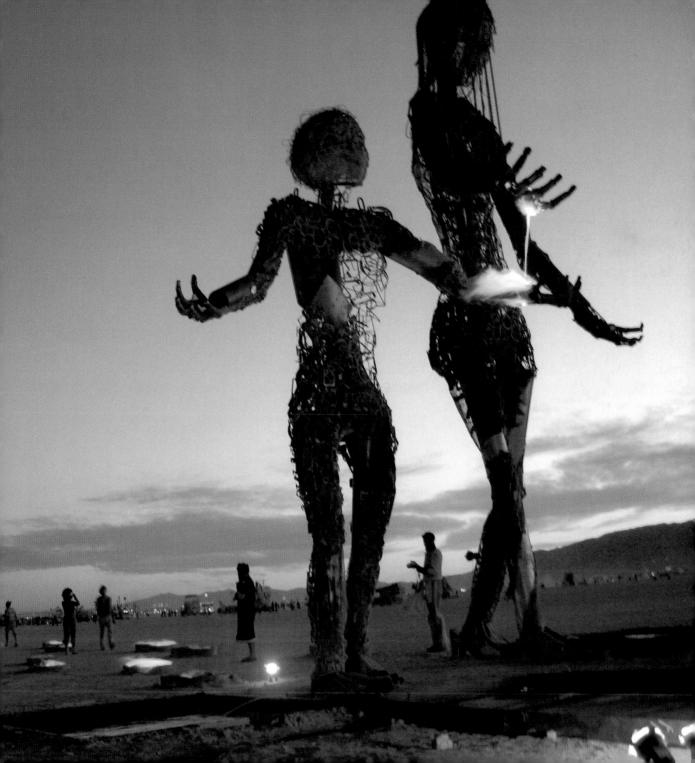

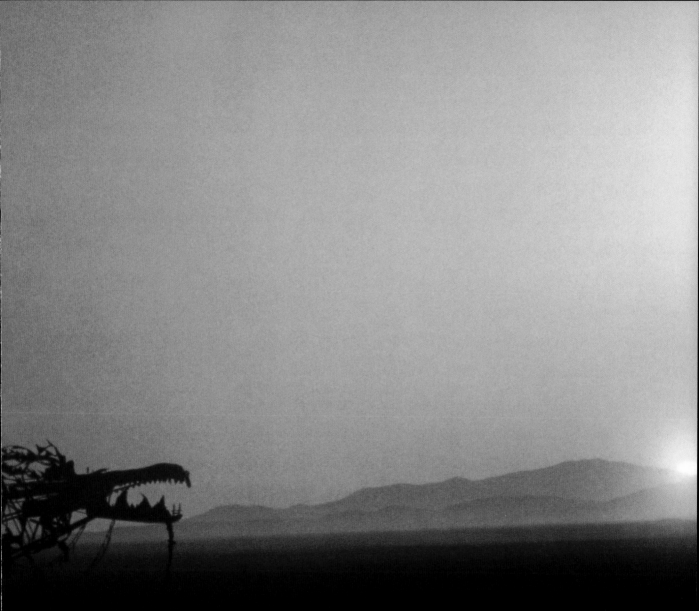

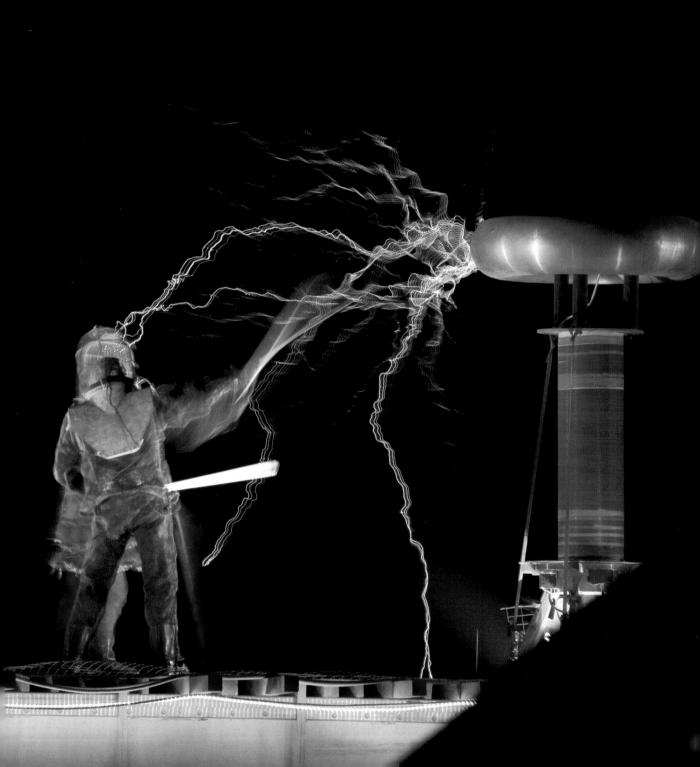

DR. MEGAVOLT

TWO LIGHTNING-SPITTING PILLARS ARE mounted on top of a box truck. Bolts of electricity branch around them, flashing brilliant, purple-tipped arcs that carry a c-c-c-c-c-couple of *h-h*-hundred th-th *th*-th-th-*th*-th-th-*th*-thousand volts apiece, jagging out fourteen feet into the night sky. It's an impressive storm, the kind that sensible folks might admire from a safe distance. Instead a crowd has gathered, hypnotized by the weird weather. They are looking up and

HOLLERING
at the TOP of THEIR
Lungs

AS IF THEIR COMBINED VOICES JUST MIGHT RIP A HOLE IN THE SKY AND BRING DOWN ENOUGH LIGHTNING TO FRY THE WHOLE

RESCENT TUBES, LURES LIGHTNING ADE TESLA COIL.

DANGER

H VOLTAGE

PANDUIT PRS0710D72

But they're not really cheering for the lightning. They are giving encouragement to a human figure that stands, unharmed, between the pillars. The man is conducting the bright bursts with his body. When he raises an arm, electricity....... *LEAPS* TO MEET HIS FINGERS IN A SIZZLING FLASH. He wears a suit of fine steel mesh and a birdcage on his head. On his chest a sign reads:

...................... **DANGER** | **HIGH VOLTAGE** | **DO NOT TOUCH.**

The man looks like a science fiction supervillain, or a junkyard Zeus. The lightning writhes around his limbs, torso, and head. He beckons it closer with a number of props—a silver trident, or a fluorescent tube that suddenly glows to life, powered by the airborne electricity. ..

............ **The current sounds like a swarm of ELECTRIC BEES.** | **It releases a whiff of OZONE,** THE FAMILIAR FRESH SCENT THAT COMES BEFORE A SUMMER STORM.

At the center of the chaos, the man looks confident, even gleeful. When he jumps into the air, white arcs of electricity stream down from his feet. He lifts a plank above his head, and the wood (WHICH IS STUDDED WITH STAPLES BEFOREHAND, FOR CONDUCTIVITY) gets zapped, then smolders and ignites. Sometimes he toasts Barbie dolls or hot dogs. Other times, he goes after the lightning with a stool and a bullwhip like a deranged lion tamer.

WHO *IS THIS LUNATIC* **lightning rod?**

You can hear a voice on a bullhorn, rousing the crowd with a postapocalyptic carnival barker's rant, shouting something like:

DR. MEGA**VOLT**
NEEDS YOUR SUPPORT,
NEEDS YOUR VIRGINS,
NEEDS YOUR DRUGS,
NEEDS YOUR ALCOHOL!

DR. **MEGA**VOLT
WILL BE YOUR
SAVIOR
IN THE DARK TIMES
TO COME
!!!!!!!!!!!!!!!!!!!!!!!!!!!

The crowd responds as one. Everybody chants,
**"ME-GA-VOLT! ME-GA-VOLT!
ME-GA-VOLT!"**

THIS *IS* *DR.* *MEGAVOLT:*..............
......
......

THIS IS DR. MEGAVOLT:

Behind the scenes, MegaVolt has more than one face. A handful of fearless friends have practiced conducting the lightning, and they take turns playing the role of Dr. MegaVolt. On any night, the part might be performed by someone different. He might be Dr. Austin Richards, the physicist who brought MegaVolt to life with his appetite for dangerous technology. He could be cinematographer John Behrens, or computer programmer Will Keller. Or he could be replaced entirely, supplanted by Mistress MegaVolt. Dr. MegaVolt's female cohort is played by Jessica Hobbs, who is also a Flaming Lotus Girl. She wears her own costume, which has a steel skirt and a breastplate with a suggestive copper spirals.

All of them rely on an arcane piece of technology, an apparatus that has fascinated Austin Richards since he was a child. The two lightning-throwing towers on Dr. MegaVolt's truck are homemade, high-voltage transformers called Tesla coils. Each coil consists of a copper-wound cylinder, crowned with a tire-shaped ring called a toroid. When powered to life, a Tesla coil steps up a standard household current, boosting it to high frequencies that reach hundreds of thousands of cycles per second. This process generates a

DRAMATIC electrical DISCHARGE bright arcs that crackle off the toroid and into the air.

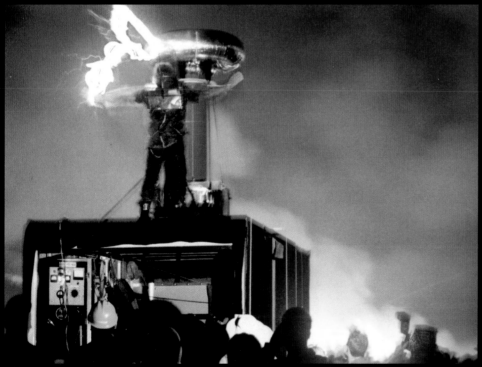

DR MEGAVOLT

Accept No Substitutes

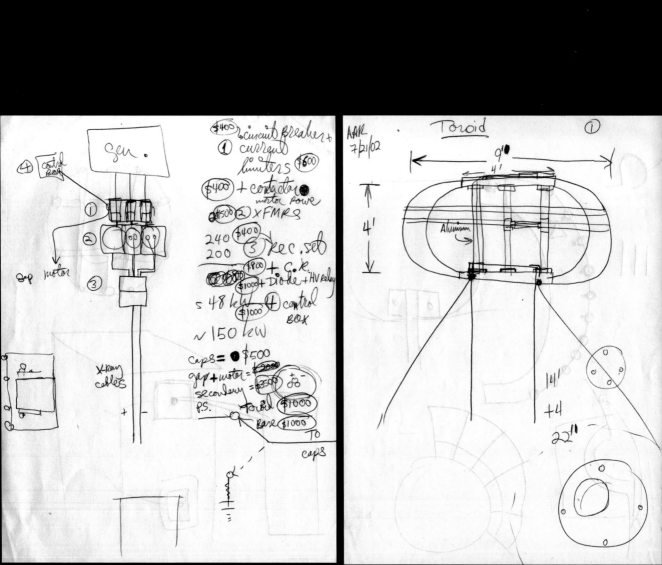

Wreathed in lightning, the coils look like a mad scientist's sinister tools; starting in 1931, special effects gurus made Tesla coils a staple of Frankenstein films. The coils' origins, however, go back to a Serbian-American engineer and inventor named Nikola Tesla, who first patented the technology in 1891. Tesla dreamed that one day his invention would broadcast wireless electrical power to homes all over the world. That vision sputtered out— IT WASN'T EXACTLY PRACTICAL, OR PROFITABLE—but Tesla coils still attract hobbyists, special effects experts, and science geeks, all drawn by the lure of making their own lightning.

Austin built his first Tesla coil at UC Berkeley back in 1991. In the same year, he started spending time with members of **SURVIVAL RESEARCH LABORATORIES,** a collective of creative technicians and thrill addicts in San Francisco who, for nearly three decades, have been creating industrial-grade robotic mayhem and unveiling the results in demonstrations they call **66the most dangerous shows on Earth.99** Their work spawned a gritty **66machine scene99** of Bay Area artists that has since rippled outward, inspiring much of the big, bone-crunching mechanical installations that end up at events like Burning Man, or at overseas tech-art festivals like Robodock in the Netherlands.

In 1996 members of Survival Research Laboratories built a cage meant to shield a human subject from Tesla coil currents. Austin encountered it at a warehouse party.....................................

66That was the FIRST TIME that I tried GETTING IN THE PATH *of a Tesla coil,***99**

HE RECALLS MATTER-OF-FACTLY.

66 I WAS CURIOUS *to see if the cage would* **PROTECT ME** *from the arcs.***99**

Austin stepped inside and, though hundreds of thousands of volts flared all around him, the currents behaved as planned: They flowed along the surface of the cage, leaving him unharmed. A few months later Austin decided to shrink the cage down to human size, building a suit he could wear while striding through the lightning. He made the outfit from pieces of dryer duct and rigid heating tubes, and walking around in it was a bit clunky. Still, the thing worked nicely with his Tesla coil, and he named his new act Electrobot. "If you didn't have the suit on, it's extremely painful," he reflects. "I've been struck by Tesla coil arcs before, and they're really nasty." A friend persuaded Austin to bring the suit and the coil to Burning Man for the first time in 1998. The coil ran for twenty minutes before it broke down. Still, a few hundred people saw the crazy guy with the lightning bolts, and one of them, Christine Kristen, better known as LadyBee, the festival's art curator, encouraged Austin to apply for a grant, which he received the next year. **From that anticlimactic beginning, THE MEGAVOLT SHOW GREW,**

becoming mobile as first one, and then two, Tesla coils were mounted on top of a box truck for Burning Man. The coils were grounded on a sheet of metal mesh on the roof and, to release any residual charge, dragging chains hung off the back. More flexible, ergonomic suits were made of steel mesh, the act got tighter, and the crowd got crazier. In the years that followed, Dr. MegaVolt conducted the arcs while bouncing on a trampoline, with a drummer and topless go-go dancers keeping time in wire cages. He hosted an installation called the Cult of St. Elmo, and about two hundred people (INCLUDING AUSTIN'S MOTHER) got to stand in a cage while it was

Z*Z*Z*Z*Z*Z*Z*Z*Z*Z*Z*Z* | **over and over**
za*za*za*za*za*za*za* | **by the arcs of**
zappppp*pp*pp*pped | **electricity.**

214

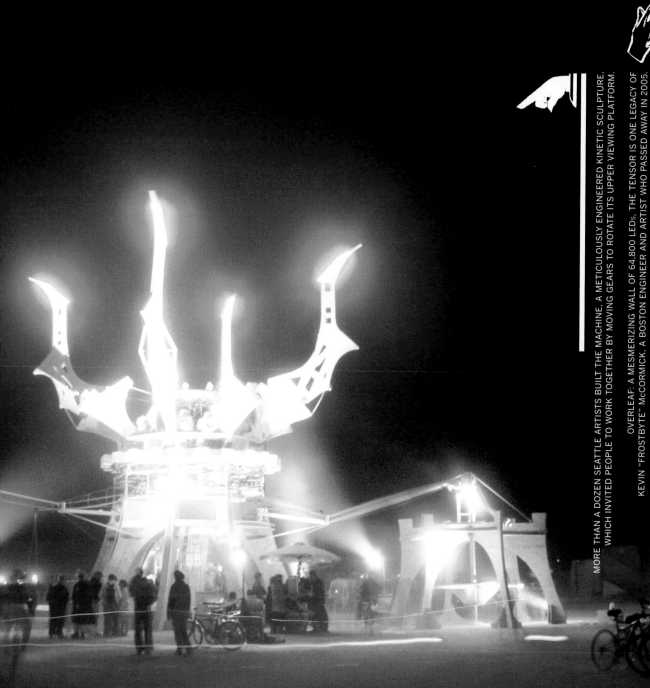

MORE THAN A DOZEN SEATTLE ARTISTS BUILT THE MACHINE, A METICULOUSLY ENGINEERED KINETIC SCULPTURE, WHICH INVITED PEOPLE TO WORK TOGETHER BY MOVING GEARS TO ROTATE ITS UPPER VIEWING PLATFORM.

OVERLEAF: A MESMERIZING WALL OF 64,800 LEDs, THE TENSOR IS ONE LEGACY OF KEVIN "FROSTBYTE" McCORMICK, A BOSTON ENGINEER AND ARTIST WHO PASSED AWAY IN 2005.

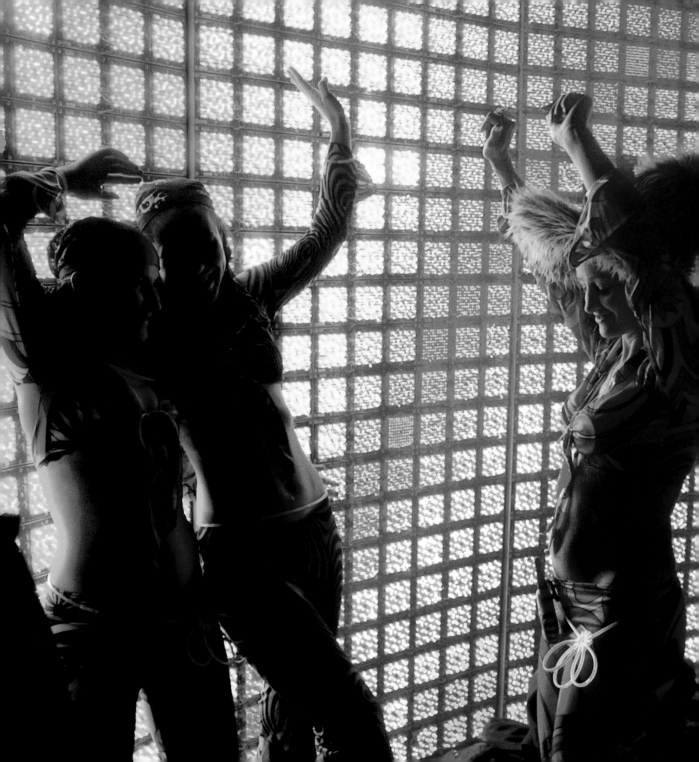

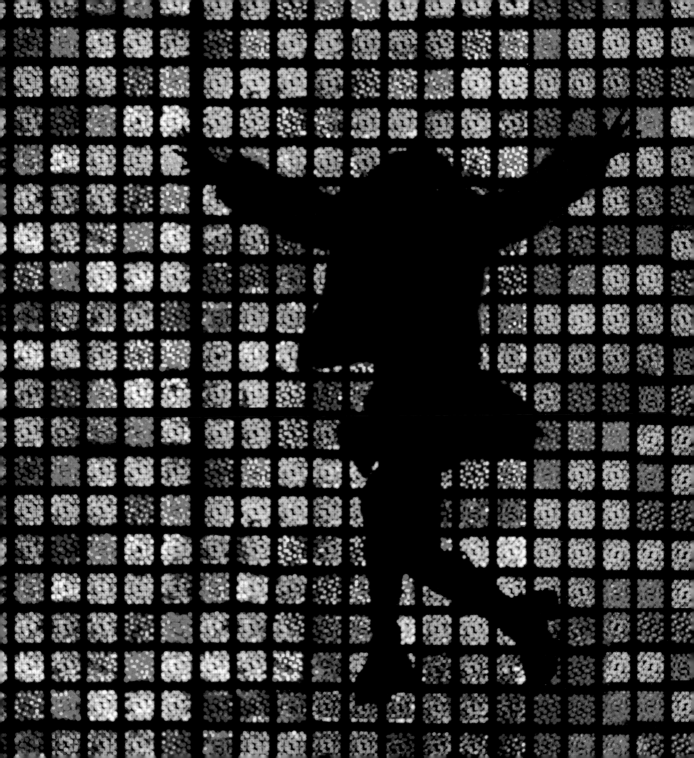

BEYOND THE DESERT,

Dr. MegaVolt ended up on television in America and Europe. He had a stint as a pitchman, performing in a television commercial for the Sizzler restaurant chain. (SOME OF HIS BURNING MAN GROUPIES COMPLAINED ABOUT HIM "SELLING OUT." AUSTIN REMEMBERS HIS REACTIONS: "IT'S MINE AND I CAN DO WHATEVER I WANT WITH IT," AND "WHAT'S WRONG WITH SIZZLER, ANYWAY?")

Austin currently lives in Santa Barbara, where he works for a company that makes thermal imaging cameras. He's more accustomed to laboratory life than the social glow of showmanship, making Dr. MegaVolt an unlikely alter ego. "I'm kind of a hero at work," he says, laughing. "The engineers really dig it." But not in the same way the burners do. Austin remembers the overwhelming reaction when MegaVolt first roamed the playa on a mobile stage in 2000.

"I put on the suit and got on top of the truck and we started driving. I really have never seen such a reaction from people, because everybody who heard it and saw it started following the truck, hundreds of people. It was a huge, huge crowd. They were cheering and carrying on," he recalls. And the adulation didn't end when the show was over: Dr. MegaVolt had become a **FESTIVAL ICON.** "What's nice about it is people show you their best side," says Austin.

❝ PEOPLE INVITE YOU TO DO STUFF. COME TO MY PARTY, & COME DO THIS. COME DO THAT, they put their best foot forward, AND THAT'S A NICE THING.❞

Sometimes they even serenade him. MegaVolt has a theme song, composed by the Mutaytor, a thirty-member band and performance troupe from Los Angeles that got its start at Burning Man. The lyrics offer some funky homage:..........

220

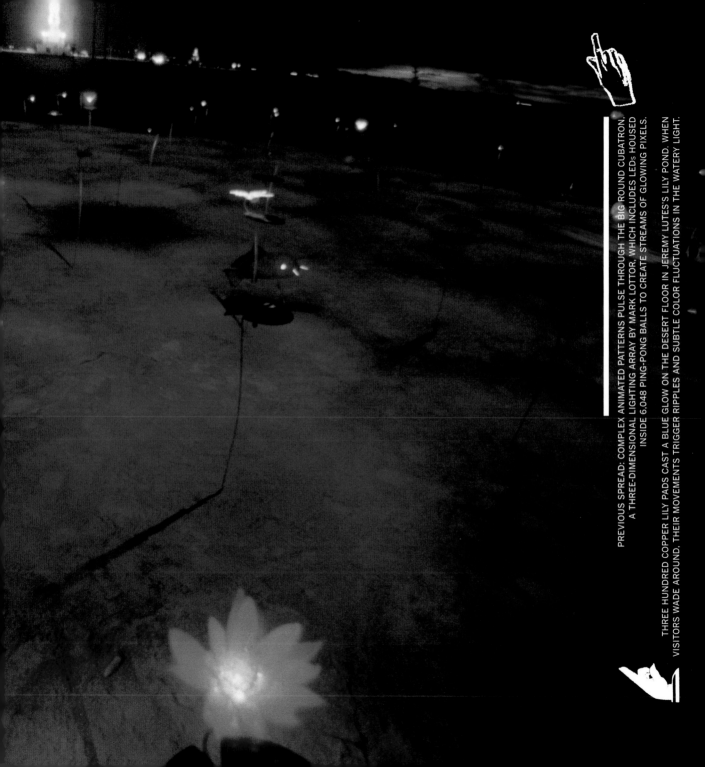

PREVIOUS SPREAD: COMPLEX ANIMATED PATTERNS PULSE THROUGH THE BIG ROUND CUBATRON, A THREE-DIMENSIONAL LIGHTING ARRAY BY MARK LOTTOR, WHICH INCLUDES LEDs HOUSED INSIDE 6,048 PING-PONG BALLS TO CREATE STREAMS OF GLOWING PIXELS.

THREE HUNDRED COPPER LILY PADS CAST A BLUE GLOW ON THE DESERT FLOOR IN JEREMY LUTES'S LILY POND. WHEN VISITORS WADE AROUND, THEIR MOVEMENTS TRIGGER RIPPLES AND SUBTLE COLOR FLUCTUATIONS IN THE WATERY LIGHT.

**.................WHO is the MAN with the LIGHTNING in his hands /
FROM the GIANT TESLA COIL that he COMMANDS?
HE'S the bad MOTHERFUCKER
called MEGAVOLT."**

How often does a geek get to be a bad motherfucker? In the desert, often. Dr. MegaVolt is one of many technology experts who strut their stuff on the playa, seduced by wide-open space and an appreciative audience, despite the suboptimal laboratory conditions of circuit-frying dust and rough weather.

Hedley Davis, a Microsoft hardware engineer who works on the Xbox 360 game console, created a massive light installation, longer than three school buses parked end to end, to bring to Burning Man for the first time in 2004. Called *ALIEN SEMAPHORE,* the installation included a dozen eight-foot-long arms of fluorescent tubing, which swiveled on their mounts, thirteen feet from the ground, to inscribe bright line patterns in the sky. Viewers could change the patterns by pressing cryptic glowing buttons on a control panel. "I never really did 'art' before, although I really did like intelligent lighting as applied to large rock-'n'-roll touring acts," Hedley explains. "I had hours of fun myself, anonymously watching others play with it and seeing what parts of my user interface worked, and what didn't."

In 2002 Oakland artist Jeremy Lutes created a **"pond"** of nearly three hundred circuit-board lily pads, which stood knee high and projected a blue, watery glow down to the desert floor at night. When visitors stepped between two of the pads, sensors registered the disruption and passed a ripple through the entire lighting grid, as if someone had waded into the blue-lit lagoon, disrupting its still surface.

Other artists create digital instruments that play tones in response to movement, or sculptures that react to the sound of voices with lights and color. They build robots that fight, and make jet engines that belch out a deafening din. Hundreds of people make glowing outfits and displays out of electroluminescent filaments called EL wire. Strands of EL wire come in more than a dozen colors; powered by batteries and pocket-size inverters, they glow and blink with the intensity of neon, but without generating any of that medium's heat. The most ardent EL wire fans create animated line drawings. Like pictures in a child's flip book, the images flash past in rapid succession to form butterflies with flapping wings, schools of swimming fish, or horses that appear to gallop through the night.

Some of the technology at Burning Man is simple and playful, based on ordinary objects that have been creatively repurposed. You might get chased by a roving tumbleweed, which is buoyed along by a remote-controlled toy car. You might encounter a rewired phone booth that invites you to **"talk to God."** Pick up the receiver, and God—ANOTHER DESERT REVELER, TAKING CALLS FROM THE OTHER END OF A HIDDEN LINE—will answer all your questions, or mock you, or demand some pizza.

The tech-art trend took hold in the mid- to late 1990s and is still gathering momentum, turning nerds into heroes each summer. Austin is proud that Dr. MegaVolt has been a part of the event's evolution; he puts it succinctly: **"I THINK**
people would have gotten
B O R E D
[with Burning Man] IF IT WAS ONLY ABOUT
BONFIRES AND **DRUM CIRCLES**
AND, YOU KNOW, RUBBING YOURSELF
WITH MUD."

HE SIGHS.
"I thought
IT WAS ALL ABOUT THAT
IN **'96.**
There was way too
much of that. **"**

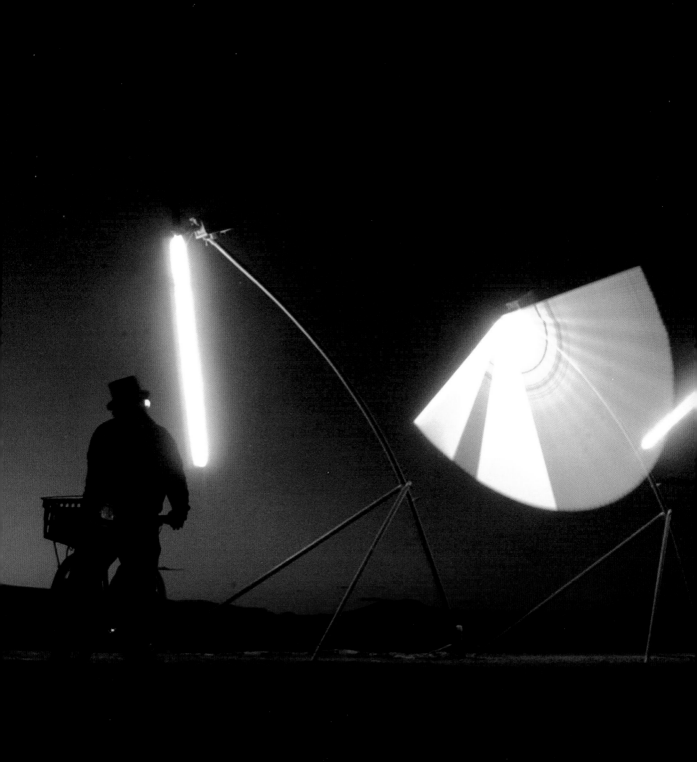

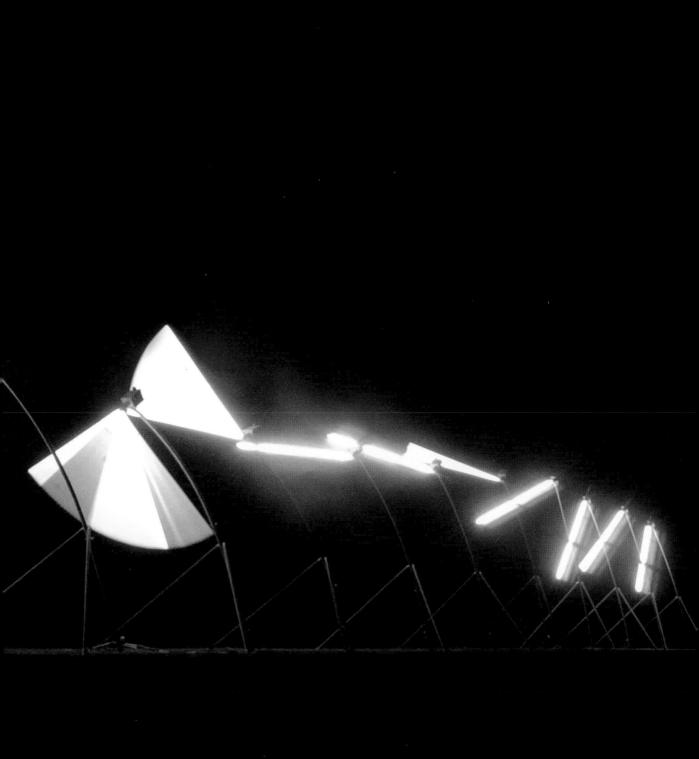

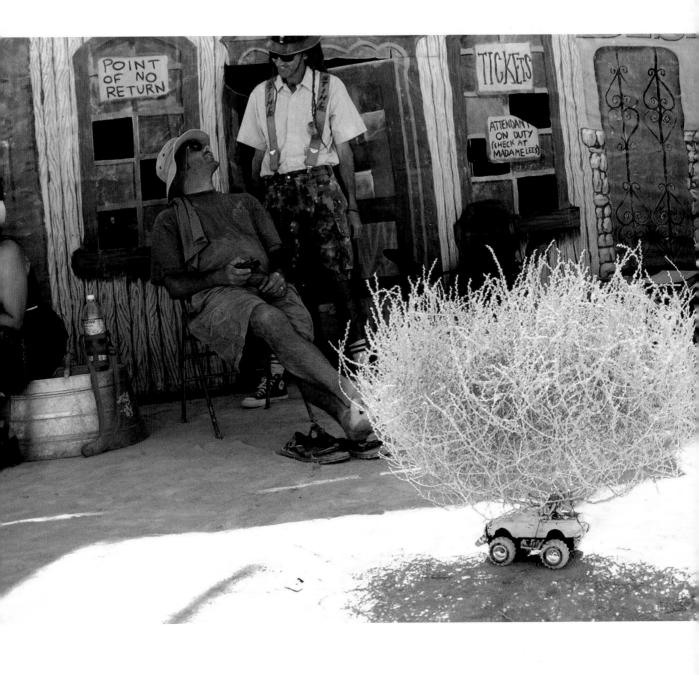

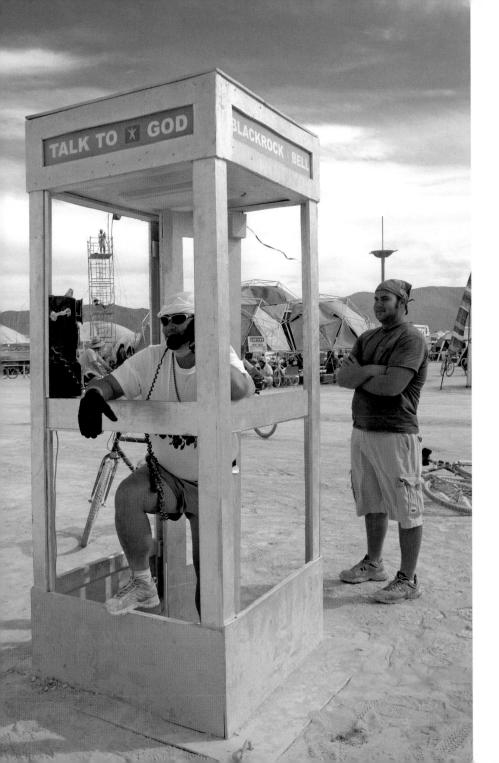

OPPOSITE: CAMP DISMAL'S REMOTE-CONTROLLED TUMBLEWEED IS THE PERFECT ACCESSORY FOR CHASING OFF BANDITS AND CATTLE RUSTLERS.

THE TALK TO GOD PHONE BOOTH OFFERS STRANGE COUNSEL.

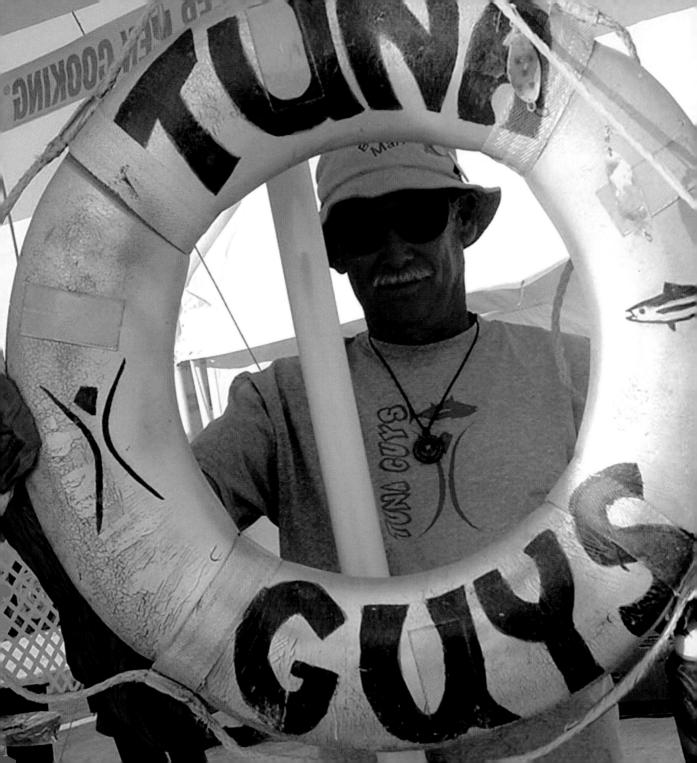

CAPTAIN REVERSE

THE TUNA GUYS' CAMP
is nothing fancy. When no one is home, you can walk
right past the white vinyl carport and the hanging
shade tarps, the skinny strip of AstroTurf, the beach
chairs and collapsible tables, and not really see the
place at all. There are few distinctive markings, apart
from some decorative O-ring life preservers (THE "MAN
OVERBOARD!" KIND), a strip of yellow caution tape (THE
WARNING READS DANGER MEN),

and a
crepe paper
fish or two.

CAP'N JIM PETERSON, A FISHERMAN
FROM COOS BAY, OREGON, HAULS
OUT THOUSANDS OF POUNDS OF
FRESH TUNA EACH YEAR TO FEED
HUNGRY PLAYA CAMPERS.

But when the propane hisses on and heat starts shimmering off the barbecue, the camp is *Transformed* **and rich scents** D R I F T *into the street like spells.*

This is how the myths, the ones about the best-fed corner of Burning Man, begin:••

SOME NUT *HAULED a BUNCH of* **F I S H** *OUT to the* **desert.**

NO, *NOT JUST a BUNCH...* **3/4 OF A TON.**

IT WAS **tuna,** *∗albacore tuna∗* hooked off the southern coast of **OREGON** AND THERE MUST HAVE BEEN ENOUGH TO FEED A THOUSAND PEOPLE.

THEY CAUGHT IT **A L L** *themselves* **and hauled it here, and** **COOKED IT.**

A **GUY** WAS SLICING **SASHIMI,** doling out morsels with a pair of long **chopsticks.**

They were just *GIVING IT* **ALL** **away.**

In Black Rock City rumors waft like cooking smells from one camp to the next; no one knows where they started, and whether or not they're true. That's how some people have heard about the Tuna Guys. The luckier ones have learned firsthand and shared a meal with them.

In nearly ten years at Burning Man, the Tuna Guys have **caught, filleted, iced, hauled, grilled,** and **served** several tons of tuna loins in the desert. They have barbecued their tuna, marinated it in the milk of young coconuts, wrapped it with bacon, stuffed it in tacos, and cut it into pieces of sushi. Usually they have some salmon around too, and shrimp that gets folded into quesadillas with Tillamook cheese, and around ten gallons of fresh-picked Oregon blueberries for making blueberry pancakes, which go nicely with the elk burgers the Tuna Guys like to cook up for breakfast.

CAPTAIN REVERSE

Led by sixty-three-year-old Jim Peterson, or Cap'n Jim, the desert smorgasbord has filled thousands of bellies, making the Tuna Guys minor heroes in a place where the culinary median is a pot of instant ramen. But none of the guys were looking for that kind of peculiar local fame. They ended up at Burning Man by chance, in a last-ditch effort to salvage a bad summer, with no idea of what they might find. Their story began with a little hard luck and a whole lot of fish.

August of 1998 was a terrible time for tuna men in the Pacific Northwest. A strong fishing season spurred by El Niño should have been good news, but it happened to coincide with an economic crisis in Japan, which pushed new competitors into the American tuna market. The yen was sinking, and Asian fishing fleets turned their attention to catching albacore, which they could sell to canneries that paid in American dollars. Before long, those canneries bought all the fish they needed, and a global tuna glut ensued. Ports along the Oregon coast were hit particularly hard. Albacore boats languished at the docks, sitting heavy in the water with holds full of surplus fish. Tuna was like water. You just couldn't sell it. You could hardly give the stuff away.

Jim Peterson, an independent fisherman in Coos Bay, was stuck with his own orphaned catch. He had to get rid of the fish somehow, and a friend's roommate had been talking nonstop about a huge party out in the Nevada desert, passing around photographs he'd taken there the year before. There were some wild scenes, folks slathered from head to toe in mud, cavorting gleefully as if they'd never been in the middle of such a delightful mess.

"It looked like they were having such fun," Jim recalls warmly. Besides being a good time, that kind of running around must build an appetite, and mud-people had to eat, just like everyone else.

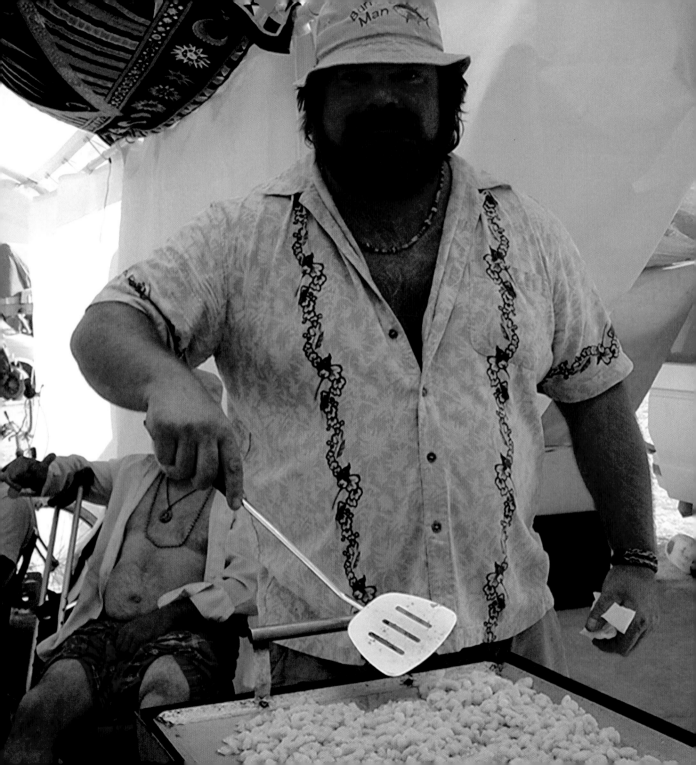

MAYBE THEY WOULD BUY HIS TUNA **It was worth a try.** Jim shared the idea with his friends, and three of them decided to come along: a massage therapist named Byron, a welder named Wally, and a tugboater named Knute, who was also a former deckhand on Jim's boat, the **Alice M.** They filleted all the tuna. When that was done, they had 1,300 pounds of loin meat. They sealed the fish in doubled-up Ziplocs, then loaded everything into a U-Haul trailer lined with solid foam insulation and packed with ice.

"We thought we were going to sell some, and if we didn't sell it there, we were going to take it to Reno and make some money somehow," Jim says. So they set off on the road to the Black Rock Desert:

FOUR men, FOUR HUNDRED FIFTY miles, & ONE overstressed trailer full of FISH.

When they passed through the gates of Burning Man, they didn't have a plan for pitching camp. The Oregon Country Fair folks had some space left, and even though it wasn't much more than an alleyway, the Tuna Guys took it. There they built a cramped, ramshackle encampment with old tents, tarps, duct tape, and a couple of shovels. They stuck a crooked silver tuna sign on a post and planted it in the ground, pointing to their site; without it, their desert hovel would have been invisible. As they settled in, they hit it off with their neighbors, the *PIÑATA FUCKERS CAMP,* who billed their attractions as

"A heavy petting zoo WHERE CAGED PIÑATAS CAN BE HAD LIKE LITTLE WHORES, AND A live piñata peep booth FEATURING THE HOTTEST, HORNIEST LITTLE CRITTERS THIS SIDE OF TIMES SQUARE."

JEFF BULL COOKS UP A BATCH OF SHRIMP FOR THE TUNA GUYS' FAMOUS QUESADILLAS.

THE PLAYA ♥PROVIDES♥

There were some unusual folks at Burning Man, to be sure. When the Piñata Fuckers were not performing **STRANGE AND SALACIOUS SKITS,** they served daiquiris. As they began to acclimate, the Tuna Guys realized that their first plan, selling fish, would be a flop. Vending was against the rules at Burning Man, and bad etiquette, too. So once they were done unpacking, they began a marathon barbecue session, feeding their eccentric neighbors, who turned out to like tuna as much as they liked piñatas (THOUGH NOT IN THE SAME WAY). They fed anyone who wandered by. They sent a few pieces of tuna over to one of Burning Man's low-wattage radio stations and, after a host praised the **❝Tuna Guys❞** (A NAME THAT STUCK) over the air, people started looking for them. Not many people found their tiny camp, but the ones who did—some folks from Ashland, Oregon, and a gaggle of fire-dancers from a San Francisco troupe called *EL CIRCO*—became fast friends.

BY THE **END** OF THE **FESTIVAL...** THE **TUNA GUYS** HAD GIVEN AWAY **hundreds** of **pounds** of **FISH** & & & & & & & & & & & & HAD A **ROLLICKING** GOOD TIME.

There was still some left over, so they cruised through Gerlach and unloaded the rest of their catch at a VFW picnic. It was too much to eat on the spot. Word spread, and soon eager locals were showing up to collect the leftover tuna loins and cart them home for canning. Finally Jim and his friends drove back home to Oregon with an empty trailer.

Since then, the Tuna Guys haven't missed a year. Burning Man is a great party, but it's also become

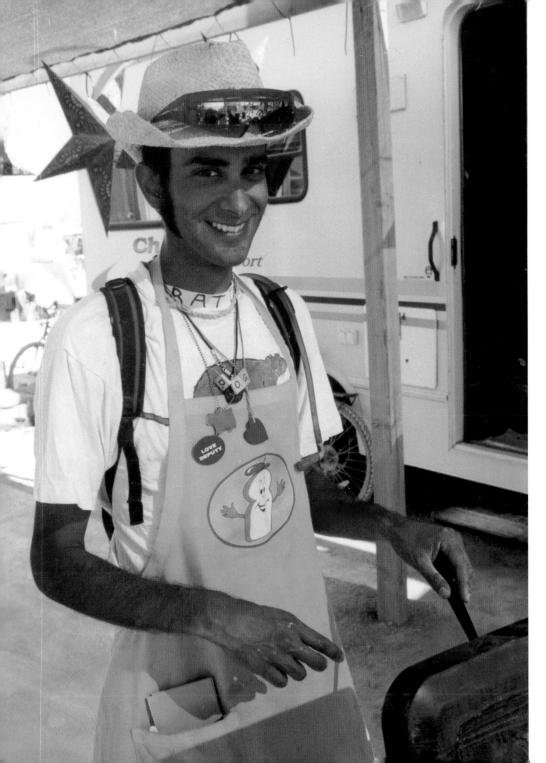

something more to them. When Jim's son, Alden, first came along in 2003, he fell in love with a woman named Amber from Salt Lake City on the very first night. The two were riding around on the Chaos Car, a Volkswagen bus with a seated bar and propane cannons. They became incurably smitten and later decided to marry. Now more than forty people camp with the Tuna Guys, including Jim's wife, Betty.

The Tuna Guys, and their extended cooking crew, are not alone in feeding absurdly large numbers of people at Burning Man. The playa is a place for sharing gifts, and no one can resist a bit of home cooking. Most mornings there's a long line trailing out from the **PANCAKE PLAYHOUSE,** which foists flapjacks (AND SOFT ROCK MUSIC) on all comers. Louder pancakes are served the morning after the Man burns, when the denizens of **CAMP CARP** hold a bruising affair called **BLACK SABBATH PANCAKE BREAKFAST.** They blast heavy metal and build the **RAMP OF DEATH,** a small (BUT HAZARDOUS AND SOMETIMES FLAMING) bicycle jump for anyone who thinks danger makes a better condiment than syrup. **PORN & EGGS** is a camp that offers just what it says. **THE LOST PENGUIN** has wine and Belgian chocolates; the **PLAYA-Q** barbecues more than two tons of food and makes legendary pulled pork sandwiches; the **PIZZA SLUTS** bring a solar oven and surprise people with special deliveries. A place called the **GUT HUT** appeared on the playa at least once, dishing out tripe to brave gourmands with the cheerful slogan **❝Happy entrails to you.❞** **FREEZING MAN,** an ice-cream truck with dancers on the roof, has handed out ice-cream treats while pumping out techno versions of tinny ice-cream truck tunes. Ben Cohen, of Ben & Jerry's ice cream, and his campmates once hand-grated hundreds of potatoes and onions (AFTER THEY ACCIDENTALLY LEFT THEIR FOOD PROCESSOR AT HOME) for potato pancakes, which they served to anyone who walked past their **LATKE PALACE.**

Food is a popular gift, but its popularity can cause problems. The Tuna Guys have found trouble on the playa since 2000, when officials from the Nevada health department shut them down, demanding to see a food service permit. Since then, the Tuna Guys have kept a low profile. To keep from violating state law, they must cook for special events and camp members only.

"We didn't violate any rules," Jim says impishly. "Although there was quite a few people who claimed to be camp members." In other words, the Tuna Guys' camp turned into a seafood speakeasy.

Even without visits from the health department, the Burning Man trip can be a headache. "We don't drive new pickups that can haul the fish," says Betty, Jim's wife. "We try to patch our old vehicles, our vans, and our Volkswagens on the way there. Every year we go, somebody breaks down." Back in 2004 they spent a whole day stuck in Grants Pass. They stalled a second time, too, thanks to a faulty fuel system on a borrowed, rattletrap pickup truck. "There was talk of abandoning the fish," Betty recalls. "Jim says, 'Well, I'm not leaving the fish,' and I go, 'Well, I'm not leaving Jim.'" And that was that. "My God, those fishermen worked on the truck in the parking lot of a restaurant in Klamath Falls, all night, all day," Betty says with a laugh. Finally they were on the road again.

But the biggest disaster came the next year. It made the national news and earned Jim a new nickname: **CAPTAIN REVERSE.** Jim was eighty miles off the coast of Newport with a deckhand, Jeremy Welsh, catching tuna for Burning Man in his beloved boat, the **Alice M.** The boat was an old thirty-eight-foot, double-ended troller, built in 1940 and used for shark liver fishing after World War II, then wrecked and salvaged before Jim bought it. Today she was in a bad mood. The transmission seized, and

this coupon is redeemable for **one tasty treat** from the roaming Freezing Man ice cream truck, while supplies last.

FREEZING MAN

one coupon per person. valid until 2pm on Sunday. after that, the remaining ice cream will be given away first-come first-served.

Black Rock Psyche-atric

Dr. Noise E Piranha, D.BS.
Corrupting the Playa since 2003

PATIENT NAME		DATE
PRESCRIPTION		REFILLS

Please don't let this hit the ground! Event photos + contact @ www.NoiseEPiranha.com

when Jim got it working again, it would only engage in reverse. Instead of radioing the coast guard for a tow, he charted a course for Newport—backward. The ordeal took thirty-nine hours, and when the **Alice M.** finally docked, the story began to spread. "It was odd, watching the wake roll out the front windows; like watching a movie in reverse," Jim told the **REGISTER-GUARD** of Eugene. The tale got picked up by the Associated Press and was read all over the country.

While everyone was buzzing about his strange accomplishment, Jim had something else on his mind. His boat was out of commission. It was already mid-August, and there was no way he'd be able to catch enough fish to keep up his Burning Man tradition. When that news went out over the Internet, burners chipped in to help. They raised a total of two thousand dollars, enough money for Jim to replace the **Alice M.**'s transmission and buy a last-minute haul of tuna from other local fishermen.

"I just can't say enough good about 'em," raves Richard Jones, a campmate from Santa Cruz who has made several visits to see the Tuna Guys in Coos Bay. "These people out there are poor," he says. "To give as much as they give, it just puts me to shame, and anybody else I know too. What they do, and how much they give of themselves from so many different directions, is just amazing."

Cap'n Jim has his own way of looking at it. "We're unlikely folks to be at an art celebration, although we certainly do appreciate it and we try to bring our art in our own way," he reflects. "But it's kind of unlikely. Because we're just fishermen, you know."

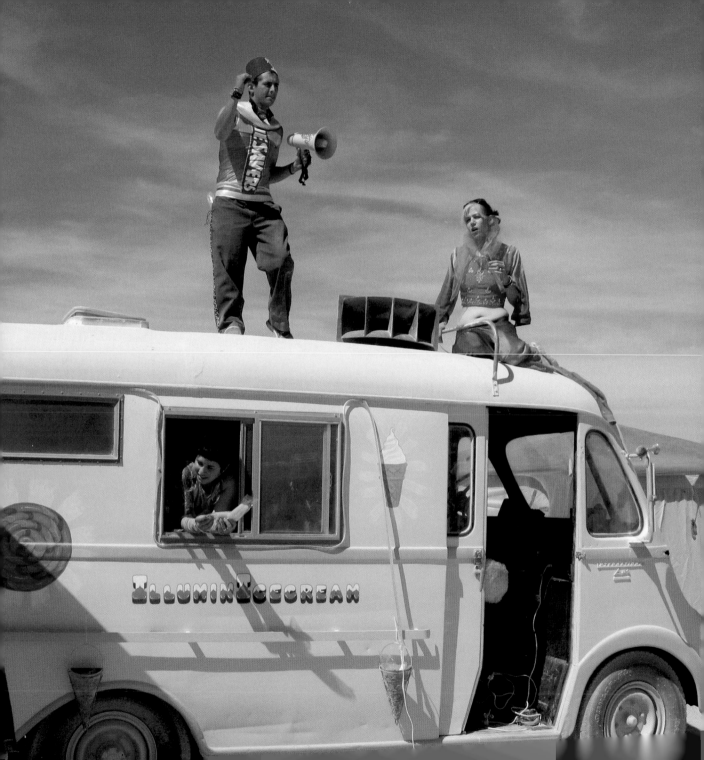

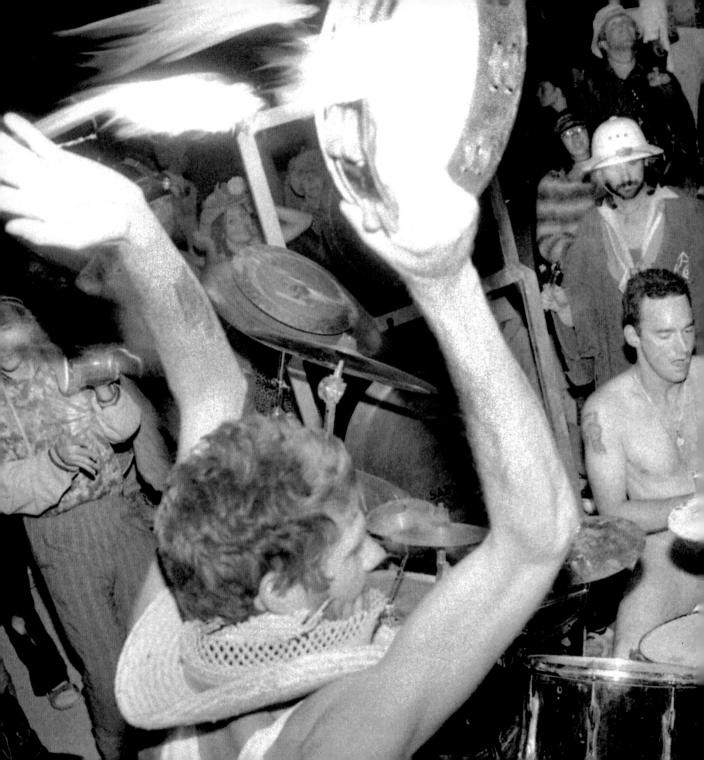

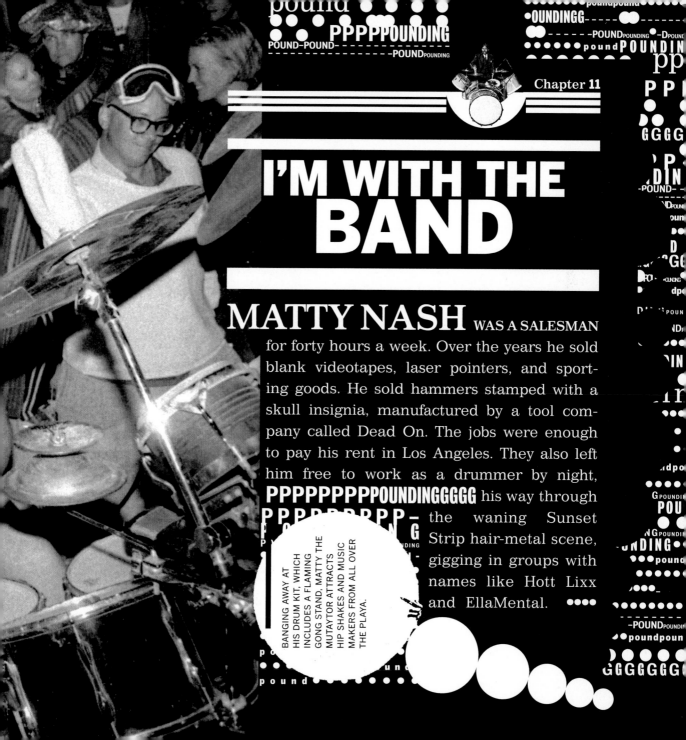

I'M WITH THE BAND

MATTY NASH WAS A SALESMAN

for forty hours a week. Over the years he sold blank videotapes, laser pointers, and sporting goods. He sold hammers stamped with a skull insignia, manufactured by a tool company called Dead On. The jobs were enough to pay his rent in Los Angeles. They also left him free to work as a drummer by night, **PPPPPPPPPOUNDINGGGGG** his way through the waning Sunset Strip hair-metal scene, gigging in groups with names like Hott Lixx and EllaMental.

BANGING AWAY AT HIS DRUM KIT, WHICH INCLUDES A FLAMING GONG STAND, MATTY THE MUTAYTOR ATTRACTS HIP SHAKES AND MUSIC MAKERS FROM ALL OVER THE PLAYA.

Matty had grown up in Chicago and performed in a bunch of Midwest punk bands before moving to L.A. in 1990. On the West Coast, the life of a merchant musician kept him busy, but he wanted more. "I just kind of was fed up with the scene, fed up with the sounds that were going around," he remembers. "I didn't really have my own musical identity." More than a decade later, at the age of thirty-seven, Matty doesn't come across like a grizzled veteran of the punk and metal days. He's still a drummer, but a new band has claimed him. ●●●●●●●●●●● ● ●●●●● ● It's ...a weird and ... well-oiled... ... MACHINE, ●●●●●●●● ●● A NEOTRIBAL RAVE-MEETS-VAUDEVILLE AFFAIR. That... Band... Was... Born... At... Burning... Man,... And... He... Calls... It The **MUTAYTOR.**

Matty sits at the helm of a thundering corps of percussionists, who batter away at a collection of more than four dozen fluorescent green drums. He has a young, eager face that glazes over while he plays, mouth agape, eyes fixed in the distance. He conducts rhythm changes by tweeting on a silver whistle like a gym coach. When the rhythm section is really heating up, he flashes an electric grin. The beats settle into a steady pulse, which propels an eclectic and enthusiastic cast of performers.

There Are KNOB-TWIDDLERS, TENDING LAPTOP COMPUTERS that SPIT OUT BREAKBEATS &&& INTERMITTENT JAGS of ELECTRONICA.
There Are FIRE-SPINNERS &&&& FIRE-BREATHERS.

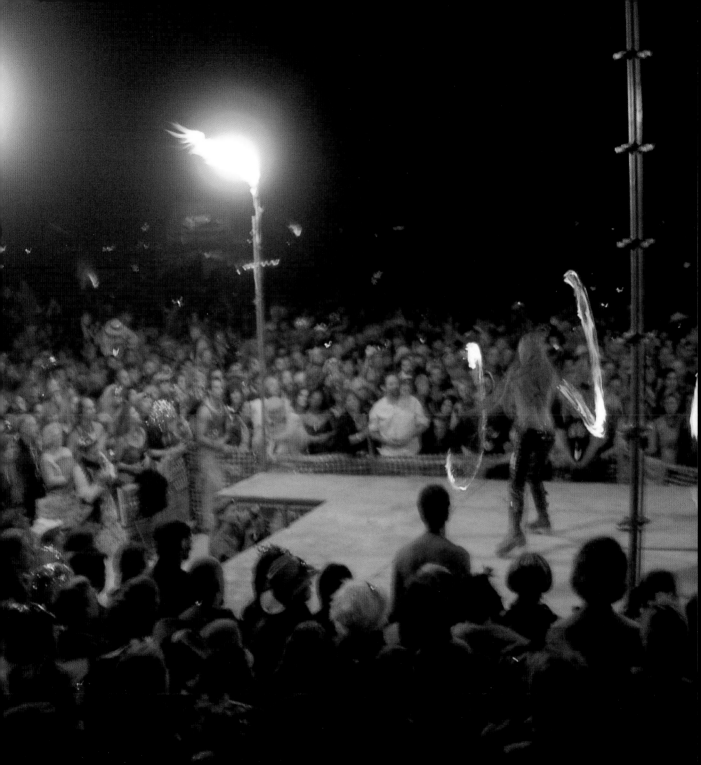

There Are DANCERS with HULA HOOPS ORBITING THEIR HIPS.

Aerialists DANGLE from the RIGGING &&&&&&& SWING LIKE HUMAN PENDULUMS.

A Green Chinese Lion——THEY CALL HIM PICKLES———TROTS OUT for COMEDY &&& BATS HIS AMPLE EYELASHES.

Sometimes THERE'S A GUY with a FLAME-THROWING ELECTRIC GUITAR,

And OCCASIONALLY DR. MEGAVOLT JOINS the RUCKUS.

WHEN THE SHOW settles into a THUMPING HULLABALOO, the audience chants a SIGNATURE CHEER:

" HOLY FUCKING SHIT ⬤!!⬤!!⬤!!⬤ "

That mantra, along with the Mutaytor itself, first rose from the denizens of Burning Man. Merry instigators traipse through the crowd, encouraging wallflowers to shake their hips. The Mutaytor has around thirty members, but sometimes they mesh so tightly with the audience that it's hard to tell.

In the beginning, back in 1998, Matty showed up in Black Rock City with a flame-throwing drum kit and plans for a solo show. His contraption had a foot pedal near the bass drum that triggered big propane bursts from a metal frame,

I'M WITH THE BAND

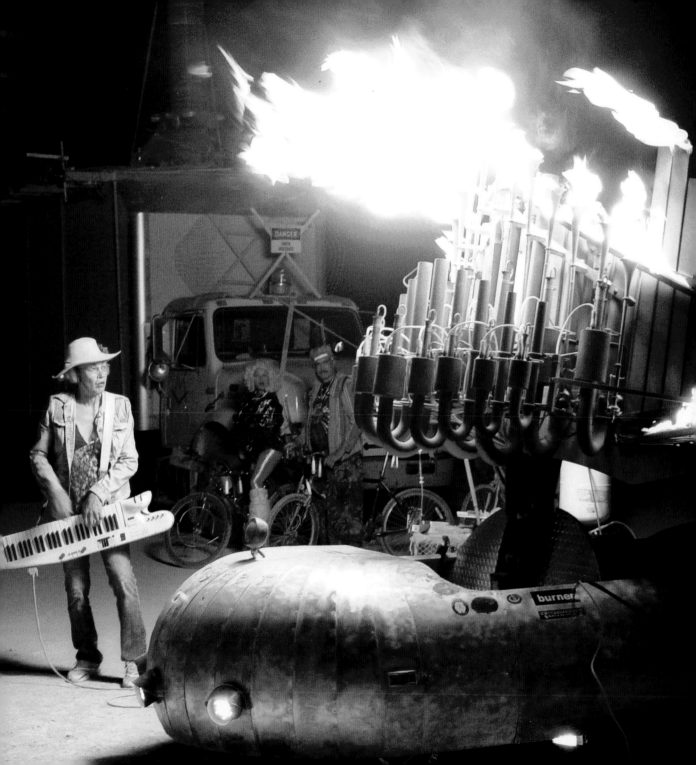

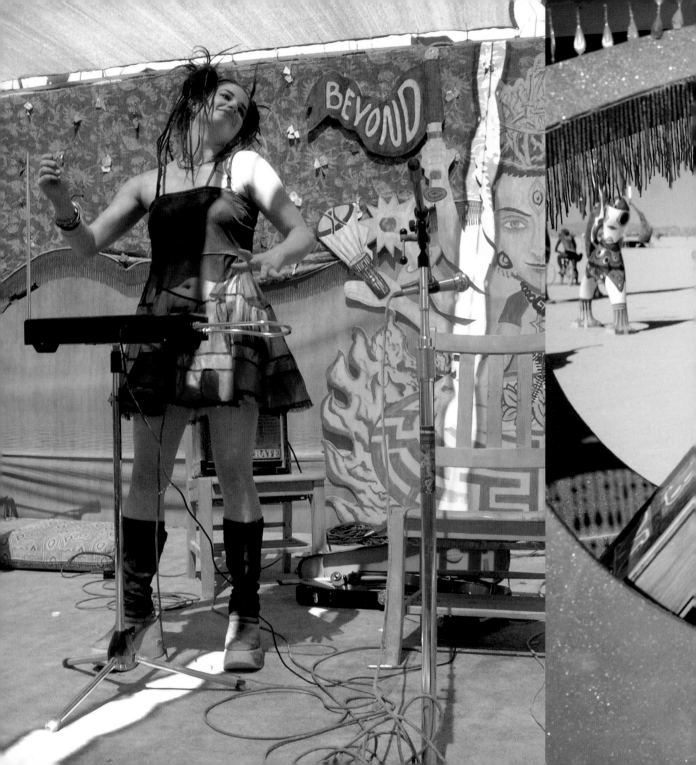

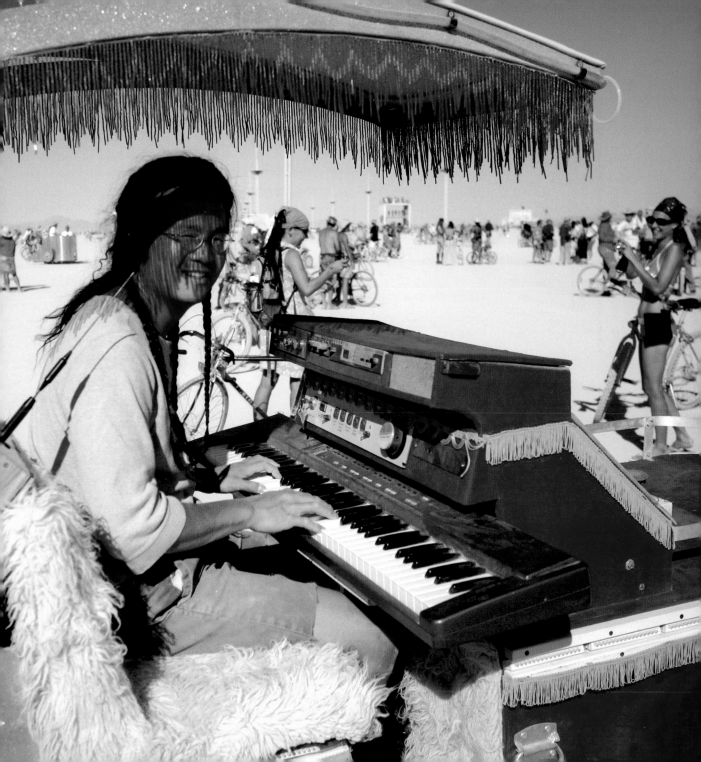

PREVIOUS SPREAD (LEFT): ONSTAGE AT CENTER CAMP, MEREDITH YAYANOS BLISSFULLY COAXES A TUNE FROM THE THEREMIN, AN EARLY ELECTRONIC INSTRUMENT KNOWN FOR ITS HAUNTING VIBRATO.

PREVIOUS SPREAD (RIGHT): TOOTLING AWAY ON A KEYBOARD, THIS CHEERFUL CHAP PLAYS OLD-TIME MOVIE MUSIC WHILE RAMBLING AROUND IN THE COMFORT OF HIS ART CAR.

DUST AND BRASS DON'T MIX: A TROMBONIST EMERGES FROM A DESERT WHITEOUT.

which held his collection of Chinese gongs. He knew he wanted to host a big performance and get people dancing. **GIGSVILLE,** the theme camp known for its Car-B-Q, had promised to let him use their stage. Other than that, he didn't know quite what to expect. When he hauled his equipment over to **GIGSVILLE** on the night the Man burned, the stage turned out to be an unglamorous ten-inch riser. It wasn't nearly large enough to hold his monstrous rhythm machine, but Matty was undeterred. He set up his drum kit in the dust, on a tattered piece of brown carpet, and sat down behind it.

"I started playing. I was naked, and it was one of those beautiful nights, practically a full moon, you know, and within moments this change started happening," Matty recalls. "People started dancing. People started clapping. You know, other drummers started approaching, *'Hey, can I jam with you?'* **'Of course.'** Belly dancers showed up. *'Hey, can I jam with you?'* **'Of course.'** Fire dancing started erupting right around me. A DJ was driving by on a mobile rig. *'Hey, can I lock in with some of the beats?'* And this thing, immediately, the very first time, just went······································

'POW!' IT EXPLODED.**"**

Matty had planned to play alone, but ended up in a wide, wild orbit of gyrating bodies and performers. He laid down a central rhythm, while other revelers riffed on it with drums and bells and turntables, arms, legs, and hips, whatever was at hand. The crowd's mutation blew Matty's mind. He dubbed himself Matty the Mutaytor and, over the next few summers, kept dragging his drums out to the desert for bigger shows. He played with a guy named DJ Satan at a camp called the SINdicate. He played with Dr. MegaVolt, clenching a pneumatic hose in his teeth to synchronize the Tesla coil's bolts with his beats. He played with

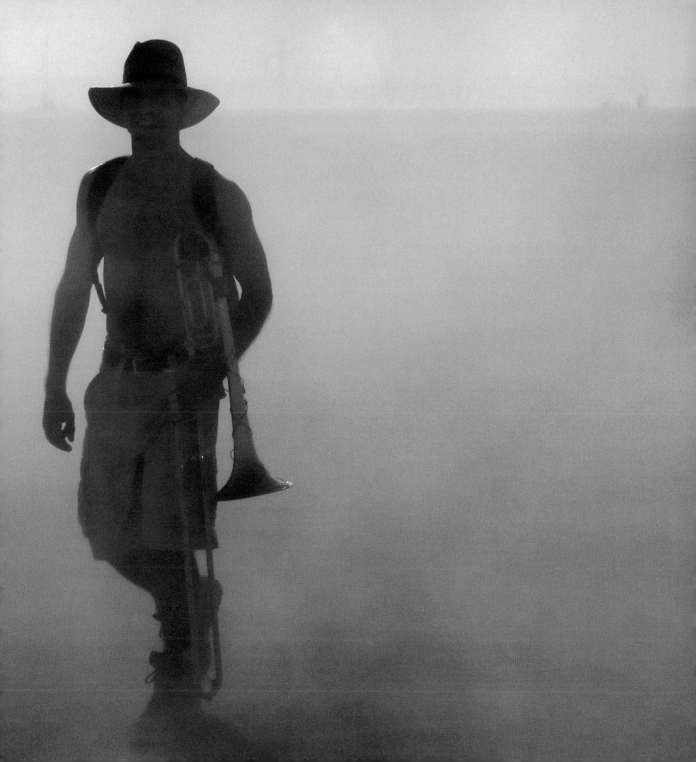

Christian Ristow, who had a homemade, five-thousand-pound roving robot claw and demolition machine, aptly named the **_SUBJUGATOR,_** which spat fire in time with the drums.

Some people who saw his show were drawn in for good. There was Buck A. E. Down, who caught a flying drumstick one night and joined shortly thereafter, mixing in electronic compositions that emanated from a purple iMac.

There was Brady Spindel, a junkyard percussionist and seasoned fire-breather, who learned the latter skill early in life to scare off schoolyard bullies ("I WAS ONE OF THREE PUNK KIDS IN A REDNECK TOWN," HE EXPLAINS). Most of the Mutaytor cast met in Black Rock City, but when the show started spilling into Los Angeles, other freaks were drawn to the flame. Andrea "Roo" Ruane, a union grip, endeared herself to the band by helping build and break down their stage at the Venice Carnival. She later became one of the group's principal fire-spinners. Hargobind Singh, a devout Sikh, joined with tabla drums and his jaal, a netlike weapon from northern India, which he modified with LEDs to spin in intricate patterns.

"I've seen a lot of big shows that claim to kind of blur the line between audience and performer," Matty declares. "The Mutaytor obliterates that line. Most of the people that are onstage were in the audience at one point saying, *I could do* **SOMETHING** LIKE THAT. **SOMETHING CREATIVE.**

A LOT OF THESE PEOPLE AREN'T PROS AT THEIR SPECIFIC AREA OF EXPERTISE."

Buck feels the same. When he joined the Mutaytor, he'd already experienced the limelight as a rock-'n'-roll front man, touring in a band called Combine, but he was more excited by the kind of

collaboration he saw growing at Burning Man. It felt more demo-cratic and less ego-driven than the commercial rock scene. "It's a do-ocracy," he says. "It's not necessarily the best ideas that get done. It's the ones that people actually have some sort of plan for making it happen, and know what they need to do and get it done and, generally speaking, that's how it happens." The Mutaytor's slogan, ••• ••••••••••••••••••••••••••••

" CHANGING CIVILIANS INTO ROCK STARS, " fits that model.

The belief that anyone, given the desire and drive, can be a superstar is very appealing. At Burning Man there are no "headliners" of the sort you can see at summertime megatours like Bonnaroo, the Warped Tour, or Ozzfest. Celebrities don't get free tickets. If they turn up, they're encouraged to be mellow and keep their heads down, so that amateurs won't shrink in the shadow of heavily produced acts. When Paul Miller, a popular turn-tablist better known as DJ Spooky, attended Burning Man for his second time in 2001, some people were worried he'd steal the show. He explains that he was subject to "paranoia on the part of the enforcers" and pursued by "a woman who was dressed like Pippi Longstocking, and she was like, 'DJ Spooky should not be able to spin, because he's a well-known DJ.'" She never caught up with him, though, and he spun an unobtrusive set at Xara, the camp

www.isthisthingon.com

that was leveled in a dust storm the year before. "I tend to think that they weren't sure if I was going to, all of a sudden, have MTV cameras flying in, or show up with Britney Spears." He laughs. "I just took it in stride. It was very amusing."

But what happens when a group that began at Burning Man gets big, and then departs? The Mutaytor played its last official Black Rock City gig in 2004—a theatrical blowout that cost twenty-five thousand dollars to produce. Depending on which band member you ask, the Mutaytor left the festival because it had gotten too expensive to outdo themselves each year, or because of "a little static" with the event's organizers. Yet life after Burning Man, back in the world of commerce, was kind to them. Matty dropped the last of his sales jobs in August 2003 to make the Mutaytor his full-time gig. The band later signed with Creative Artists Agency, the talent company that manages the likes of Steven Spielberg, Madonna, and Bruce Springsteen. They have jammed with former members of the Grateful Dead and Phish, and even Walter Cronkite, who tapped along on a floor tom during an Earth Day festival in 2006.

Not all of their old fans are psyched about the change. "There's a lot of people with a chip on their shoulder about the fact that we've become successful in the conventional sense of the word," says Buck. "As always happens with any underground movement, when you achieve a certain level of success, there will always be someone with some abandonment issue, or saying that you've sold out, or whatever." (In 2007 change would come more painfully to the group. Matty would make an unexpected televised appearance as the target of an Internet sex sting, and in an effort to distance that mess from the band he'd made, would step away from the Mutaytor. The band would vow to continue without him.)

STILL,

the Mutaytor can't quite abandon Burning Man. They've been playing regional offshoots of the festival, organized by burners across the country. They're also still addicted to the annual desert migration. The year after the Mutaytor officially left Burning Man, its members hijacked an art bus called the Garage Mahal and performed five stealth shows while touring the playa. Like the old days, there were no big stages and spotlights. Just dance, dust, and drums.

Buck suggests that the playa and the music biz aren't actually that different for the Mutaytor. "It's about the unlikeliness of making it happen, the feel-good nature of doing something with all of your friends, against all odds, and making it work in this utterly hostile environment," he says. ..

............... **"WE JUST** TRADED THE **P L A Y A** *—for the—* **music** **industry,** WHICH IS ABOUT AS **UNFORGIVING & BRUTAL** A PLACE TO DO A R T AS THE MIDDLE OF THE **D E S E R T,** REALLY. **"**

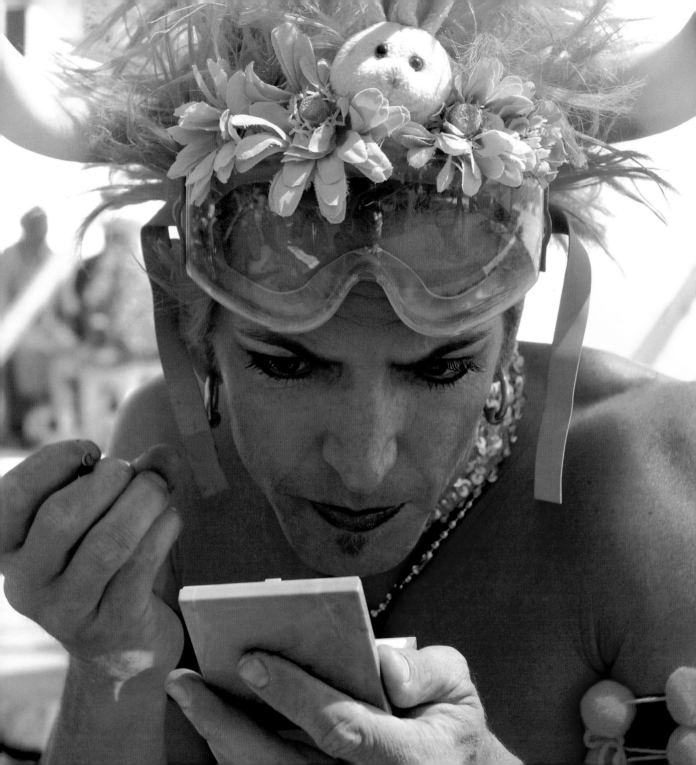

TRADING
FACES

"**NOW** WE HAVE SOMETHING from the other end of the spectrum, the primitive spectrum!" declares an announcer. "From one million B.C., or even earlier! Not only must she contend with the ravenous skeletosaurus and the gigantic blunderdon, but the sleazy attentions of Cro-Magnons and troglodytes on the playa.

Yet SHE IS **UNBOUND &&&& READY TO** show off the **LATEST** in NEOLITHIC WEAR."

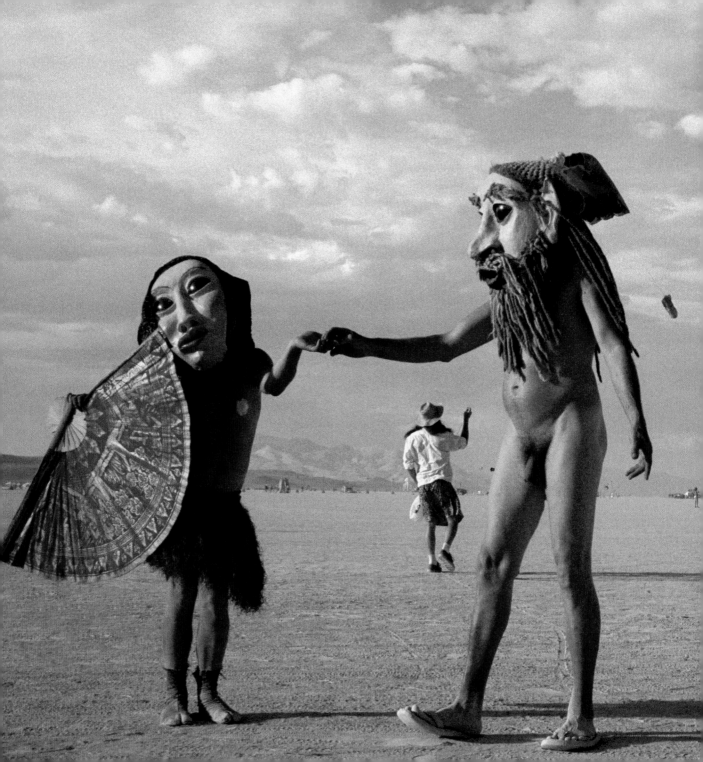

A woman in a shaggy wig, bone earrings, and a furry brown skirt saunters down the catwalk in Center Camp. She waves to the audience, and they greet her with hoots and applause. Hundreds of people have gathered to witness what the emcee—A FEZ-WEARING FELLOW NAMED DR. HAL—has just dubbed "the parade of pulchritude." This is the annual Burning Man fashion show, a tradition that began in 1992. Since then, it has emboldened would-be fashion plates to dress up like space aliens and sheiks; bumblebees, cowpokes, and Victorian aristocrats; obnoxious tourists, whirling dervishes, nuns, Dick Cheney, and even a can of Campbell's soup ("CREAM OF FUCK"). For some folks, being naked is a costume—it just doesn't have pockets. Other people dress in homemade garments created with unusual materials. You might see a frock fringed with tennis balls, an evening gown of rubber gloves tied together at the fingers, or a tailcoat made of wine corks.

"I was a little bit nervous about it at the time, waiting to get on the stage," says Keith Pomakis, a thirty-seven-year-old software developer from Ottawa. He had driven cross-country for three days to attend his first Burning Man in 2002. Somewhere between Iowa and Nebraska, he'd dyed his hair blue. Other accents were added before the fashion show: orange and black greasepaint, a patch of fake fur tied to his chest, fuzzy ears, and a long, tufted tail. He prowled down the runway on his hands and knees, in a trio of growling tigers.

Is he accustomed to being onstage?

" **N O .**
Not at all.
No. I don't . . . no, "
HE STAMMERS.

"So it was fun to actually do that. Probably just because of the type of environment Burning Man is, it's probably one of the few locations I'd feel comfortable trying something like that, which is part of the fun of it, being a little different."

Not everyone arrives at the fashion show ready to be a tiger, or a geisha, or a gargoyle. Some folks have left their finest threads at home. So every year, Annie Coulter, who runs the pageant, lugs out her own collection of sixty to a hundred outfits, along with a mirror, accessories, hangers, and a rolling rack. At home in San Francisco, Annie directs fashion shows with professional models in authentic couture. Here, she sets up shop backstage and waits for the frenzy to begin.

"They take skirts that I've carefully made to be part of an outfit, and wear them on their heads. They turn them inside out. The men will wrap them around like fake bras," she says, delighted. "That's one of the best things for me, to see what people do with what I've made. I let them go crazy on the rack."

She loves seeing introverts become divas, buoyed by support from the crowd. "A good audience will give you good energy, so there's an exchange," she explains. "It's not just you going up there with an excess of energy, saying, 'Look at me!' although that's certainly part of it. It's the audience saying,

'YOU'RE **COOL**, **WE LIKE YOU**, WE LIKE the WAY YOU **look**, WE'RE LAUGHING at YOUR **jokes**, **YOU'RE GREAT.'**

Her divas have come to appreciate that attention so much that, in recent years, Annie has had to employ a "hook," someone who escorts (or in some cases, carries) entertainers offstage. "They'll sit up

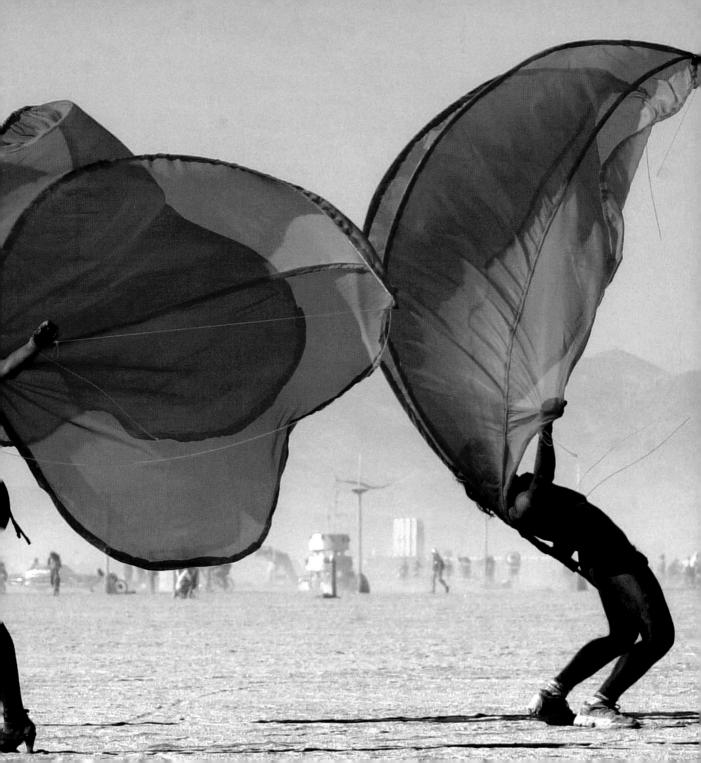

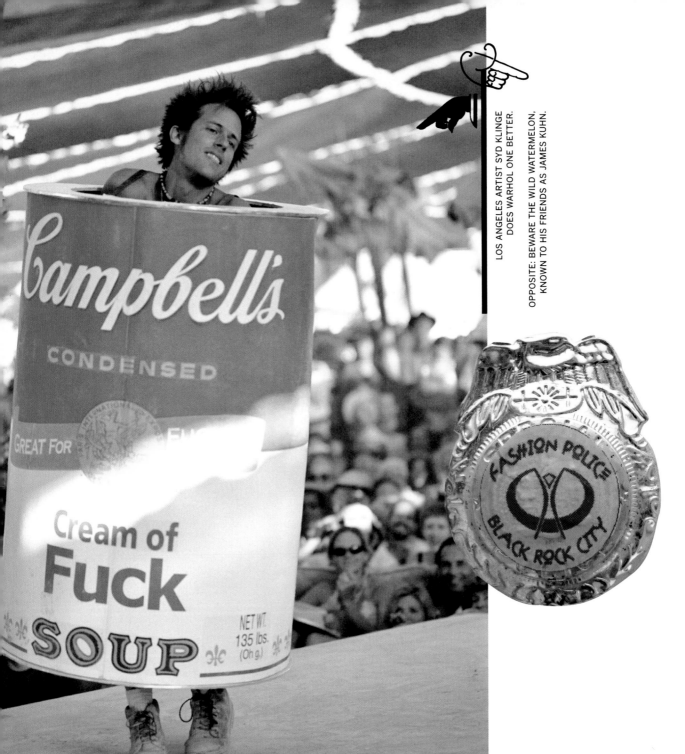

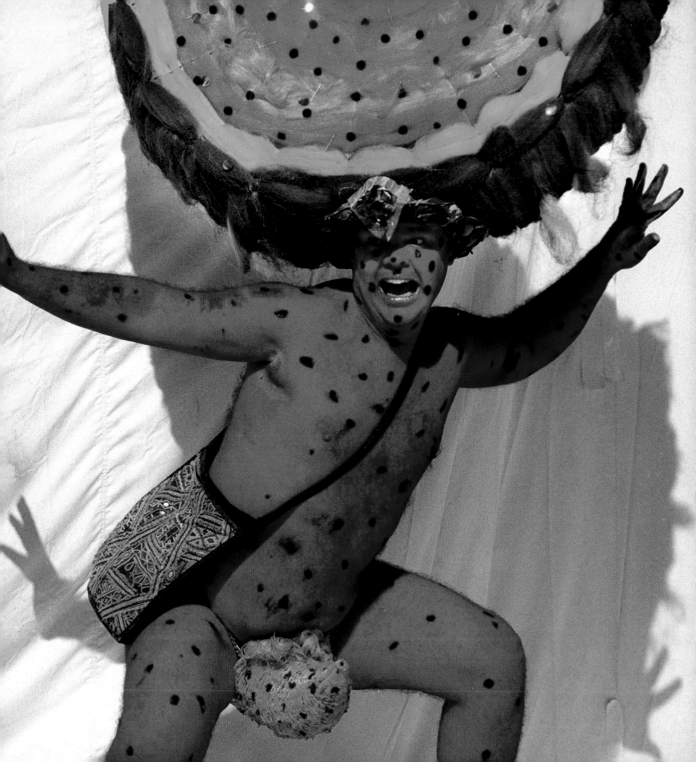

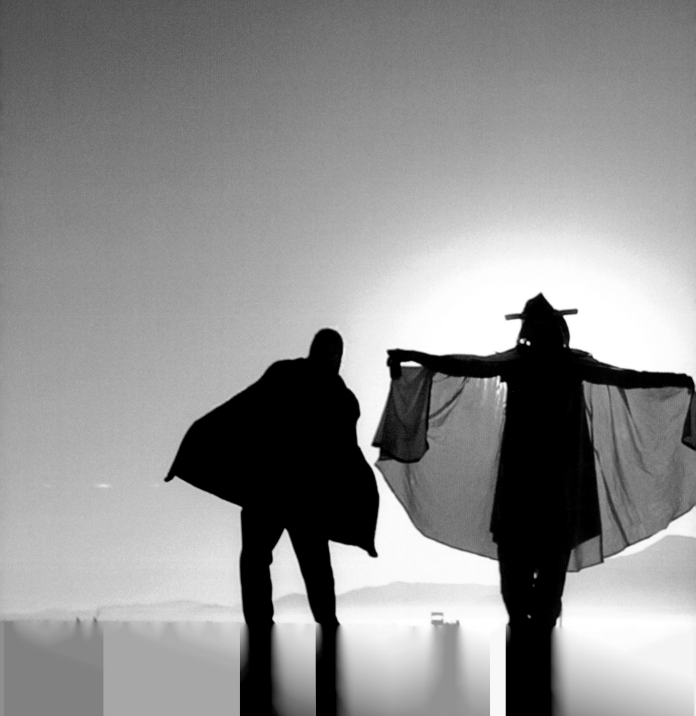

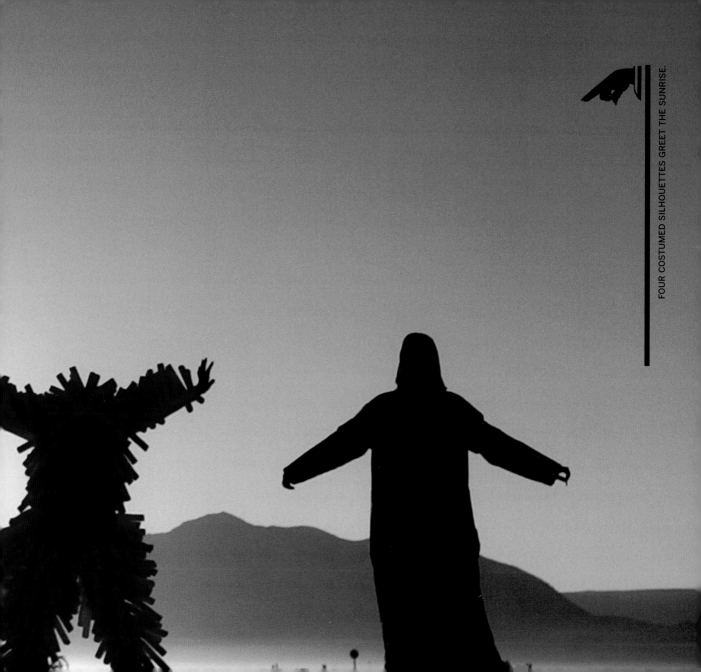

there and mug, and pose, and it would be fine except that, in show-business time, the audience gets tired of you after about five seconds," she says. "So we need to keep the pace going."

Annie has been guiding the fashion show since it started. In the early days she borrowed whatever stage she could cajole people into abandoning for a few hours; once, she had to mount two shows on consecutive days, because some people got lost in a whiteout and couldn't find the first one. Back then, Annie was an experienced dancer, model, and costumer, but less practiced in the arts of desert survival. She used to keep her affairs in a flimsy army tent, until it finally collapsed in a windstorm and wrapped her up like a mummy. That was not a fun costume to wear; the winds kept blowing and rolled her a hundred yards across the desert.

Now she has the fashion show down to a science. She rents an RV. Her costumes fit into seven bins. She has a following of irrepressible models who return year after year, including the self-proclaimed King and Queen of Burning Man, who strut around in royal regalia, and an enthusiastic woman named Anat, who always shows up to model multiple outfits. "Nothing could keep her away," Annie says.

" YOU COULD HAVE A FASHION SHOW ON THE MOON AND ANAT WOULD FIND A WAY TO PUT ON HER *fetching* **OXYGEN TANK** AND COME MEET YOU UP THERE. "

When the fashion show began in 1992, there was more of a contrast between the catwalk and the streets of Black Rock City. Though burners were the descendants of a costume-heavy culture—EVENTS SPONSORED BY THE SUICIDE CLUB AND THE CACOPHONY SOCIETY OFTEN CALLED FOR SPECIAL ATTIRE—most of them didn't dress up every day in the desert.

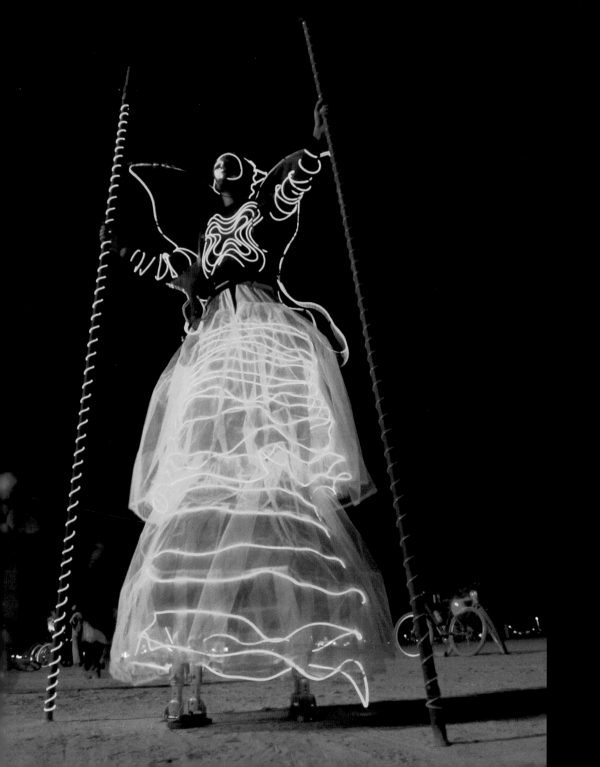

GLOWING COSTUMES, LIKE THIS LOVELY FIBER-OPTIC ENSEMBLE, HELP KEEP PEDESTRIANS SAFE BY REVEALING THEM TO ART CARS AT NIGHT.

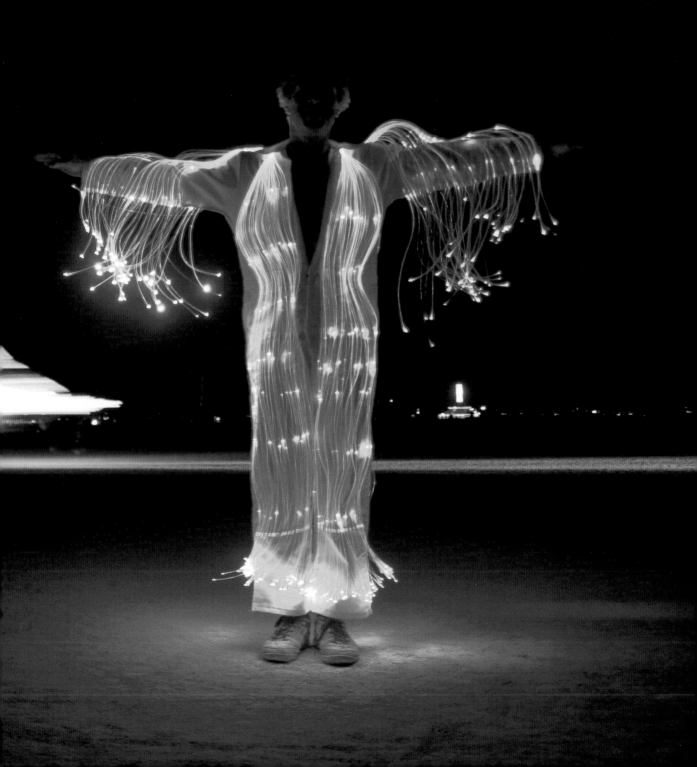

A MIRRORED HUMAN FIGURE CONFRONTS ITS OUTLINE IN WHO ARE YOU NOW? BY MICHAEL EMERY.

There was one formal cocktail party before the Man burned, and that was an occasion for tuxedos and ball gowns, opera gloves and dinner jackets. At other times, elaborate costumes were less common. Nowadays, dressing up in the desert is practically de rigueur, and you're more likely to stand out in flip-flops and a T-shirt than you are in fishnets or horns, wings or vinyl. Like playa names, costumes let people try on new identities, project different attitudes, and change how strangers will react to them. There are no fashion police here, apart from the snarky wordsmiths at PISS CLEAR, who once referred to body glitter as "raver scabies" and offer sporadic, deliciously catty advice. ("SARONG? SO WRONG.") Otherwise, tolerance reigns, unless you're dressed in remarkably poor taste. For example, men who wear shirts but go naked below the waist (A PRACTICE CALLED "SHIRTCOCKING") are begging to get shot by the pants cannon: a homemade, pressurized weapon that slings slacks over great distances. The first pants cannon arrived on the playa in the trigger-happy hands of the DPW. Now it's a venerable prank, replicated by fans in a handful of different camps and often fired from atop the Black Rock City Post Office. Depending on your attitude, the pants cannon is also a public service and an admirably proactive form of criticism.

Costume changes invite comedy, but they can also be disquieting. Larry Harvey, for example, is known for sporting one identifiable look, with a Stetson and perpetually lit cigarette as his only accessories. That kind of consistency creates expectations. A few years ago, after undergoing treatment for pancreatitis, he donned his old hospital gown and assumed the bewildered mien of a patient recovering from a stroke. He staggered around his camp, acting disoriented and feeble. "I was saying, 'Can you help me? I was told to come here. Should I lie down?'" Larry recalls. His hands

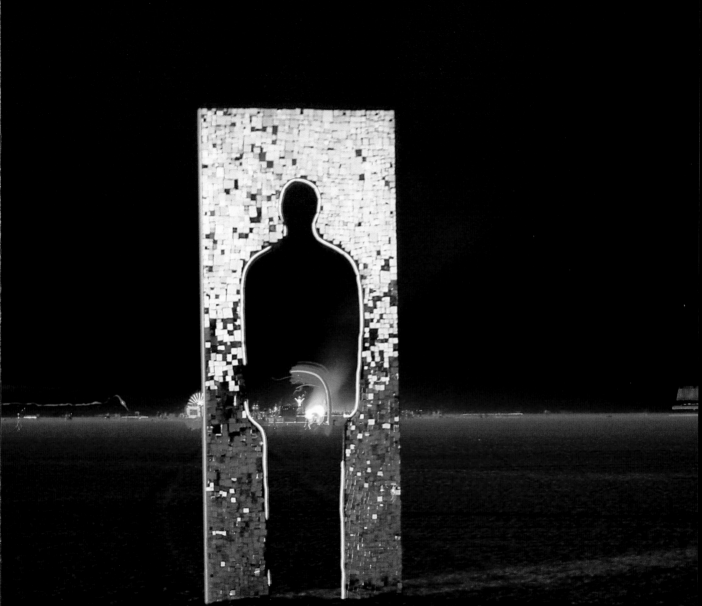

trembled as he clutched a single-serve box of Lucky Charms and pointed out the marshmallows. "I said, 'You can have some. You can have the purple and the yellow ones, but the orange ones are mine. They help . . . they help. But you can have the others. Would you like one?'" His friends were more freaked out than amused. "This started getting on their nerves, because I wasn't supposed to be this person fixing to die, and they didn't like it," he says. "And they were so used to seeing me in this fixed form, right? It startled them."

In another episode, Larry drew scathing stares when he ditched his Stetson and wandered around Burning Man in aviator shades and a baseball cap. He says he didn't think much about the cap before putting it on. The logo read **DEA.** "I forgot what I was doing," he says. Usually burners recognize him with enthusiasm, rather than undisguised hostility, so this was a big change. "That was kind of fun," he adds, "and I still wear it once in a while."

Most burners use costumes to create new identities, but a few people focus on disguising their old ones. When Joan Baez went to Burning Man in 2005, she spent most days incognito, with an orange scarf wrapped around her head. This also made it easier to decline solicitations, including one from a gentleman who offered to whip her. Of course, there were moments when the mask came off, like the time she posed for a picture, licking the face of a life-size replica of President Bush, clad in a soaked and somewhat transparent slip (SHE'D BEEN CHASING A WATER TRUCK). Or the time she wandered into one of the free costume boutiques scattered throughout the city and pinned herself into a billowy, white wedding dress.

"I felt like Cinderella in that thing, and it had a tiara on it saying 'Bride to Be,' so I went dancing down the street and discovered that men were terrified," she remembers with a chuckle. "They saw the

dress and they'd say, 'Oh, congratulations!' and I'd say, 'Well, it hasn't happened yet.' And they would get so busy building a new tent, or anything, because they felt put on the spot. I was shouting, 'Anybody wanna get married?'" Perhaps her proposition didn't seem entirely unlikely; dozens of couples get hitched in the desert each year. (AND, TO SOME BURNERS' CHAGRIN, A DAYTIME TALK SHOW CALLED *THE VIEW* HAS NAMED BURNING MAN AMONG THE TOP FIVE MOST UNIQUE PLACES TO POP THE QUESTION. ALSO LISTED? TURTLE ISLAND IN FIJI AND A MOONIE MASS MARRIAGE IN SEOUL.)

"Finally some very short, very cute gay kid came up," she recalls. "He's wearing a halter or something, and he said, 'I'll marry you.' I said, 'Oh, cool,' so we had our picture taken by a number of people, and then he almost kissed me on the mouth, but it was too much for him, so he ran off. And my friends, by then they were getting nervous about it. You know, 'Come on, Joan.' They were like, 'Somebody's going to see you.'"

She hadn't planned to enact her public identity as a folk singer at the festival at all. But when news of a catastrophe came, that changed. Days earlier, a hurricane had devastated New Orleans. She agreed to join a memorial for lives lost there.

EXPRESS YOURSELF

10TH ANNUAL BURNING MAN FASHION SHOW
Labor Day Weekend
Black Rock City, Nevada

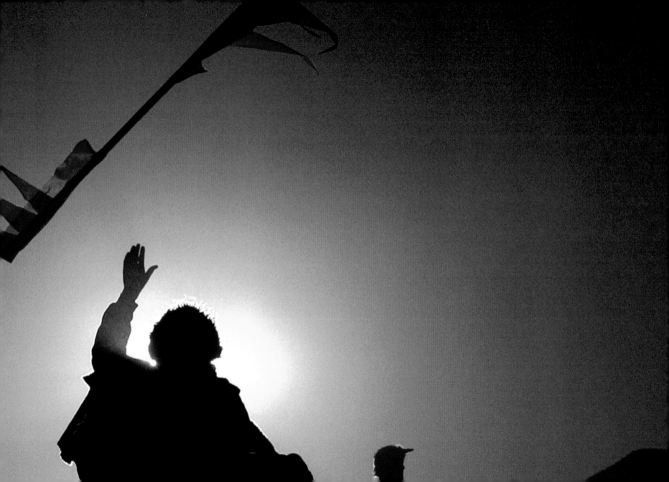

...
...
...Her hair was
painted in

COTTON-CANDY PASTELS

— bullhorn in hand, —
SHE SANG *"Swing Low, Sweet Chariot"* & *"Amazing Grace ."*

PEOPLE WERE SURPRISED TO
SEE HER THERE.
THEY WERE RESPECTFUL AND
QUIET.
" IT TOOK SOMETHING LIKE KATRINA TO GET
ME TO BE ME, "
SHE SAYS.

A BURNER TOSSES A DOUBLE-ENDED FLAG AT DAWN.

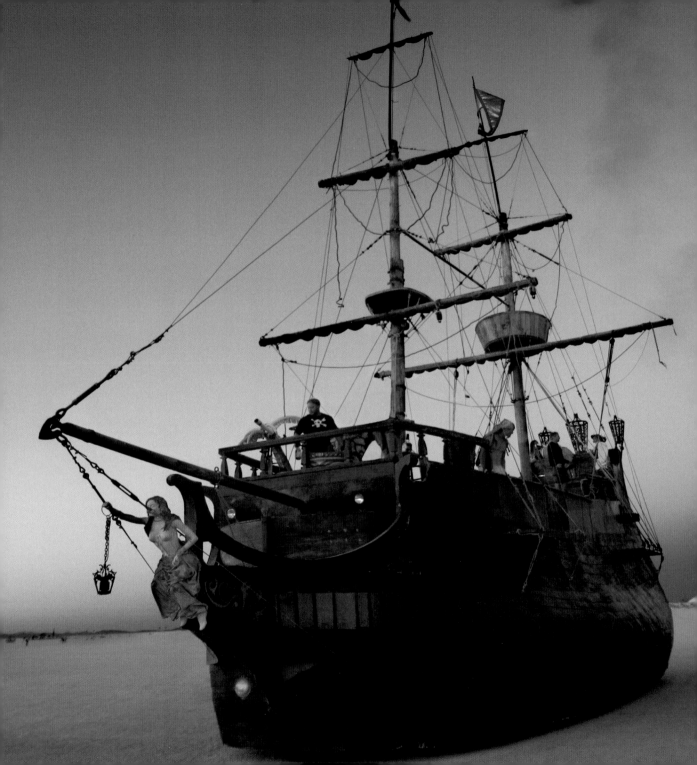

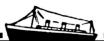

THE VOYAGE OF LA CONTESSA

WHEN YOU ARE WEARY OF WALKING OR biking across Black Rock City, it's easy to hail a ride. You can clamber aboard a neon disco bus, hop on a motorized flying carpet, or chase after a wheeled dragon, waving your arms like a castaway, until it slows down to pick you up. Hitchhiking en masse, however, is harder. It's nearly impossible if you're traveling in the company of a few dozen comrades, and if your entourage happens to be a raucous marching band—thirty or forty people armed with brass, percussion, and a take-no-prisoners attitude—

YOU MAY AS WELL ADMIT DEFEAT.

SEAFARERS EXPLORE LA CONTESSA, A HALF-SCALE MOBILE REPLICA OF A SIXTEENTH-CENTURY SPANISH GALLEON, CREATED BY MEMBERS OF THE EXTRA ACTION MARCHING BAND.

Or you could just bring your own outsize vehicle to Burning Man. For Simon Cheffins, the forty-two-year-old founder of San Francisco's *EXTRA ACTION MARCHING BAND,* that seemed like a feasible solution. "The marching band had been out a couple times as a big group, and we were too big to catch rides easily," he recalls. Simon has worked as a master carpenter for the Palo Alto opera and a prop builder for Miss Nude World USA, and he possesses the kind of practical skills that can realize outlandish dreams. His first plan for moving the band around the desert was a motorized birthday cake.

"Initially, the idea was modeled after a Busby Berkeley film," says Simon. "You know how he would have these elaborate stages, with these revolving layers going in different directions, the helical double staircases revolving around each other? I wanted to do something like that, make a stage, essentially. A mobile stage."

The idea of a stage stuck, but the cake did not. When the 2002 theme for Burning Man was announced as "THE FLOATING WORLD," Simon realized switching to a maritime model would increase his chances of winning a grant from the festival. "It was pretty obvious I wasn't going to get funded for a birthday cake," he explains. So he determined that what the band really needed was a boat. More precisely, the band required a

HALF-SCALE replica of a sixteenth-CENTURY SPANISH GALLEON, which could be built on a bus frame and serve as a vessel for the errant navigational desires of its ragtag crew. Simon conducted extensive research. Friends brought him ships in bottles. He

spent six months as a volunteer in the rigging of the **Balclutha,** a historic craft that ran aground in 1904, was later restored, and is now docked at the San Francisco Maritime Museum at the western end of Fisherman's Wharf. Simon came up with a name for his motorized galleon: **La Contessa.** He drafted a proposal, and Burning Man awarded him a $15,000 grant for the boat's construction.

For Greg Jones, a thirty-nine-year-old trumpet player in the band, the project coincided with a post–September 11 slump in his day job as a design engineer. "I didn't have any work because of the economy," he says. So he took on the boat as a challenge, spending eight hours a day developing a computerized blueprint for the hull and decks. Other band members and friends assigned themselves to details. Kelek Stevenson made flaming lanterns for the poop deck, and Monica Maduro sculpted a voluptuous female figurehead to mount on the bowsprit. Steve Valdez took charge of steel fabrication and built a giant third axle, dubbed the ship's "training wheels," to help support the weight. The band acquired a decommissioned school bus, wood from a salvage yard, and two telephone poles for masts. Dozens of people pitched in, and the galleon gradually came to life. (ON THE PLAYA, LA CONTESSA WOULD BECOME SO POPULAR THAT HER CREATORS CUT A SET OF SPECIAL KEYS WITH THE EXTRA ACTION LOGO, WHICH FRIENDS AND BANDMATES COULD USE AS BOARDING PASSES IF THE DECK WAS GETTING FULL.)

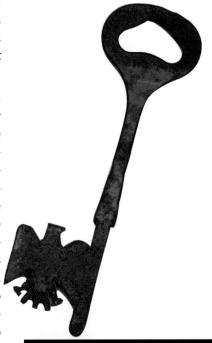

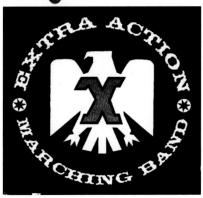

"It was the BIGGEST, BADDEST THING AROUND, AND EVERYBODY KNEW IT," recalls Zachary Rukstela, an electrical engineer who plays the cymbals. "Everyone wanted to help." "Ballad of La Contessa," a song by three of his bandmates, tells a more fanciful tale of the boat's beginnings:

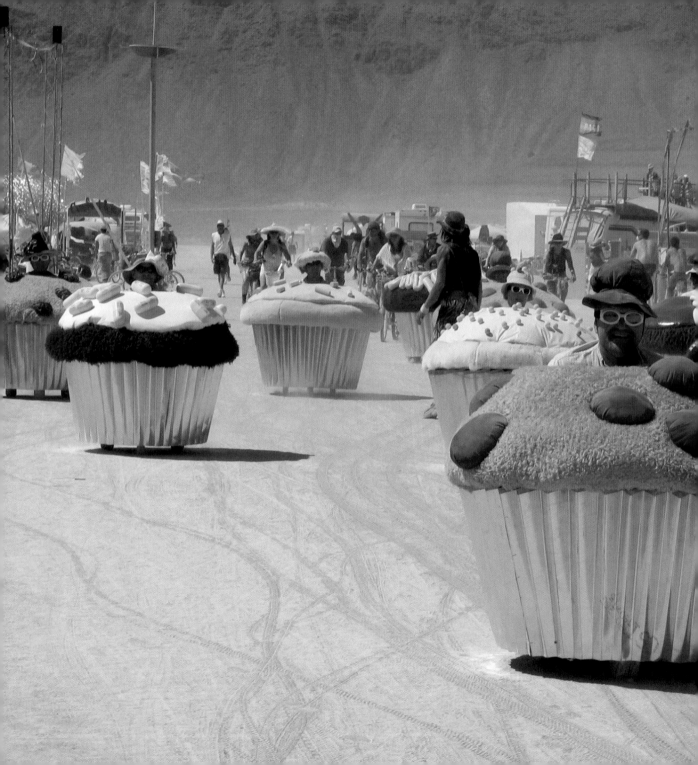

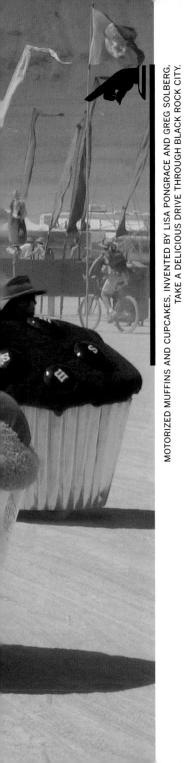

THEY toiled for a thousand WHITE NIGHTS to build the SHIP that they sailed. **ALL** bound together with SALT and SPUNK, BUCKETS of *BLOODY NAILS . . .* **THEY** sailed to the END of the *OCEAN.* The SEA turned into *SAND.* **THEY** battened the *HATCHES* and dropped all the *ACID* **AND** set SAIL across the *LAND.*

Though *LA CONTESSA* dwarfs most of them in size, creative vehicles have been clunking, crawling, and cruising around Burning Man for more than a decade. The first one arrived in 1993, when Michael Michael drove out to the desert in his half-crumpled Oldsmobile, a relic from the 1989 San Francisco earthquake. The car had been buried under a load of bricks, and he named it 5:04 P.M. for the time the tremor hit. Over the next few years, Burning Man became a hub for the vehicular avant-garde. It attracted art car aficionados like Harrod Blank, whose fleet includes a Dodge van with two thousand cameras and a restyled Volkswagen Beetle called *OH MY GOD!* (PRESUMABLY A COMMON REACTION TO THE CAR'S BRIGHT COLORS, BUMPER GARNISHED WITH FAKE FRUIT, GUTTED TELEVISION ON THE ROOF, ETC.). Tom Kennedy, another prolific art car builder, came up from Houston with *RIPPER THE FRIENDLY SHARK* (A TOOTHY, SILVER-FINNED REINCARNA- TION OF A FORMER NISSAN SENTRA). Tom kept bringing more elaborate cars, and in 2002 he arrived with the *WHALE,* a glowing white levia- than with a moving tail that spouted water by day and fire at night.

NOWADAYS, the Department of Mutant Vehicles—BURNING MAN'S OWN DMV— inspects and certifies more than 500 art cars for driving each year. Typical Burning Man traffic includes spacecraft and double-decker buses with bars and sound systems, along with a mobile menagerie of giant cats, rats, fish, snails, and the occasional lobster or cockroach. The *NEVERWAS HAUL,* a three-story Victorian house on wheels, looks like something

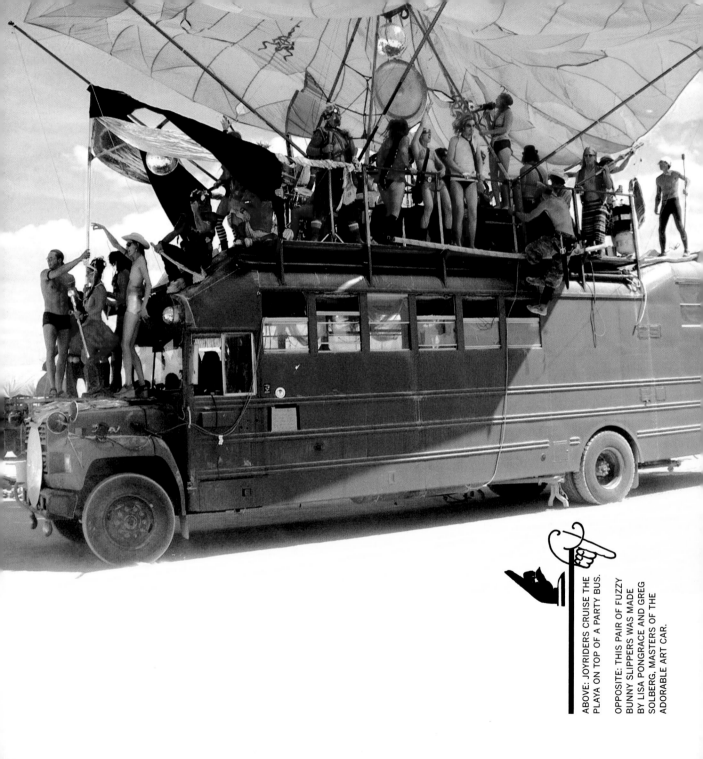

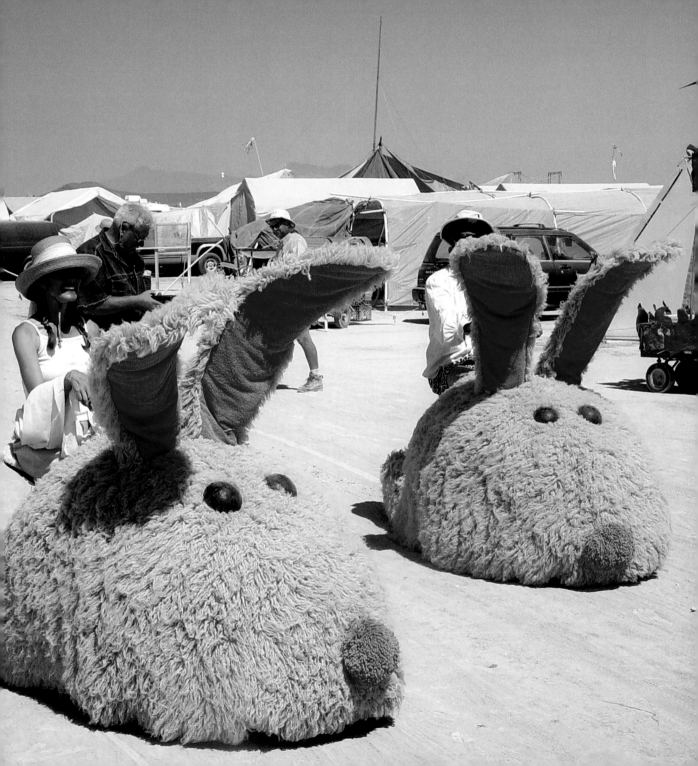

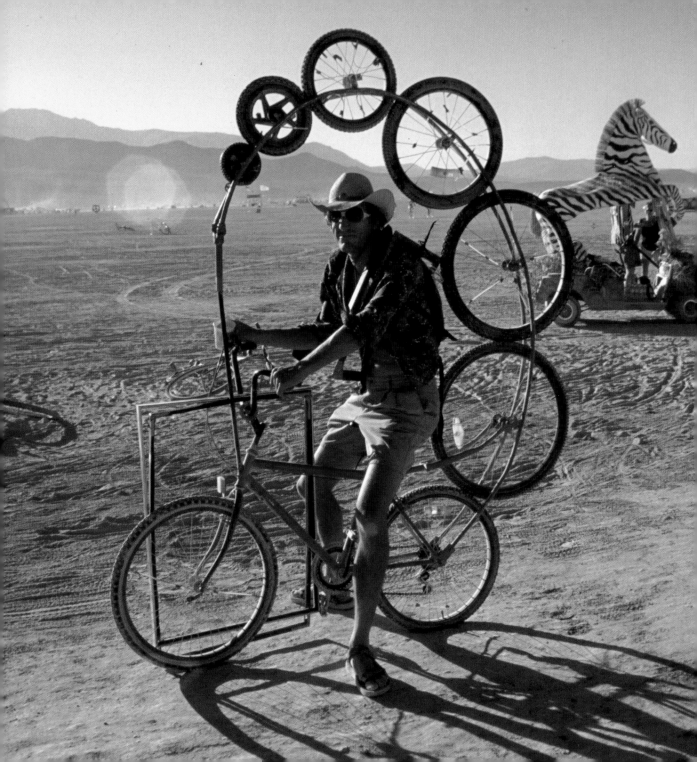

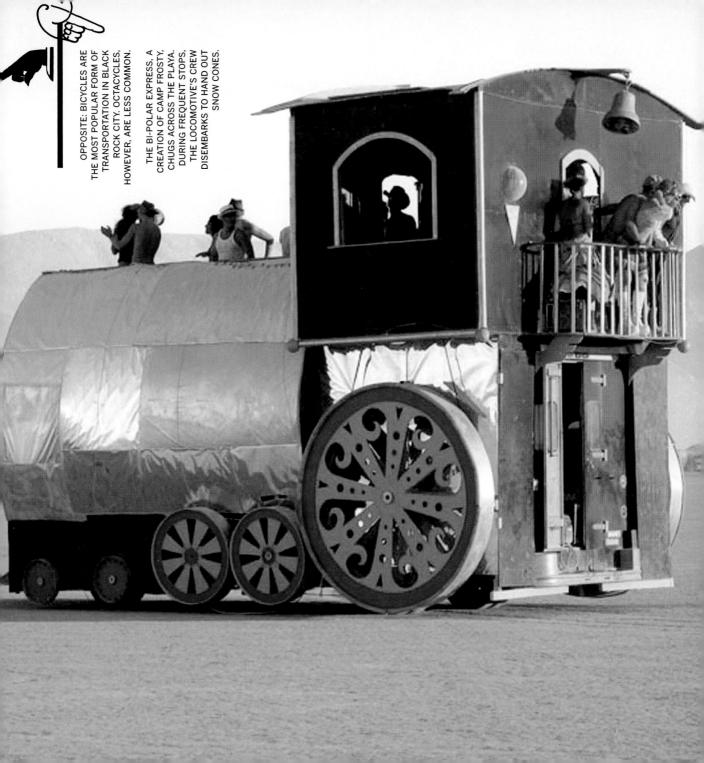

OPPOSITE: BICYCLES ARE THE MOST POPULAR FORM OF TRANSPORTATION IN BLACK ROCK CITY. OCTACYCLES, HOWEVER, ARE LESS COMMON.

THE BI-POLAR EXPRESS, A CREATION OF CAMP FROSTY, CHUGS ACROSS THE PLAYA. DURING FREQUENT STOPS, THE LOCOMOTIVE'S CREW DISEMBARKS TO HAND OUT SNOW CONES.

DEPARTMENT OF
MUTANT VEHICLES
BURNING MAN
2004

DMV HOTTIES

DEPARTMENT OF
MUTANT VEHICLES
BURNING MAN
2004

DMV HOTTIES

from a Jules Verne fantasy. Two Berkeleyites, Greg Solberg and Lisa Pongrace, are especially beloved for their smaller single-occupancy vehicles: a pair of pink bunny slippers and a gang of roving cupcakes. Their fleet runs on repurposed electric motors from wheelchairs and golf carts with batteries that plug into stationary solar panels for recharging.

In August 2002 *LA CONTESSA* arrived at the Black Rock Desert in pieces. Her hull and decks were assembled, and the masts and sails were raised. The belly of the boat became a luxurious lounge, complete with a bathtub full of pillows and a bar behind the driver's seat of the old school bus. "We were just going frantic all week to try to get it done," Zachary says. "I didn't personally get to enjoy Burning Man that year, because we worked on the galleon

It was just

The ship wasn't finished until the final days of the festival; that week was consumed by work. But everyone had been watching the galleon grow. Before she even set sail, *LA CONTESSA* had already entered the pantheon of Burning Man's most ambitious projects. People were stunned by her grace and scale. The ship was up and running for a few days, and the next year she returned to the playa, ready to add to her legend.

LA CONTESSA quickly earned a reputation for mischief. She took sunrise cruises outside the festival enclosure—or, as simon calls it, the "pen"—by slipping through a gate hidden on the far side of the fence. "There was one time where we got sick of looking for the gate," Simon recalls. "We were driving along the fence, and we can't find the fucking thing, and so we turned into the pen a little ways. I turned around where I could just see the fence, and I just hit it straight on, in third gear." With the fence's mangled netting behind them, the passengers on deck were ecstatic. Simon could hear them cheering from down below as *LA CONTESSA* emerged from captivity, barreling into the open desert.

After sunset, the sailors' favorite sport was chasing Tom Kennedy's art car, the whale. This was no easy game. Maneuvering *LA CON-TESSA* is complicated. It takes two people: a driver, who steers from inside the hull and peeps out from a tiny, half-useless windshield, and a pilot, who stands on deck with a radio, relaying directions to the driver below. When Greg was at the pilot's post, he kept a lookout for the whale. It would approach *LA CONTESSA* from behind, then veer nimbly to one side and speed past, spouting fire as casually as a kid might blow a raspberry.

H E R E H E R E H E R E H E R E
they come! they cooooome!!! they cooooooooooo
o o o o o o o o o o o o o o m e !!! "

Greg would holler into the radio. At the helm, Simon would cut the wheel and swerve into the whale's path. Sometimes the ship and the whale barely avoided a crash. "They were about ten or twelve feet in front of us, and I was doing probably fifteen miles an hour, which seems pretty fast out there when you're cutting across a seventy-foot-long whale," Simon says, recalling one encounter. "They lifted up the tail of the whale, and the bowsprit just cut underneath it."

LA CONTESSA was also notorious for her shadow. She was dimly lit, with flame-powered lanterns and one weak headlight. An on-board aesthetic policy banned glow sticks and blinky lights from her decks, except for when the crew went "hippie fishing" (A POPULAR PRANK: TIE GLOW STICKS TO THE END OF A FISHING LINE, CAST THEM INTO THE DESERT, AND REEL IN WHOEVER PICKS THEM UP). The lack of illumination made *LA CONTESSA* look more authentic. It also made her very hard to see at night.

"One of my favorite things to hear is from people who are sort of laying on the ground in the middle of nowhere, and they're looking up at the stars and then suddenly, without any explanation, the stars just disappear—*all* OF THE STARS DISAPPEAR—and there's this black void that's in the shape of this ghost ship," Simon reminisces.

"They can barely SEE THE SHIP; ALL THEY CAN SEE IS ITS SHAPE MOVING ACROSS THE NIGHT SKY, AND THAT'S REALLY **MAGIC.**"

The price of that magic, however, turned out to be probation. "Rangers would be looking for *LA CONTESSA,* and know that it was playing chase with the whale, and be like right next to it and not able to see it," explained Jewelz "Grits" Cody, the former manager of the Department of Mutant Vehicles. "There were a lot of people that were really frightened because they couldn't see it, it was so dark." In addition to maintaining the five-mile-an-hour speed limit, art cars are required to drive slowly and use bright lights at night. But the galleon was dark and fast. Despite repeated warnings from the Black Rock Rangers and festival bigwigs, she stayed that way, and after her appearance in 2003 was officially barred from Burning Man.

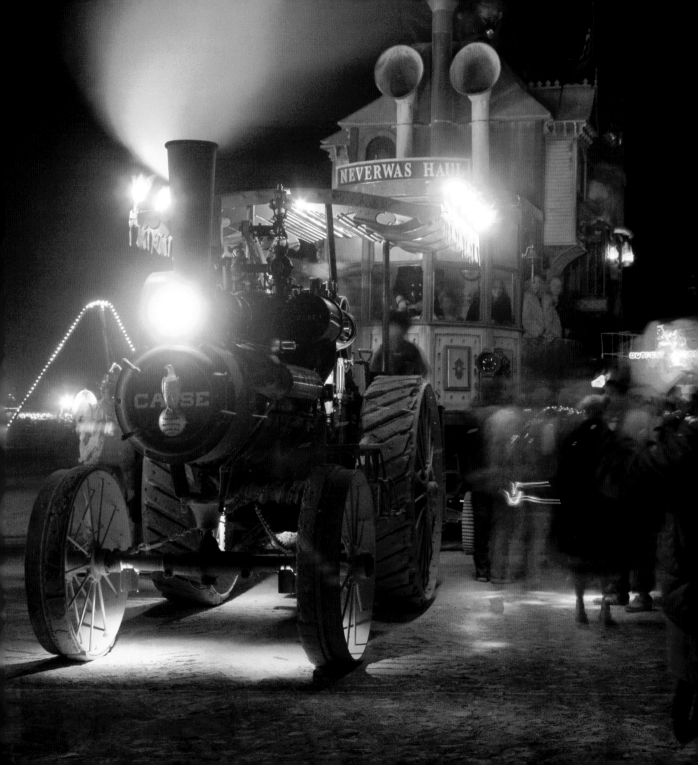

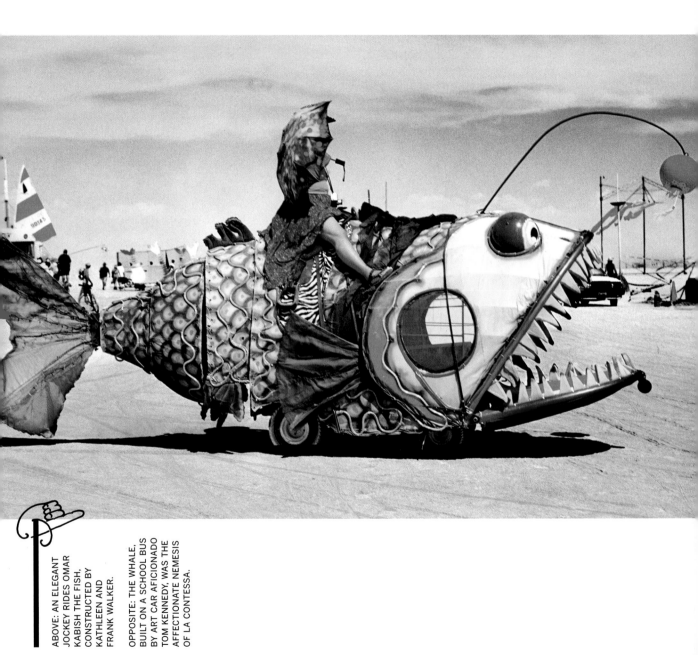

ABOVE: AN ELEGANT
JOCKEY RIDES OMAR
KABISH THE FISH,
CONSTRUCTED BY
KATHLEEN AND
FRANK WALKER.

OPPOSITE: THE WHALE,
BUILT ON A SCHOOL BUS
BY ART CAR AFICIONADO
TOM KENNEDY, WAS THE
AFFECTIONATE NEMESIS
OF LA CONTESSA.

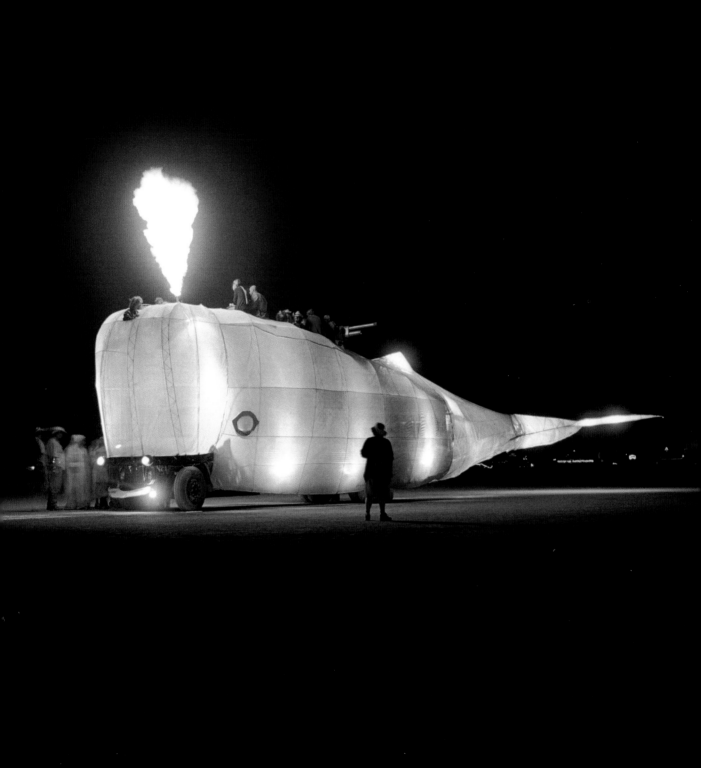

The ban didn't last. *LA CONTESSA* returned from exile in 2005. That year the Burning Man organizers agreed to release her from the "pen" for one evening cruise around the outer desert. The plans were made quietly. Around forty passengers had assembled on the ship by ten o'clock Tuesday evening. They brought their ticket stubs along and disembarked at the front gate, where they received official wristbands for re-entry. Then they got back on *LA CONTESSA* and sailed away from Black Rock City. "As soon as we got out, everyone's attitudes lifted and skyrocketed," Greg says. "The farther you would get away from the lights and the ***nchk-nchk-nchk!***"—HE IMITATES A TECHNO BEAT—"the higher people would get. You know, it was just this energy." Of course, they were doing some of the things one might do at Burning Man—FLIRTING, SINGING, DRINKING—but away from all the bedlam, in the rarefied context of a private party. "Everyone was in great spirits about being one of the chosen ones," he recalls. "That felt really great, and then, in five seconds, the attitude totally changed."

THAT WAS WHEN *La* CONTESSA **HIT THE SHOALS.**

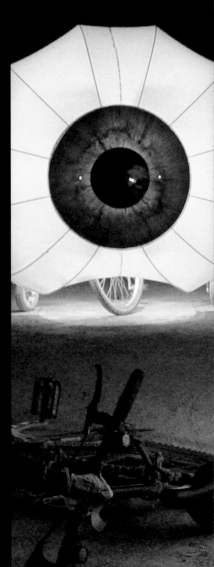

Unbeknownst to the revelers, their vessel had gotten lost in the dark. She had strayed off course, away from the flat heart of the playa, toward its lumpier northern edge. One moment the ship was gliding along smoothly, and the next, she crashed into a scrubby dune the size of a doghouse. The lower starboard side of the hull was torn away. Passengers were tossed across the deck like rag dolls. Kiki Pettit Jewell, a passenger who was twelve weeks pregnant at the time, flew a dozen feet and hit her head on a mast. "I remember the lurch. I opened my eyes and I was on the floor," she says. "It happened too fast to really react, and then it was over."

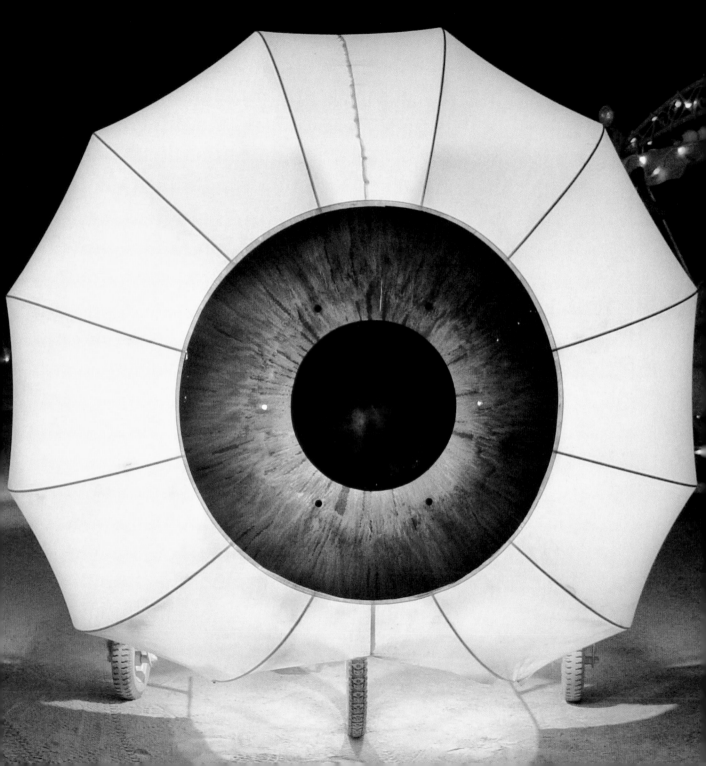

LA CONTESSA had been in minor accidents before: hit by a motorized torpedo, knocked around by Tom Kennedy's whale, and roughed up by the DPW, who had spent two weeks carousing on her decks—and then repairing them—before the festival began in 2003. But this was a genuine shipwreck. "I don't know what happened, really," says Simon. He had planned to relax that night and hadn't taken his old seat at the helm. "We drove it off the fucking edge of the world."

The passengers disembarked with nasty cuts and bruises. No one was hurt seriously enough to warrant a trip to the hospital. Kiki remembers that people were worried about "the pregnant lady" but, apart from a "big old goose egg" on her forehead, she was fine. The merry mood dimmed briefly, as the revelers assessed their predicament and compared scrapes. Then they resurrected the party. "About fifteen minutes later there were people with instruments playing, and singing, and laughing," Kiki says. "It was all pretty festive."

Meanwhile, an exaggerated report of catastrophic injuries had been radioed back to Black Rock City. Soon a phalanx of ambulances and police cars would appear in the distance, their colored lights approaching rapidly. The stranded passengers would be shuttled back to the festival, a couple of miles away, leaving *LA CONTESSA* alone in the dark. The next day would bring both good news and bad. The boat was still drivable, and the hull would be easy to repair, but the ship's stereo system had been stolen, along with some expensive tools. The maiden figurehead had also been snatched up, replaced by a ransom note that demanded, **"What's she worth to you?"** In a fit of passion the next afternoon, Simon would scrawl his answer on brown paper, hammering it into the stern of the ship with three-foot steel nails. "She is worth all of my blood," read his note, "and therefore all of yours." The figurehead was returned by the end of the day.

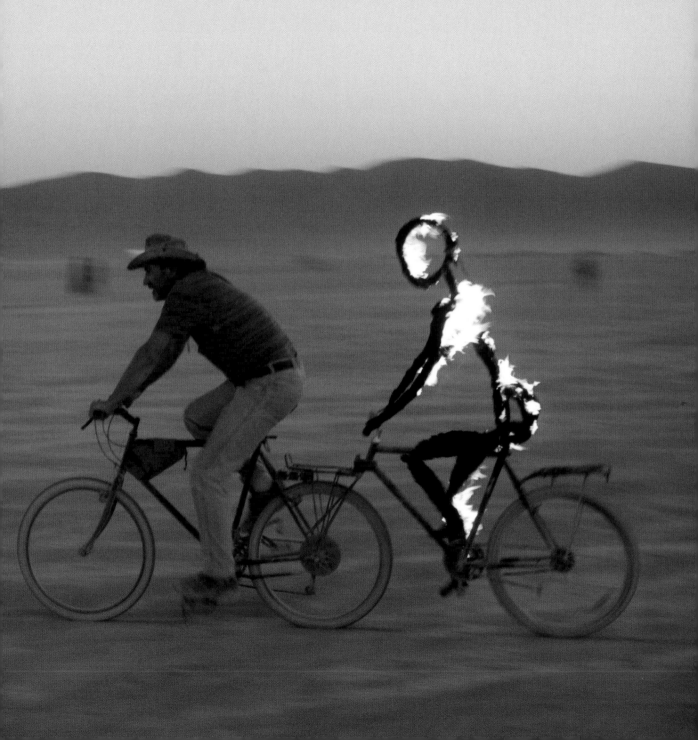

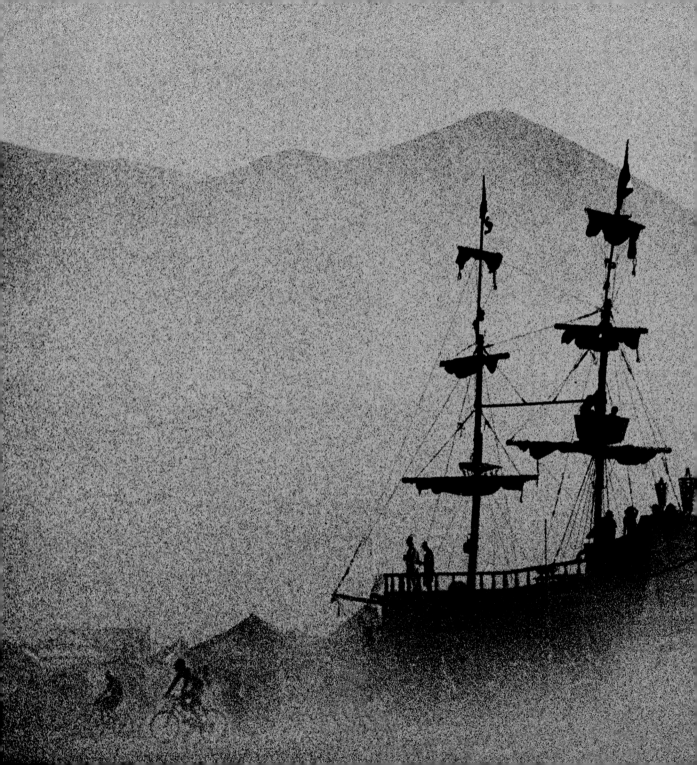

Fast-forward a year and a half, and the voyage of *LA CONTESSA* would end for good. An arson fire on the Nevada ranch where she'd been parked for the winter would reduce her hull to ashes, surprising and saddening her crew.

But before all that could happen, there was still a salvageable shipwreck on dry land, and an evening to complete. There was nothing for the passengers to do but wait. Simon walked off into the desert. The stranded revelers, stunned but giddy, sat with their splintered ship in the dark. A member of the *EXTRA ACTION MARCHING BAND* named Sean Lee took up his banjo to serenade them. He played another song written for the galleon, a swashbuckling number called "La Contessa." A few people already knew the words, but suddenly the lyrics rang with new meaning. He sang:

..

...............**A SAILOR'S** life is COLD and HARD,

THE END comes DARK and FAST.

SO mark my WORDS, you SCURVY *LOT*,

TONIGHT may be your *LAST*.

DRINK your WHISKEYS *UP*, me boys,

AND take a FRISKY *LASS*,

AND we'll pull the *HOOK*, and strike the *BOOK*,

AND make the *MAINSAIL* FAST:

SINGING *LA CONTESSA*,

LA CONTESSA,

LA CONTESSA ROVE!

LETTING GO

PAST THE LAUGHTER AND

the neon lights, convivial smiles and boisterous games, there is another face to Black Rock City. Walk far out into the desert, past the Man. There you'll see it: a sanctuary with pale wooden walls as intricate as lace. It looks vaguely Eastern, like a monastery that levitated out of Tibet and somehow landed here. This place is called the Temple. This is where burners gather to mourn.

THE TEMPLE OF JOY BY DAVID BEST AND CREW IS PIERCED BY RUSSELL WILCOX'S LASER BEACON AT NIGHT.

INFLUENCED BY JAPANESE SCULPTURAL LANDSCAPES, THE TEMPLE OF STARS WAS ORIENTED HORIZONTALLY AND STRETCHED FOR A QUARTER-MILE ACROSS THE DESERT. IT WAS ALSO CALLED THE TEMPLE OF FORGIVENESS.

Inside, the mood is somber. The walls are covered with inscriptions to lost fathers, sons, mothers, daughters, and friends. With each passing day, the script gets denser. Dog-eared photographs of the departed and other shreds of memory—NEWSPAPER CLIPPINGS, DIARIES, AND MILITARY IDENTIFICATION TAGS—form a collage in the Temple alcoves. One time a note appeared on the Temple's central altar, which is dedicated to suicides. It took the form of a poem, with an anguished refrain: "I've got a gun that's under my bed." The date indicated that the writer had pulled out his gun and shot himself three decades ago. Someone who loved him had been clutching that scrap close for a very long time, only to let it go here.

If you've come to Burning Man for the simple pleasures of howling at the moon and dancing until you fall over, the spectacle of sadness may feel maudlin. Death is, after all, the ultimate buzzkill. But living in a temporary city has a strange way of reminding people that they are temporary too. •••••••••••••••••••••••••••••••••

••• A LINE FROM POET ROBERT FROST CAPTURES THAT FEELING OF **TRANSIENCE,** SO EVIDENT HERE:

"NOTHING **GOLD** CAN STAY."

The Temple won't stay for long either. It will burn on Sunday, the night after the Man goes down. By that time, many of the revelers will already be gone, and the Temple will become the focal point of the half-empty city.

Sunlight streams through the Temple's filigreed walls. It filters down on dozens of bowed heads and dapples patterns into the dust. Big, burly men, the kind of guys who look like they could tear a phone book in half and then eat it, have been known to cross the Temple's threshold and burst into tears. Drifters pass in and out of the

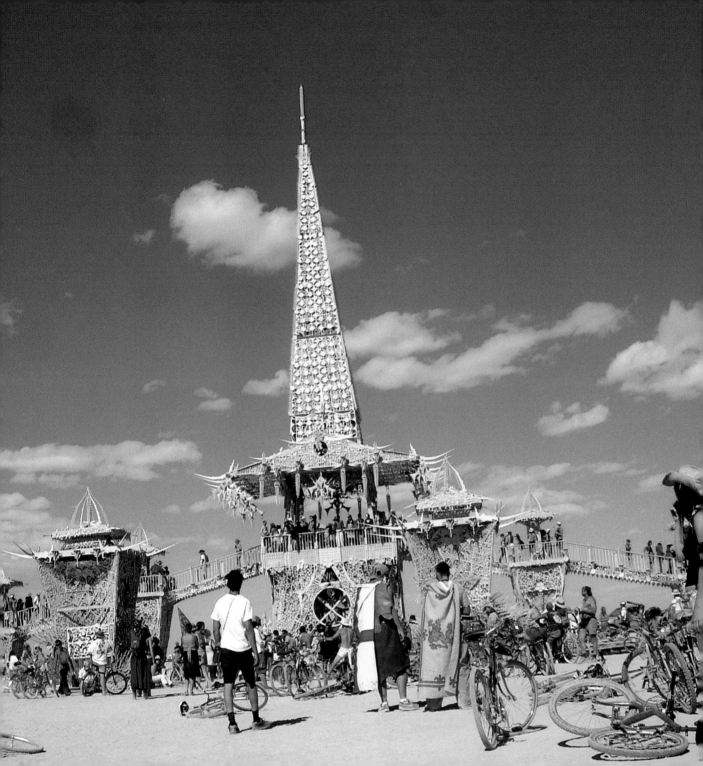

sanctuary at all hours. They stop to read the small tributes that other visitors have left there. Some of the notes are angry, some beg for forgiveness, and most of them reach out to people who are gone. Others are endearingly offbeat, like a placard that was once posted for a Siamese cat named **Sponge Cake** (1989–2004), with a photographic tribute and message: **"We love you!"**

The Temple hasn't always been a landmark of Black Rock City. It arrived at Burning Man in 2000, quite by accident. At the time, David Best, a sculptor and inveterate art car builder from Petaluma, had already been attending the festival for a couple of summers. He always arrived with a fleet of unusual vehicles from his ranch. One year he lugged out a bunch of old Christmas trees, which he fashioned into a pine forest. David was a scavenger by habit. While dreaming up new projects, he spent hours foraging through Dumpsters, looking for materials he could recycle into his art. One day he found an unlikely treasure: a bunch of Russian birch plywood panels, discarded by a company called B.C. Bones that made interlocking dinosaur puzzle kits for kids. Fossil shapes had been cut out of the panels. The holes they left formed delicate patterns.

"I liked this stuff, and I didn't know what to do with it," says David. He is sixty-two years old, with unkempt gray hair, a white beard, a weather-lined face, and blue eyes. "So I just started collecting it."

That urge may have seemed eccentric, but Ray Rogers, the owner of the dinosaur company, was more than happy to oblige him. "I saw this scruffy guy digging through my debris box," he says with a laugh. "As long as he was taking stuff out and not putting stuff in, I didn't care." He started setting aside all his scrap wood for David.

As the pile grew, David began crafting plans. He wanted to take the wood to Burning Man and build a house. But less than two weeks

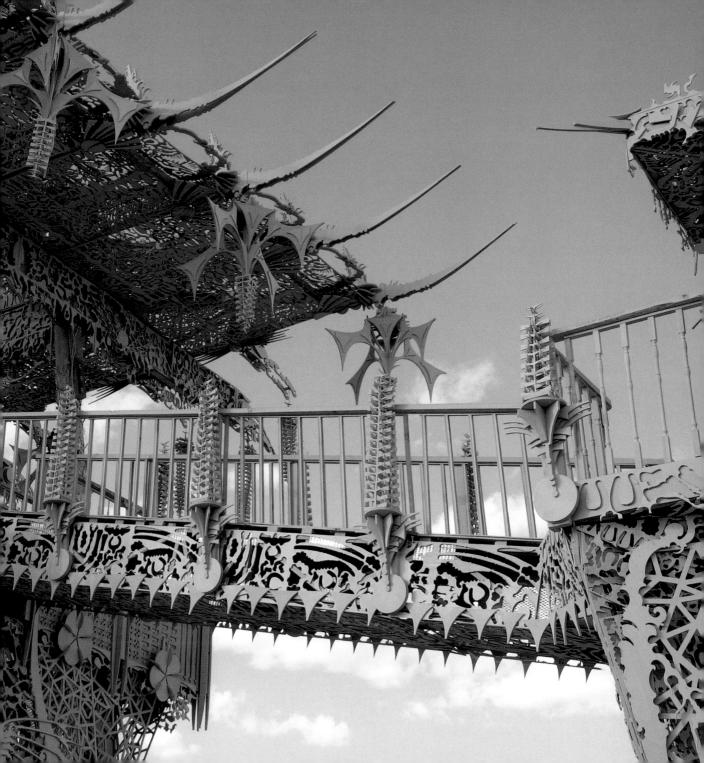

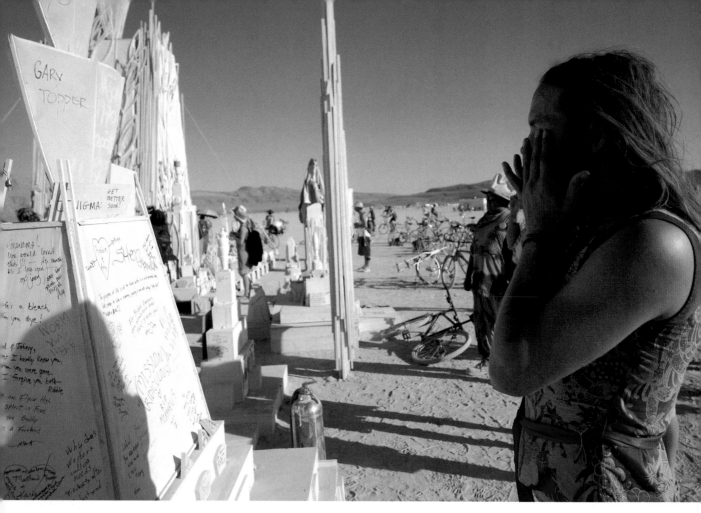

A PILGRIM WEEPS WHILE
READING INSCRIPTIONS
AT THE TEMPLE OF
HOPE IN 2006.

OPPOSITE: A CELLIST
PLAYS IN REVERIE AT
THE 2005 TEMPLES OF
DREAMS.

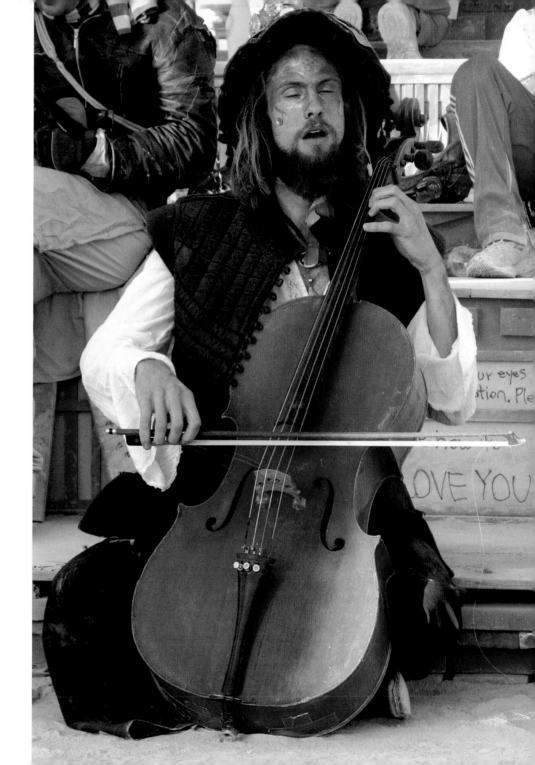

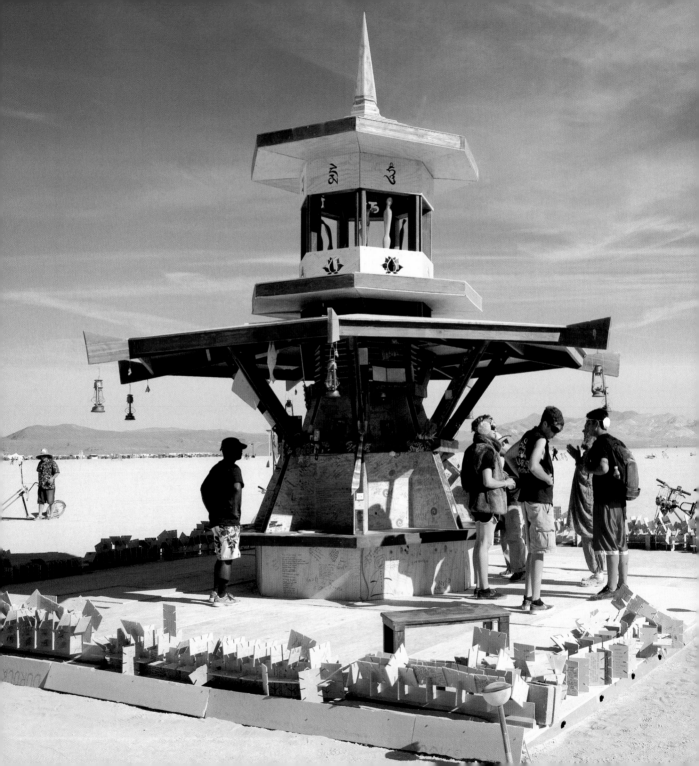

before the festival, something terrible happened. A guy named Michael Hefflin, who was thirty-three years old, had spent the day helping in David's workshop. Around midnight, he headed for home on his motorcycle. It was a 1990 Ducati Desmo, a racing bike, and he revved it up past a hundred miles per hour on a dark country road. Then he lost control. Two of his roommates were riding ahead of him on a second motorcycle, and he slammed into them. They survived the crash, but Michael wasn't so lucky. The **PRESS DEMOCRAT** of Santa Rosa had the story the next day. He had died on the spot, after a two-hundred-foot skid down Petaluma Hill Road.

So the house David had planned to build became a memorial. It was a place for reflection, and he named it the ***TEMPLE OF THE MIND.*** He placed a picture of Michael inside. When visitors came, he told them about the accident. Burners were moved by his expression of grief and began adding their own in words and pictures. They composed notes on scrolls of paper and blocks of wood, piling them high on a central altar. By the time the house of dinosaur wood was consumed in flames at the end of the week, it carried messages from nearly two thousand people.

Not everyone had heard about the Temple before it was reduced to ash. Marisa Lenhardt, from the ***THUNDERDOME DEATH GUILD,*** was upset when she learned about the fire. She wished she had written something to honor her mother, who had passed away two years earlier. Later she learned that David King, her campmate and friend, had seen to it, though he didn't know her mother's name.

He wrote,

"*Marisa's mom.*"

INSPIRED BY DAVID BEST, SEATTLE BURNERS BUILT THE TEMPLE OF LIGHT TO HONOR SIX YOUNG VICTIMS OF A GUNMAN WHO OPENED FIRE AT A LOCAL POST-PARTY GATHERING IN MARCH 2006.

OVERLEAF: MATTHEW AND LAURA REOCH'S CIRCLE OF INFINITY, A MIRRORED SCULPTURE, REFLECTS SCENES AROUND THE TEMPLE OF HONOR IN 2003

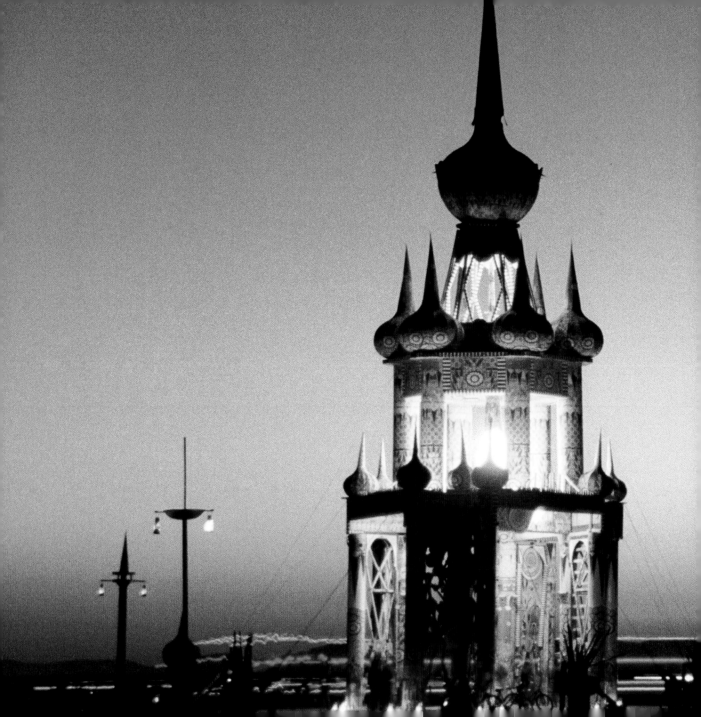

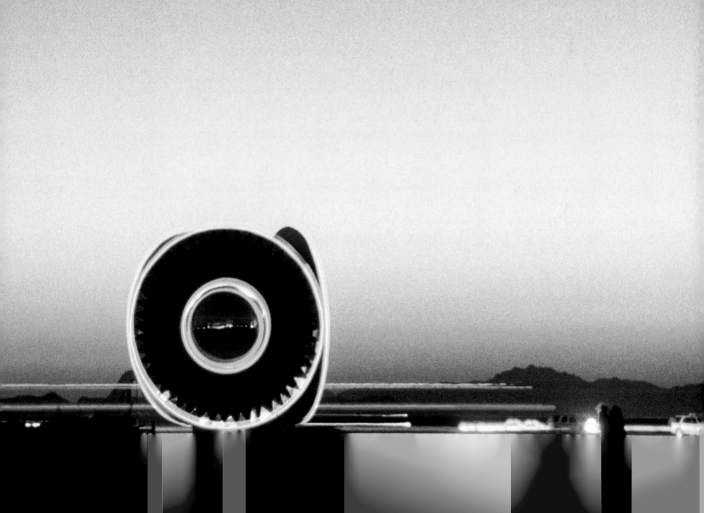

THAT FIRST TEMPLE
STIRRED UP
**STRONG
FEELINGS.**

"It wasn't like we planned it," says David Best. "Obviously we didn't plan it. You know, it's like if you put a cross on the side of the road where someone got hit, and there are people putting flowers on it."

Still, he thinks that something even deeper had happened. "The community had peaked, it had gotten as high as it could get in terms of a party," he suggests. "It had gotten as sophisticated as it could get in terms of health and safety. The thing they didn't have was a temple or a church. It's a necessity in that kind of culture to have a place for people to reflect. The Temple became a public service, like the porta-potties and the café. It's a necessity in a community to have that."

David had found a vein of untapped emotion at the festival. "I'm not spiritual. I'm not mellow," he insists. "I'm not any of the things that a person that builds a temple should be." He kept building the temples anyway. Over the next four years, he conceived bigger and more ambitious structures with names like the **TEMPLE OF TEARS,** the **TEMPLE OF JOY,** and the **TEMPLE OF HONOR.** And no matter how complex and huge they became, he burned each of them at the end of the festival. It felt like powerful magic.

When Ray Rogers went to Burning Man to visit his donated dinosaur parts, he was overwhelmed by how they had evolved. He saw all the people mourning. He saw other things too. "A couple got married in front of it and made love right in the dirt in front of it. I'd never seen that before," he recalls. Even in the midst of a gigantic party, the popularity of the Temple made sense to him. "You can't have life without death," he suggests. "Mexicans have the Day of the Dead, and they celebrate it. I think we're all messed up here.

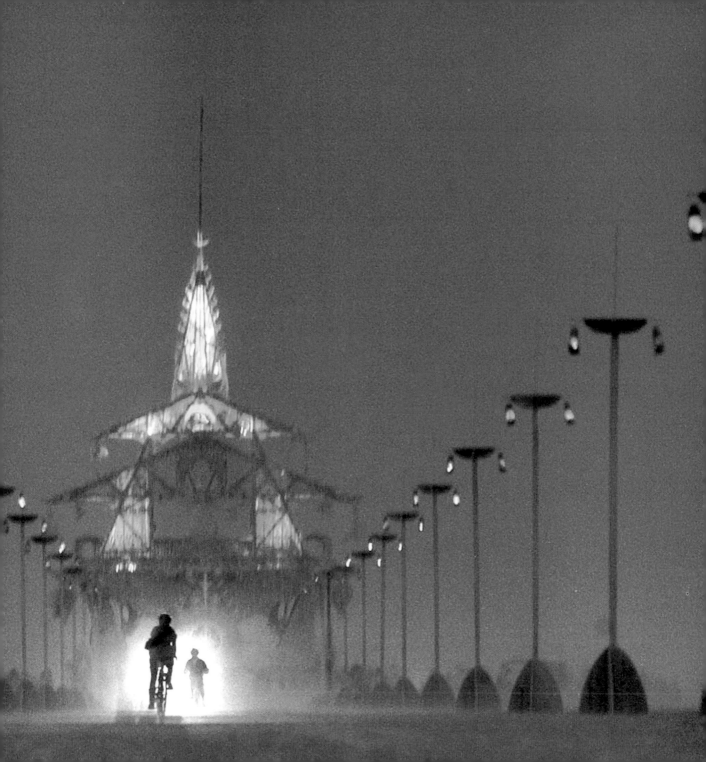

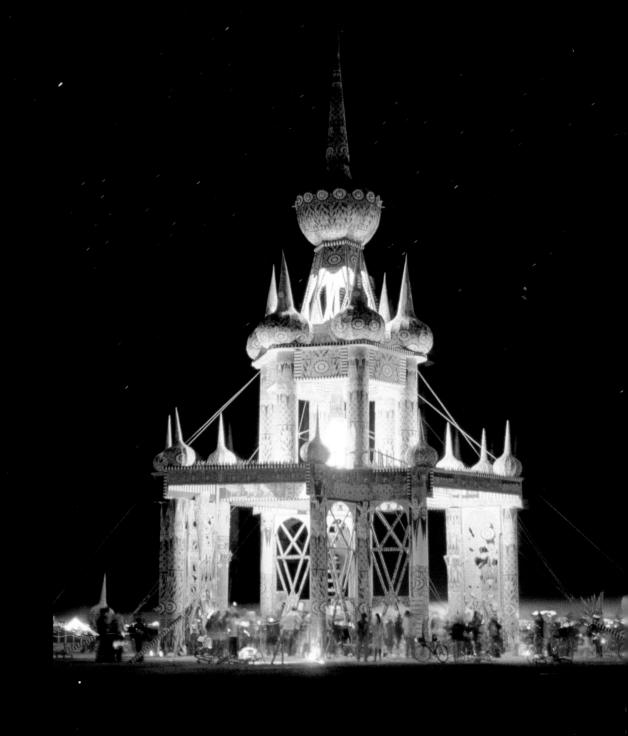

[Death] is part of life, but you can't talk about it." American soldiers, he notes, come home from Iraq in coffins that are kept from public sight. Grief is sequestered and hidden. Perhaps that's not the best way to heal things. "The common feeling is that there's hope," Ray says, describing the mood emanating from the Temple. "That's the common feeling at Burning Man."

As the Temple became a center of solace, a widening circle of burners wanted to be a part of it. Dozens of them emerged to join the construction effort. A guy called Fireman Dave showed up in 2001. Not long before, he had been called out on an emergency— A CHILD HAD FALLEN OFF A CLIFF—only to learn that the victim was his young daughter. He started working on the Temple. He would spend half a day building, and the other half weeping. In 2002 the *TEMPLE OF JOY* was dedicated to the victims of the September 11 attacks; it was also dedicated to his daughter.

The *TEMPLE OF JOY* also gave comfort to the *TUNA GUYS.* They'd lost a campmate, a Vietnam vet called Westy Bob who succumbed to hepatitis C, and divided his ashes. Half of the pile was shot from a cannon over the waters of Coos Bay (WHEN THE WIND SHIFTED, THE MOURNERS ENDED UP PICKING ASH FROM THEIR HAIR, BUT THAT'S ANOTHER STORY). The rest of the ashes traveled out to the desert. "We put his ashes in the Temple burn, and it was magic. It was truly magic," Cap'n Jim Peterson says quietly. Westy Bob had been a friend and, at one time, a deckhand on his fishing boat.

❝ THAT TEMPLE BURN, IT REALLY HELPS A LOT OF PEOPLE, I THINK, ❞ ADDS JIM.

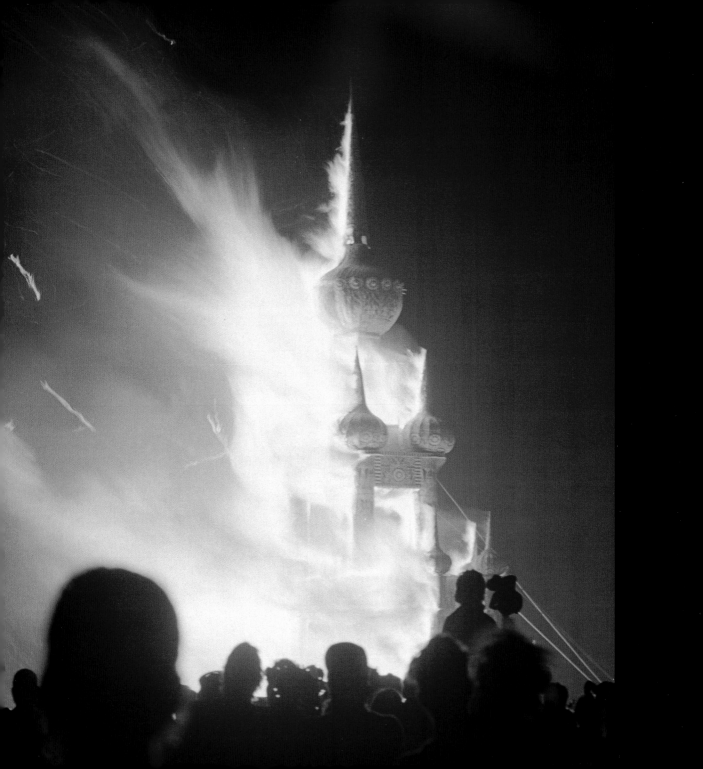

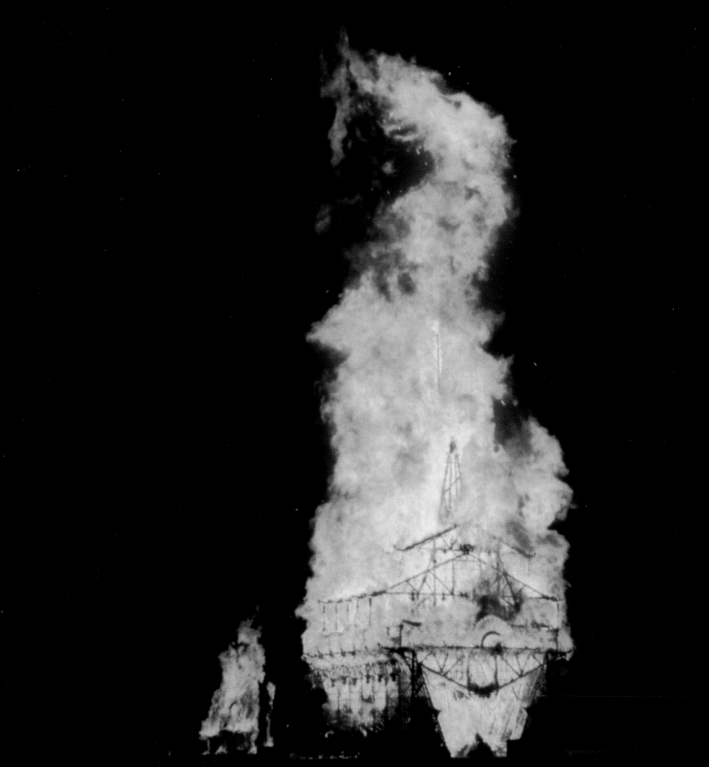

PREVIOUS SPREAD (LEFT): THE PAPER-BASED TEMPLE OF HONOR BURNS RAPIDLY.

PREVIOUS SPREAD (RIGHT): THE TEMPLE OF JOY GOES UP IN A TOWERING COLUMN OF FIRE.

TEMPLE OF STARS

CREW

Burning Man 2004

David Best retired from building temples on the playa in 2005. That job has been taken over by his crew, led by an artist named Mark Grieve, whose surname sounds eerily suited to the task. Meanwhile, David is working to broaden his temples' reach. He wants to build them outside of Burning Man, though adapting them to other environments has been tricky. He put one up in San Rafael to honor day laborers, and a landowner made him take it down, fearing an influx of "Nevada craziness." On Hayes Green in San Francisco, a second temple was met with enthusiasm, though police didn't understand the Burning Man tradition and arrested a young man they caught writing on it (THE CHARGES WERE LATER DROPPED). Of course, neither of these two temples was planned for immolation, and that's another tough change. Some of David's most moving experiences happened around those desert fires, and he still likes to tell the stories.

"So the Temple goes down," he begins. "I'm standing there exhausted and this guy in Eddie Bauer clothes, like a lawyer or a doctor—he's all clean, real clean, not a burner or a tattooed person—comes up to me and says, 'My son committed suicide and you set him free.'" David's eyes widen. "That we could make something out of scrap plywood that would make that person feel that his son was set free from some weird place in this world, and make *him* feel free . . ." He trails off for a moment.

66 What an incredible honor.
And it was like, this guy *believed* it.
I DON'T KNOW WHAT THE HELL WAS HOLDING HIS SON BACK.
BUT WHATEVER IT WAS,
HE FELT FREE. 99

LETTING GO

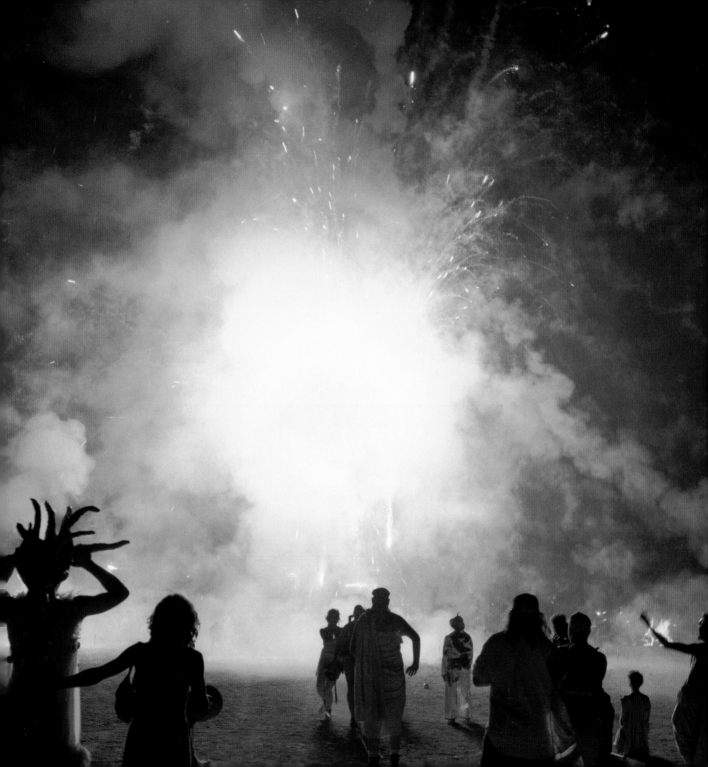

LEAVE NO
TRACE

THIS STORY HAS AN END IN ITS beginning. The figure of the Man was built to be burned. He was propped up so he could fall down, assembled to be undone. On Saturday evening his arms are raised from his sides. THEY STRETCH OVER HIS HEAD IN A CONQUERING **V.**

All day long burners have been milling around, visiting pieces of art that they haven't seen yet, knowing that it will all be gone soon. *Now the pace quickens.* People wolf down hastily prepared dinners and dig into crates of costumes, looking for one that hasn't been worn yet, something grand for the finale. They pull on hats and wigs, then lace up dusty boots. As the desert dims, everyone is getting ready.

THE 1998 BURN WOWS FESTIVAL VETERANS WITH LOUD, BLINDING BURSTS OF EXPLOSIVES. PYROTECHNICS AROUND THE MAN GOT BIGGER AND BOLDER THROUGH THE 1990s AS THE CROWDS GREW.

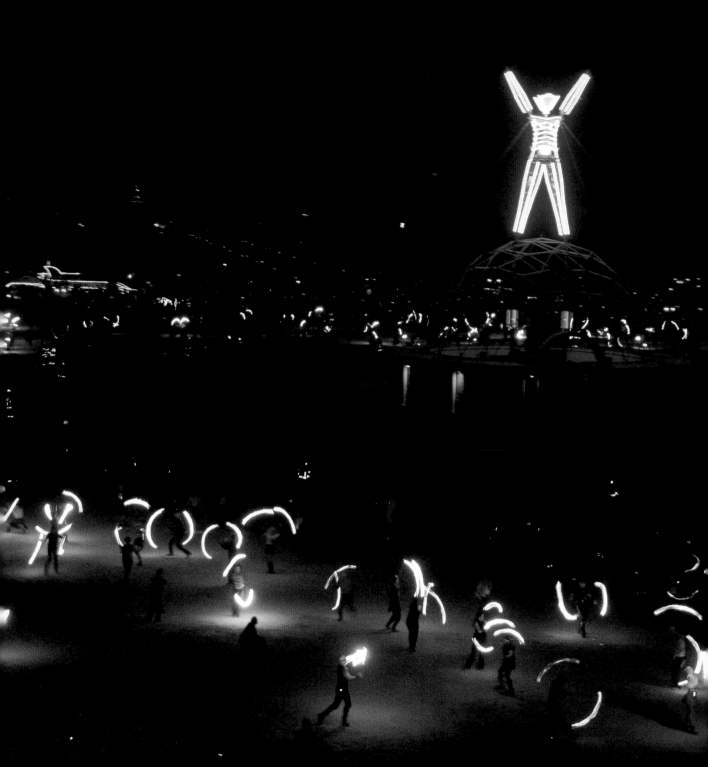

TIME ERRATIC IN BLACK ROCK CITY.

The week was full of languid afternoons and nights lived end to end. Cell phones and watches were hidden away. Now, however, the Man stands like a towering hourglass, and everyone knows what is about to happen. Some of them are already thinking about tomorrow's traffic. They are breaking down their own corners of the city, wrenching rebar from the ground and stowing away shade tarps. Others are hustling to arrive at the Man first and stake out a good view. Before long, the crowd is thick, filling in the space behind the early arrivals. This is the only spectacle that brings everyone together. Nearly forty thousand people are here, gathered around in a rough circle.

Back when Black Rock City was a smaller place, you could see the human hand that set the Man aflame. Different figures have kindled the blaze: a torchbearer, a fire-breather, a guy flailing around in a combustible suit, an archer with a flame-tipped arrow. Now the sparks seem to erupt from nowhere. First comes a barrage of fireworks. Then the Man ignites. You have seen this before: The blaze starts at his ankles and spreads slowly upward. After the fire engulfs his head, he has a few defiant minutes, standing and burning. Then the Man goes down. Throngs of people rush the center, as if to tackle him. But you can't tackle a bonfire; they just want to get close. A couple of folks toast marshmallows on the Man's remains. The rest knock around in a tight, jostling ring. If you stumble here, strangers will stop and pull you to your feet.

When the spectacle of the Man starts to fade, people amble off into the dark. Now the city feels like a wheel flung from its axle.

ON BURN NIGHT, FIRE-SPINNERS PERFORM FOR AN EXPECTANT CROWD AROUND THE MAN.

Attempts to navigate are haphazard, because the one big beacon is gone. Other parts of the city start to go too. Some artists set fire to their creations. Familiar landmarks are blotted out by smoke. Pranksters and souvenir seekers pull down the street signs, and suddenly it's harder to find your way back to camp. For many revelers, that doesn't matter; there's no going home now. They'll stay up dancing and wandering until the night recedes and the wine is just a headache.

At sunrise, wisps of smoke are still rising off the desert. A few sleepers sprawl in the dust. There's a wide patch of ash where the Man fell, and a handful of relic hunters kneel to sift through the heap, looking for bolts, scraps of wire, and melted neon tubes. The pile is still full of embers, and they dig into it with sticks, a rake, a pair of salad tongs, looking for souvenirs. Some of them build impromptu sculptures from the wreckage and leave them there. The rest brush dust from their artifacts, squint at them in the sunlight, then tuck them away.

BY MIDMORNING THE CITY IS **AWAKE.** Thousands of bleary-eyed burners start pulling down their tents. They wobble around on bicycles, visiting friends they may or may not see again, exchanging bear hugs and e-mail addresses. Campsites are scoured for stray trash. Cardboard, wood scraps, and any other garbage that can be incinerated gets dragged out to the burn platforms. Other refuse is bagged and crammed into cars. Bafflingly, the bags take up more space than the original supplies did, and they promise a smelly ride back to civilization.

Some people wait another day before they leave. The Temple will burn tonight, after the city has thinned out. That gathering is a simpler show. There are no fireworks, just flames. A subdued

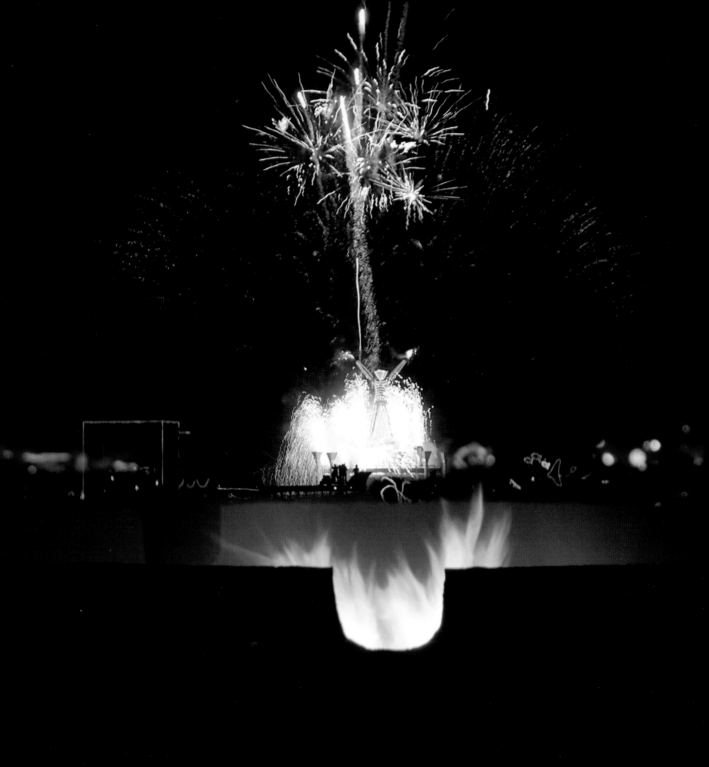

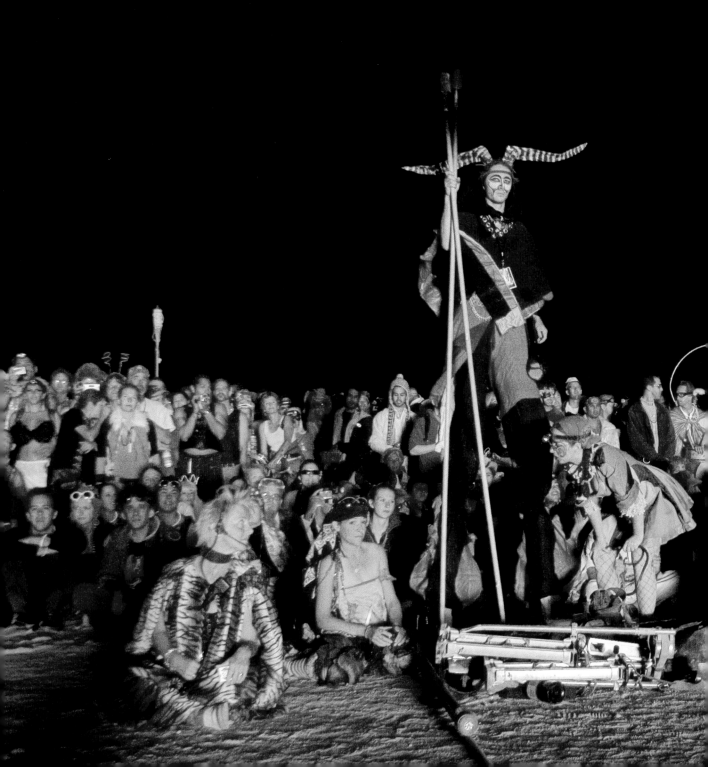

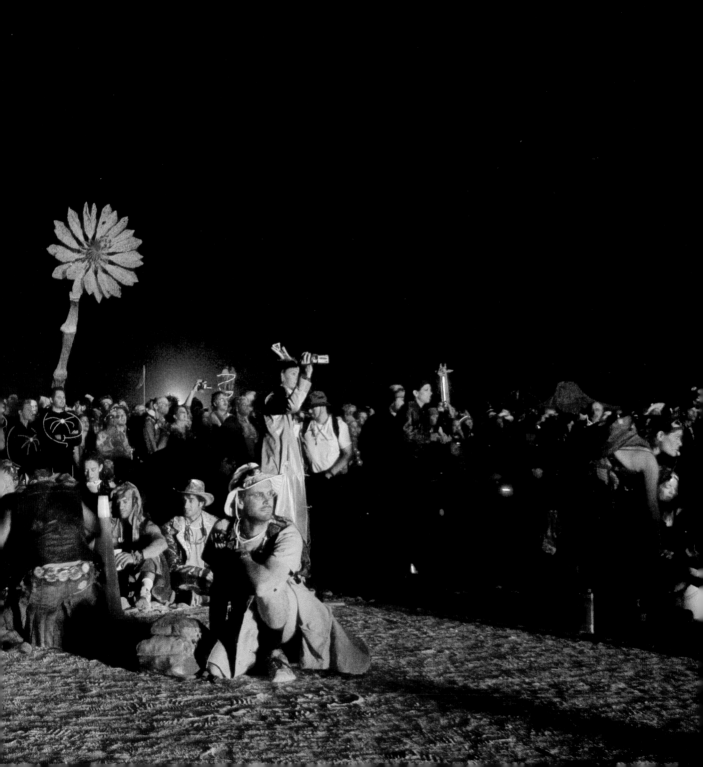

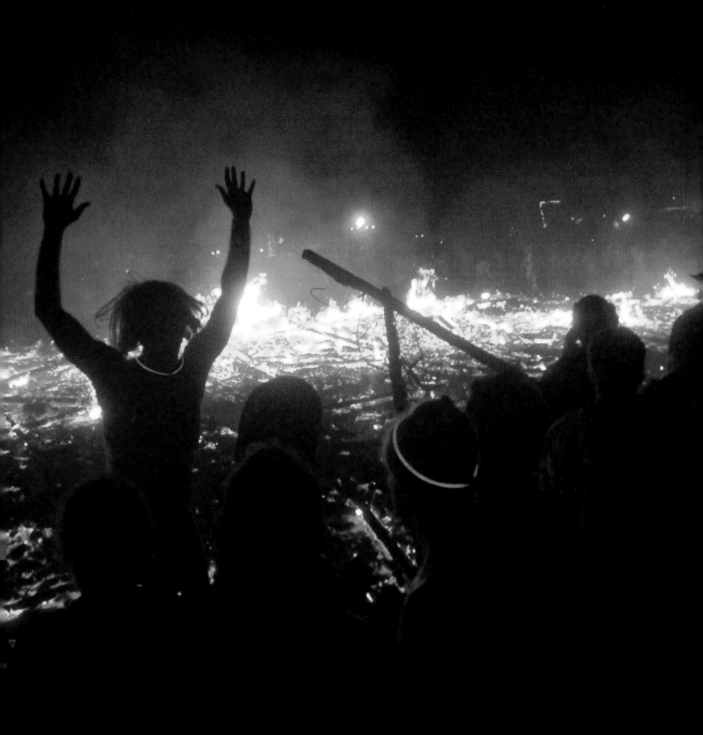

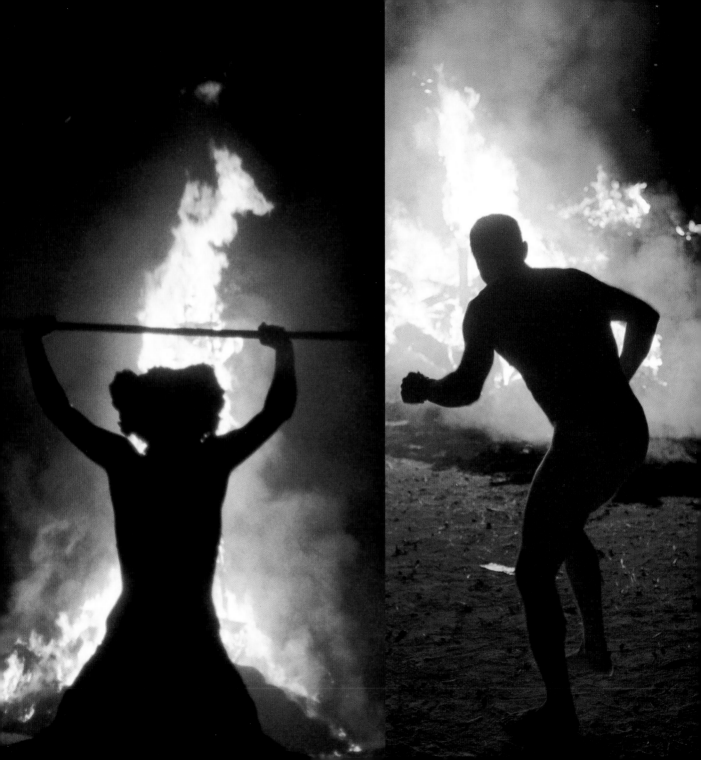

crowd will watch as the structure is consumed, along with all the notes and pictures left inside it.

Long lines of cars stretch in every direction. Burning Man Information Radio hosts live traffic reports, which implore outbound burners to drive slow, be patient, stay in camp a bit longer to miss the worst of it. Thousands of cars are funneled down to a single lane. Volunteers for the departure process, called Exodus, brandish stop signs and flags in the heat. There's a little outpost where people are collecting leftover provisions, which one map sarcastically labels the **"DPW EXTORTION AREA."**

In the weeks that follow Burning Man, around seventy members of the DPW will stick around to scour evidence of the city from the playa, fulfilling the ecological mantra of

LEAVE NO TRACE.

First the reusable building blocks of the city—from individual lampposts to the massive Center Camp Café—will come down. Then the entire site will be painstakingly picked over for trash, which ranges in size from miniscule (BITS OF GLITTER AND PISTACHIO SHELLS) to infuriatingly large (ABANDONED SOFAS OR BICYCLES). Burners are expected to leave immaculate campsites; some do a better job of this than others. A few succeed in the desert but fail on the road, where poorly tied garbage bags liberate themselves from the roof racks of their speeding cars. The bags end up sitting beside the highway like plump, plastic tumbleweeds and become another chore for the DPW.

LEAVE NO TRACE

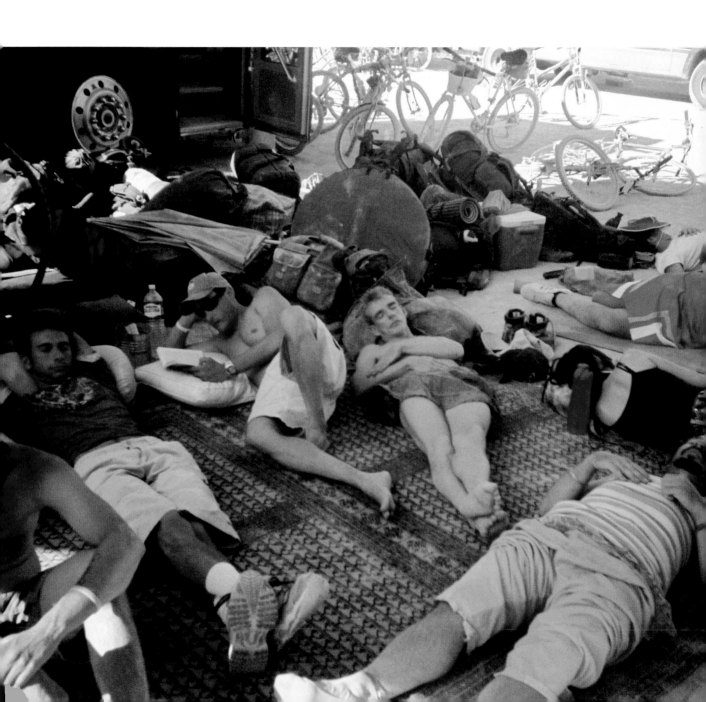

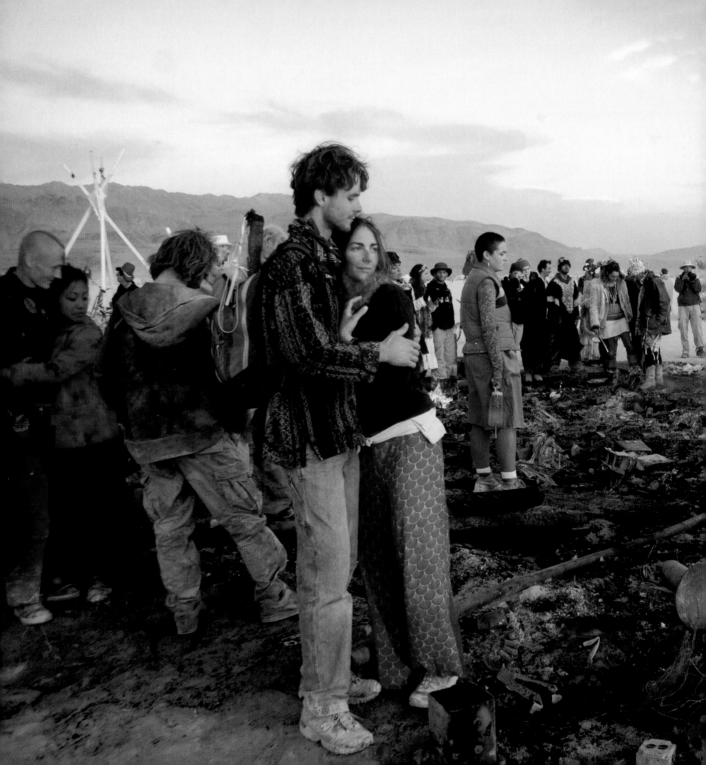

Cleaning up is a grubby job with little margin for error. The federal Bureau of Land Management inspects the site twice after the event, sweeping over transects of dust on a hunt for leftovers. "You pick up every piece of foreign material that's on the ground, any kind of piece of plastic, or little piece of wood, or nails," explains Dave Lefevre, an outdoor recreation planner for the BLM. "Mostly all we do find are very little things. Every now and then, we'll find a tent stake that was driven in deep, and they missed it during cleanup, but generally, we go through and look at all the little stuff, and we have a standard that they need to meet for the average of all the plots [of land]. It's a pretty tight standard, and we just tightened it," he says. "It's about twice as tough now, and they're still only halfway there."

"Making it go away is magic," says Tony "Coyote" Perez, the DPW site manager. "It chokes me up every time." Making the volunteers go home will also be a challenge. They develop a bond to the place and to each other, but when there's nothing more to be done, they'll have to leave like everyone else. And Tony explains, laughing, **"**I always say, **'TAKE OUT YOUR DRIVER'S LICENSE.**
LOOK AT THE ADDRESS.
GO THERE.'"

For most festivalgoers, the process of leaving Black Rock City is arduous. Sometimes they wait for hours, as cars crawl to the gate and get released in staggered groups, to lessen the volume of traffic on the highway. Finally the desert turns into blacktop, where passengers wave and blow kisses to the last of the Exodus crew, or breeze right past them, eager to be under way. Then the procession winds into Gerlach, where students are washing dusty cars for a fund-raiser; through Empire, where burners flock to the store for sandwiches; all the way to Reno.

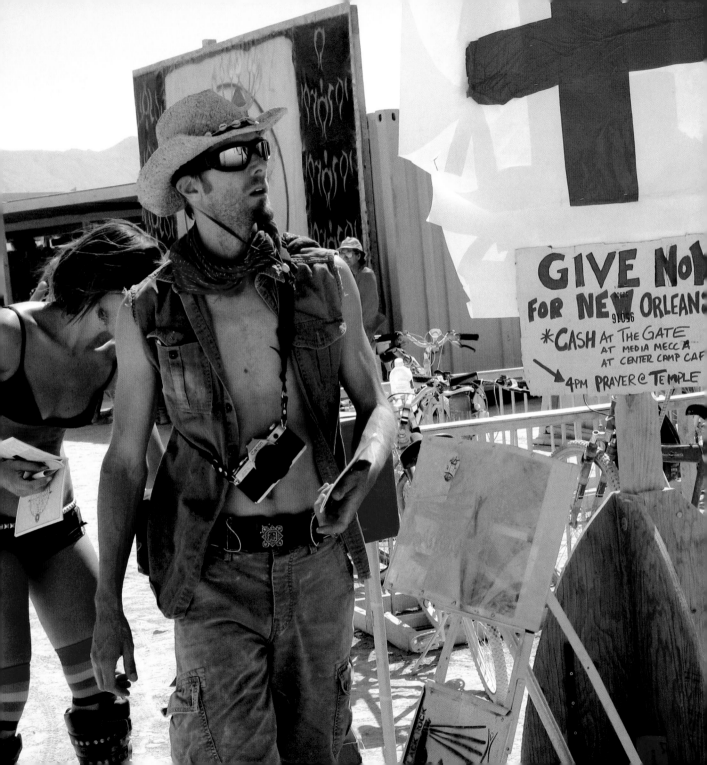

GIVE NO[W]
FOR NEW ORLEANS
*CASH AT THE GATE
AT MEDIA MECCA
AT CENTER CAMP CAF[E]
→ 4PM PRAYER @ TEMPLE

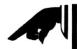

IN 2005 THE FESTIVAL'S MEDIA KIOSK BECAME A HUB FOR POST-KATRINA INFORMATION AND FUND-RAISING.

After a week in the desert, re-entry feels strange. Layers of dust and sunblock lift off your skin in the shower, clouding the water around the drain. There are newspapers to read, phone calls to return, dozens of missed e-mails. The old reflexes return slowly, and you need to remind yourself about little things, like looking both ways before you cross the street. Burners have a lexicon for describing culture shock. You are returning to "the default world." You are "decompressing." You are suffering from a severe case of "the reality bends" or "post-playa depression." The afflicted tend to vent their feelings by telling endless Burning Man stories to friends or anyone else who will listen. Do this for too long and they will think you have joined a cult. Some people try to delay the emotional hangover, the weird quietness that comes when the adventures are done.

In early September, when the festival has just ended, there's a list that often makes the rounds by e-mail. Anonymously composed a few years ago, it's called **"How to Experience Burning Man in the Comfort of Your Own Home."** People keep adding to it. The list includes such suggestions as: ●●

STACK ALL YOUR FANS IN ONE CORNER OF YOUR **living room.** TURN THEM ON **FULL. DUMP A** vacuum cleaner bag IN FRONT OF THEM.

SET UP A **DJ SYSTEM** DOWNWIND OF A **3-ALARM FIRE.** PLAY A SHORT LOOP OF **DRUM 'n' BASS** UNTIL THE EMBERS ARE COLD.

SPRINKLE DIRTY SAND IN **ALL** your food.

SPEND THOUSANDS OF DOLLARS ON A **DEEPLY** PERSONAL artwork. **HIDE** IT IN A **FUNHOUSE. BLOW** it up.

Throw a **SPRAWLING, DRUNKEN, WEEK-LONG PARTY.** SPEND THE NEXT **5** WEEKS **METICULOUSLY CLEANING** EVERY SQUARE INCH OF YOUR HOUSE.

●●●●●●●●●●●●●●●●●●●●●●●●●●●●●●●●●●●●●
●●●●●●●●●●●●●●●●●●●●●●●●●●●●●●●●●●●●●
●●●●●●●●●●●●●●●●●●●●●●●●●●●●●●●●●●●●●

A COUPLE KISSES AT SUNRISE.

OPPOSITE: WHEN BURNING MAN IS DONE, A LINE OF TRUCKS AND CARS STRAGGLES AWAY FROM THE DESERT.

The strategies are good for a laugh. None of them, however, seem likely to cure the weird ache of alienation that settles in when Black Rock City is gone. Getting back takes adjustment. The sky feels narrower after you leave the desert. The endless views give way to layers of buildings and tangled highways.

There are routines to follow.

And for a few weeks, LIFE AT HOME CAN FEEL CRUSHINGLY,

EVEN EMBARRASSINGLY,

MUNDANE.

TWO OF THE THREE HUMAN FIGURES IN LEAPING GIANTS, AN INSTALLATION BY KAREN CUSOLITO AND DAN DAS MANN, REACH SKYWARD.

AFTERGLOW

A DOZEN PEOPLE

were hanging around Diva Boot Camp when they heard New Orleans was gone.

"This woman came by who was covered in piercings and rough tattoos, and she was hysterical, really upset," recalls Seth Schoenfeld, a general contractor from San Francisco. The woman wandered into Seth's camp—MARKED ON THE ESPLANADE WITH A TWO-STORY OBSERVATORY THAT LOOKED LIKE A YELLOW PLATFORM BOOT; IT WAS HARD TO MISS—and told them that her hometown was underwater. There was a hurricane, the levies overflowed, and now federal bureaucrats were wringing their hands while people were hungry, stranded, drowning, homeless.

News of the outside world is hard to come by at Burning Man. Rumors pass from camp to camp, and half of them start off as pranks. (DID YOU HEAR THAT MICHAEL

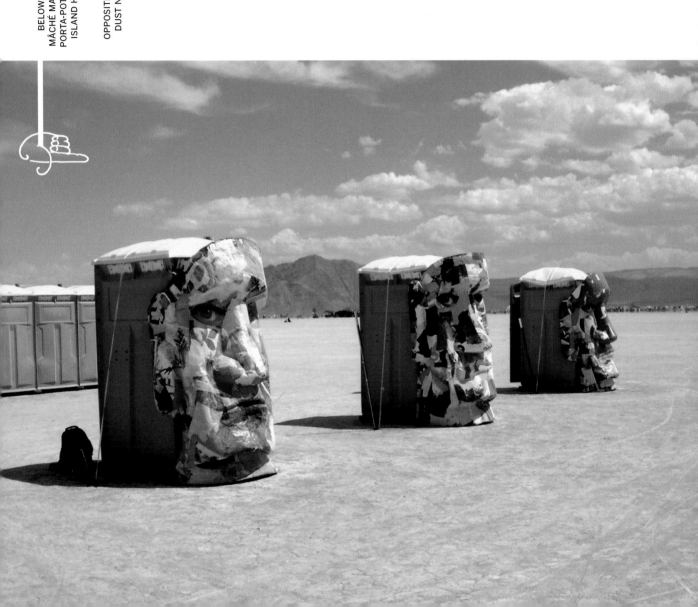

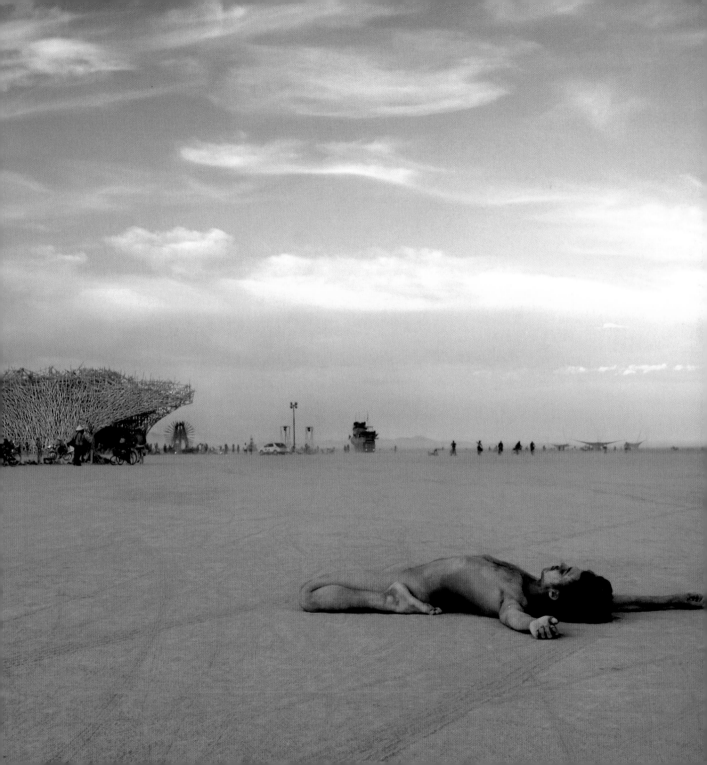

JACKSON GOT SHOT? THAT JENNA BUSH IS HERE? THAT THE POLAR ICE CAPS HAVE MELTED?) But this was the summer of 2005, and disaster reports that had already saturated the rest of the country were spreading slowly in the desert. Burners huddled around newspaper clippings at Center Camp Café. ..

.......................... SUDDENLY

BLACK ROCK CITY

FELT *EVEN* *MORE*

REMOTE

THAN U S U A L.

"To hear that there were so many people just trying to live their own lives, whose lives have been destroyed, while I was out in the desert wearing clothes I'd never wear again, and using things that I throw away later, and just making garbage, and flushing money down the toilet, was like . . ." Seth trails off. "It was very humbling."

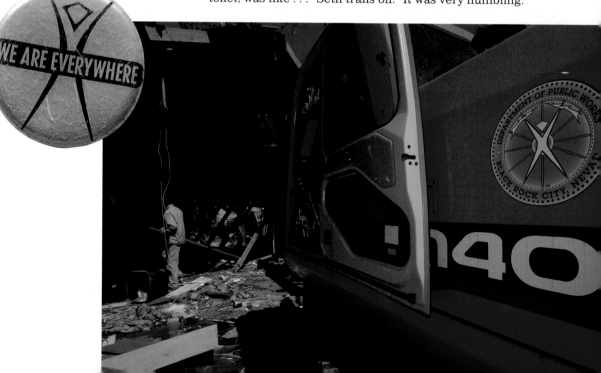

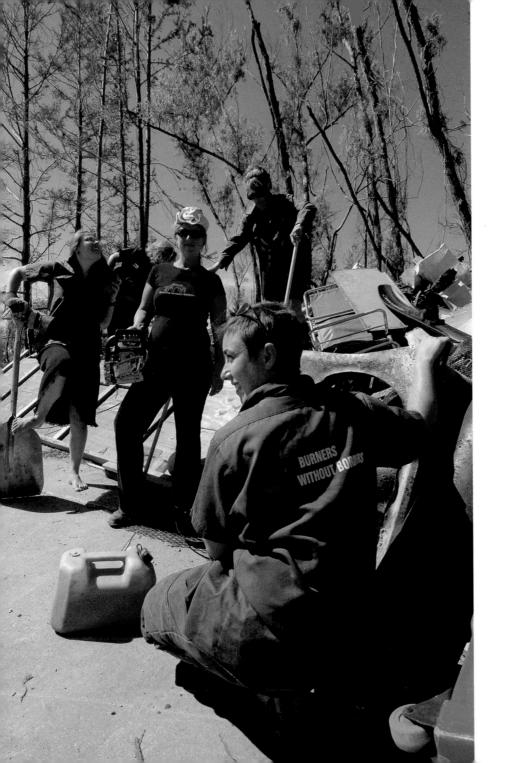

OPPOSITE: AN EXCAVATOR—BEARING THE PROUD DPW LOGO—HELPS CLEAR THE DEBRIS LEFT BY HURRICANE KATRINA.

CREW MEMBERS IN MISSISSIPPI TAKE A BREAK FROM POST-KATRINA DISASTER RELIEF JUST LONG ENOUGH TO MUG FOR THE CAMERA.

A few weeks after the festival ended, Seth went down to Mississippi, where some burners were starting a new art project: renovating a ruined Buddhist temple. Vietnamese immigrants in Biloxi had spent almost two decades raising enough money to build the temple. The day after it was consecrated, Hurricane Katrina bore down as the monks prayed inside. A Burning Man crew set to work repairing it in mid-September, using bulldozers and cranes that were still covered in desert dust. Their campsite was a sprawl of tents, bicycles, tarps, and generators. A geodesic dome sheltered their twenty-four-hour free supermarket, which was stocked with donations and open to the neighborhood. They called their compound Camp Katrina. The crew also got a name: ***BURNERS WITHOUT BORDERS.***

"Burning Man resourcefulness, in terms of building someplace livable out of a very harsh environment, was very much there. The only thing missing was the party. The art, the drugs, the party, the sex," Seth says. Laughing, he adds, "It's not like I have sex at Burning Man anyway. I really don't. In the desert, it's kind of gross."

The Burners Without Borders team completed the temple, demolished sixty houses, and hauled away tons of debris, working first in Biloxi, then building a more elaborate camp in Pearlington, near the Louisiana border. New volunteers arrived, exhausted ones left; at any time the crew numbered between twelve and twenty people. Every Saturday night they burned artwork made of scraps salvaged from the disaster around them. This went on for nearly seven months. And then, in early April, there was just an empty parking lot where their camp had stood. They'd packed up and scattered to homes across the country.

Camp Katrina was not your average post–Burning Man reunion, but it's a particularly compelling example of how the festival seeps out into the world. In a typical year, burners convene at dozens

Epilogue: AFTERGLOW

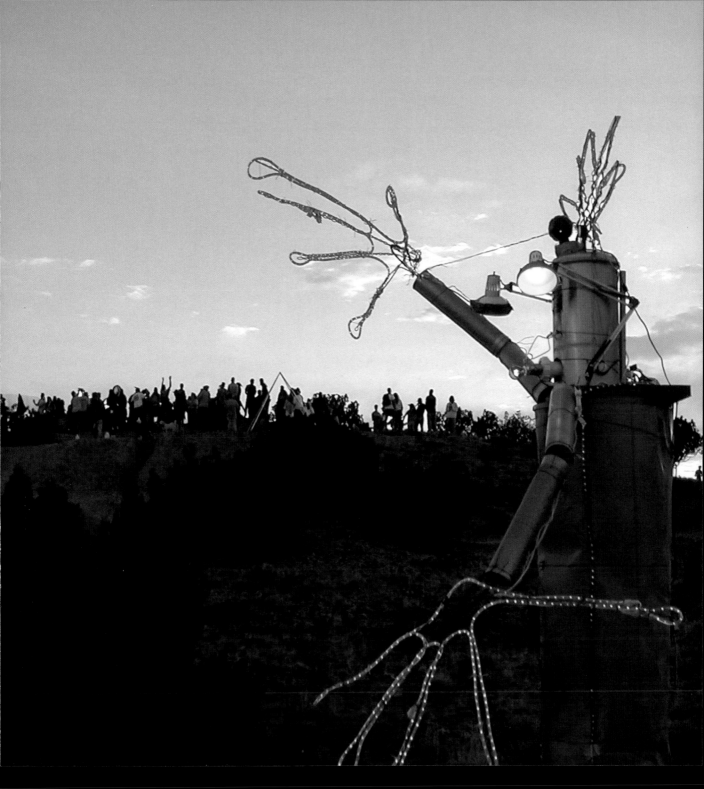

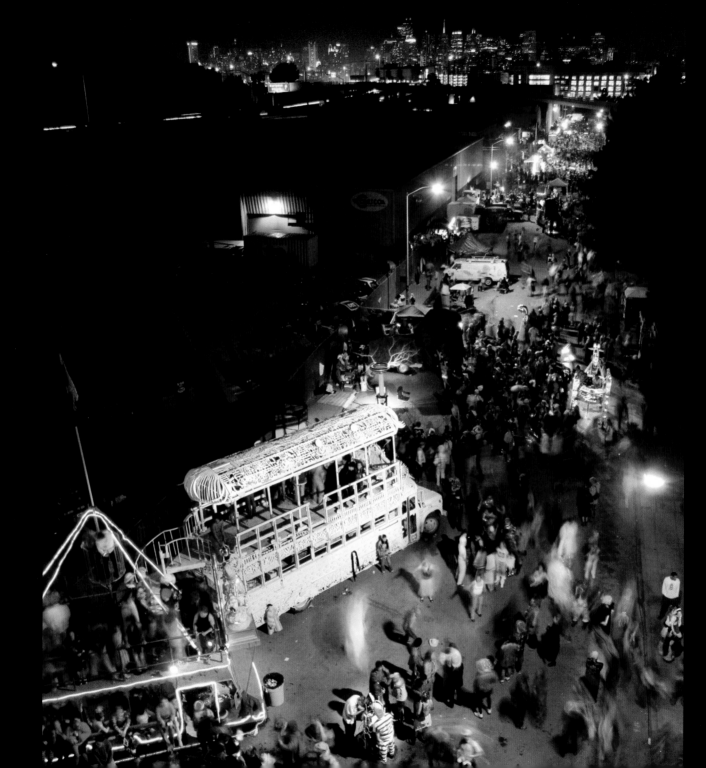

of local gatherings after leaving the playa. They throw Decompression parties, nights of revelry and nostalgia held each fall in warehouses, clubs, and streets from Los Angeles to New York, London, and Tokyo. Each spring they organize regional burns, small offshoot festivals that fill long weekends and attract hundreds of campers, who usually torch a big wooden sculpture when they're through. Sometimes they burn a man, but the effigy is just as likely to be a pony, a monkey, or a giant wine glass. The largest of these events, Burning Flipside, began in 1998 and now draws 1,500 people to the hill country west of Austin, Texas, where they build a temporary city called Pyropolis each Memorial Day weekend. Regional burns happen across America and beyond. In recent years they've cropped up in Spain, where European burners hold a festival called Nowhere, and New Zealand, home of the Kiwiburn.

Burning Man has become a social nexus for far-flung friends, even during the fifty-one weeks of the year when Black Rock City doesn't exist. They do things together. In the months following September 11, a group of them made burn barrels. They hauled the elaborately cut oil drums down to the World Trade Center site and sparked them up for the workers, who had already started gathering around bonfires to ward off the chill.

When they're not getting together, burners have lively discussions online. They prank each other, building fake websites to announce that Black Rock City has been bought out by MTV or become part of **AN ALL-INCLUSIVE VACATION PACKAGE**

COMPLETE WITH *Meals, a Tour Guide,*
"Trading Trinkets!"
Your Own Air-Conditioned Tent!
And Front-Row Seats
for the Burn!

ONLY
$1,400

345

On sites like Tribe.net and ePlaya, Burning Man's online bulletin board, burners swap stories and brainstorm art projects. Quite often, they also argue about the nature of the event that brings them together. They write sharp polemics and meandering manifestos, debating each other with an intensity that often surprises (AND SOMETIMES ALIENATES) the uninitiated. Has Burning Man gotten too big? Too tame? Too saturated by cops, reporters, or day-tripping tourists? Is the event too insular? Or is it getting too distracted by outside politics and problems? Why does it attract a predominantly white, well-educated crowd? Does this year's theme suck? Are we about art or community, and can the two really be separated? Should the punks kick out the ravers, then barbecue the hippies? Some of the most contentious topics touch on how the event is run. Are the people who organize the festival (KNOWN TO THEIR CRITICS AS THE "BORG," A CONTRACTION OF "BURNING MAN ORGANIZATION" THAT REFERS TO THE ALL-ASSIMILATING BAD GUYS ON **STAR TREK**) too heavy-handed? Are they trying to take over the world?

Their altercations took a new tone in 2003. In California, folks were preoccupied by the recall election that made Arnold Schwarzenegger their governor. Tensions were swirling around the fate of George W. Bush, who was running for his second term in the upcoming presidential election, promising a future that,

to put it mildly, did not appeal to most burners. And that was the year John Perry Barlow—A FORMER LYRICIST FOR THE GRATEFUL DEAD, THE COFOUNDER OF THE ELECTRONIC FRONTIER FOUNDATION, AND A LONG-STANDING BURNING MAN DEVOTEE—delivered a jolt to the desert faithful. In a missive titled **"From Burning Man to Running Man,"** he wrote:

> "IF SOMEONE LIKE **KARL ROVE** *had wanted to neutralize* THE **MOST CREATIVE, INTELLIGENT,** AND **PASSIONATE MEMBERS** OF HIS **OPPOSITION,** HE'D *have a hard time coming up* WITH **A BETTER TOOL** THAN **BURNING MAN. EXILE THEM** TO THE **WILDERNESS, GIVE THEM** A **CULTURE** *in which alpha status requires* **MONTHS** OF **FOCUS** AND RESOURCE-CONSUMPTIVE **PREPARATION, PROVIDE THEM** WITH METRIC TONS OF **PSYCHOTROPIC CONFUSICANTS,** AND THEN . . . **IGNORE THEM.** IT'S *a pretty safe bet that* **THEY WON'T** BE OUT **REGISTERING VOTERS,** OR **DOING ANYTHING** *that might actually* **THREATEN ELECTORAL CHANGE,** *when they have an* **ART CAR** TO **BUILD.**"

Toward the end of the dispatch, he added a conciliatory note:

> "*Lest there be any misunderstanding,* I HAVE NOT BECOME **ANTI—BURNING MAN.** IT WILL *probably remain* ON MY **LITURGICAL CALENDAR** NEXT YEAR, *as will a few other* **COUNTERCULTURAL HOEDOWNS.** *As I've said before,* I'M WITH **EMMA GOLDMAN,** WHO SAID, 'IF I CAN'T DANCE, I WANT NO PART OF YOUR REVOLUTION.' *But while I believe* THAT DANCING IS A **REVOLUTIONARY ACT,** *it is clear to me that* WE CAN'T SIMPLY **DANCE THIS DARKNESS** OUT OF **OFFICE.**"

Some burners took his argument for treason, while others found it resonant. In any case, John Perry Barlow got to dance the following summer. He went to New York City, where he orchestrated random outbreaks of hip-shaking outside of the Republican National Convention. Then he flew out to catch the last few days of Burning Man.

And so the debate continues. Should burners groove their way into grassroots politics? Should they organize more efforts like Camp Katrina? Are they doing all these things already, just in contexts that don't bear the Burning Man brand? Many people believe Burning Man has changed their lives. What they can do with that feeling after the festival, and whether they should do it together, has always been less clear.

Larry Harvey wants Burning Man to become a movement. The goal is somewhat vague. It is not, he has suggested, about pushing a political ideology; more about spreading values like creative expression and community building. Whatever it is, he wants it to be big. "Our ambitions are immense," he says. "What I tell staff is: 'Where we are right now, in relation to the future ten years down the road, is like [Baker Beach] compared with the event today.' And I mean it." Encouraging the spread of Burning Man regional events, like Flipside and Nowhere, is one prong of this strategy. So is the Black Rock Arts Foundation, the festival's non-profit arm, which awards grants for interactive art across the country. And Burners Without Borders, if it takes off, also figures into that picture.

"I've got a ten-year plan to create a think tank," Larry adds. "I want to do what the Right did. Let's publish! Let's affect the opinion-making class, who affect finally the news anchors, and whether they smile or sneer, or what story they choose to report.

Epilogue: AFTERGLOW

That's how it's done.
THAT'S HOW YOU
M O V E
the world.
It's a lot of work, but we can

that."

Larry often projects a kind of mellow drowsiness. When he says these things, however, he looks like he might leap from his chair, fling open the windows of his small San Francisco apartment, and declaim his visions to the passersby down in Alamo Square.

He is aware that it all may sound a little crazy. "I'm still talking in the same yeasty, grandiose way I was to begin with," he says, softening. "The only difference now is that people listen now, and think, 'Well, maybe.'" After all, no one thought Burning Man would last this long. No one knows what to make of it: Larry starts torching a stick figure with his friends on Baker Beach, and some two decades later, he's the de facto mayor of a temporary city of almost forty thousand people. You can't argue against the craziness of that.

But when he starts talking about movements, some folks think that Larry's all hat and no cattle. Getting nonconformists to rally around a symbol as malleable as the Man is one thing; lining them up behind a banner is another. And if they don't want to go there, it's unlikely they can be lured. Already they have expressed fears that the event is becoming a franchise; that its rampant, oddball creativity will calcify into a credo; that its opposition to dogma will get, well, dogmatic. Finally it all comes back to the same question, the one about whether Burning Man has grown too big.

That concern has hung in the air for a long time. In 1996 there were eight thousand people in Black Rock City. That was twice as many as the year before, and the unease was so palpable that even the LOS ANGELES TIMES took note:

> **66SOME MOURN THE POPULATION EXPLOSION . . .**
> *as an influx of* **PASSIVE, SLACK-JAWED GAWKERS**
> **AND THE DEATH OF BURNING MAN COOL,99**

read the article. Presciently, it also suggested,

> **66LIKE A VIRUS MORPHING TO SURVIVE,**
> **[BURNING MAN] IS MUTATING AND GROWING**
> *in the face of* ALL THE FORCES
> THAT WOULD **KILL IT.99**

Longevity once seemed impossible. The event was too dangerous, weird, and impractical to last. But all that "morphing" and a bit of good luck have kept it alive. In 2006 the federal Bureau of Land Management issued the festival its longest lease ever: a five-year special event permit, which will allow it to continue in the Black Rock Desert through 2010. Now that the event's survival has been assured, people have more time to mull what forms the future will take.

The event is still evolving. It raises questions faster than they can be answered. After two decades, people still care deeply about the strange metropolis they've created, even if they can't agree on what it is, or what it means, or if they should bother to define it at all.

There's always been a bit of a Vegas attitude surrounding Burning Man: What happens in Black Rock City, stays in Black Rock City. But how could it? Nothing stays in Black Rock City for long. It's around for a week each year, then it disappears. The only traces that remain are the scraps people bring home: pictures, trinkets, maps, sunburns, and stories.

When everyone else has left, the DPW clears away the remains of Burning Man. The last thing they take down is the fence. Seven miles of stakes and orange netting hemmed in the festival. Now it's a circle with nothing inside. When they uproot it, the patch of dust where Black Rock City stood will dissolve back into the desert. The blankness will stretch unbroken for miles.

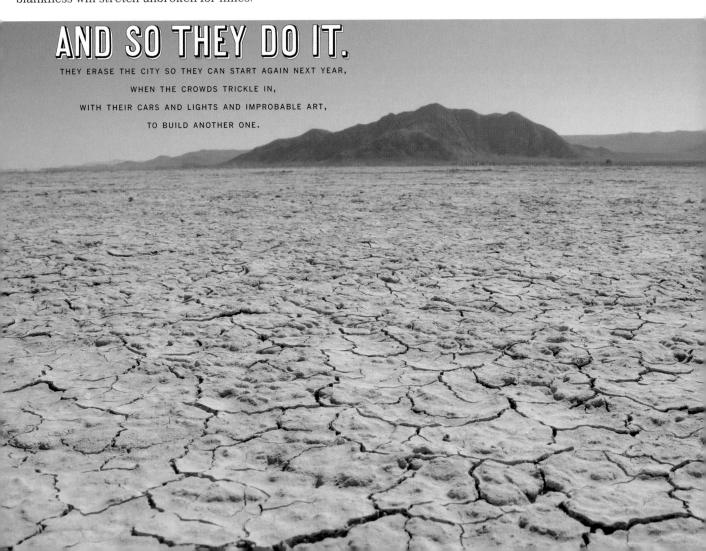

AND SO THEY DO IT.

THEY ERASE THE CITY SO THEY CAN START AGAIN NEXT YEAR,

WHEN THE CROWDS TRICKLE IN,

WITH THEIR CARS AND LIGHTS AND IMPROBABLE ART,

TO BUILD ANOTHER ONE.

A COUPLE HUNDRED PEOPLE shared their time, tales, photographs, troves of artifacts, and coffee with me to make this book happen. I'm grateful to everyone who helped, and I hope they see their experiences reflected here.

Special thanks are due my agent, Paul Bresnick, and my editor, Tricia Boczkowski, who set this project in motion with the support of publisher Jennifer Bergstrom.

Martin Venezky—part book designer, part whirling dervish—built intricate patterns from a wild palette of pieces. Greg Kirmser tackled photo research with enough energy to beat a California blackout.

The crew of the Burning Man mother ship—in particular Larry Harvey, Maid Marian (MARIAN GOODELL), Danger Ranger (MICHAEL MICHAEL), LadyBee (CHRISTINE KRISTEN), Actiongrl (ANDIE GRACE), and Dave X—fielded my questions with openness and good humor, and granted access to the festival archives.

Dale Maharidge and Douglas Wolk, two of my best friends and favorite writers, read early drafts. Both of them took breaks from their own book projects to lend insight to mine, and I am indebted to them. Michael Evans, Wes Simpkins, Chris Hackett, and Stephanie Zola all helped me keep my head together, as did Team Bruder, my family.

I'd also like to thank the whole flock of *FLAMING LOTUS GIRLS* (IN PARTICULAR, REBECCA ANDERS; POUNEH MORTAZAVI; CHARLIE GADEKEN; ROSA ANNA DEFILIPPIS; CAROLINE MILLER; AND LYNN BRYANT, THE GIRLS' GRAPHIC DESIGNER EXTRAOR-DINAIRE), the mighty MegaVolts (INDIVIDUALLY AUSTIN RICHARDS, JESSICA HOBBS, JOHN BEHRENS, AND WILL KELLER), the entire school of Tuna Guys (INCLUDING JIM AND BETTY PETERSON, SHARON "MOM" CUNNINGHAM, AND RICHARD JONES), the Thunderdome's brave bruisers (ABOVE ALL, MARISA LENHARDT AND DAVID KING), the stalwart sailors of *LA CONTESSA* (ESPECIALLY HELMSMEN SIMON CHEFFINS AND GREG JONES), and the crowd-pleasing cast of the Mutaytor.

And David Best, John Law, Annie Coulter, Rosanna Scimeca, Fred Hagemeister, Mark McGothigan, Paul Madonna, Jeff Wood, Athena Demos, Katherine Chen, PISS CLEAR editor Adrian Roberts, the Madagascar Institute, Ray "Rat" Leslie, and the delightful denizens of Groovig and Illumination Village.

Finally, I'll thank the Invisible Man, an offstage provocateur and fearless friend, who knows who he is and what all this nonsense really means, though he's not telling. . . .

Photo Credits

Photographers

Dan Adams / danjadams@charter.net

Ted Beatie / tcb@phoenixnest.org

Tom Bodhi Reeves—Blink!
 www.cleu.org/blink

Zac Bolan / zbolan@mac.com

Jessica Bruder / jessbruder@gmail.com

Dan Coplan / www.dancoplan.com/photo

Rick Egan / netmoser@aol.com

Charles Evans Jr.
 charlie@acappellapictures.com

Steven Fritz / SFritz2994@aol.com

Gabe Gross / gabe.j.gross@gmail.com

NK Guy / www.burningcam.com

Richard Hammond

Stewart Harvey

Kristin Helgason
 kristin.helgason@gmail.com

Casey Henkel

Cheryl Herman
 cherman@randomhouse.com

Richard Jones

Gabe Kirchheimer / gabekphoto.com

Christine Kristen
 ladybee@burningman.com

Stephen Llewellyn / spl888@gmail.com

Tomas Loewy-Lansky / tomas@coolpool.us

Kevin Meredith
 www.analogintelligence.co.uk

Caroline Miller (mills)
 mills@flaminglotus.com

Fabian Mohr / www.fabianmohr.de

Irene Neumansky
 irene@madmadscientist.com

KK Pandya and Burners Without Borders
 burnerswithoutborders.org
 kkpandya@gmail.com

Thomas K. Pendergast
 tpenny737@yahoo.com

Keith Pomakis
 pomakis@pobox.com

George Post / gpp@lmi.net

Kate Raudenbush
 kateimages@earthlink.net

Kevin "Kevissimo" Rolly
 Kevissimo@Kevissimo.com

Eric Slomanson
 slomophotos@earthlink.net

bucky sparkle / zygoticbucky@gmail.com

Tim Timmermans
 www.timtimmermans.com

Brian W. Tobin / brian@brianwtobin.com

T.P(W.T.t.P)
 hero@actionadventuresquad.com

Tania Wolfe / jonathan@skydyes.net

Mike Woolson / mike@jumbobrain.com

Joe Zarate-Sanderlin
 jofezasa@gmail.com

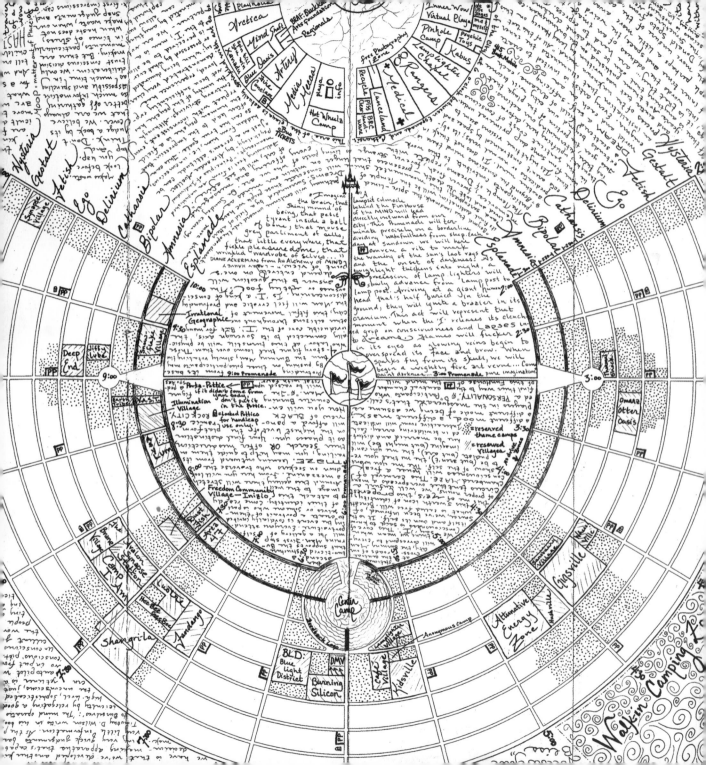